Una Linda Raza

A cada tierra, su uso.
Every land has its own customs.

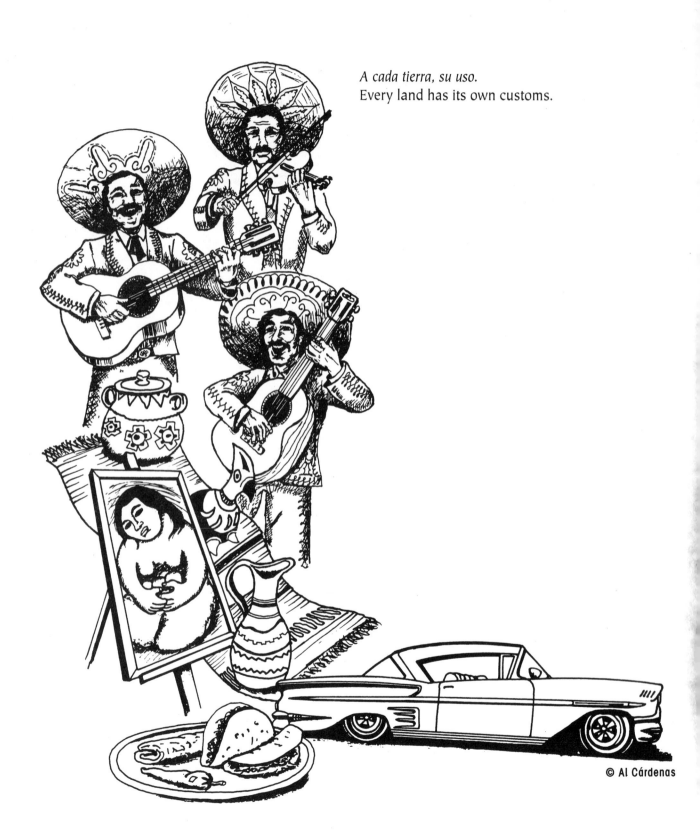

Una Linda Raza

Cultural and Artistic Traditions
of the Hispanic Southwest

Angel Vigil

FULCRUM PUBLISHING

GOLDEN, COLORADO

I dedicate this book to my daughters Tess and Sarah.

Copyright © 1998 Angel Vigil

Cover design by Deborah Rich
Cover painting © 1998 Carlos Frésquez
Graphics © 1998 Al Cárdenas
Interior art © 1998 Carol Kimball

Library of Congress Cataloging-in-Publication Data
Vigil, Angel.
 Una linda raza : cultural and artistic traditions of the Hispanic Southwest / Angel Vigil.
 p. cm.
 Includes bibliographical references and index.
 ISBN 1-55591-958-8 (paperback)
 1. Hispanic Americans—Southwest, New—Social life and customs—Miscellanea. 2. Hispanic Americans—Social life and customs—Miscellanea. 3. Southwest, New—Civilization—Spanish influences—Miscellanea. 4. North America—Civilization—Spanish influences—Miscellanea. 5. Hispanic American arts—Southwest, New—Miscellanea. 6. Hispanic American arts—Miscellanea. I. Title.
F790.S75V54 1998
305.868073—dc21 97-24290
 CIP

Printed in the United States of America

0 9 8 7 6 5 4 3 2 1

Fulcrum Publishing
350 Indiana Street, Suite 350
Golden, Colorado 80401-5093
(800) 992-2908 • (303) 277-1623
e-mail: fulcrum@fulcrum-books.com • fulcrum@fulcrum-resources.com
websites: www.fulcrum-books.com • www.fulcrum-resources.com

Credits for Illustrations, Photography and Written Works

The frontispiece is by Alfredo Cárdenas. © 1996. Used by permission.

The drawings of the Spanish *conquistador,* p. 1, the Texas Franciscan missionary, p. 3, and accompanying text are reprinted from *Riders of the Border* by José Cisneros, Texas Western Press, El Paso, Texas, © 1971. Used by permission.

The photo of Mission San Juan Capistrano, p. 4, courtesy of the Museum of New Mexico. Photo by George Law, 1925. Negative number 46368. Used by permission.

The map of the states and territories formed from the Mexican Cession and Gasden Purchase, p. 5, is reprinted from *Latino American Encyclopedia,* vol. 6, courtesy of Marshall Cavendish Corporation, Tarrytown, New York, © 1996. Used by permission.

The stories *The Five Suns,* p. 9, *Our Lady of Guadalupe,* p. 47, *The Three Branches,* p. 100, and the play *La Batalla de Cinco de Mayo,* p. 204, by Angel Vigil are reprinted with the permission of Libraries Unlimited, Englewood, Colorado; (800) 237-6124.

The Aztec Sun Stone image, p. 16, reprinted from *American Designs,* Hart Publishing Company, © 1979. Public domain image.

The stories *Los Tres Ratoncitos,* p. 104, and *'Mana Zorra and 'Mano Coyote,* p. 106, retold by Angel Vigil. © 1996.

The image of the Vigil family crest, p. 21, reprinted from *V. & H.V. Rolland's Illustrations to the Amorial General* by J. B. Rietstap, published by Genealogical Publishing Co., Inc., Baltimore, Maryland, © 1967. Used by permission.

Photograph of Jennifer Trujillo's *Quinceañera,* p. 23, reprinted with permission of Dolores D. Trujillo. Photo by Angel Vigil, © 1996.

The photo of the Hispanic wedding procession, p. 30, courtesy of the Museum of New Mexico. Photo by B. Brixner. Negative number 12034. Used by permission.

La Entriega verses and translation, p. 34, *los Días* verse, p. 53, and *aguinaldos* verse, p. 55, are reprinted with the permission of Olibama Tushar and Charlene Garcia Simms, *El Escritorio* Publishing, Pueblo, Colorado.

The dance description of *Marcha de los Novios,* p. 31, adapted from *La Entriega de los Novios,* by Dr. Lorenzo A. Trujillo and Marie Oralia Trujillo. Used by permission.

The music transcription of *Marcha de los Novios,* p. 32, by Dr. Brenda Romero, © 1995. Used by permission.

The article, "*Día de los Muertos,*" p. 40, is by Dr. George Rivera, © 1996. Used by permission.

The photos of the family gravesite vigil, p. 40, and the gravesite decoration, page 41, by Dr. George Rivera, © 1996. Used by permission.

The instructions and illustrations for making *pan de muertos,* p. 44, and making a star *piñata,* p. 91, are from *Look What We've Brought You from Mexico* by Phyllis Shalant. © 1992 by Silver Burdett Press, Simon & Schuster Elementary. Used by permission.

The photo of *Los Pastores,* p. 52, courtesy of the Museum of New Mexico. Photo by Aaron B. Craycraft. Negative number 13695. Used by permission.

The music and verses of *Los Días,* p. 54, are reprinted with the permission of Drs. Bea Roeder, Brenda Romero and Lorenzo Trujillo. The verses are from the Ruben Cobos Collection of New Mexican Hispanic Folklore at Colorado College, Colorado Springs, Colorado.

The music of *Los Aguinaldos,* p. 55, is reprinted from Américo Paredes, *A Texas-Mexican Cancionero: Folksongs of the Lower Border.* Urbana: University of Illinois Press, 1976.

The photo of Don Julio, p. 65, is by George Rivera, © 1996. Used by permission.

The photo of the Chimayó weaver, p. 69, courtesy of the Museum of New Mexico. Photo by T. Harman Parkhurst. Negative number 6918. Used by permission.

The photo of the *jerga* weaving, p. 70, courtesy of the Museum of New Mexico. Photo by Arthur Taylor. Negative number 71538. Used by permission.

The photo of the *Saltillo* blanket, p. 71, is reprinted with the permission of the Colorado Springs Fine Arts Center, Colorado Springs, Colorado. Photo number 1017.

The photo of the *Rio Grande* blanket, p. 71, reprinted with the permission of the Colorado Springs Fine Arts Center, Colorado Springs, Colorado. Photo number 882.

The photo of the *Chimayó* blanket, p. 72, by Angel Vigil, © 1996.

The photo of the *reredo,* p. 74, courtesy of the Museum of New Mexico. Negative number 48651. Used by permission.

The photo of the San Ignacio de Loyola *retablo,* page 75, reprinted with the permission of José Esquibel. Photo by Angel Vigil, © 1996.

The photo of Our Lady of Guadalupe *bulto,* page 76, reprinted with permission of Juan D. Martínez. Photo by Angel Vigil, © 1996.

The photo of the San Miguel *bulto*, p. 76, reprinted with the permission of the Colorado Springs Fine Arts Center, Colorado Springs, Colorado. Photo number 2362.

The photo of the Mexican *colcha*, p. 78, reprinted with the permission of the Colorado Springs Fine Arts Center, Colorado Springs, Colorado. Photo number 842.

The photo of *Los Días colcha* embroidery, p. 78, is reprinted with the permission of Josephine Lobato. Photo by Angel Vigil, © 1996.

The *colcha* blanket activity, p. 79, is adapted with the permission of Marie Vescial Risbeck. The original article appeared in the November/December 1993 issue of *Piecework* magazine, Interweave Press, Loveland, Colorado.

The *colcha* picture activity, p. 82, is adapted with the permission of Josephine Lobato.

The tin *nicho* photo, p. 83, is reprinted with the permission of Paul A. Zamora. Photo by Angel Vigil, © 1996.

The photo of Francisco Delgado, p. 84, courtesy of the Museum of New Mexico. Photo by T. Harmon. Negative number 71180. Used by permission.

The tin lantern, p. 85, and *Papel Picado*, p. 95, activities and design templates are adapted from workshop handouts by Angelique M. Acevedo, © 1996. Used by permission.

The photo of the Huichol Indian, p. 96, by Donald Cordry from *Mexican Indian Costumes* by Donald and Dorothy Cordry, copyright © 1968. Used by permission of the University of Texas Press.

The photo "Three Musicians of the *Baile*," p. 118, courtesy of the Museum of New Mexico. Oil painting by Bert Phillips. Negative number 19396. Used by permission.

The photo "Corpus Christi procession," p. 123, courtesy of the Museum of New Mexico. Negative number 144801. Used by permission.

The music and verses of *Las Mañanitas*, p. 124, are reprinted with the permission of Dr. Brenda Romero, © 1996.

The music and verses of *De Colores*, p. 127, from *Songs of Mexico* by Jerry Silverman, © 1994 by Mel Bay Publications, Inc., Pacific, MO 63069. All rights reserved. International copyright secured. B.M.I., used by permission.

The photo of Groupo Tlaloc, p. 132, is by Saul Pliuskonis, © 1994. Used by permission.

The photos of *Los Matachines de Pueblo*, pp. 137–138, are reprinted with the permission of *Los Matachines of Pueblo*. Photos by Angel Vigil, © 1996.

The music and dance description of *El Valse de la Escoba*, p. 142, are reprinted from *Music of the Bailes of New Mexico* (IFAF, 1978) by Richard Stark, The International Folk Art Foundation, Santa Fe, New Mexico. Used by permission.

The music and dance description of *Valse de los Paños*, p. 143, are reprinted with the permission of Dr. Lorenzo Trujillo, © 1996.

The photo of *Su Teatro*, p. 151, is reprinted with the permission of *Su Teatro* © 1996. Photo by Daniel Salazar.

The play *Cuentos*, p. 153, is reprinted with the permission of Dr. Carlos Morton and Angel Vigil, © 1988.

The photo of the mural, p. 174, is reprinted with the permission of Carlos Fresquez. Photo by Angel Vigil, © 1996.

The photo of the mural, p. 175, is reprinted with the permission of The Art Center of the West/ Denver Civic Theatre, Denver, Colorado. Photo by Angel Vigil, © 1996. (Fig. 18.2)

The photo of the mural, p. 175, is reprinted with the permission of Carolota Espinoza. Photo by Angel Vigil, © 1996. (Fig. 18.3)

The photo of *Barrio* Logan mural, p. 176, is by Mary Motain-Meadows, © 1996. Used by permission.

The mural-making activity, p. 177, is adapted from a workshop handout by Anthony Ortega. © 1996. Used by permission.

The photo of the lowrider car, p. 184, is reprinted with the permission of Alfredo Herrera. Photo by Angel Vigil, © 1996.

The photograph of the lowrider bicycle, page. 186, is reprinted with the permission of LeRoy Rodríguez. Photo by Angel Vigil, © 1996.

The photo of preparing and cooking *chile*, p. 189, courtesy of the Museum of New Mexico. Photo by Irving Rusinow. Negative number 9367. Used by permission.

The chile poem, p. 189, is reprinted with the permission of Abelardo B. Delgado, © 1996.

The recipes *Tortillas*, p. 193, *Calabacitas*, p. 193, *Posole*, p. 193, *Menudo*, p. 194, *Arroz a la española*, p. 195, *Sopaipillas*, p. 195, *Empanaditas*, p. 196, *Biscochitos*, p. 197, *Capirotada*, p. 197, *Flan Caramelisado*, p. 198, and *Atole*, p. 198, are adapted from *Comidas de New Mexico* by Lucy Delgado, © 1979. Adapted with the permission of Angelina Delgado Martínez.

The music of *Juan Charrasqueado*, p. 216, and *Valentín de la Sierra*, p. 217, are reprinted from *Hispanic Folk Music of New Mexico and the Southwest* by John Donald Robb, University of Oklahoma Press, Norman, Oklahoma, © 1980. Used by permission.

The activities, information, photographs, stories and plays by Angel Vigil throughout this book are reprinted with his permission.

The illustrations by Carol Kimball throughout this book are reprinted with her permission.

The graphics by Alfredo Cárdenas throughout this book are reprinted with his permission.

Contents

Foreword

By Rudolfo Anaya

With the ever-expanding role of the Hispanic community in the United States, it behooves teachers everywhere to make their students aware of this cultural group. But teachers often complain that they don't include elements of Hispanic culture in their classrooms because they have no guide to follow. *Una Linda Raza* is the perfect guide, both for teachers and the general reader.

Angel Vigil has not only given us a history of the coming of the Spaniards to the New World, he has documented the indigenous Native American role. He presents a thoughtful and balanced review of historical events in México and in the Southwest, bringing us to the present day.

But what really makes this book a gift to teachers is the inclusion of many teaching activities. Here you find precise lesson plans, from building a *piñata* to researching your family's genealogy. There are songs to sing, riddles to solve, plays to enact in the classroom and history lessons to learn.

All of the activities are grounded in a cultural setting. When you read about the Christmas *Posadas* or *Los Pastores*, the background is provided. One is never lost in this book; the path is carefully laid out. The mixing of the Old World customs with the Native American traditions blossoms as we are taught how things came to be.

The strength of *Una Linda Raza* is not only the history it presents, but that it presents cultural concepts in concrete plans that engage the student. This is a wonderful "hands-on" book. Each activity is presented in a clear and thorough manner. This book is truly for all those teachers who have waited for a guide to teaching the Hispanic culture.

The cultural ways of this Spanish-speaking community of the borderlands are alive today. Living next door to Latin America assures us that the culture will constantly be enriched. Many of the activities in the book are reflected in daily life. But whether you live in the Southwest or not, your students will profit from this book. Dip in and join us in learning why we call our community *una linda raza*.

—Rudolfo Anaya

Preface

(the *cuento* of this book)

The oft-quoted aphorism "It takes a whole village to raise a child" is especially realized in Hispanic culture. With the family being the most important aspect of Hispanic life, extended Hispanic families serve as the "village," providing a supporting and nurturing environment for both children and adults. Before the urbanization of Hispanic life in this century, rural families lived close to each other, sharing the work and resources of the family farm. Even with the urbanization of Hispanic culture, families often live in the same neighborhood, thus facilitating regular contact among family members.

A unique system in Hispanic culture that further enhances the extended family and its role in nurturing and raising children within the culture is the system of *compadrazgo* (co-paternity). Parents select a child's *padrinos* (godparents) at the time of a child's baptism or confirmation. The *padrino* can be either a family member or a non-family member. The *padrinos* become godparents to the child and *compadres*, or co-parents, to the parent. This special honor gives parents lifelong *compadres* and gives children lifelong *padrinos*. The *padrinos* become second parents to the child, and the parents have another set of adults to assist with the raising of their children. *Compadrazgo* contributes to the family in the manner in which it extends and strengthens the family. Also, even though family members could be *padrinos*, the frequent choosing of non-family members results in whole communities being related by marriage, blood or the system of *compadrazgo*. With *la familia* being the central aspect of Hispanic culture, the system of *compadrazgo* strengthens the culture by creating communities with close family ties, common values and shared responsibilities.

The greatest benefit of the Hispanic extended family experience is in the inter-generational exchanges that are possible when relatives live either in the home or nearby. In the extended family, children know their grandparents. Aunts and uncles know their nieces and nephews, and cousins are each other's playmates. Within the experiences of the extended family, parents find support in raising their children from other family members. Each family member has a life centered in *la familia*. Each gives to *la familia*, and in an elegant reciprocity *la familia* nourishes each member.

I grew up in an extended Hispanic family, enhanced by the system of *compadrazgo*, in New Mexico. My daily life was filled with the activities of childhood—school, play and family. My own family of parents, two sisters and a brother was the center of my world. But my extended

family of grandparents, aunts, uncles, cousins, *compadres* and *padrinos* was also at the center of my childhood experiences.

My most common childhood memories involve family gatherings—large family gatherings. Birthday parties, weddings, baptisms, Easter, Christmas, church, picnics and, yes, even funerals. My playmates were not my friends from school but rather my cousins. Two of my cousins and myself were the three musketeers, inseparable, one for all and all for one.

My childhood memories are filled with details of this extended family. Even the passing of the years and the dimming of adult memory has not faded these early memories. A simple recitation of a few of these memories reveals a rich life centered in family experience and strong in folklore heritage.

I remember going to my grandmother's farm and eating a delicious white homemade goat cheese with a heavy sweet molasses poured on it. I can hear my father singing an old joyous Spanish song at a wedding. I can taste the fresh, warm, just-off-the-griddle, jam-covered tortillas my aunt made especially for me whenever I came for a visit. I can feel the small hard beans under my little fingers as I sort them from one pile to another, carefully completing my childhood job of cleaning the beans by picking out the rocks before the beans are cooked. I can see my mother kneeling and praying, eyes closed, hands folded, before the altar to *"la Virgen"* she kept in her bedroom. I can hear my mother sternly admonishing me not to turn around in church or I'd turn to stone. I can hear the rustle of my sister's fancy, lacy white First Communion dress. I can see my parents, aunts and uncles sitting around a large round kitchen table at my grandfather's house, sharing a pot of *posole* with red chile, telling *cuentos*, laughing and reminiscing about the good old days, their own childhood. I can hear the hushed, droning, muffled voices of my aunts saying the rosary at a *velorio*, or wake, before a funeral. I can feel my parents' warm and firm hands on my head as they gave me their blessing when I left home.

These memories and many more reveal a truth about my family. I did not realize or appreciate this truth until I discovered it as I was working on my first book, *The Corn Woman: Stories and Legends of the Hispanic Southwest*. In the research phase of writing this book, I had accomplished the scholarly work of researching and reading original sources and recording many hours of field recordings of *los ancianos*, the elderly of the Hispanic community. Only after sharing my work with my mother and aunts did I discover an important truth—my own family was a source of folklore. My mother and her sisters shared their childhood memories with me to such an extent that they have become a final and confirming rich source of cultural knowledge for the books I write.

This realization that my own family was a living example of Hispanic cultural practices changed the way I viewed my childhood. As an adult I now look back on my childhood memories and realize that living in an extended Hispanic family meant much more than just having a lot of relatives and seeing them often. My own memories confirm that my family itself was a repository of generations of Hispanic culture. Without consciously determining their purposes, my grandparents, parents, aunts and uncles had passed on the traditions of Hispanic culture to the

following generation simply by continuing the family practices as they themselves had experienced them in their own childhood.

In my present life as an artist, educator and author, I am deeply aware of the importance my family has played in making me the person I am today. Only recently have I come to appreciate that all my cultural awareness about myself as a Hispanic person also originated with my family. Now I realize that I too am a repository of Hispanic cultural traditions and practices. Within my own family it is now my turn to pass on this culture to my own children. That the family is at the center of Hispanic culture is a truth all Hispanics know in their hearts. Culture is created and continued in the crucible of the family. Generation after generation have passed on the wisdom of the elders, the deep appreciation of spirituality, the love of the land and the lore learned from years of experience. Culture flourishes because families have continued to practice the traditions of previous generations.

While traditional Hispanic culture has a strong legacy in families and communities, the negative aspects of urban life have placed a litany of ills upon Hispanic culture that is lamented by parents and educators alike. Even a cursory survey of these ills reveals a culture under stress: the breakup of the extended family, the weakening of the church as a centering spiritual force in communities, the crisis in education, the loss of Spanish as a primary language, the xenophobia of forces devaluing Hispanic culture's contributions to American society, the troubling questions about race and culture in American society and, lamentably, the loss of cultural traditions among Hispanic youth today. Often it appears as if Hispanic culture is at its greatest crisis just as the Hispanic community is positioned to soon become the largest American minority group.

Even with the stark realization that Hispanic culture is threatened from both external and internal forces, there are positive signs of the culture's vibrancy and perseverance. One reassuring aspect of Hispanic culture is that, in spite of its present struggles, Hispanic culture is a centuries-old presence in America. Its roots are old and deep. Its traditions are strong because they developed over centuries and through generations. Its cultural practices remain within the experiences of the family.

Another positive development is the deliberate effort communities throughout the Southwest are making to reestablish traditional practices. Communities, families and individuals are searching for ways to maintain a historical cultural heritage in the environment of late-twentieth-century America. Their efforts are not only to preserve cultural traditions but to create them anew with new meaning in a modern cultural context.

A third sign of the culture's enduring spirit is the development of school curriculum that is more culturally sensitive and inclusive of diverse American experiences. In school, students can learn about cultural traditions in classroom activities, and this learning can help reinforce and extend family experiences.

Churches, community centers and art centers are leading the way in sponsoring culturally based activities, both religious and artistic, as a strategy to strengthen and support individuals, families and communities. Visual, performing and literary artists are building upon the works of the past to give new voices to their

That the family is at the center of Hispanic culture is a truth all Hispanics know in their hearts.

cultural heritage. And schools are realizing the value of recognizing the beauty, wisdom and contributions of diverse student populations.

Like a story unfolding through time, Hispanic culture endures, growing and changing as each new generation makes its own contributions. The story begins in the daily living experiences of the family, continues out to the shared life of a community and returns confirmed and strengthened to the family. Culture and tradition really are a never-ending story. The childhood memories of one adult are part of a mosaic of shared memories and family practices, the whole of which form the culture of a people.

And so ends the *cuento* of this book, a book that begins with the discovery of memories of childhood and journeys through the realization of a family's cultural heritage. This book represents my deep belief that Hispanic culture has great contributions to make to society. It also is my effort to assure that its beauty extends beyond my own family. I also hope that this book about the cultural and artistic traditions of the Hispanic Southwest will help people of all cultures recognize part of themselves in the practices of the Hispanic culture, and thereby recognize that we are all part of a greater spirit, the human culture we all share.

Acknowledgments

This book is the result of the generous contributions of many people. They have supported this project both personally and professionally. Personally, they provided me with a supportive network of friends with whom to share my enthusiasm. Professionally, they have shared their own great knowledge of Hispanic culture, language and tradition and through their contributions, greatly improved the thoroughness of the book.

I wish to thank my editor, Suzanne Barchers, for providing me the opportunity to write this book, as well as my publisher, Fulcrum Publishing, for their commitment to publishing books about Hispanic culture.

I am once again greatly indebted to my illustrators, Carol Kimball and Afredo Cárdenas, for sharing their beautiful and sensitive artistry on another one of my projects.

Dr. Carlos Morton, Olibama López Tuschar, Carlos Frésquez, José Esquibal, Dr. George Rivera, Saul Pliuskonis, Anthony Ortega, Mary Motain-Meadows, Donie Nelson, Angelique Acevedo, Cynthia Baca, Angelina Delgado Martínez and Patricia Sigala all graciously provided material for the book, as well as innumerable insightful comments.

I wish to especially acknowledge the support and help of Dr. Bea Roeder, Dr. Brenda M. Romero and Dr. Lorenzo Trujillo. Their careful reading and editing of the text improved its depth and quality immeasurably. Most of all, I appreciate their personal support and belief in this project. I respect each of them greatly and am honored they gave of their time, knowledge and friendship.

Finally, I wish to thank my family, my wife Sheila and my daughters Tess and Sarah. Their support, love and understanding throughout the project was all that any writer would hope for from his family.

Introduction

Una Linda Raza is a presentation of the primary cultural and artistic traditions of the Hispanic Southwest. The book is intended to be a general introduction and guide to the cultural and artistic practices in the daily lives of the Hispanic people of the American Southwest. In addition to thorough descriptions of the origins and meaning of cultural traditions, the book also includes activity guides for families, schools and cultural centers interested in learning and practicing the various cultural traditions. In this manner *Una Linda Raza* gives the reader a guided introduction to the traditions of one of America's oldest cultures.

This book strives to present the beauty behind the cultural and artistic traditions of the people of the Hispanic Southwest. *Una Linda Raza* means "A Beautiful People." The true beauty of a people is not in their physical appearances but in the strength of their efforts to live a good life on this earth: a life with spiritual meaning, a life centered on the nurturing strengths of the family, a life of sharing and giving to the larger community. The cultural practices of a people are the ways and means by which they express their understanding of their life and by which they attempt to bring goodness to their families, their children and their communities. The most life-fulfilling cultures have a resonate wholeness through which they provide their people the means to integrate all aspects of life and living. By studying and sharing the cultural practices of another culture it is possible to come to understand them in the best way possible—to see them as they see themselves. *Una Linda Raza* is a glimpse into the heart and soul of the people of the Hispanic Southwest.

> The true beauty of a people is not in their physical appearances but in the strength of their efforts to live a good life on this earth: a life with spiritual meaning, a life centered on the nurturing strengths of the family, a life of sharing and giving to the larger community.

WHY ARE SOME TRADITIONS IN THE BOOK AND SOME NOT?

One of the great pleasures of compiling a book such as this is collecting people's suggestions as to what traditions to include in the book. Undoubtedly, however, there will be disappointments about what is left out. Because this is a general introduction to the cultural and artistic traditions of the Hispanic Southwest it does not include every tradition possible. The Hispanic culture of the American Southwest extends from Texas to California and includes traditions ranging from the Spanish Colonial New Mexicans to the Mexican-influenced people in the cities of southern California. It includes an older generation that is still connected to a rural life, a generation that fought with valor in World War II, Mexican and Latin American immigrants, college-educated middle-class families as well as a vibrant younger generation. All of these are

dedicated to participating in the American way of life, contributing to the American economy and culture and searching for their place in the "American dream."

From rural farmers to urban lowriders, Hispanic culture is amazingly diverse and varied. The effort in this book is to find a common ground, a shared set of cultural traditions that takes the aspirations and traditions of such a varied people and represents the common culture they all share. Of course, within any large and diverse group such as this, there will be differences of cultural practices and experiences, depending on personal and family practice, as well as regional diversity and variation. While there are traditions that are not covered in this book, the book does intend to be a thorough presentation of the primary Hispanic traditions in the Southwest. These primary traditions are the cultural practices that are common, shared and valued throughout much of the Southwest. In addition, many regional customs are included to enrich the awareness of the diversity of the region's Hispanic culture. The goal of the book is to allow the reader to be able to recognize, understand and participate in these cultural traditions as they exist in the southwestern states that were once part of Mexico: Texas, Colorado, New Mexico, Arizona, Utah, Nevada and California.

A guiding image for this book and its selection of customs and traditions is the traveler who journeys from southern Texas, up through New Mexico, into Colorado, across Utah, down through Arizona, through Nevada and then on to southern California. This book presents the practices, the sights and sounds that this traveler would most commonly and frequently encounter on the cultural journey through the Hispanic Southwest. Imagine a pause for a meal, an invitation to a home for a family celebration, a visit to a church, a stop at an art center, a night at a community celebration, a walk through the old section of the town. Each of these stops along this cultural journey is an opportunity to experience the richness and diversity of Hispanic culture in the Southwest. And each of these stops will affirm the shared cultural traditions common to the people of the Hispanic Southwest.

The evolution of Spanish culture through its development in the New World over centuries has also produced cultural traditions that are uniquely expressed in the American Southwest.

HOW IS THIS BOOK ORGANIZED?

The book begins with a discussion of the history and settlement of the Hispanic people in the American Southwest. This historical overview seeks to establish the southwestern Hispanic culture within the historical context of the momentous merging of European culture with the indigenous culture of the New World. The evolution of Spanish culture through its development in the New World over centuries has also produced cultural traditions that are uniquely expressed in the American Southwest. This beginning chapter addresses the question How did we get here?

The book organizes its information on cultural and artistic practices according to traditions and within the context of a family's and community's life. The intention is to place the information in categories that help reveal the relationships between cultural traditions. Each section has a discussion of the origins and meaning of the cultural tradition. These discussions address the question Why do we do the things we do?

Here's a list of short summaries of the sections of the book:

Part I. *La Historia*—**A Short Version of a Long Story.** The history and settlement of the Hispanic people in the American Southwest.

Part II. *La Familia*—**Family Celebrations.** An introduction to the renewed family and community interest in the study of Hispanic genealogy. Also, three celebrations and periods of transition within family life: coming of age, marriage and death.

Part III. *La Iglesia*—**Religious Celebrations.** Four religious traditions in the month of December: the Feast of Our Lady of Guadalupe, *Los Pastores* (The Shepherds' Play), *Las Posadas* (The Christmas Story), and *Los Días* (The New Year's Day Procession).

Part IV. *Curanderismo*—**The Healing Arts.** The role of *la Curandera,* the healer, and the importance of *remedios,* natural remedies, in Hispanic culture.

Part V. *Las Artes*—**The Arts.** This large section presents many traditional arts and crafts—and cooking—as well as new artistic expressions in Hispanic culture.

Part VI. *El Mundo*—**The Affairs of the World.** Two historical and political celebrations: *El Diez y Seis de Septiembre* and *El Cinco de Mayo.*

HOW DO I PARTICIPATE IN A CULTURAL ACTIVITY?

Each chapter includes activities. The activities are simple and general, and most importantly, low cost. None require the practiced hand of the artist or craftsperson. And each is within the capability of the family, the generalist and the classroom teacher. The primary purpose of the activities is to learn about the cultural tradition. An equally important purpose is to have fun participating in a cultural tradition and making something of cultural value. A family can use the activities to continue or reestablish cultural traditions in the family. A classroom teacher or youth leader can use the activity guides as part of a general curricular unit.

A wide range of activities are presented in order to give the reader a diverse set of choices, depending on personal and classroom interest, time and resource availability, student age, student developmental and skill level and teacher educational goals. In addition to the usual and expected arts and crafts activities, this book includes unique activities from the fields of genealogy, storytelling and theater. The activities are designed to be self-explanatory with carefully guided instructions.

The activities are meant to be used by schools and community centers wanting to have Hispanic-based activities as part of their classes or program. Of course, the greatest hope is that these activities will become family activities enjoyed by adults as well as children. The activities fall into several general categories:

Arts and Crafts. These are learning projects requiring the collecting of necessary materials and the careful following of instructions. The goal of these activities is the construction of Hispanic art or folklore objects that can be used in cultural activities and traditional arts. Each activity explains the history and meaning of its particular tradition.

- Design and make a Day of the Dead *ofrenda* (altar).
- Make *Pan de Muertos* (bread for the *Día de los Muertos* celebration).
- Make an *aguinaldo* (little gift) for *Las Posadas*.
- Make a *retablo* (altar piece) portraying a saint.
- Make a *colcha* (quilt) blanket.
- Make a *colcha* picture.
- Make tinwork lanterns and frames.
- Make a *piñata*.
- Make *papel picado* (a cut-paper decoration).
- Make an *Ojo de Dios*.
- Make a *farolito/luminaria* (candle-lit paper bag).
- Make *cascarones* (eggshells).
- Design and make a community or classroom mural.

Research, Study and Writing Projects. Some traditional practices provide opportunities for more intellectual activities, as compared with other more hands-on, craft-oriented activities. Designed for an older student, they contribute to the intellectual engagement of the older, more mature child in a family setting as well.

These projects do not have the "let's-make-it-in-one-afternoon" aspect of the arts and crafts projects, but they will result in a deeper, more long-lasting educational experience.

- Research and make a personal calendar pictograph.
- Research and write *cuentos*.
- Research and complete a family genealogical chart.
- Research and design your own *quinceañera* (girl's fifteenth birthday celebration).
- Research and write an *Entriega* (the verses of advice for newlyweds).
- Research and compare traditional and modern herbal remedies.
- Research weaving styles, natural dye colors and local weavers.
- Research folk proverbs and riddles, and base a creative writing story on them.

Traditional Stories. These stories are meant to be read alone or aloud with a group, and most definitely they are meant to be passed on. Storytelling is a great activity enjoyed by children and adults alike. No special preparations are necessary. People are natural storytellers and children love to listen to a good story. Just turn off the TV, snuggle into a favorite chair and let yourself slide into the world of the story. Even better, gather the children or your friends around and tell the story. You can present the school librarian's version of the story by reading it aloud or be bold and enter the realm of the traditional storyteller and tell your own version of the story.

This book presents five stories, representing various aspects of the oral tradition of the Hispanic Southwest. Each of the five stories in this book represents a major story category. The activity guides that follow each story are designed to introduce the qualities defining the story category and to provide activities for further understanding of the story and its category type.

The activities are all creative writing activities. The instructions suggest an outline to follow to help organize ideas and to structure the writing. The end goal of these writing exercises is to share the stories with family, friends or classmates.

The stories created in these writing activities can be either read or told from memory. If told from memory remember to instruct children (or adults) that oral storytelling does not have to be strictly and exactly memorized. It is more important to remember the major parts of the story and to allow yourself to improvise the story as it is told.

This book has creative writing activity guides following each of these stories:

1. "The Five Suns"—Aztec myth of creation
2. "Our Lady of Guadalupe"—religious story
3. "The Three Branches"—religious story
4. "*Los Tres Ratoncitos*"—chiste
5. "*'Mana Zorra and 'Mano Coyote*"—a children's animal trickster tale

Plays. Hispanic culture has always had theater as part of its cultural experience. Two plays about various aspects of Hispanic culture are presented in this book. The play scripts presented are a unique addition in a book about cultural practices.

The plays in this book can be used in two ways. The first is to present an informal or classroom reader's theater presentation or staged reading of the play. Reader's theater is a long-established practice in educational theater and works well in school, community and family situations. Staged readings are a standard event in professional theater. The techniques of both are very similar and lend themselves very well to amateur reading of plays. Gather the players and the audience (if there is one), assign the parts and read the play aloud. After reading the play lead a discussion about the meaning of the play and its relevance and place in Hispanic culture.

A second choice is to do a production of the play. Please be advised that the plays in this book are subject to royalty and permission requirements. Professional and amateur theaters wishing to produce the plays must secure performance rights and pay royalty fees. Those interested in producing the plays need to contact the publisher about these arrangements.

- *Cuentos*—a modern *teatro* play
- *La Batalla de Cinco de Mayo*—a historical play

Music. Several transcriptions of Hispanic songs are included. These songs are intended to give the reader the additional choice of playing selected traditional songs. The music is intended for the reader (or willing friend of the reader) who can play an instrument and enjoys actually hearing what a traditional song sounds like.

- "*La Marcha de Novios*"—wedding march
- "*Los Días*"—New Year's tradition
- "*Los Aguinaldos*"—New Year's tradition
- "*Valse de los Paños*"—traditional waltz
- "*El Valse de la Escoba*"—traditional waltz
- "*Las Mañanitas*"—birthday song
- "*De Colores*"—traditional song
- "*Valentín de la Sierra*"—Mexican *corrido*
- "*Juan Charrasqueado*"—Mexican *corrido*
- "*La Llorona*"—traditional song

Dance. It is the experience of the author that it is impossible to reconstruct a dance on paper, even with musical notation and the well-known "footsteps-on-the-page" diagrams. A common comical anecdote shared among teachers and youth leaders is the description of their efforts to make a dance with children following the diagrams and descriptions on the written page.

Dance is a social and physical activity and is best learned by the traditional and proven master-apprentice method. The best way to learn a dance is to have someone teach it to you or to jump in when a group of people are doing the dance. Fortunately, the dedicated efforts of Hispanic people throughout the Southwest to maintain and preserve their culture have resulted in many communities having dance groups and dance teachers presenting and offering classes in the traditional dances.

For a teacher, youth leader or parent who wants to learn how to do the dances described in this book or how to have Hispanic dance as a recreational activity, the best way to learn the dances is to join a local group or take a few classes at a local community center, church or arts center. Almost all community celebrations of *El Cinco de Mayo*, *El Diez y Seis de Septiembre* and other Hispanic events will have a local dance group, usually consisting of both adults and children, performing the traditional dances. These groups are always eager for new students and members. Direct participation in dance is the fastest, easiest and, by far, most enjoyable way to learn the traditional dances of the Hispanic Southwest. The greatest benefit of this approach is that it is the best way to experience the real beauty and meaning behind Hispanic dance—to express the joy of the culture and the meaning it has as an expression of cultural pride and unity.

Even with the above comments in mind, I have included activity guides with music for three simple group dances. These simple dances can be constructed by a careful following of directions. The described dances are easy and fun group dances, worth the time to learn and dance. These dances are equally suited for adults, families and children.

- *"La Marcha de Novios"*—wedding march
- *"Valse de los Paños"*—traditional waltz
- *"El Valse de la Escoba"*—traditional party game waltz

Traditional Recipes. These recipes were selected as a sampling of traditional foods. The recipes are meant to be adult-supervised activities. Several of them require the frying of foods, and, of course, children should never be left alone in the kitchen cooking with hot oils. For families, adults and children, cooking together is one of the best family-enhancing experiences possible. For adults the cooking of these recipes will give the cook, and lucky diners, the experience of eating the rarest of cuisines—home-cooked traditional foods.

- *Chile Verde*—green chile
- *Frijoles*—beans
- *Tortillas*
- *Calabacitas*—green summer squash
- *Posole*—hominy stew
- *Menudo*—tripe soup
- *Arroz a la española*—Spanish rice

- *Sopaipillas*—fried bread
- *Empanaditas*—mincemeat-fried turnovers
- *Biscochitos*—anise cookies
- *Atole*—blue cornmeal drink
- *Capirotada*—bread pudding
- *Flan Caramelisado*—caramel flan

WHAT ABOUT ALL THE SPANISH IN THE BOOK?

This book is written for the general English-speaking reader who has no knowledge of the Spanish language. It is important to use the language that is a central part of the Hispanic experience. The use of Spanish gives the book's discussions cultural integrity and gives the reader enhanced knowledge of actual cultural terminology. Throughout the book all Spanish words and terms are italicized, and a glossary of the Spanish used in the book appears at the end of the book.

WHAT DO THE SPANISH SAYINGS BEFORE EACH CHAPTER MEAN?

The Spanish sayings are *dichos*, folk proverbs. Hispanic culture is especially rich in *dichos* as part of its oral traditions. There are *dichos* for almost every imaginable situation. The *dichos* open each section as a reflective bit of folk poetry and wisdom to preface the discussions of the various topics of the book.

The use of Spanish gives the book's discussions cultural integrity and gives the reader enhanced knowledge of actual cultural terminology.

WHY ARE MODERN ARTISTS PROFILED IN A BOOK ABOUT OLD TRADITIONS?

One of the primary points of awareness this book strives to make is that Hispanic artists are leading a Renaissance of traditional cultural and artistic practices. While the traditions presented in this book are based in older practices, they are in no way museum artifacts—yet. The maintenance and preservation of cultural traditions requires committed, skilled and aware individuals comprising families and communities that value their cultural practices. This book presents modern artists as models of the way individuals are maintaining and reestablishing their traditions in their communities.

WHY IS THE WORD "HISPANIC" USED IN THIS BOOK?

It is very important to pay attention to the language used in describing a people and their culture, especially in our era of cultural and political sensitivity. There is often confusion as to what to call the descendants of the Spanish *conquistadores*, especially those living in the American Southwest. Also, there are diverse opinions as to what is the correct word to use: "Hispanic," "Mexican-American," "Spanish," "Chicano," "Latino." Each term has its advocates and detractors. Each term has its historical origins, and each term has its proper application.

Of course, the real answer is to call people what they want to be called. But even within the Hispanic community there is great divergence of opinion as to what is the correct term. But Hispanic culture consists of many individuals, and one of its great beauties and strengths is its own diversity.

In truth there is no one correct term. Sensitivity, awareness and

knowledge are the only true guides. Sensitivity reminds us that people value ethnic terms that accurately reflect their ancestry and personal values. Awareness teaches us that ethnic identification is affected by history and its fluid events. Knowledge gives us the understanding of why one term is preferable over another. So let's wade into these turbulent waters of nomenclature and learn why all these terms are so important.

Hispanic

This term is the most commonly used, especially by authors writing for the general public. In addition, it has been used by generations of scholars studying Spanish language and culture in the Americas. Advocates of the word support its use because it represents the concept of a cultural heritage, lineage and language with its origins in Spain. As an adjective it describes the numerous ethnic groups, especially in the American Southwest, that have Spanish surnames, heritage and culture in common. For these reasons I have chosen to use this word in this book.

Detractors of this term find offense with it for several reasons. One is that it does not allow for recognizing the importance of indigenous cultures as influencing culture either in Mexico or the American Southwest. Another is that they view it as a governmentally mandated generic term that did not originate from within the culture itself.

This last contention is derived from the belief that the term "Hispanic" came into general usage because of its identification as an ethnic category in the 1980 U.S. Census. The September 1996 issue of *Hispanic* magazine has an interesting article that describes and explains the events and reasons that led to the selection of the word "Hispanic" as an ethnic designation category in the census. The article explains why, even with an awareness of the controversy over the term "Hispanic," many people continue to support its use.

There are diverse opinions as to what is the correct word to use: "Hispanic," "Mexican-American," "Spanish," "Chicano," "Latino." Each term has its advocates and detractors.

Hispano

"Hispano" is the Spanish adjective for Hispanic or Spanish. This word is often used by Spanish-language speakers when referring to Spanish ancestry. It's also used as an indicator of cultural pride in Spanish ancestry.

Mexican

This term describes Mexican citizens who work or visit in the United States. "Mexican Nationals" is another term that describes Mexican citizens in the United States. Historically, many American citizens of the Southwest can claim Mexican ancestry because the Southwest was part of Mexico from 1821 to 1848.

Mexican-American

This term describes U.S. citizens who are of Mexican ancestry, descendants of Mexican parents or naturalized citizens with origins in Mexico. This term is acceptable to many Mexican descendants. This term parallels the use of the term African American in American culture.

Spanish

This term describes a population who identifies primarily with the original Spanish settlers of the American Southwest. The strongest concentration of

these people live along the Rio Grande Valley of New Mexico and Colorado. While they admit to a shared culture and language with Mexico, they view themselves as descendants of the Spanish and not as Mexican. In their daily language they refer to themselves as Spanish or Hispano.

"Manito" is another term describing the descendants of the Spanish Colonials of southern Colorado and northern New Mexico. *"Manito"* is the diminutive form of the Spanish word for brother, *hermano,* and it expresses a tender caring and warm brotherhood.

Chicano

This term is a relatively recent term describing people of Mexican origin or descent, living in the United States. There are several theories about the origin of the word. A widely believed source for the word is the pronunciation of the word "Mexican" by field laborers from Mexico working in the United States in the 1930s and 1940s. Native Nahuatl speakers from the Mexican state of Morelos called themselves "Mesheecanos."

The pronunciation is derived from the Nahuatl language pronunciation of the "x" in "Mexico" as a "sh" sound. Nahuatl, like English, has a "sh" sound Spanish does not have. Early Spanish chroniclers used an "x" to render the sound in Spanish, as in "Mexico."

"Xicano" is a Nahuatl word meaning "children of the earth." Eventually this pronunciation evolved into "Chicano" and entered the general language. Because its origins were with poor laborers its early use was often derogatory.

Mexican-American activists in the 1960s who took part in the Brown Power Movement in the U.S. Southwest used the word "Chicano" to describe themselves. They believed that the use of the word "Chicano" was a statement of cultural pride. The word came into widespread usage to represent a positive cultural and political perspective about being of Mexican, and therefore indigenous Spanish, descent, in the United States.

The word "Chicano" has its strong advocates and detractors. Its advocates speak of its use as an important point of cultural pride and awareness and its recognition of indigenous culture, especially Mexican Aztec culture. Its detractors are uncomfortable with its militant overtones and its former derogatory implications.

Latino

This term refers to people having a heritage related to Latin American cultures. "Latino" is the Spanish word for "Latin." The term "Latin" describes the origins of the romance languages, one of which is Spanish, the language spoken throughout most of Mexico, Central and South America.

"Latino" has recently become widely accepted and is the preferred term for many people in place of either "Hispanic" or "Chicano." Its advocates prefer it because it is a self-chosen term, it includes a larger cultural base than "Hispanic" and it does not have the militant and derogatory associations of "Chicano."

Part I

La Historia:
A Short Version of a Long Story

No lo que fuiste, sino lo que eres.

Not what you were, but what you are.
We are our own history.

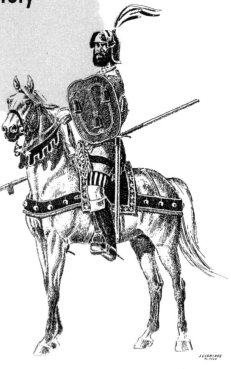

"In fourteen hundred and ninety-two, Columbus sailed the ocean blue." The story behind this little children's rhyme marks the beginning of traditional Hispanic culture in the New World. The history of Hispanic culture in the American Southwest is the story of centuries of blending of the European-Spanish culture the *conquistadores* brought with them with the indigenous cultures that existed when they arrived.

Columbus's voyage of exploration represented the birth of European expansion in the "new world." His discovery of a New World led to the conquest of indigenous culture by European powers and changed the world forever. It was a short thirty years between Columbus's discovery of America and the defeat of the Aztec empire in Mexico. The original *conquistadores* who came to the New World in their *caravelas* (Spanish galleons) were explorers who came looking for gold and personal glory.

Later missionaries would come with a religious mission. These military adventurers, colonists and missionaries would create a New Spain, based upon the cultural heritage of the Spain of the Old World.

When the *conquistadores* landed in the New World, long-established cultures flourished in all parts of the New World. Of primary interest is the Aztec culture, the dominant culture of Mexico at the time of the Spanish arrival.

The Aztecs, or Mexica, arrived in the Valley of Mexico in the thirteenth century. A wandering band of nomadic people, their fabled history told of their origins in a mythical land to the north, Aztlán. The true location of Aztlán is lost in antiquity, but many Hispanic people believe that Aztlán was the northern frontier of Mexico, the land that is today the American Southwest. The legend of Aztlán is especially powerful for Chicanos living in the U.S. Southwest, many of whom believe that the Southwest is the site of legendary Aztlán.

According to the legend of Aztlán, the Aztec god Quetzalcoatl had told his people to look in their wanderings for a lake with an island in the middle of it. On the island would be a cactus, and on top of the cactus would be an eagle with a snake in its mouth. By this sign they would know they had found the place to establish their empire. Legend, of course, has the Aztecs finding this

Figure I.1. Early sixteenth-century conquistador. A horse soldier of the time of the Conquest of Mexico must have been equipped with odd and outdated pieces of armor, a salade for a head covering, a breastplate, sword, dagger and lance, probably a coat of mail and the ever-present adarga, which were oval shields adapted from the Moors and were made of stiff leather; therefore, they were rather light and tough. Swords usually came from the forges of Toledo. Firearms were few and were reserved for very special occasions. Jingle bells were attached to the breastplate and croup straps of the saddles to impress the natives and create turmoil among them.

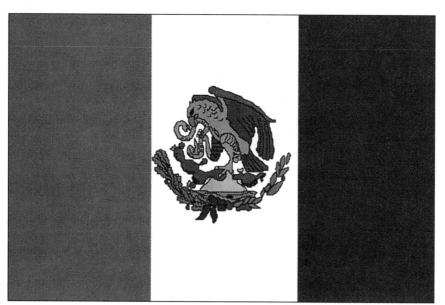

Figure 1.2. The Mexican flag with the central image of the Aztec legend of the discovery of what would one day be the site of Mexico City. The discovered lake was Lake Texcoco and in the center was the island Tenochtitlán. The Aztecs made Tenochtitlán the center of their empire and the Spaniards built their capital, Mexico City, at the site of Tenochtitlán.

The Aztecs had a profound and complex culture, which evolved during their nomadic wanderings from their mythical homeland of Aztlán.

island with the cactus, eagle and snake. The Mexican flag has as its central image this miraculous image: an eagle on a cactus with a serpent in its mouth.

The Aztecs had a profound and complex culture, which evolved during their nomadic wanderings from their mythical homeland of Aztlán. After they settled in Tenochtitlán they established a culture, which was the final culmination of a series of advanced cultures, in the Valley of Mexico.

The Spaniards marveled at Tenochtitlán for they had never seen a city of its size and complexity before. The city had a water system and parkways and was surrounded by ingenious canals and fields for growing an abundance of food. They had evolved a sophisticated system of time measurement and kept records of commerce and history. They also had an education system and an established literary tradition. Their cosmology was based upon myths of a pantheon of gods, most associated with their existence as an agricultural and warrior society.

The Aztec empire was at its zenith when the Spanish first encountered it. A Spanish soldier, Bernal

Díaz del Castillo, gives us a stirring description of its magnificence in *The Discovery and Conquest of Mexico* (1928), his history of personal recollections written fifty years after the conquest.

> We saw so many cities and villages built in the water and other towns on dry land … we were amazed and said it was like the enchantment they tell of in the legend of Amadís … some of our soldiers even asked whether the things we saw were not a dream … I do not know how to describe it, seeing things as we did that had never been heard or seen before, not even dreamed about … never in the world would there be discovered other lands such as these. (1928, pp. 269–70)

His description of the great Aztec marketplace of Tlatelolco gives support to the belief that the Aztec empire was equal to any in Europe at the time of the conquest.

> We were astounded at the number of people and the quantity of merchandise that it contained … for we had never seen such a thing before … some of the soldiers among us who had been in many parts of the world, in Constantinople, and all over Italy, and in Rome, said that so large a market place and so full of people, and so well regulated and arranged, they had never beheld before. (1928, pp. 298, 302)

Unbelievably, in spite of their highly sophisticated culture, the dominance of their empire and their great strength as a warrior culture, the Aztecs would not prevail against the Spanish. Hernán Cortés was the conqueror of the Aztecs. With a little more than five hundred men and aided by his consort and interpreter (the woman the Mexicans would

later refer to as the traitorous *la Malinche*), he succeeded in defeating the glorious Aztec empire.

Several important factors contributed to the rapid conquest of the Aztec people by Cortés. One was the help of *la Malinche,* an indigenous woman who, as his translator, facilitated his first contacts with native populations. Another was the *conquistadores'* use of the horse, which had never been seen by the Aztecs. A third was the Spaniards' use of firearms and metallic armor, also never seen by the Aztecs. Also the Aztecs had a sacred legend foretelling the return of their god, Quetzalcoatl, from the East. The Aztecs originally believed that the Spaniards were gods and that Cortés was their returning god, Quetzalcoatl. Finally, the diseases of Europe, especially smallpox, decimated the defenseless Aztecs.

With the conquest of the Aztecs the Spanish were the dominant European power in the New World, and they began systematic colonization of its new territories. They set up governmental and economic systems in order to control the new lands and the people they found on those new lands. They established cities based upon the traditional Spanish city, with a *plaza* at its center. Around the *plaza* were public buildings and the church.

The economic system was based upon the *encomienda*, a system of land distribution that allotted land and native workers to Spanish settlers who had given governmental or military service to the Crown. The land estates were *haciendas*, the land owners were *patrones* and the native slaves were *peones*. The laws of the *encomienda* system were supposed to protect the native workers, but there were common abuses resulting in a condition of almost slave servitude for the native workers. Even though it lasted for centuries, this system and its harsh injustices eventually were replaced after Mexican independence from Spain in 1821.

Over time there was inter-marriage between native people and Spaniards. A descriptive system of bloodline nomenclatures created classes within Spanish society. *Peninsulares* were pure Spaniards born in Spain, *criollos* were pure Spaniards born in the New World, *mestizos* were mixed Indian and Spanish, *mulatos* were Black and Spanish, *zambos* were mixed Black and Indian. During the colonial period the greatest discrimination, after *Indios* and Blacks, fell on the people of *mestizo* and *zambo* bloodline.

Missionaries from Spain came to the New World determined to convert native people to Catholic Christianity. They established missions dedicated to educating the native converts and teaching them the Spanish religion, language and culture.

In addition to the immense task of establishing New Spain, the Spanish also continued their vast exploration of the New World. While Spaniards explored both North and South America, this historical overview is most concerned with the northern outposts of the Spanish empire. In 1539 explorer Francisco Vásquez de Coronado, under orders from the viceroys of New Spain, entered the northern frontier of New Spain searching for the legendary Seven Cities of Gold. His search was futile, but his explorations established the northern

With the conquest of the Aztecs the Spanish were the dominant European power in the New World.

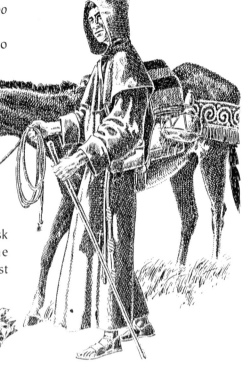

Figure I.3. Franciscan missionary of 1750.

frontiers of New Spain for colonizing expeditions.

In 1598 Don Juan de Oñate led the first expedition to succeed in establishing a permanent colony in New Mexico, along the Upper Rio Grande Valley. Soon after, the clergy and military followed, further colonizing the northern frontier of New Spain. These early Spanish settlers founded the first Spanish communities in northern New Mexico and southern Colorado, in the Upper Rio Grande Valley and, later, the San Luis Valley. After twelve years, with the assistance of the San Juan Tewa Pueblo at San Gabriel, which the Spanish named "San Juan de los Caballeros," Santa Fe was established as the administrative outpost of this area in 1610.

Another path of settlement was along the coast of the northwestern frontier. Father Junípero Serra was a Franciscan missionary in California in the 1700s. He was instrumental in the founding of twenty-one missions in California along *el Camino Real* (the Royal Highway), a road connecting all the missions along the California coast, from San Diego to San Francisco.

Through the decades following the establishment of New Spain, the Spaniards founded missions and military settlements, followed by civilian settlements. As these civilian settlements expanded throughout the northern frontiers of New Spain they contributed to the consolidation of Spanish culture in the New World.

Throughout the seventeenth century, colonists came into the northern regions and brought with them the Hispanic and indigenous (or Indio-Hispanic) cultural elements of Spanish colonial society. These colonists represented the various groups present in Mexico at this time. These included Spaniards, who had settled in Mexico, children of these Spaniards, *mestizos* of Spanish and Indian parentage and Indians from various ethnic groups in Mexico.

For generations these communities developed, adhering to a Hispanic way of life. The early settlers

Figure I.4. Mission San Juan Capistrano, dating from 1776, is the sixth of the twenty-one California missions. It is considered by many to be the most picturesque of the group.

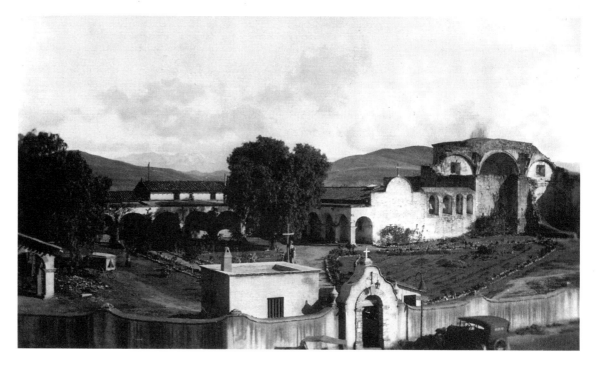

brought with them the language, religion and customs of Spain. These Spanish customs were somewhat modified and influenced by indigenous culture. Throughout the text of this book are many instances in which established Hispanic traditions are the reflection of the influences of indigenous culture on the Hispanic settlers.

Joined by these common cultural bonds, they forged a strong sense of community among themselves. Geographically and politically isolated in what would eventually become the American Southwest, isolated across hundreds of miles of barren frontier, distanced from the centers of Mexican political cultural life, they nevertheless maintained a culture with Spanish roots while adapting to their new land.

In 1810, after almost three hundred years of Spanish rule, the Mexican people began a fight for independence from Spain. On September 16, the most important national holiday in Mexico, Father Miguel Hidalgo rang his church bell in Dolores, Mexico, and thus began an eleven-year struggle for independence. Finally in 1821 Mexico gained its freedom from Spain and became a sovereign nation.

Mexico's great victory of independence was short-lived, however. Mexico was soon to lose half of its lands to the United States, which was operating in the Americas under a policy of Manifest Destiny, a militant policy that had as its central image a country with borders spanning from sea to sea. This policy of Manifest Destiny empowered the United States to aspire to Mexican land.

In 1844 U.S. President James K. Polk was elected on a policy of western expansion. In 1846 Polk confronted the Mexican army at the Texas-Mexican border and thus began the Mexican-American War.

In 1810, after almost three hundred years of Spanish rule, the Mexican people began a fight for independence from Spain.

Figure 1.5. States and territories formed from the Mexican Cession and the Gadsen Purchase.

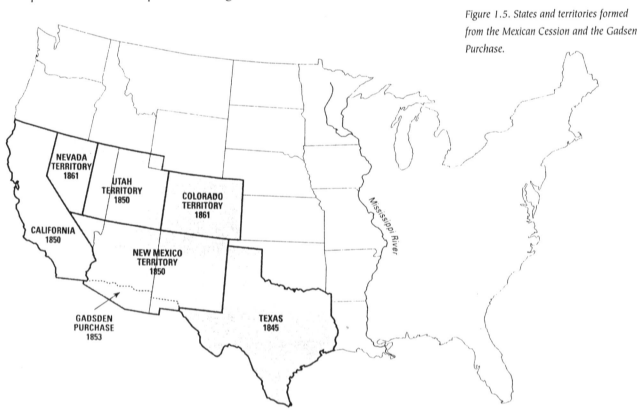

In 1848 the Treaty of Guadalupe Hidalgo ended the Mexican-American war. This treaty ceded the northern portion of Mexico to the United States. The area containing all or parts of California, Arizona, Nevada, Colorado, New Mexico and Texas became part of the United States.

A common sentiment about this political loss of Mexico's northern land is expressed in one item of folk legend, which features a person from the time commenting about his sudden change from a Mexican citizen to a U.S. citizen: "I didn't leave my country. My country left me." (A variation of this folk saying has the man saying, "I didn't cross the border. The border crossed me.")

Even though these Hispanic communities of the northern Mexican frontier suddenly came under the jurisdiction of the U.S. government, their way of life remained relatively unchanged in their remote villages. The traditional way of life in these Hispanic communities unfolded as it had for generations. Even though they were now U.S. citizens, culturally their life remained centered in the Hispanic traditions, which had ruled Mexico for more than three hundred years.

The history of modern Hispanic life in the American Southwest is marked by a firm continuation of the centuries-old Spanish colonial culture combined with the influence of Mexican immigration in the twentieth century. Mexico experienced a revolution in 1910, and one result of its social disruption was the immigration of Mexican Nationals to the United States. Also, throughout the twentieth century Mexico has been a steady source of agricultural workers for the United States. This immigration of workers has been both legal and illegal. It has been legal under several U.S. government–sponsored labor programs. However, when those government programs expired, the immigration and employment of Mexican workers in the United States continued. Illegal immigration continued to exist because of the desire of Mexican workers to seek work and increased prosperity in the United States and American employers' willingness to hire illegal workers because of their low wages.

In conclusion, we can view the history of the Hispanic Southwest as characterized by four distinct historical periods:

> Mexico experienced a revolution in 1910, and one result of its social disruption was the immigration of Mexican Nationals to the United States.

1598–1821	The Spanish colonial period, 223 years of Spanish rule and influence. The year 1598 is the year Juan de Oñate established the first Spanish settlements in the northern frontiers of New Spain, present-day New Mexico.
1821–1848	A relatively short twenty-seven-year period of Mexican nationality. Mexican independence from Spain was achieved in 1821.
1848–1910	American frontier settlement. A time of large immigration of Anglo Americans into the Southwest. The establishment of U.S. nationality.
1910–present	The Mexican Revolution of 1910 caused the beginning of large-scale Mexican immigration into the Southwest. The twentieth century—a period of cultural tension, economic striving and cultural struggle between assimilation and preservation.

This short historical overview reveals several important reasons for the existence of a continuing and strong Hispanic culture in the American Southwest. The simplest reason is that the people of the Hispanic culture have lived in the region for centuries. Their culture evolved as a result of several powerful influences:

- The continuous influence of indigenous cultures existing in Mexico at the time of the arrival of the Spanish in spite of Spanish efforts to totally eradicate it.

- The Spanish colonial period of Mexican history securely established Spanish culture, especially its language and its religion.

- The continuing revitalization of the culture by Mexican immigrants. Even the annexation of the northern Mexican frontiers by the United States and the dominant presence of American Anglo culture has not been enough to extinguish the Hispanic culture of the Southwest.

For almost four hundred years Hispanic culture has existed in the area now recognized as the American Southwest. Through centuries of exploration, conquest, settlement, war and defeat, Hispanic people have maintained their presence and culture in the American Southwest. Transported from Spain, evolved in Mexico, adapted in America, Hispanic culture is a centuries-old experience continuing to animate the lives of Hispanic people throughout the Southwest.

© Al Cárdenas

Figure I.6. The mestizo *image, representing the blending of the Spanish and Mexican Indian cultures to produce the Hispanic-Indio people.*

1

"The Five Suns"— The Aztec Creation Myth

According to Aztec cosmology the Earth has had five eras. The Aztecs marked each of these times with the re-creation of the sun. In their creation myth the Earth is destroyed four times before the present fifth and, for the Aztec people, final age of the sun. The Aztec creation legend describes the events that determined their great and tragic fate.

Contained in their creation story are explanations for several natural phenomena as well as the origins of many aspects of their lives. But their creation myth goes beyond the usual "How It Came to Be" and "Why It Is So" of most common creation myths. The Aztec creation myth is especially powerful because it presents to the Aztec people a complex cosmology that places them at its center as a chosen people called upon to give life to the sun. The Aztecs led a life very prescribed by religious ritual. All aspects of their lives were governed by the requirements of their position as the chosen people of the sun. Their relationship to their gods was unusual in that their gods depended upon them for sustenance. In turn, according to their cosmic vision, they were dependent on their own gods for continued life.

This creation myth has an important and, for Aztec history, critical corollary myth about the god Quetzalcoatl. Quetzalcoatl was described by the Aztec people as a fair-skinned god with a beard, who battled with an equally powerful god, Tezcatlipoca, for supremacy in the Aztec cosmos. Tezcatlipoca tricked Quetzalcoatl and got him to commit a vile act against the morals of his people. Because of this the people banished Quetzalcoatl from the land. Quetzalcoatl left in a boat traveling to the East. He prophesied to his people that one day he would return from the East to reclaim his divine rights. It was foretold by the Aztec people that Quetzalcoatl would return to them in the year "One Reed," according to their calendar.

It was in 1519 when the Aztec emperor Moctezuma received reports of a bearded fair-skinned person coming from the East. It was the year One Reed, and the Aztecs believed that Cortés was their god Quetzalcoatl returning as had been prophesied. This belief, originating in myth, was one significant contributing factor in the Spanish conquest of the Aztecs.

This myth contributed to the beginning of the Hispanic time in the New World. The Spaniards brought with them their stories and legends from Europe and arrived on a land populated by a people who had their own powerful stories. Like the great battles of the creation legend between Tezcatlipoca and Quetzalcoatl for supremacy, the Spaniards and Aztecs fought a great battle for supremacy. History records the victory of the Spanish over the Aztecs. And with that victory was laid the foundation for the eventual prominence of the Spanish in this part of the New World.

The Five Suns
Retold by Angel Vigil

Excerpted from The Corn Woman:
Stories and Legends of the Hispanic Southwest

In the beginning, time and space were created at the same instant. During this time of creation The Ometeotl, The Creator Pair, The Lord and Lady of Duality gave birth to two gods, Tezcatlipoca and Quetzalcoatl.

The first god born of the Creator Pair was Tezcatlipoca. He was the supreme divinity of the Aztec people. He was called Smoking Mirror, god of darkness and light. This dark god of the night was the god of fate, both beneficial and destructive. The Aztec emperors prayed to Tezcatlipoca that he might bless their reign.

The second god born of the creator pair was Quetzalcoatl, the Plumed Serpent. This wise and benevolent god was the creator god, the god of civilization and learning.

The eternal struggle between these two gods, Tezcatlipoca and Quetzalcoatl, for ascendancy is the history of the Aztec people. According to Aztec cosmology the competition of these two gods for the honor of being the sun caused the destruction of the heavens and earth four times. Each time their battle destroyed the earth. But after each battle the earth was created anew. Our present time is the time of the fifth sun.

In the time of the first sun the earth was ruled by giants who lived on acorns and roots. It was a time of power for Tezcatlipoca. He declared that it was his right to lead the sun through the sky on its daily journey lighting the heavens above and the earth below. With great pride he would daily harness the sun and lead it on its fiery path to the end of the day.

Quetzalcoatl felt that it was not right for Tezcatlipoca to have the glory of carrying the sun. He knew that he was the god destined for the honor of controlling the sun. One day he followed Tezcatlipoca into the sky and struck him with one mighty blow, knocking Tezcatlipoca from the sky.

As Tezcatlipoca fell, in his anguish he turned into a jaguar. As he fell upon the earth in the form of a jaguar he devoured all living things on the earth and the earth was covered in darkness. In this way the time of the first sun had come to the end with the destruction of the earth. The Aztecs marked this day of destruction with the name "4 Jaguar."

Now it was Quetzalcoatl's turn to carry the sun on its daily journey. As the plumed serpent he proudly brought light to the dark earth. The earth was created anew and it was the time of the second sun. During this time the earth was ruled by monkeys who existed on pine nuts.

From his fallen state Tezcatlipoca could see Quetzalcoatl in his glory as the carrier of the sun. Now it was Tezcatlipoca's turn to destroy the earth. He rose into the sky and delivered a fierce blow to Quetzalcoatl. Quetzalcoatl fell to the earth with such force that a great windstorm destroyed all living creatures. For the second time the age of the sun had ended with the destruction of the earth. The Aztecs called this day "4 Wind."

Quetzalcoatl felt that it was not right for Tezcatlipoca to have the glory of carrying the sun.

By this time the gods had grown weary of this battle between Tezcatlipoca and Quetzalcoatl. They decided to give another god the honor of being the carrier of the sun. They selected Tlaloc, the god of rain.

As Tlaloc began his fiery journey with the sun high upon his back both Tezcatlipoca and Quetzalcoatl plotted against him. They attacked Tlaloc and Tlaloc fell upon the earth causing a celestial rain of fire that scorched the earth. Once again the earth and its sun were destroyed. The Aztecs marked the end of this third age of the sun by the day "4 Rain."

Now the gods were even more angered by the actions of the two battling brothers, Tezcatlipoca and Quetzalcoatl. They once more selected another god to carry the sun. This time they selected the sister of Tlaloc. She was Chalchiuhtlicue, the goddess of corn.

In their great jealousy that any other god should carry the sun Tezcatlipoca and Quetzalcoatl once again struck down the appointed carrier of the sun. As Chalchiuhtlicue fell to the earth the sky opened up with the heavenly waters. A great flood covered the earth and for a fourth time the earth and all living creatures on the earth were destroyed. The Aztecs called this day "4 Water."

It is this time between the fourth and fifth sun that was most important to the Aztec people. For it was during this time that their world, our world, was created.

During this time of darkness between the fourth and fifth suns the world was flooded and there was not a living creature on the earth. The sky had also fallen onto the earth and there was no heaven above. Tezcatlipoca and Quetzalcoatl looked down upon the earth and knew that their time of battle must come to an end if there was to be another sun.

They both descended upon the earth and went to the two ends of the fallen sky. They stood firm and using their godly powers they became towering trees growing forever upward. They lifted the sky back into the heavens. Once the sky was back in its place they walked across the sky and met at the center to gaze upon the world down below.

To this day the celestial path they walked is marked by a trail of stars. On a clear night you can see the long white trail in the sky marking their footsteps. To the people of our time this path is called the "Milky Way."

Next they descended into the depths of the flooded waters and found a crocodilian creature, Cipactli. They raised her to the surface of the waters. Transforming themselves into snakes they wrapped themselves around her and tore her asunder.

The gods were angered by this cruel act by Tezcatlipoca and Quetzalcoatl. They decided that they would take the remains of Cipactli and create a new earth. The gods took the top half of Cipactli and made the heavens above. They then took the bottom half and made the earth below. They took her hair and made forests, trees and herbs. They made pools and springs from her eyes. From her mouth they made flow the waters which sustain life on our earth. Her shoulders became mountains and her nose became valleys. Finally, they used her skin to make the grass and the small flowers of the valleys.

It is this time between the fourth and fifth sun that was most important to the Aztec people. For it was during this time that their world, our world, was created.

Now there was once again earth and sky. But there were still no people on the earth. Quetzalcoatl decided that he would bring living people back to the earth. In order to do this he descended into the land of the dead. There he met the Lord God of the Dead and the Underworld, Mictlantecuhtli. He asked the Lord God of the Dead if he could have the bones of all the people who had lived on the earth in the previous four suns.

Before he answered, Mictlantecuhtli, the Lord God of the Dead, gave Quetzalcoatl a challenge. He gave Quetzalcoatl a solid wooden horn and insisted that he play music on it. Immediately Quetzalcoatl called upon the worms from the Land of the Dead to help him. The worms burrowed inside the solid wood and ate it until the inside was as hollow as a wooden flute. Quetzalcoatl then played the most haunting melody on the wooden flute and the Lord God of the Dead knew that Quetzalcoatl had outsmarted him.

Finally, the Lord God of the Dead answered Quetzalcoatl's question. He said yes on one condition. When the people made from those bones die they must return to the Land of the Dead. Quetzalcoatl agreed to this condition, but in his heart he knew he was lying to the Lord God of the Dead. Quetzalcoatl wanted his people to live forever and never return to the Land of the Dead.

As Quetzalcoatl was leaving with the bones the Lord God of the Dead realized that Quetzalcoatl was lying and sent the quail birds to capture him before he escaped with the bones.

As he was running Quetzalcoatl tripped and fell, breaking all the bones he was carrying. As he collected them he noticed that they were now all different sizes. Since we are made from these bones that is why to this day the people of this earth are of all different sizes.

The quail birds caught up with Quetzalcoatl and began to peck at the broken bones. As they pecked at the bones they became weaker and weaker. It is because of this damage that the quail birds caused to the bones that the people who came from the bones are too weak to live forever. In this way the request of the Lord God of the Dead holds true. One day we must all return to the Land of the Dead.

Quetzalcoatl took the bones to the gods. They put the bones into a sacred vessel and ground them into a fine powder. They then sliced their skin and shed their blood into the vessel. In four days the first man emerged from the vessel, then in four more days the first woman. The people of the earth had once more been created. The gods declared that since they had shed their blood to give creation to the people of the earth, in turn the people of the earth must also shed blood to give life to the gods.

As he returned from the heavens Quetzalcoatl noticed an ant going into a mountain called the Hill of Sustenance. Quickly changing himself into an ant, he followed it into the mountain. Once inside the mountain he saw that the mountain was filled with maize: full, rich, yellow corn. Quetzalcoatl used his powers to cause lightning to split open the Hill of Sustenance. As the Hill opened up all the corn spilled out onto the land. Quetzalcoatl stole a piece of this corn and brought it to the people of the earth. The people ate this corn and realized that it was food from

As he was running Quetzalcoatl tripped and fell, breaking all the bones he was carrying. As he collected them he noticed that they were now all different sizes. Since we are made from these bones that is why to this day the people of this earth are of all different sizes.

the gods and that it would sustain life for them. That is why to this day corn is the staple of life for the descendants of the Aztec people.

First sky, then earth. Now people and food. The earth was created for the fifth time. But still it was a time of darkness on the earth because the sun did not rise in the sky.

The gods gathered to find a god who would sacrifice himself in order to give life to the sun. All the gods were willing but when the sacrificial fire was built there was no god brave enough to fling himself into the fire. Finally, two gods said they would sacrifice themselves to give life to the sun. One was a rich and proud god. The other was a poor, humble god named Nanahuatzin.

The gods prayed for four days and four nights. At the end of the time of prayer the rich and proud god approached the fire. When he felt its great heat his courage faltered and he stepped back from the flames. Nanahuatzin prayed for four days and four nights and at the end of his time of prayer he approached the flames and in one brave and bold moment he leapt into the fire. Immediately the flames roared up and he was transformed into the sun. By his noble sacrifice life came to the sun.

In the excitement of the fierce fire the jaguar jumped into the flames. The fire was too hot for the jaguar and as he came out of the fire he was covered with spots of ash. To this day the jaguar is covered with black spots as a reminder to the world of his courage in jumping into the fire.

The moon, seeing that the sun was coming alive, tried to rise before the sun. To punish this audacity the gods took a rabbit and slapped the moon in the face. That is why to this day as you look at the full moon you can see the markings of a rabbit on its face.

Finally the sun was born again by the sacrifice of Nanahuatzin and was ready to rise again. The gods declared that because the sun was born out of sacrifice it would be necessary for the people of the sun to continue to provide sacrifices in order to give life to the sun on its daily journey across the sky.

But there was no one to carry the sun into the sky. The gods selected one of the strongest of all the gods, Huitzilopochtli, for the important job of carrying the sun into the sky to mark the beginning of the age of the fifth sun.

Huitzilopochtli, the Aztec god of war, had been born in a fierce battle. His mother, Coatlique, the mother of innumerable gods, had given birth to 400 sons and one daughter. The 400 sons had become the first stars and the one daughter, who was called Coyolxauhqui, became the moon.

After giving birth to these celestial children, Coatlique had retired to the temple for a life of chastity, work and prayer. One day, as she was cleaning the temple, she noticed a bundle of down feathers falling from the sky. She gathered the down feathers and placed them under her smock. Later, as she looked for the bundle of down, she discovered that it was gone but in its place she was pregnant with child.

The 400 sons and the daughter were incensed that their mother was once again pregnant. They plotted to kill the unborn child. As they approached the unsuspecting mother the unborn child, Huitzilopochtli, was suddenly born fully armed for battle. He killed the 400 sons and

In the excitement of the fierce fire the jaguar jumped into the flames ... and as he came out of the fire he was covered with spots of ash. To this day the jaguar is covered with black spots as a reminder to the world of his courage in jumping into the fire.

dismembered the one daughter. For this fearless and bold act of vengeance the Aztecs made Huitzilopochtli their god of war.

The gods then selected the warrior god Huitzilopochtli to do daily battle against the forces of darkness. Each day Huitzilopochtli carries the sun on his back as it vanquishes the darkness of the night. As he did in his epic battle of birth he daily sends the stars and the moon back to the darkness and lets the sun rule supreme. The light of the sun had finally returned to a new earth and its people.

The Aztec people placed this eternal and daily battle between the forces of light and the forces of dark at the center of Aztec cosmology. Their sacred and chosen calling was to provide the precious nectar which gave daily life to the sun in its battle against the forces of darkness.

The earth had finally been created for a fifth time. The earth from Cipactli. The people from the bones from the Land of the Dead. Food, sacred maize, from the Hill of Sustenance. And the sun itself from noble sacrifice.

It was the age of the fifth sun. Our own age. The final age of the Aztec people.

The light of the sun had finally returned to a new earth and its people.

ACTIVITY—CREATION STORY

Write your own creation story. Creation myths are common to all cultures of the world. At one time or another all people have tried to answer the eternal philosophical and religious questions—how did we get here and why are we here? In non-literate cultures keepers of the stories, the elders of the tribe, had the sacred responsibility of passing on the creation stories. These creation stories were an important aspect of oral tradition.

The Aztec creation myth is in many instances what is called a pourquoi tale, a "why tale." Pourquoi stories, named after the French word for "why," are one type of creation story that tells how and why things came to be as we know them today. All cultures have creation stories that explain how the world came to be and why things are the way they are.

"Why the Buffalo Has Horns and a Big Hump," "Why the Giraffe Has a Long Neck," "Why the River Winds Around," "Why People Wear Moccasins," "Why the Stars Are Up in the Sky" and "How the Skunk Got Its Stripe" are a few examples of possible story titles for pourquoi tales. The U.S. Native American oral tradition is especially rich in these types of stories.

Instructions

1. Reread "The Five Suns" and list all the instances where the origin of something is explained.

2. Read other creation legends and compare their explanations with those in the Aztec version. For additional reading in this area the book *In the Beginning*, by Virginia Hamilton, is an extraordinary collection of creation tales from around the world. The book *And It Is Still That Way*, by Byrd Baylor, has pourquoi stories collected from Arizona Native American children.

3. Write your own pourquoi story. Use the following outline to help you organize your ideas.

 - Begin with your title. Form it in the shape of the sentence "How the_____ Got Its _____" and fill in the blanks with your ideas. Another title shape is "Why the _____ is _____."

 - Start your story with a description of what it was like *before* the change happened. Describe with as much detail as possible why things seemed normal before the change.

 - Then describe some trouble that started because the change had not yet happened. This part is the conflict of the story and all good stories have an exciting and interesting conflict that makes the reader curious as to how the characters will resolve the conflict.

 - Now comes the pourquoi part of the story. Think up some change in the character (as presented in your title) that helps solve the trouble in the story.

 - Finally, describe why things are better after the change and why the change seems normal now.

4. Read or tell your story to your family, friends or class.

2

The Aztec Sun Stone

The Aztec creation myth contains the story of their cosmology. The sixteenth-century Spanish friars collected the Aztec creation myths. The myths explained the origins of the Earth, the natural world and its phenomena of the cycle of day and night, the cycle of vegetation and the creation of life. Their creation story provided the Aztecs with the cosmic principles by which they ordered their life on Earth.

In 1790 workers excavating beneath the Zocalo, the central *plaza* of Mexico City, unearthed a monumental stone sculpture—the Aztec Sun Stone. The stone measured 12 feet in diameter and weighed 24 metric tons. The stone miraculously had avoided the historically disastrous Spanish destruction of all Aztec artifacts in the years immediately following the conquest.

The Sun Stone is not a functioning calendar as it is so often misrepresented. It is a sacred image representing the Aztec creation myth of the Five Suns. The glyphs within the stone depict the Aztec sacred religious year. In truth, the Sun Stone is a religious object giving visual representation to the Aztec cosmology, their concept of the universe and their place in it. The Aztec creation legend and the Aztec Sun Stone are companion creations presenting to the world the sacred beliefs of the Aztec culture. An examination of the primary imagery on the Sun Stone reveals its representation of the Aztec creation legend and the Aztec cosmos.

The inner circle of the stone contains the story of the Five Suns, the five creation epochs. The center image is the fifth epoch and represents the present-day Earth, *Tlaltecuhtli*. Some interpretations of this image name it *Tonatiuh*, the fifth sun. The four surrounding glyphs represent the four ancient epochs, each of which ended in the destruction of the Earth:

- 4 Jaguar—the first era: the Earth destroyed by jaguars.

- 4 Wind—the second era: the Earth destroyed by wind.

- 4 Rain—the third era: the Earth destroyed by a rain of fire.

- 4 Water—the fourth era: the Earth destroyed by a flood.

The second circle surrounding the Five Suns area represents the Aztec's sacred calendar of days. The Aztecs had a complex system of two calendars. The two calendars intermeshed, like two gears revolving around one another, and provided the Aztecs with a complex but accurate marking of time.

One was an annual ceremonial calendar of 365 days, the *xiuhpohualli*, which regulated the cycles of annual seasonal festivals. This calendar was divided into eighteen months of 20 days each, accounting

The Sun Stone is not a functioning calendar as it is so often misrepresented. It is a sacred image representing the Aztec creation myth of the Five Suns.

for 360 days. The remaining 5 days were a period of transition between the old and the new, dangerous days during which bad luck could occur.

The second calendar was a ritual calendar, the *tonalpohualli*, a 260-day cycle used for divination. This calendar was comprised of thirteen cycles of 20 named days. The second, inner ring of the Aztec calendar presents these 20 sacred days of the ritual calendar, each day with an Aztec name and a corresponding English translation.

The outer circle of the Sun Stone depicts twin serpents. These serpents, *xiuhcóatl*, represent the universe that surrounds the Earth. The *xiuhcóatl* lived in the night sky. The seven glyphs on the serpents' headdresses represent the seven star Pleiades, the most important constellation to the Aztecs. At the end of their fifty-two-year calendar cycle Aztec priests would take sighting of the Pleiades in the skies during a sacred Fire Ceremony as celestial confirmation that their world would continue for another fifty-two years.

The Sun Stone contains several other miscellaneous glyphs:

- Thirteen Reed: 1427, the mythical beginning of the fifth sun.

- Amatl: four knots, tied bands of paper bark, the four groups of Thirteen years comprising the Aztec sacred fifty-two-year cycle.

- Sun rays: the source of sacred life.

- The sacrificial obsidian knife (often mistaken for a tongue).

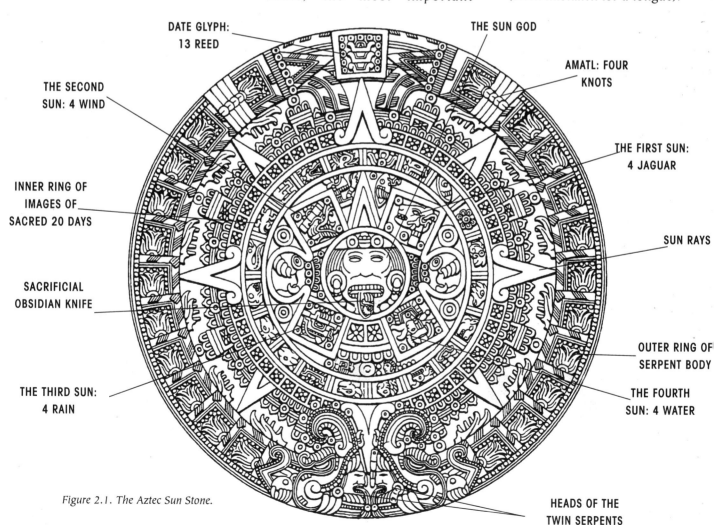

DATE GLYPH: 13 REED

THE SUN GOD

AMATL: FOUR KNOTS

THE SECOND SUN: 4 WIND

THE FIRST SUN: 4 JAGUAR

INNER RING OF IMAGES OF SACRED 20 DAYS

SUN RAYS

SACRIFICIAL OBSIDIAN KNIFE

OUTER RING OF SERPENT BODY

THE THIRD SUN: 4 RAIN

THE FOURTH SUN: 4 WATER

HEADS OF THE TWIN SERPENTS

Figure 2.1. The Aztec Sun Stone.

DAY 1
CIPACTLI
CROCODILE

DAY 2
EHECATL
WIND

DAY 3
CALLI
HOUSE

DAY 4
CUETZPALIN
LIZARD

DAY 5
CÓATL
SERPENT

DAY 6
MIQUIZTLI
DEATH

DAY 7
MAZATL
DEER

DAY 8
TOCOHTLI
RABBIT

DAY 9
ATL
WATER

DAY 10
ITCUINTLI
DOG

DAY 11
OZOMATLI
MONKEY

DAY 12
MALINALLI
GRASS

DAY 13
ACATL
REED

DAY 14
OCELOTL
JAGUAR

DAY 15
CUAUHTLI
EAGLE

DAY 16
COZCACUAUHTLI
TURKEY

DAY 17
OLLIN
MOVEMENT

DAY 18
TECPATL
OBSIDIAN

DAY 19
QUIAUHUITL
RAIN

DAY 20
XOCHITL
FLOWER

Figure 2.2. The twenty sacred days of the Aztec Sun Stone. Each day has its day number, Aztec name and English name.

ACTIVITY—GLYPH CALENDAR

Create your own life glyph calendar. (A glyph is an image representing something or someone. The images on the Aztec Sun Stone are called glyphs.)

Materials

Glyph chart
Drawing paper
Pencil, felt markers, colored pencil
Scissors
Glue

Instructions

1. Make a list of your favorite things to do.

2. Make a list of the important events in your life.

3. Make a list of the most important people in your life.

4. Draw a single image for each item on your three lists.

5. Draw a self-portrait.

6. Cut out your images and arrange them according to category.

7. Glue your images and self-portrait in the correct circle category. Fill in the circles with your images. Divide the circles into as many parts as you need and add more rings if necessary.

8. Show you life glyph calendar to a friend and see if they can tell your life story.

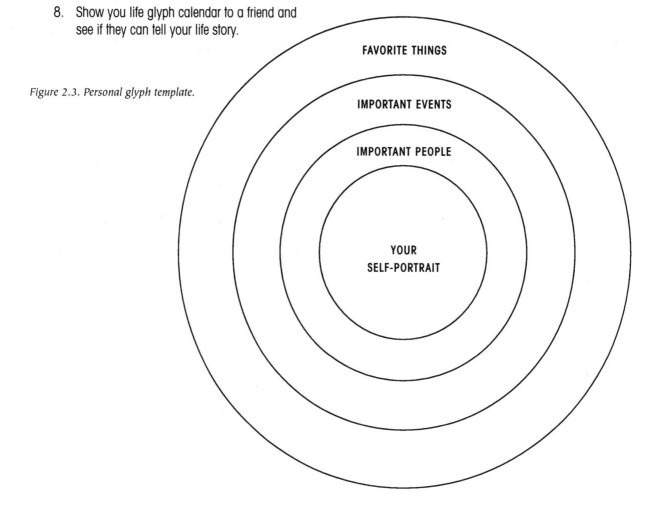

Figure 2.3. Personal glyph template.

Part II

La Familia:
Family Celebrations

Contra amor y fortuna no hay defensa alguna.
There is no defense against love and fortune.
Love will find a way.

La familia, the family, is at the center of Hispanic life. Even as many of the old traditions are changing or fading away, the family continues to be of central importance to Hispanics. The family provides a home for each member and gives meaning to each member's life. Hispanic people always have the family as their central reference point and value.

The most important work a family does is to support emotionally its adults and nurture and raise its children. Second, it is within the family that people experience cultural traditions and pass on cultural practices from one generation to the next. Each time a family gathers for a family celebration it reinforces and continues its culture.

The great strength of the Hispanic family is that it is more than the nuclear unit of parents and children. Uncles, aunts, grandparents, cousins, godparents and in-laws all form a large extended family for each other. Even deceased family members and their memory remain a positive presence in the family. Within this extended and intergenerational family people share the experiences of their lives.

The study of family genealogy, *nuestras raíces* (our roots), is a renewed activity in Hispanic families and communities. For these families and communities the researching of heritage and lineage is a source of cultural pride and knowledge.

In addition, three key Hispanic cultural events especially reveal the importance of family in the celebration of life. These experiences are the coming of age of *Quinceañera*, the wedding ceremony of *la Entriega de Novios* and the memorial of *el Día de los Muertos*.

The following discussions of these family cultural traditions are drawn from traditional practices. While they appear to represent the accepted standard for the tradition, they are meant only to illustrate the major and common aspects of the tradition. There are as many variations of these practices as there are families. As with any family event, every family adapts the celebration to its own needs, available resources, family history and preferences.

One of the hallmarks of true folklore is the existence of these variations because they indicate that the cultural practices are alive within the traditions of family life. The history of folklore is marked by the evolution and adaptation of cultural practices to fit the changing needs of families and individuals.

Each time a family gathers for a family celebration it reinforces and continues its culture.

3

Family Genealogy— *Nuestras Raíces*

The knowledge and appreciation of one's ancestors has long been a basic tenant of traditional cultures.

Hispanic educators, scholars, researchers and community leaders founded the Genealogy Society of Hispanic America (GSHA) in 1989. Its mission statement describes that the purpose of the GSHA is to promote Hispanic genealogical research, thereby expanding awareness and knowledge of Hispanic culture and Hispanic historical contributions. As a national organization with local chapters spread throughout the Southwest, GSHA works with libraries, schools, museums and historical associations to provide support to institutions and individuals requiring assistance with genealogical research.

GSHA is an invaluable aid to anyone wanting to begin a genealogical study and to introduce the study of Hispanic heritage and lineage to families, children and communities. Its address is Genealogical Society of Hispanic America, P.O. Box 9606, Denver, CO 80209-0606.

While genealogical research is rewarding for the middle-aged adult with a growing awareness and need for a "roots" journey, it is especially important for families striving to establish cultural awareness and pride in children. The knowledge and appreciation of one's ancestors has long been a basic tenant of traditional cultures. As today's family struggles with the stresses of modern life, children need more than ever the grounding security of a strong family. The shared discovery of a family's heritage and lineage is an extremely positive strategy for enhancing family and individual knowledge and pride. In addition, genealogical research is an inter-generational family activity that can be shared by both adults and children.

There are many resources for the beginning genealogist. Many cities have genealogical societies that can offer support and information. Also, local libraries have a genealogy section, which is always a good place to start. Below are several helpful reference books available from the library.

- *Spanish and Mexican Records of the American Southwest* by Henry Beers. A survey of records available for Arizona, California, New Mexico and Texas.

- *The Source* by Arlene Eakle and Cerny Johni. An excellent introduction to genealogical research tools, with a chapter on research in the Spanish and Mexican Southwest.

- *Tracing Your Hispanic Heritage* by George R. Ryskamp. Discusses techniques and principles of research and specific types of records found in Hispanic research.

- *Ethnic Genealogy*, edited by Jessie Carney Smith. Includes a chapter on Hispanic genealogy.

- *Romance of Spanish Surnames* by Charles R. Maduell. Gives the meaning and geographic origin of approximately 1,500 common Spanish surnames.

- *Dictionary of Surnames* by Patrick Hanks and Flavia Hodges. The title says it all. An interesting place to look up the origin and meaning of your family name.

- *Origins of New Mexico Families* by Fray Angelico Chavez. The classic genealogical study of original New Mexico families in the seventeenth and eighteenth centuries.

- *V. & H.V. Rolland's Illustrations to the Amorial General* by J. B. Rietstap. The best place to look up your family crest.

Especially recommended is the Southern California Branch of the Genealogical Society of Hispanic America's guide for the beginning genealogist, "Searching for Your Hispanic Roots in the Southwest." It is filled with practical suggestions about how to begin your genealogical search. It is available from the Genealogical Society of Hispanic America, Southern California Branch, P.O. Box 2472, Santa Fe Springs, CA 90670.

Figure 3.1. The Vigil family crest.

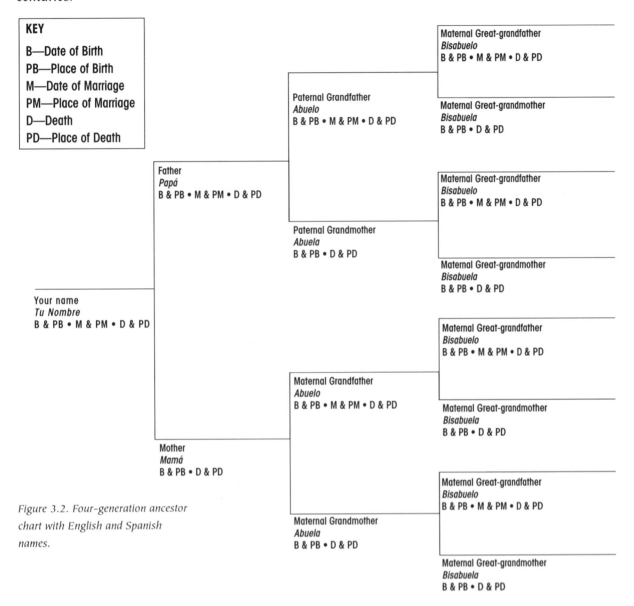

Figure 3.2. Four-generation ancestor chart with English and Spanish names.

KEY

B—Date of Birth
PB—Place of Birth
M—Date of Marriage
PM—Place of Marriage
D—Death
PD—Place of Death

Your name
Tu Nombre
B & PB • M & PM • D & PD

Father
Papá
B & PB • M & PM • D & PD

Mother
Mamá
B & PB • D & PD

Paternal Grandfather
Abuelo
B & PB • M & PM • D & PD

Paternal Grandmother
Abuela
B & PB • D & PD

Maternal Grandfather
Abuelo
B & PB • M & PM • D & PD

Maternal Grandmother
Abuela
B & PB • D & PD

Maternal Great-grandfather
Bisabuelo
B & PB • M & PM • D & PD

Maternal Great-grandmother
Bisabuela
B & PB • D & PD

Maternal Great-grandfather
Bisabuelo
B & PB • M & PM • D & PD

Maternal Great-grandmother
Bisabuela
B & PB • D & PD

Maternal Great-grandfather
Bisabuelo
B & PB • M & PM • D & PD

Maternal Great-grandmother
Bisabuela
B & PB • D & PD

Maternal Great-grandfather
Bisabuelo
B & PB • M & PM • D & PD

Maternal Great-grandmother
Bisabuela
B & PB • D & PD

ACTIVITY—GENEALOGY CHART

Research and complete your family genealogy chart.

Instructions

1. Go to the library and read some books on genealogy to get some ideas. Two good ones for children are *The Great Ancestor Hunt: The Fun of Finding Out Who You Are*, by Lila Perl and *Roots for Kids: A Genealogy Guide for Young People*, by Susan Provost Beller.

2. Begin by interviewing members of your family. Gather the following information:

 * Dates of birth

 * Places of birth

 * Marriage dates

 * Places of marriage

3. Ask your parents or guardians about their parents. Gather the same information about your grandparents.

4. While you are interviewing family members, try to find the answers to these questions. The answers will give you a better picture of your family history.

 * What country did your relatives come from?

 * Why did they leave their country?

 * When did they come to the United States?

 * Did they change your family name?

 * Does your family have a coat of arms? (Check in *V. & H.V. Rolland's Illustrations to the Amorial General*, by J. B. Rietstap.)

 * What does you family name mean? (Check in *Romance of Spanish Surnames*, by Charles R. Maduell.)

5. Now comes the hard part. In order to go further back than your grandparents you will have to search for the information. "Family Research: Getting Started" has all the information to help you know where to start searching. The best place, of course, is to always begin by interviewing family members and looking through family records and papers.

6. Complete the ancestor chart as far back as you can.

7. Go to the public library and find out about the genealogical clubs in your area. Attend a meeting and share your genealogy research with them.

8. Start a genealogy club at your school or in your class. Share with the club members all that you've learned about how to do a genealogy hunt.

4

Coming of Age—
Quinceañera

Cultures have the coming of age ceremony to mark the passage from adolescence to adulthood and to initiate the adolescent into the adult world. This rite of passage is an important part of the structure of a society for it establishes membership in the adult society. It also is important for it conveys to the adolescent the responsibilities of adulthood. These celebrations also signal to all witnesses that the culture will continue as one generation joins another in keeping the traditions alive.

Cultures throughout the world have various rites of passage. In the Jewish culture it is the *bar mitzvah* and *bat mitzvah*. In the Navajo culture it is the *kinaalda*. In American Anglo culture it is the debutante ball. In Hispanic culture it is the *Quinceañera*, the celebration of a young girl's fifteenth birthday. The name *Quinceañera* is a combination of two Spanish words, *quince* for fifteen and *años* for birthday. The *Quinceañera* is an affirmation of religious faith and it signifies the entrance of a young woman into adulthood in society and the church.

The *Quinceañera* has stronger roots in Mexican culture than in southwestern Hispanic culture. But, as is true whenever two cultures influence each other, the practices of Mexican culture have influenced American culture and it is common

to find both Mexican and Mexican-American families celebrating the *Quinceañera*.

The preparations for a traditional *Quinceañera* often take months. The planning can be as involved as a formal wedding and the celebration itself can be as expensive as a wedding. In older, more traditional times, the girl's parents determined many of the decisions concerning the *Quinceañera*, but in modern practices the girl has more say in the decisions. Typical decisions involve the buying or making of the fancy dress to be worn, the date of the celebration, the guest list, the banquet menu, the arrangements for the Mass and the members of the attendant court. The extended family is especially important in these decisions for they often are responsible for various aspects of the celebration and help with the expense.

The celebration of the *Quinceañera* consists of two parts. The first is the church ceremony. During the church ceremony the girl

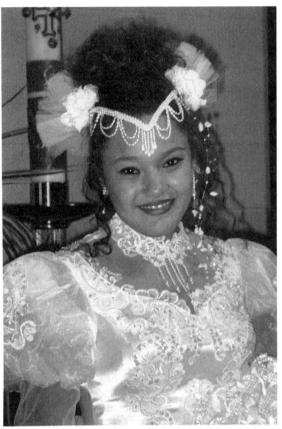

Figure 4.1. *Jennifer Trujillo, Denver, Colorado, celebrates her* Quinceañera.

is escorted by a court of honor. The court consists of fourteen *damas,* young women, each one representing a year in the honoree's life. Fourteen *chambelánes,* young men, escort the *damas.* The honoree herself represents the fifteenth year and is escorted by the *chambelán de honor.*

The church Mass is a continuation of the religious events the girl has previously experienced. The Mass serves as a rededication to the religious faith expressed in the girl's baptism, Holy Communion and confirmation. The Mass also is the girl's rededication to the spiritual aspects of her life. Often the Mass includes a sermon stressing the values of family and the religious life and asks for the blessing of the girl's patron saint. The priest instructs the young woman to seek positive role models, noting that the Blessed Virgin Mother is an excellent role model for religious women.

During the religious ceremony of the *Quinceañera,* the girl's godparents will often give her gifts of special significance. Common gifts are a cross, a ring, a religious medal and flowers. The cross represents her Christian faith. The ring is a symbol of the responsibilities the young woman has to her community and her church. The religious medal is another symbol of her Christian faith. As a symbolic act of devotion, the girl will take the gift of the flowers and lay them at the feet of the statue of Our Lady of Guadalupe in the church. As an accompanying symbol to these gifts, the young woman will wear a white dress as a symbol of her purity.

After the Mass the *Quinceañera* moves to its second part, the fiesta! Either after the Mass or later in the evening the family hosts a reception in honor of the young woman. The reception begins with the introduction of the parents and the honoree, as well as members of her family. In this manner the *Quinceañera* is the introduction of the young woman to society. The first dance is a waltz in which the young woman dances with her father. Next she dances with her *chambelán de honor.* Then the celebration continues with toasts, food, music and more dancing.

The *Quinceañera* can vary from an event as simple and modest as the repeating of one's baptism vows to a celebration rivaling the most grand formal wedding. The young woman's *padrinos* often help the parents with the expenses and the arrangements of the *Quinceañera.* In some *Quinceañeras* the *padrinos* each provide one element of the event, such as the cake, flowers, etc.

The heart of the celebration is the rite of passage of a young woman into the adult world of the church and society. One often performed *Quinceañera* ritual is for the young woman to throw a doll into a crowd of young girls, symbolizing her departure from childhood.

The *Quinceañera* serves to confirm the importance of the family and the culture that sustains the family. Its final message is the affirmation of the adult role the young woman is to play in her family, the church and society.

> **The heart of the celebration is the rite of passage of a young woman into the adult world of the church and society.**

ACTIVITY—RITE OF PASSAGE CEREMONY

Research and design your own *Quinceañera*. The *Quinceañera* is a rite of passage celebration for Hispanic young women. Other cultures have their own rites of passage ceremony. All are occasions marking the transition from childhood to the threshold of adulthood. With each comes increased privilege as well as responsibility.

This activity is to help you design a personal rite of passage ceremony. If you come from a culture with its own rite of passage ceremony, this activity is not meant to take the place of that important ceremony. If you choose to, analyze your own culture's rite of passage ceremony using these activities to help you understand and appreciate it better.

Instructions

1. Research and compare other rites of passage.

 - Go to the library and find books that contain rites of passage of other cultures. The Jewish, African (Maasi) and Native American (Mescalero Apache) cultures are good places to begin.

 - Make two lists, one for activities that you like and another for those you dislike. Why do some activities appeal to you and some do not? Are there any activities you would like to include in your own ceremony?

 - Do a survey. Ask your friends and classmates about the rites of passage in their families. Ask them to tell you about them. Especially ask if any of them have had one of their own.

 - If you come from a culture with a rite of passage ceremony, talk to adults in your family who have been through it. Ask them to explain its importance to you. Ask them what they think about the ceremony and what it was like for them.

 - Why do you think cultures have rites of passage for young people?

2. Plan a rite of passage ceremony for yourself.
 Answer the following questions. Even though they seem to be simple questions, each answer needs to include an explanation of why you chose that answer and why your answer is important.

 - Where will it be?

 - When will it be?

 - Who will lead it?

 - Who will be there?

 - What will happen?

 - What will you say?

 - How will you prepare for it?

 - What is the most important thing that will happen in it?

 - Who will take part in it with you?

 - What role will your parents, siblings and friends have in it?

 - Will there be any symbolic objects used?

 - Will it be religious?

 - Will there be music? What type?

 - Will special clothes be required?

 - Will special food be required?

 - How will it end?

 - What do you want people to remember about the ceremony?

- What do you want to remember about it?

- What will be the meaning of your ceremony, the things that happen, the things people, including you, say? How would you explain its meaning to someone else?

- How will this ceremony make you feel more grown up?

- What would it take to really make this celebration happen? Who will help you?

3. Define privileges and responsibilities.

- Make a list of the new privileges you think you should have after your rite of passage ceremony. Explain why you think you should get these privileges.

- What should be your new responsibilities after the ceremony? Explain why.

- In what ways will you be different after the ceremony?

- In what new ways do you want people to think about you after the ceremony?

4. Make it happen.

- Share your ideas, plans and answers to these questions with your parents or friends.

- Ask your parents or friends what they think about your plans.

- Ask them or your friends to help you have your own rite of passage ceremony. Make sure you carefully consider the cost of your event. A low-cost event can be as beautiful and significant as an expensive one if you put your efforts where they should be—on the meaning of the event (and not its showy trappings).

5

Marriage—*La Boda* and *La Entriega*

De amor y amor, sólo amor.
From love comes only more love.

La vida de los casados los ángeles la desean.
The angels envy the lives of married people.

The traditional Hispanic courtship and wedding consist of several clearly defined cultural practices. These traditions serve as the anchors of this most important rite of passage as young people leave home to begin families of their own. The traditions of courtship and the wedding ceremony assure that the individual marries with respect and integrity within the community.

The practices of the marriage rite of passage also serve to confirm the cultural values of the community. With their message that marriage is a sacred sacrament, these traditions contribute to the strength and importance of the family, the center of Hispanic culture.

In "the olden days" marriages followed these traditional practices strictly. Courtship was a very closely chaperoned experience. Often young women had little say in the choice of their husband. Families guarded young women carefully, as a courtship outside the accepted cultural practices would bring shame upon the young woman, and thus also the family. Parents and the extended family had clear roles and responsibilities in courtship and wedding activities. Of most importance was that the courtship and wedding be honorable in the eyes of the church and the community.

Today, as with all modern cultural practices, the courtship and wedding ceremony are as varied as families themselves. Also, modern life has greatly freed young women from the strict control of their families. In addition, modern culture has influenced the Hispanic wedding ceremony, sometimes in ways as simple as the bride wearing "something borrowed, something blue" as well as the wedding activities of the bridal shower, the bachelor party and the rehearsal dinner. The constant influence of Mexican culture also continues to be a part of evolving cultural practices in the Southwest. Traditional Hispanic families, however, still practice many of the "old ways." The honor of the woman and man are still of central importance. The wedding ceremony still reflects the important role of religion in Hispanic life. In addition, respect for the family and its traditions still determine individual choices about the wedding ceremony.

The following description of traditional Hispanic courtship and wedding practices represents traditions that have been passed down through families in the Hispanic Southwest for centuries. While not many families still adhere to all of these traditions, the modern wedding ceremony of Hispanic families is based upon these traditions and is a blend of traditional and modern customs. In many aspects, the ceremony retains the most important

Today, as with all modern cultural practices, the courtship and wedding ceremony are as varied as families themselves.

cultural elements from the past and continues to reflect important Hispanic family values.

The traditional Hispanic courtship and wedding consists of five phases. The first is *el Pedimiento*, the proposal. Next is *el Prendorio*, the engagement. *El Casorio*, the wedding, is next, followed by *el Baile*, the reception and dance. The last part is *La Entriega de los Novios*, the presentation of the bride and groom.

El Pedimiento de Mano, the proposal by hand, the asking of the father for the bride's hand in marriage, was the beginning of the courtship process. In stricter times, families controlled the contact between young men and young women. Young people had no casual social contact. Young women especially were always accompanied by a family member. A traditional *dicho*, or folk saying, humorously describes this situation:

> *Adonde va el violín, va la bolsa.*
> Wherever the violin goes, the case goes.
> (said about mothers who always chaperone their daughters)

If a young man wished to marry a young woman he first told his own family of his intentions. His parents, or oldest male sibling, representing the young man, would in turn approach the young woman's family, or oldest patriarchal figure, and ask for the young woman's hand in marriage and for permission for the courtship to proceed. This formal request for marriage could also be presented to the young woman's parents in a letter of proposal. The groom's parents would write the letter and hand deliver it to the parents of the bride. If the family accepted the marriage, the marriage

banns, or church announcements, were posted in the church bulletins and plans were made for the engagement party.

If a family refused the petition of marriage, they could convey the rejection with an especially colorful folk expression. Families referred to the refusal with the saying *darle las calabazas*, translated loosely as "giving him squash or pumpkins." Sometimes, in order to signal a rejection, the bride's family would place squash, pumpkins or even a pumpkin pie on the doorstep of the hopeful, but rejected, groom. The family could also convey the rejection with a more conventional letter delivered within three or four days of the proposal.

Dorothy and Thomas Hoobler, in *The Mexican American Family Album*, present a description of an interesting and unusual south Texas courtship tradition. It is unusual because in traditional Hispanic families the honor of the bride is paramount and families take great caution to ensure that there is not any appearance of impropriety in the bride's behavior. An unmarried young woman going to live in another family's house would require a special vigilance by all involved not to cause dishonor in the young lady. As presented by the Hooblers, however, just such a situation served the needs of the courtship process. It also describes a much older and stricter set of values and standards concerning the suitability of young people for marriage.

> It used to be that when a boy's father went to the home of the girl to ask her father for his daughter's hand that the girl's father would say, "Well, I don't know. I'll tell you what. Send your boy over to my house for two months and we'll see how

El Pedimiento de Mano, the proposal by hand, the asking of the father for the bride's hand in marriage, was the beginning of the courtship process.

he works. We'll see what we can expect from that young man!" Then the father of the boy would agree to do this. But he would tell the father of the girl that he, also, wished to see how the girl behaved and what kind of worker she was. He suggested that the girl come to his house for two months. That way there was an exchange.

The girl would get up at three in the morning and see what kind of condition the *nixtamal* (*tortilla* dough) was in, and she would set the fire, bake the *tortillas*, and tidy up the place. At her family's home the boy would be working himself to death; he would be walking in from the fields with a load of corn on one shoulder, and a load of sweet cane on the other shoulder ... After two months, when the parents had seen how well the children were able to work, they would give them permission to wed. (1994, p. 81)

After the *Pedimiento*, the next step was *el Prendorio*, the engagement party. The word *prendorio* comes from the word *prenda*, or jewel. A traditional part of the engagement party has the father of the bride introduce her to the groom's family with the words, *"Aquí tiene a la prenda que usted busca."* (Here is the jewel [prenda] you seek.)

In more traditional times this party took place the day before the wedding. Some family traditions had the party eight days before the wedding. In modern times, with families scattered throughout the country, families hold *el Prendorio* at a time allowing for important family members to be present.

The bride and her parents invited the groom and his family to their home. The engagement party's most important activity was to present the bride and groom to each other's families. Even though they already knew each other, this ritual formality served to express and affirm bonds between the two families. Family members would begin to call each other *compadre*. A *compadre* is technically the godparent of one's child. In general usage, however, *compadre* refers to a special relationship in Hispanic culture, for a *compadre* is a close friend and part of one's extended family.

When the father of the bride introduced her to the groom's family at *el Prendorio* he began by referring to the bride as "the precious jewel you claim." The bride and groom then each presented themselves to each other's family with the formal phrase "consider me at your service." Then the bride and groom exchanged gifts, usually small gifts such as a rosary, shawls or jewelry, and the two families would present gifts to the bride. The party then continued with a dinner celebration.

El Casorio, the wedding, was a religious ceremony. A Holy Mass of Matrimony sanctified the wedding vows between the bride and groom. During the Mass the bride and groom dedicated their vows to each other, and the priest gave the church's blessing to the marriage. The bride and groom were accompanied by the *padrino*, the best man, and the *madrina*, the maid of honor.

Two traditional customs especially added to the wedding ceremony. The first had the *padrino de lazo*, one of the groom's men-in-waiting and keeper of the special *lazo* or rope, placing an ornamental rope, usually with beads representing the rosary, around the wedding

The engagement party's most important activity was to present the bride and groom to each other's families.

couple to symbolize their unity and the importance of religion in their lives. In modern practice a double-looped rope placed over the wedding couple symbolizes the bonds of marriage, the ties that bind. The *padrino de arras* gave the couple the *arras*, a little box containing coins, to symbolize a life of prosperity. Modern Hispanic weddings often contain the traditions of the *lazo* and the *arras*, but just as often, they have been supplanted with the custom of throwing rice on the bride and groom as they exit the church.

After the wedding, a procession led the bride and groom to a reception hall for *el Baile*, the dance party following the wedding. Musicians,

typically a guitarist and violinist, traditionally led the processional march of the newlyweds, playing *la Marcha de los Novios*. The traditional order of the procession has the musicians first, followed by the bride and groom. Next came the *padrinos*, family and guests.

Two traditions still practiced at modern dances are the *marcha* dance and the dollar dance. At the reception hall, after the procession, the wedding party would begin the reception with *la Marcha de los Novios* dance. In the dance couples march around the room and then form an arch with their arms, under which the bride and groom waltz through.

In modern practice a double-looped rope placed over the wedding couple symbolizes the bonds of marriage, the ties that bind.

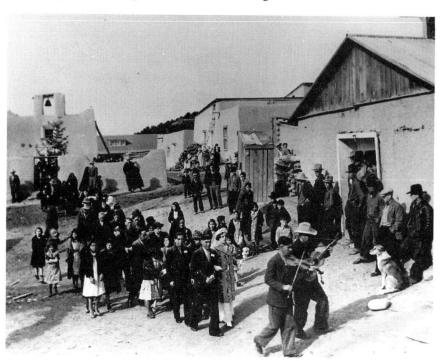

Figure 5.1. Hispanic wedding procession leaving the church in the traditional Marcha de los Novios *procession, Córdova, New Mexico, February 15, 1939.*

ACTIVITY—*MARCHA DE LOS NOVIOS:* THE WEDDING MARCH

This march announces the arrival of the wedding party at the reception and wedding dance. The invited guests join in the march.

The steps of the wedding march are best described as country steps, essentially a walking step, done with a very smooth, shuffling gait, taken in time to a promenade rhythm.

1. Starting point (the point of beginning, POB) is at the entrance of the hall or room. There must be a designated lead couple. The wedding couple goes after the wedding march *padrinos*.

2. Couples form a line with the woman to the right of the man and to the outside of the circle.

3. Couples promenade, counterclockwise, making a complete circle around the room.

4. When the lead couple reaches POB again, they turn and lead the dancers up the center line of the circle.

5. At the end of the walk up the center line of the circle, the couples separate, women going single file to one side and men to the other side, continuing back to POB.

6. At POB the couples reunite and crisscross, the first couple going one way clockwise, the second couple going the opposite way, counterclockwise.

7. The reunited couples alternate directions crisscrossing and continue to dance along the path of the circle to a point opposite from POB.

8. When the lead couple reaches the place opposite POB they stop and form an arch with their arms.

9. The next couple goes under the arch and immediately forms an extension to the arch with their arms.

10. All couples continue under the arch and add to the arch.

11. When going under the arch, dancers go single file.

12. When all dancers have formed a long arch, the wedding couple goes last under the arch.

13. As the wedding couple comes out of the arch all couples join hands and open up the arch forming a large circle.

14. The wedding couple dances in the middle of the circle.

15. After a while they are joined by the other couples. They all dance until the music stops.

Figure 5.2. The wedding couple completes the dance through the arch formed by the arms of the wedding guests.

MARCHA DE LOS NOVIOS
Based on a transcription/arrangement by Eva Nuañez and Lorenzo Trujillo
Transcription by Brenda Romero

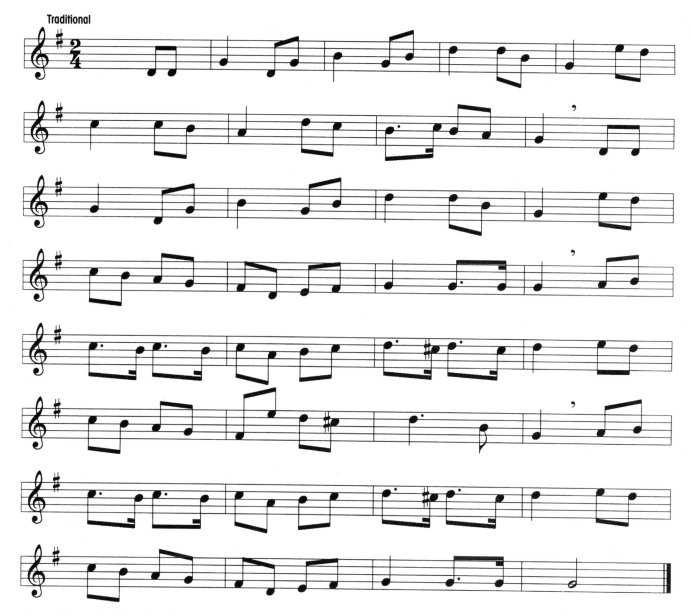

Figure 5.3. La Marcha de los Novios
traditional music.

Modern custom has a flower-decorated car leading the procession to the reception, with the horn blaring all the way. It is also common for modern wedding parties to have a *Mariachi* band as musical entertainment.

The final part of the traditional wedding ceremony was the *Entriega de los Novios*, a ceremony particular to Colorado and New Mexico, in which the bride and groom are given to each other by their parents and family and given final advice and blessings. In the olden days the wedding party returned after the reception to the bride's home. The *padrinos*, the bride's and groom's attendants, would present the newly married couple to their parents. In modern wedding ceremonies, *La Entriega* takes place at the reception near the end of the wedding dance.

Dr. Lorenzo Trujillo describes one theory as to the origins of *La Entriega*, which supposes that it became part of the wedding ceremony because priests were scarce in colonial times. *La Entriega*, therefore, served as a matrimonial service for a couple wanting to be married. It provided a public, ritual and religious ceremony for families and communities to mark the rite of passage from single to married life. (1995, p. 11)

The *entregador*, or *poeta*, of the village would sing a long set of verses to the married couple on the sacredness of marriage. The music was in the form of a waltz and the verses were a combination of traditional and improvised stanzas. The verses were in the form of a traditional romance with four-line stanzas, eight syllables per line, with the second and fourth lines rhyming.

The verses began by invoking the teachings of the church as spiritual guides to the couple. Verses followed, which presented more secular but nevertheless important lessons for a spiritually based successful marriage. The verses began with the singer apologizing for his lack of skill as a singer. Next came verses reflecting religious teachings. The final verses admonished the *padrinos* to assist the bride and groom in fulfilling their marriage vows and bless their marriage.

Families pass down their own versions of *La Entriega*, which are modified for the occasion according to the improvisational skills of the *entregador*, and to include the names of the bride, groom and their wedding party. At the end of *La Entriega* the couple's parents, godparents and relatives line up and give their own blessings to the marriage.

One colorful tradition has the couple kneeling on the floor on a spread-out white sheet. People throw money on the sheet for verses they particularly like. The money goes either to the wedding couple or to the *entregador*. Traditionally, the money went to the musicians, but today it usually goes to the wedding couple.

A similar modern tradition is the dollar dance, a favorite part of the modern wedding reception. The bride and groom dance with guests who each pins money onto the bride and groom's clothing. The money collected is an additional gift to the wedding couple to help begin their marriage in prosperity.

Olibama Tushar, in her book *The People of El Valle*, presents a traditional *Entriega*. In her English translation presented in another volume, *Acordándose del Pasado, Extenderse al Futuro*, she states:

Families pass down their own versions of *La Entriega*, which are modified for the occasion according to the improvisational skills of the *entregador*, and to include the names of the bride, groom and their wedding party.

Remember that the "Pueta" was usually an unlettered man, and when composing a poem he sometimes did not seem to make sense, just for the sake of rhyming, so I have not tried to write the translation in verse but with just the meaning he is trying to convey. (1995, p. 13)

The following *Entriega*, collected and translated by Olibama Tushar, is an excellent example of this traditional practice.

LA ENTRIEGA
Collected and translated by Olibama López Tushar

Yo no canto porque me sigan	I am singing not so you may accompany me
ni porque mi voz es buena	nor because I have a good voice
canto para que no caiga	I am singing so there will be no regrets,
el pesar sobre la pena.	nor sorrow.
Dios es el Ser Infinito	God is the Infinite Being,
María segundo ser	Mary is in second place.
Pues el mismo Jesuscristo	(We know) this is so
Nos lo ha dado a conocer.	Because Jesus Christ told us so.
Que todas las potestades	For all the rulers are under his dominion
están bajo su poder	as the Celestial Father, and
como padre celestial	therefore, we must obey him.
y lo hemos de obedecer.	
Estando el mundo formado,	When the world was formed
faltaba un ser que se hiciera	only man was lacking
Fué con el nombre de Adán	Therefore, in the image of God
como imagen verdadera.	Adam was created.
Y lo hizo que se durmiera	(God) caused him to fall asleep
y en un hermose vergel	in a beautiful garden,
le dió una compañera	and, there he gave him a companion
Pa (para) que estuviera con él.	to be with him.
Y luego despertó Adán	And when he woke, Adam
Con una voz admirable	with a joyful voice
Le recibió por esposa	received her as his wife,
Por obedecer al padre.	thus, obeying his father.
Y llegaron a la iglesia	(The bride and groom) arrive at the church
y suben a comulgar	and go up to receive communion,
y alli les entriegan las arras	and there they receive the "arras"
y el anillo pastoral.	and the pastoral ring.

El haber tomado las arras,
y el anillo pastoral,
es una prueba patente
que el matrimonio es legal.

The act of receiving the "arras"
and the pastoral ring
is patent proof that the
marriage is legal.

Se echaron un juramento
de guardar felicidad
uno al otro; es esta vida
vivir con felicidad.

They then vowed one to the other
to protect each other's happiness and
that they would live
in joy and harmony together.

Y escúcheme el esposado

que le voy a amonestar
Esta cruz que Dios le ha dado
no la vaya a abandonar.

Therefore, (wedded couple) listen
to me
as I am going to admonish you
not to abandon the cross
that God has given to you.

Porque le hago responsable
entre el justo tribunal,

y esto queda recordado,
en la mesa del altar.

Because I am making you responsible
(to do this) before the Supreme
Tribunal
and this admonition is recorded
on the altar.

Si deja su cruz por otra,

ella pegará un suspiro,
y a usted lo hago responsable

ante el tribunal divino.

If you abandon your cross for
another,
she will give a great sigh
(she will be very unhappy) and I
hereby make
you responsible before the Divine
Tribunal.

El estado no es para un rato,
ni para un día, ni dos
Es para una eternidad
mientras vivos sean los dos.

This (matrimonial) state is
not for a little while,
nor for a day or two.
It is for eternity, while both shall
live.

No piense que porque manda,

y en este punto veloz,

porque crianza dan los padres
y natural solo Dios.

Don't think this is just a
commandment
because it is the parents who train
the child.
But it is God who gives each one
his character (and natural ability).

Y ese manto que posea

de la cabeza a los pies
representando a la Virgen,
Nuestro padre, San José.

The veil that you wear from head
to foot
represents the Virgin (Mary)
and our father
St. Joseph.

Y en la primera mesa están
padres, novios y padrinos,
Tambien el Señor está

para consagrar el vino.

Llegaron los esposados

como a las once del día
Dios los haga bien casados
Como San José y María.

Y el padrino y la madrina
sentados en un balcón
entriegan a sus ahijados

y les echan la bendición.

The parents, the bride and groom
As well as the matron of honor
And the best man now sit at the
first table;
and God is present to bless the wine.

The wedded couple arrive at
eleven
in the morning.
God bless your marriage
As he did that of Joseph and Mary.

The best man and matron of honor
sitting on the balcony
now return the couple to their
parents
and give them their blessing.

ACTIVITY—THE WEDDING CEREMONY

Research and write your own *Entriega*. The *Entriega* is one of the most important parts of a traditional Hispanic wedding. It is the final occasion at which the parents, through the *entregador,* give advice to the newlyweds.

The *Entriega* has several traditional qualities.

- The verses were in the form of a traditional romance with four-line stanzas, eight syllables in a line, with the second and fourth lines rhyming.

- The verses began by invoking the teachings of the church as spiritual guides to the couple. Verses that presented more secular but nevertheless important lessons for a spiritually based successful marriage followed.

- The verses began with the singer apologizing for their lack of skill as a singer.

- Next came verses reflecting religious teachings.

- The final verses admonished the *padrinos* to assist the bride and groom in fulfilling their marriage vows and bless their marriage.

Instructions

1. Reread *La Entriega,* by Olibama López Tushar. Make a list of the advice you find in it.

2. What type of advice you would give a newlywed couple?

3. What do you think are the most important things a newlywed couple should be reminded about in order to have a good and successful marriage?

4. Interview your friends and ask them questions #2 and #3. Write down their answers.

5. Interview adults, your parents, relatives, religious leaders, teachers and neighbors. Ask them to answer questions #2 and #3. Write down their answers.

6. Go to the library and find some books about weddings in other cultures. Read about these weddings and try to find out what the culture is trying to teach the wedding couple through the activities of the wedding.

7. Try to find a wedding to go to. As the wedding is taking place pay attention to what people say during the wedding. Listen to the speeches and scriptural reading and try to understand their messages about being married.

8. Organize all the answers to all the above questions and activities, including your own, in a ranked list with most important at the top, down to least important.

9. Now you've gathered the information you need. Now you can write your own *Entriega* and give the advice you think is most important.

 - Write the *Entriega* verses in the form of a poem. (Your poem needs to have four lines to a verse.)

 - If you want to do an advanced version of the *Entriega* make each line have eight syllables and make the second and fourth line of each verse rhyme.

 - Begin your *Entriega* with an introduction about yourself and why you're giving advice.

 - Make the middle part of your *Entriega* the place where you give your advice to the bride and groom.

- Near the end of your *Entriega* tell other important people at the wedding to help and advise the bride and groom also.
- End your *Entriega* with a farewell and wish for a good marriage.

10. Read your *Entriega* to your parents, teacher and classmates. Ask them what they think about your advice.

11. Go to a priest, rabbi or judge and share your *Entriega* with them. Ask them if it would be good advice to give to a couple they are marrying.

6

Death—
Día de los Muertos and the *Ofrenda*

La vida es sueño.
Life is a dream.

Día de los Muertos, Day of the Dead, is a celebration during which families remember and honor relatives who have died. The celebration of the Day of the Dead is a blending of religious practices of two major cultures—the Mexican Aztec and the Spanish Catholic.

The Aztecs believed death and life were closely intertwined. They believed that the dead were an important part of the world of the living and that the spirits of the dead could affect the living. They had a complex cosmology that reflected their beliefs about the afterlife. According to this cosmology, a dead person travels through a nine-level underworld, *Mictlan*, and faces many dangerous trials. In order to aid the spirit in its underworld journey and trials, the Aztecs had the practice of burying the dead with many objects from the dead person's life that would be useful in the long and dangerous journey through *Mictlan*. They placed both personal and household objects in the grave to help the departed spirit.

Other beliefs about the afterlife included the paradise of Tlaloc, called Tlalocan, where those who drowned could enjoy a life of singing, games and other pleasures. Warriors who died in battle and mothers who died in childbirth assisted the sun in its daily journey through the sky. For the Aztec, death was a mere passing from one world to another.

When the Spanish arrived in the New World, one of the Aztec customs they encountered was the celebration of the dead. The Aztecs had a complex concept of death based upon one's station in life. Their underworld had nine regions, each reserved for specific categories of people as determined by their occupation in life.

Over time, the Aztec calendar evolved to include celebrations in honor of the dead. A festival honoring dead children was held in the ninth month of the Aztec solar calendar; the celebration to honor dead adults was held in the tenth month of the calendar. Warriors were honored during the fourteenth month, which corresponds to November in the modern calendar.

On these dates the dead returned to Earth to visit family and friends and to see that they were remembered. In turn, families would hold celebrations to pay their respects to the dead. These celebrations included the preparation of favorite foods in order to make an offering to the visiting family members.

The Spanish brought their own customs honoring the dead to the New World. One of these was the custom of All Saints' Day and All Souls' Day. These Catholic customs were religious days dedicated to

The Aztecs believed death and life were closely intertwined. They believed that the dead were an important part of the world of the living and that the spirits of the dead could affect the living.

praying for the souls of departed family members and friends. November 1 was All Hallows, or All Saints' Day, a day to honor the saints of the Catholic Church. November 2 was All Souls' Day, a day to pray for departed souls. All Hallows Eve, October 31, eventually became secularized into Halloween.

It was one of the coincidences of history that the customs from two such different cultures overlapped on the calendar. In time the ancient Aztec and the Spanish Catholic customs merged in the New World into the Mexican celebration we know as the Day of the Dead.

Professor George Rivera, Ph.D., University of Colorado at Boulder, has observed many *Día de los Muertos* celebrations in Mexico and is active in establishing and celebrating the tradition in the Hispanic Southwest. He contributes the following essay on the meaning and practice of celebrating the *Día de los Muertos* in both Mexico and the Hispanic Southwest.

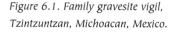
The days preceding November 2 are usually referred to as *Días de los Muertos* (Days of the Dead).

Día de los Muertos

The fiesta of *Día de los Muertos* (Day of the Dead) is observed annually in cemeteries throughout many parts of Mexico, especially in the states of Oaxaca and Michoacan. This event begins with an all-night vigil on November 1, which is known as *Noche de Muertos* (Night of the Dead), when family members spend the night at the cemetery, and terminates on November 2, which is the Day of the Dead.

Aztec *codices* and Spanish chroniclers noted that the Aztec solar year contained festivals associated with the dead. In pre-Columbian times the indigenous Indian population of Mexico believed that once a year the souls of their dead were given divine right by the gods to visit the living. Catholicism tried to eradicate this practice of "worship of the dead," but the priests were unsuccessful in removing it as a yearly observance. The Day of the Dead survived attempts at extinction and was eventually integrated with Catholic observances of All Saints' Day (November 1) and All Souls' Day (November 2).

The days preceding November 2 are usually referred to as *Días de los*

Figure 6.1. Family gravesite vigil, Tzintzuntzan, Michoacan, Mexico.

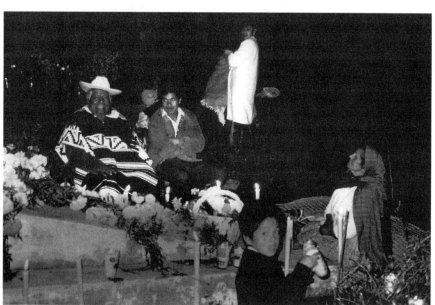

Muertos (Days of the Dead). On November 1, and the last day of October, grave-site activity begins in preparation for *Noche de Muertos* (Night of the Dead). In Mexico, families attend to the graves of their dead by cleaning them and removing weeds and overgrowth.

After a grave of a loved one has been cleaned, it is decorated with the following:

- *cempasuchil* (marigold) flowers, which are referred to as the "flowers of the dead" and whose fragrance helps guide the souls of the dead to their grave site, where relatives await them;

- candles to illuminate the journey for the souls of the dead;

- food and beverages that were the favorite food and drinks of the deceased so that the souls of the dead can eat the spirit of these and leave the actual food to be eaten by the living;

- a photograph of the dead so that the soul might recognize its previous physical form;

- other familiar objects of the deceased, a favorite tool or something from a hobby or other favorite activity, and a piece of clothing (like the favorite jacket of the deceased) to warm the dead upon their visit.

In Mexico, Mexicans also build altars, known as *ofrendas* or offerings, for their dead in their homes. These are decorated, and decorations are removed on November 1 so that all decorations can be placed at the grave site for the all-night vigil. In addition, the practice of constructing altars is especially noticeable in Mexico City in museums and public parks during the Days of the Dead.

Chicanos, who live in the United States and are of Mexican descent, also have adopted the Days of the Dead as a time of annual observance. Because Chicanos have adapted to Anglo customs, all-night vigils with grave decorations in cemeteries are not part of the U.S. celebration. Instead, Chicano artists create altars for the dead in museums or alternative art spaces and decorate these altars with all of the elements noted to be associated with grave decorations.

Chicanos sometimes create an altar to a deceased member of their family or some other deceased individual in their life, but most of the altars created for Days of the Dead are dedicated to historical figures or have reference to some social issue. Thus, you can find altars dedicated to such historically important deceased figures as Emiliano Zapata (Mexican revolutionary), Diego Rivera (Mexican artist), Frida Kahlo (Mexican artist), César Chavez (Farm Workers' union leader), and to such social issues as deaths created by gang violence, spousal abuse, HIV/AIDS, etc.

Because the Days of the Dead occur very close to Halloween, it is usually confused with this day in American society. Though skeletons and skulls are used to decorate some altars, the Days of the Dead have nothing to do with Halloween. (No one celebrating this event wears masks or goes house to house requesting candy.) The Days of the Dead represent the continuation of a cultural phenomenon that predates the arrival of Christopher Columbus. It exists today in Chicano culture as part of cultural revitalization of a very spiritual and sacred moment.

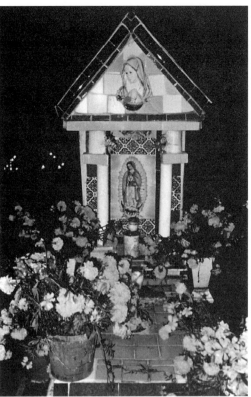

Figure 6.2. Grave decoration and tomb of Guadalupe, Michoacan, Mexico.

Though skeletons and skulls are used to decorate some altars, the Days of the Dead have nothing to do with Halloween.

The *Ofrenda*

Making an *ofrenda* is a time for families to remember the strengths and love in a family and to celebrate the people who have lived in the family.

The *ofrenda*, the altar, is one of the best family activities of the Day of the Dead celebration. The constructing of the altar is an activity every family member can participate in. Making an *ofrenda* is a family commitment. Making an *ofrenda* is a time for families to remember the strengths and love in a family and to celebrate the people who have lived in the family. In many aspects making an *ofrenda* is as much for the living members of the family as it is for the departed. The *ofrenda* is an especially good activity for younger children because it allows them to participate at an appropriate level and still feel as if they contributed something important to the *ofrenda*.

Take your time, be thoughtful, plan ahead, let everyone participate. There are no rules on how to make your *ofrenda*. Every *ofrenda* is different and every *ofrenda* is personal. Some are plain, some are ornate. Some are sparse, some are filled up. Some look like professional artists made them, some have a homemade quality. Some are traditional and look like they were imported from Mexico, some are modern and speak to an urban American life. The most important ingredient is the love you have for your family.

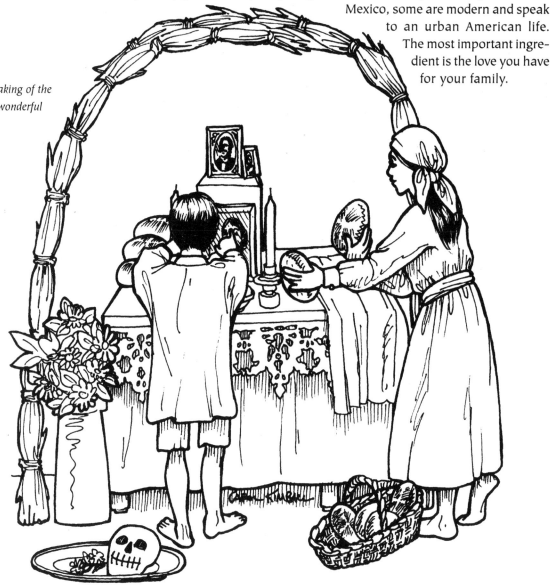

Figure 6.3. The making of the ofrenda *can be a wonderful family activity.*

ACTIVITY—DAY OF THE DEAD *OFRENDA*

Instructions

1. Have discussions with family members on the meaning of the *ofrenda*. The *ofrenda* is a memorial to a loved one who has passed away. It allows family members to help build an *ofrenda* that honors the departed and helps the living remember the beauty of the lives of their departed loved ones.

2. As a family, decide whom to honor in this year's *ofrenda*. You can honor more than one person with your *ofrenda*.

3. Set up a table to be used for the *ofrenda*. Place it in a spot where it can remain for several days.

4. If you wish, place boxes on the table to create levels and places to put things.

5. Cover the table and boxes with tablecloths or pieces of material.

6. Now comes the easy and fun part. Place things on the table that have meaning to you about the life of the person(s) you are honoring with the *ofrenda*. Take time to help young children decide on something to put on the *ofrenda*.

Here are some suggestions and examples of what could be placed on both traditional and personal *ofrendas*.

family photos

artwork

personal trinkets

personal mementos

pan de muerto

Bible

scapulars

chile ristras

religious cards

flowers (Marigolds are especially associated with *ofrendas*. In Mexico, marigolds are placed on the floor before the *ofrenda* to lead the souls to it.)

beverages (especially a glass of water for the thirst of the spirits after their journey)

anything of value or personal memory from the life of the departed

papel picado

letters

candles

banners

crosses

other religious objects

wreaths

books

the name(s) of the departed

incense (Copal, a tree resin incense, is most associated with the *ofrenda*.)

food (fruit, nuts, bread), favorites of the deceased

an altar arch (made of braided cornhusks, sugarcane, bamboo, garland, foil, tissue paper, branches)

The book *Indio-Hispanic Folk Art Traditions*, vol. II, by Bobbi Salinas-Norman, is an especially good reference for making decorations for an *ofrenda*. Another excellent resource is the video *El Día de los Muertos: Day of the Dead*. This award-winning documentary looks at the ways in which different people, both *Tejanos* and non-*Tejanos* (Mexican Texans and non-Mexican Texans), use this poignant celebration as a time to create personal expressions of love for those who have died. Rated for grades 7 through 12 with an accompanying teacher's guide, it is available from the Institute of Texan Cultures: (800) 776-7651.

ACTIVITY—*PAN DE MUERTO* BREAD

Pan de muerto is traditional bread made for the Day of the Dead celebrations. It can be eaten as part of the celebration or shaped into loaves and placed on the *ofrenda* as food for the visiting souls. In Mexico the bread is often made in the shape of skeletons.

Ingredients

1/4 cup milk
1/4 cup (half a stick) margarine or butter, cut into eight pieces
1/4 cup sugar
1/2 teaspoon salt
1 package active yeast
1/4 cup warm water
2 eggs
3 cups all-purpose flour, unsifted
1/2 teaspoon anise seed
1/4 teaspoon ground cinnamon
2 teaspoons sugar

Instructions

1. Bring milk to a boil and remove from heat. Stir in butter, sugar and salt.
2. In large bowl, mix yeast with warm water until dissolved and let stand 5 minutes. Add the milk mixture.

3. Separate the yolk and white of one egg. Add the yolk to the yeast mixture, but save the white for later. Now add another whole egg to the yeast mixture.
4. Measure the flour and add to the yeast and eggs. Blend well until dough ball is formed.
5. Flour a pastry board or work surface very well and place the dough in center. Knead until smooth. Return to large bowl and cover with dish towel. Let rise in warm place for 90 minutes. Meanwhile, grease the baking sheet and preheat oven to 350° F.
6. Knead dough again on floured surface. Now divide the dough into fourths and set one aside. Roll the remaining three pieces into "ropes."
On greased baking sheet, pinch three rope ends together and braid. Finish by pinching ends together on opposite side. Divide the remaining dough in half and form two "bones." Cross and lay them atop braided loaf.

7. Cover bread with dish towel and let rise for 30 minutes. Meanwhile, mix anise seed, cinnamon and sugar together.
8. Beat egg white lightly.
9. When 30 minutes are up, brush top of bread with egg white and sprinkle with sugar mixture, except on *crossbones*. Bake at 350° F for 35 minutes. (High-altitude baking: Bread may rise faster; check after 20 minutes. It has risen enough when it has doubled in bulk. Bake at 375° F for 25 to 30 minutes.)

Part III

La Iglesia:
Religious Celebrations

Tiene más Dios que darnos que nosotros que pedirle.
God can give more than we could ever ask for.

Dios amanece para todos.
God brings the dawn for all.
God's graces are for everyone.

Religious life is one of the fundamental experiences of the Hispanic culture. It is often said that one cannot enter Hispanic culture without passing through the doors of the Catholic Church. When the *conquistadores* came to the New World in search of gold and personal glory they were soon followed by Catholic missionaries on the holy mission of bringing Catholic Christianity to the New World. Along with the cultural practices of language and folklore, these early explorers and settlers firmly established their religion in the New World.

A simple recalling of the names of settlements established by these early missionaries and settlers scattered throughout the American Southwest illustrates the importance of religious life for these pioneers of the New World: San Francisco, San Diego, Los Angeles, San Antonio, San Jose, Santa Barbara, Santa Fe.

The common practice for the founding missionaries was to give religious names to the early settlements, names that continue to this day.

From the earliest instances of civilian settlement in the New World the Catholic Church was central to the lives of Hispanic people. With such a long heritage of religious activity, the Hispanic culture has innumerable opportunities for its people to practice and celebrate their faith. The Christmas season is an especially important time of religious observations. The season begins with the Feast of Our Lady of Guadalupe. The Christmas season features two community-wide celebrations: the performance of two religious plays, *Los Pastores* and *Las Posadas*. The season includes the New Year's procession of *Los Días* and ends on January 6 with *el Día de los Reyes Magos*, the Feast of the Epiphany.

When the *conquistadores* came to the New World in search of gold and personal glory they were soon followed by Catholic missionaries on the holy mission of bringing Catholic Christianity to the New World.

The Feast of
Our Lady of Guadalupe

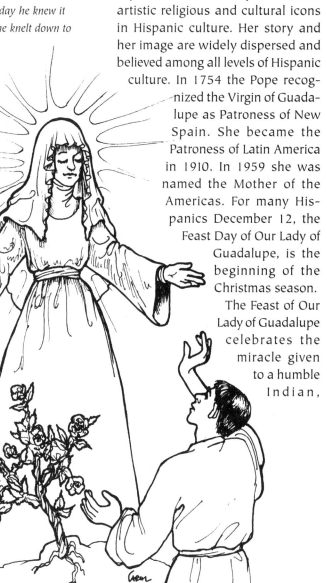

Figure 7.1. When Juan saw the roses on that cold winter day he knew it was a miracle and he knelt down to pray.

Our Lady of Guadalupe and the image of her surrounded by a wreath of roses and enveloped by the sun's rays is one of the most powerful and artistic religious and cultural icons in Hispanic culture. Her story and her image are widely dispersed and believed among all levels of Hispanic culture. In 1754 the Pope recognized the Virgin of Guadalupe as Patroness of New Spain. She became the Patroness of Latin America in 1910. In 1959 she was named the Mother of the Americas. For many Hispanics December 12, the Feast Day of Our Lady of Guadalupe, is the beginning of the Christmas season.

The Feast of Our Lady of Guadalupe celebrates the miracle given to a humble Indian, Juan Diego, on a hill in Mexico on December 9 through 12, 1531. After the conquest of the Aztecs in 1521 the Spanish missionaries began their mission to convert Aztec society to the Catholic religion. One successful strategy the missionaries practiced was combining Catholic beliefs with indigenous practices. The legend of the Virgin of Guadalupe is a clear example of this successful mission. The legend of the Virgin quickly became very powerful in Mexico and spread throughout the territory of New Spain. Today, the legend is regarded as a Hispanic truth representing the possibility of apparition and the miraculous for believers of the Catholic faith.

The legend of the Virgin of Guadalupe takes place on a hill named "Tepeyac." Tepeyac was the site of an Aztec shrine to the Aztec Mother Goddess Tonantzín, the protector of earth and corn. The Aztecs came to the shrine of Tonantzín to pray. After the conquest the Spanish missionaries built a shrine to the Virgin on the site of the shrine to Tonantzín. After the legend of the Virgin came into existence, the missionaries facilitated the Aztec conversion to Catholicism and the worshipping of the Virgin by painting pictures of the Virgin in which she looks like an Aztec princess, and by having her speak in Nahuatl, the Aztec language.

NUESTRA SEÑORA DE GUADALUPE
THE STORY OF OUR LADY OF GUADALUPE

Retold by Angel Vigil

Excerpted from *The Corn Woman: Stories and Legends of the Hispanic Southwest*

On one cold winter morning in December, 1531, an Aztec Indian man named Juan Diego was walking to church. It had been ten years since the mighty battles with the men of Cortés had ended. The soldiers and warriors had put down their weapons and now peace had returned to his land. Juan himself had recently converted to Christianity. It was his habit to go to the church for religious instruction.

His church was not in his village but in Tlatelolco, a village just outside of Mexico City. His usual path took him by the houses in the village but this morning for some reason he decided to walk over the hill of Tepeyac.

As he neared the top of the hill he heard voices singing. Now he had heard the voices of people singing the holy praises to the Lord in church but he had never heard such beautiful music as this in all his life. He heard the tinkling of bells and the voices moved around him like the wind itself. He thought that this must be what the voices of heavenly angels sound like.

As he reached the top of the hill the beautiful singing voices and music stopped. Everything became very still and Juan no longer even felt the coldness. He heard his name being called, "Juan, Juan."

Suddenly he saw a bright cloud with the shafts of a colorful rainbow coming out of it. The cloud came to a stop before him and when the cloud split in two there was a woman standing there. The woman looked like a beautiful Aztec princess. Her clothes shone like the sun and she was surrounded by the heavenly light. When she spoke Juan heard the heavenly music he had heard before. He knew it was a miracle so he fell to his knees to pray.

"Juan," the heavenly woman said, "I have chosen you to deliver a message to the bishop at the cathedral."

"But beautiful woman," answered Juan, "I am a poor Indian. I am not worthy to deliver a message to the bishop. Why have I been chosen?"

With a soothing kindness in her voice the woman answered, "I am the Blessed Virgin Mary, the mother of the Lord Jesus Christ. Just know that I have chosen you to be my messenger on this earth. Go to the bishop and tell him that he is to build a church for me here on the top of this hill. The church is to be a shrine which will show my love for all my people. Go, give the bishop my message."

Juan ran faster than ever to the cathedral to give the Virgin's message to the bishop. When he arrived at the cathedral he knocked on the door to the bishop's quarters. The bishop's helpers opened the door and asked Juan what he wanted. He told them, "I have a message for the bishop from the Virgin Mary, the Mother of God."

When they heard this they could not help but laugh to hear a poor Indian tell such a story. But Juan was persistent and eventually they let him in to see the bishop. The bishop listened to Juan's story but did not

"Juan," the heavenly woman said, "I have chosen you to deliver a message to the bishop at the cathedral."

believe him. He told him, "Juan, your story is incredible. Imagine the Virgin appearing to you on a hill with a message for me to build a church! Go for now and I will think about it."

Juan left feeling like a failure. He knew the bishop's helpers had laughed at him and that the bishop had not believed his story. He felt that he had let the Blessed Virgin down. When he returned to Tepeyac he once again saw the Virgin. She floated on air as if nothing were holding her up except her heavenly powers.

"O Holy Mother. I have failed you. The bishop did not believe me. I knew I was not worthy."

"Juan, do you not know that now you are within my graces? I have chosen you and I will make it be as it should. Go back to the bishop and give him my message again. A church must be built in my name on this hill."

Juan returned to the bishop a second time. Again the bishop did not believe Juan. He said, "Juan, if you have truly seen the Blessed Virgin Mary, bring back a sign that the miracle is real. If not, then never come to me with this story again."

On his way back to tell the Virgin that he needed a sign Juan received the news that his uncle was dying of typhoid fever. Juan immediately rushed to the side of his uncle but when he arrived he found out that it was almost too late. His uncle asked him to bring the priest because he knew he would not last for another day.

Juan opened his *tilma* and roses tumbled onto the floor. Roses fell out of the tilma like snow falling to the ground.

Juan rushed to the Virgin to tell her what the bishop had said and to ask forgiveness for not coming right back. "O, Blessed Virgin. I was late because my uncle is dying and is not expected to last another day. Also, the bishop requires a sign that you really spoke to me. Please help Blessed Mother."

"Juan, do you not know that I am here to help you? I have already cured your uncle. He will live. Now go to the top of the hill where only the cactus grows. There you will find a rose bush in bloom. Take those roses to the bishop and he will believe."

Juan went to the top of the hill and there was a beautiful rose bush in full bloom. When Juan saw the roses on that cold winter day he knew it was a miracle and he knelt down to pray. He knew that when the bishop saw the roses that had bloomed in the middle of winter and smelled their beautiful fragrance, he would believe his story. Juan gathered the roses in his *tilma*, which is a kind of poncho. He showed the roses to the Virgin and she said, "Now take these to the bishop and tell him to build the church in my honor."

When Juan arrived at the cathedral for the third time the bishop's helpers refused to let him see the bishop. Juan told them that he had the sign the bishop had asked for. They said, "If you have the sign let us see it. Let us see the sign of a miracle. Then you will see the bishop."

Juan opened his *tilma* and roses tumbled onto the floor. Roses fell out of the *tilma* like snow falling to the ground. Beautiful, fresh roses lined the inside of the *tilma*. In their astonishment the bishop's helpers reached out to touch the roses and felt their soft, smooth petals. They knew that it was indeed a miracle.

When Juan showed the bishop the roses the bishop also knew that it was a holy sign from heaven. As Juan opened his *tilma* more roses fell to the ground. Even more miraculously, inside Juan's *tilma* was the image of the Holy Mother as Juan had seen her on the hill of Tepeyac. The bishop and his helpers fell to their knees at the sight of the holy image and prayed to the Virgin.

The bishop built a church on the site Juan showed them on the hill of Tepeyac. Now the site is called Guadalupe. To this day Juan's *tilma* with the image of the Holy Mother is inside the shrine to the Blessed Virgin. Prayerful worshipers can look at the *tilma* and be reminded of the love the Holy Mother has for her people. For all eternity the shrine to Our Lady of Guadalupe is a reminder of the miraculous apparition that appeared to Juan Diego many years ago.

The bishop built a church on the site Juan showed them on the hill of Tepeyac. Now the site is called Guadalupe.

ACTIVITY—OUR LADY OF GUADALUPE: RELIGIOUS STORY

Create a miracle story. The miracle story has a long history in both oral and literary tradition. One of the early religious folk dramas in the Hispanic Southwest was *La Aparición de la Virgen de Guadalupe.* A corresponding *cuento* telling the same story is "Our Lady of Guadalupe."

Of course, the primary event of a miracle story is the occurrence of a miraculous event to solve the problem or conflict of the story. A secondary aspect of a miracle story is the intercession of a powerful, somewhat magical, person to assist in the solving of the story's problem. A third important quality of a miracle story is that the characters in the story learn an important lesson, usually a moral lesson, because of the successful resolution of their problems.

Traditional folklore has many instances of the miracle story. "Cinderella" and "Aladdin and His Magic Lamp" are two examples of miracle stories from children's folklore. "Our Lady of Guadalupe" is a religious miracle story and tells a more serious and important story than most children's magic stories. But it does adhere to the tale type and is a good example of the structure of this type of story.

Instructions

1. Reread "Our Lady of Guadalupe" and answer these questions.

 - What is the problem of the story?

 - Why does the bishop not believe Juan's story the first two times?

 - Who helps Juan?

 - What are the clues in the story that the Virgin has magical powers?

 - Why is the miracle of the roses such a good miracle?

 - What are the lessons people learn?

2. Write your own miracle story. Use the following outline to help you organize your ideas.

 - First decide upon the main character in your story. Girl, boy, group of friends?

 - Now give your main character a goal or task to accomplish. Complete a journey, deliver a special present, find a hidden object, etc.

 - The third important part of your story is to explain why it is important for your character to complete the task. If the reader does not know why it is important for the character to complete the task then the reader will not be interested in your story. Is someone on a holy mission? Is fate of the Earth at stake? Is family honor at risk? Is a loved one in danger? Try to imagine a problem that is important to solve.

 - Now it is time for the special part of a miracle story. Decide what type of miracle event would really help your character. Then decide about a powerful person who could help. Genie, saint, magician, mad scientist, etc.

 - A critical part of the story is explaining why the powerful person helps your character. Good deed, heavenly helper, special concern, special love, etc.

 - The end of your story is when you show how the miracle helps your character complete the task. At the end of your story your character needs to realize who the powerful helper is and to be thankful for the magical help.

3. Read or tell your story to your family, friends or class.

8

Las Posadas and *Los Pastores*

Las Posadas and *Los Pastores* are two traditional plays dramatizing the journey of Mary and Joseph searching for lodging in Bethlehem and the birth of the Christ Child. *Las Posadas,* The Christmas Story (literal translation is "the inns"), originally was part of an annual cycle of plays used to teach Christian values in Spain during the Middle Ages. The play is a community celebration lasting nine nights during which the community dramatizes Mary and Joseph's search for lodging. The dramatization of *Las Posadas* is a community event with participants celebrating the Christmas season with food and good cheer in all the houses at which they stop.

Costumed as Mary and Joseph, and accompanied by a legion of children playing angels and shepherds, community members proceed nightly from house to house seeking lodging. Olibama López Tushar, in her book, *The People of El Valle, A History of the Spanish Colonials in the San Luis Valley,* describes a traditional *Las Posadas* in which a community member playing Lucifer goes from house to house for eight nights and persuades the owners of the house not to give lodging to Mary and Joseph. A typical refrain had the owners of the house refusing to grant lodging because they had been warned, by Lucifer, that Mary and Joseph were thieves come to rob them. On the ninth night, Christmas Eve, Mary and Joseph finally receive lodging.

Mexican legend tells that the practice of *Las Posadas* began in the New World when Fray Diego de Soria received permission from the Pope to celebrate nine *Misas de Aguinaldo,* or Gift Masses, from December 16 to 24. These Masses celebrated the Holy Nativity and occurred at the convent of San Aguatín de Acolmán near Mexico City.

Los Pastores, The Shepherds' Play, is the most well known and popular Nativity play in the Hispanic Southwest. It is a dramatization of the biblical account of the birth of Christ, telling the story of the journey of the shepherds following the heavenly star to the manger in Bethlehem. The play is a descendant of the Medieval European religious plays. Liturgical dramas have existed in Europe since the ninth century, and the Nativity play was an established part of Spain's dramatic literature during Spain's Golden Age. Lope de Vega's *Los Pastores de Belén* is one of the primary examples of the well-developed genre of Spanish Nativity plays. Franciscan missionaries probably wrote versions of the play in Mexico, based upon European models, and carried these plays from the interior of Mexico to the northern provinces.

Los Pastores presents the biblical events of Christ's birth. It also

The dramatization of *Las Posadas* is a community event with participants celebrating the Christmas season with food and good cheer in all the houses at which they stop.

depicts the eternal struggle between good and evil and mankind's effort to resist temptation. The final victory of Archangel Michael over Lucifer heralds the birth of the Christ Child.

While its themes are serious and religious, its great popularity is because it also has comedy, fun and irreverence woven into the story. In this manner it is similar to the *Second Shepherd's Play* of the Wakefield cycle in Britain. Several of the play's characters are buffoons tricked by temptation, and several of its scenes are almost slapstick in nature. Traditional performances featured ad-libs poking fun at community members and playfully exaggerated characterizations of Lucifer and the comic characters.

One of the lines of the play, spoken by a lazy buffoon named Bartolo, has entered the common language as a *dicho*, a folk proverb. The line is *"Si quiere la gloria verme, que venga la gloria acá."* "If glory wants to see me, let glory come to me." The line is spoken in response to a plea for the lazy shepherd to get up and travel with his companions to witness *"la Gloria,"* the Christ child. Today, people use the dicho to refer to a lazy person who does not want to do something.

Traditional performances of these plays often combined the two. A performance of *Las Posadas* would typically precede a performance of *Los Pastores*. Communities and churches, however, when performing the two together, would condense them into a one-day event. The celebration would end with Christmas Eve Midnight Mass, *La Misa del Gallo*. The community referred to this Mass as "the Mass of the rooster" because they often came home so late they would hear the rooster crowing. Another legend about *La Misa del Gallo* is that the name comes from the rooster that crowed over the stable in Bethlehem at the birth of Christ.

The parts of both of these traditional plays were greatly desired by adult and children alike, especially the part of Lucifer in *Los Pastores*. Lucifer was more of a trickster than an embodiment of evil and allowed for much playful exaggeration. Often parts were passed down through families and scripts were handwritten legacies passed down from one generation to the next.

Most versions of the play *Los Pastores* are written in Spanish, passed down through families and are not available to the general public. I have written an English version, appropriate for students, based upon several traditional versions. While language and plot have been simplified, it contains all the primary characters and all the essential textual elements of the full versions. The play is in my book *¡Teatro! Plays from Hispanic Culture for Young People*, Libraries Unlimited, P.O. Box 6633, Englewood, CO 80155-6633; (800) 237-6124.

Figure 8.1. Los Pastores, *Sante Fe, New Mexico, ca. 1915, depicting the battle between San Miguel and Lucifer.*

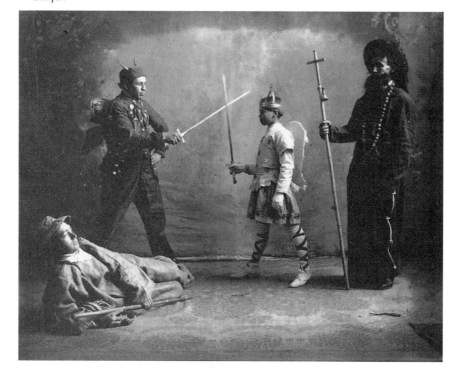

9

Los Días

Another traditional custom of the holiday season was the New Year's Eve celebration of *dando Los Días*. The phrase *Los Días* referred to the custom of community members passing throughout the village to *"dar los Días,"* "give the days," greeting and serenading on New Year's Day. The custom combines the tradition of serenading people on their saint's day with the Nativity tradition of *Las Posadas* of parading through the village. The tradition gives a community the opportunity to affirm its harmony and unity.

At midnight people would begin to go from house to house and sing *"Los versos del año nuevo,"* the New Year verses. The tradition was to go to the houses of the Manueles, the men named Manuel. Manuel is the Spanish name for Emmanuel, the sacred name referring to Christ. Manuel is a common Spanish name so a community would typically have more than a few houses to serenade. At each house the community members would sing verses and then would join the owners of the house for a celebration with seasonal food such as *biscochitos* (anise

cookies), *empanaditas* (mincemeat-fried turnovers), *posole* (hominy stew) and *tamales*.

In Spanish and Mexican tradition, people serenade others on their saints' day instead of their birthday. Calendars note the saint honored for each day, so, for instance, everyone knows that January 1 is the day to serenade anyone named Manuel.

The opening verses of religious invocation and the greeting of *los Manueles* were followed by improvisational verses for members of the Manueles's family. These verses were often humorous and meant to be lighthearted. Often the singer would compose these verses beforehand, but the best singers could improvise on the spot. The verses are in the form of a traditional romance with four-line verses, eight syllables per line, and the second and fourth lines rhyming.

The following music is representative of the many regional variants.

Olibama Tushar, in her book *The People of El Valle*, presents *Los Días* verses including the following greeting.

Oiga, Señor Manuel
Aquí caigo, aquí levanto
Vengo a darle los Días
Que es día de su santo
(1992, p. 100)

Listen, Señor Manuel
Here I fall, here I rise
I come to greet you
For it is the day of your saint.

The phrase *Los Días* referred to the custom of community members passing throughout the village to *"dar los Días,"* "give the days," greeting and serenading on New Year's Day.

Drs. Brenda M. Romero, Lorenzo Trujillo and Bea Roeder have collected several regionally different *Los Días* traditional songs. The following verses and music are from their collections representing many regional variants.

An opening verse would begin with a prayerful invocation.

<table>
<tr><td>

En el nombre de Dios comienzo
y el de la Virgen María
que Dios nos saque con bien
en este dichoso día.

</td><td>

In the name of God I begin
and of the Virgin Mary,
on this auspicious day
may God bring goodness to us.

</td></tr>
</table>

A second verse addresses the Manueles.

<table>
<tr><td>

En el marco de esta puerta,
el pie derecho pondré
y a los señores Manueles
los buenos días daré.
(1995, 3, 4)

</td><td>

On the threshold of this door,
I will put my right foot
and to gentlemen named Manuel
I will wish "good days."

</td></tr>
</table>

LOS DÍAS
Arranged by Eva Nuañez and Lorenzo Trujillo
Transcribed by Brenda Romero

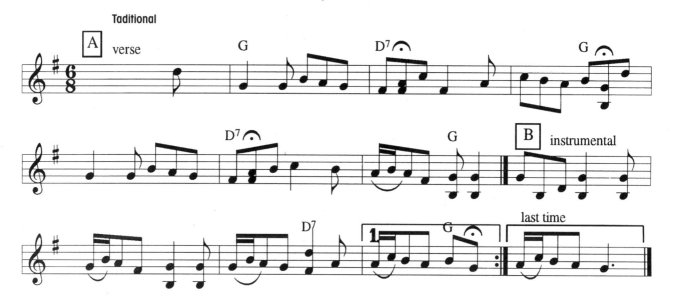

Figure 9.1. Traditional Los Días *music.*

10

Christmas Season Traditions

As a season of celebration the Christmas season included many other traditional customs. These included the giving of *aguinaldos* (little gifts) and the lighting of *farolitos* and *luminarias*. Also, the stories and symbolism surrounding the poinsettia (as well as the poinsettia itself) were important features of this celebration.

The term *aguinaldos* comes from the *Misa de Aguinaldos*, the original Mexican Masses celebrating Mary and Joseph's journey to Bethlehem.

The Masses included the giving of gifts to the native populations to entice them to attend the Masses. In traditional *Posadas* the hosts of the homes along the procession would give small gifts to guests. Children participating in *Posadas* would recite a verse requesting *aguinaldos*. Olibama Tushar, in her book *The People of El Valle*, presents a typical verse, which sounds very much like the modern "trick or treat" on Halloween.

De nos aguinaldos, si nos han de dar,
Porque la noche es larga y
tenemos que andar.
Oremos, oremos, que
angelitos somos
Del cielo venimos a pedir oremos.

Y si no nos dan, puertas y
ventanas quebraremos.
(1992, p. 120)

Give us gifts, if you will
Because the night is long
and we have to go.
Let us pray, let us pray,
for we are little angels
We come from heaven to ask
for prayers.
If you don't give, we will
break your doors and windows.

This musical transcription of the verses requesting *aguinaldos* is slightly different and more religious than the southern Colorado–northern New Mexico version described by Olibama Tushar. It is a Texas-Mexican version presented by Américo Paredes in *A Texas-Mexican Cancionero: Folksongs of the Lower Border*.

LOS AGUINALDOS

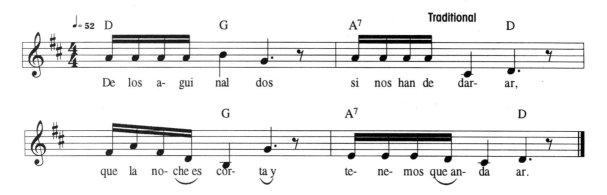

Figure 10.1. Traditional los aguinaldos music and verses from south Texas.

De los aguinaldos
si nos han de dar,
que la noche es corta
y tenemos que andar.

Desde Puente Piedra
venimos andando,
al Niño Chiquito
venimos buscando.

¿Quien cortó el cogollo
de la verde caña?
El Niño Chiquito,
Príncipe de España.

¿Quien cortó el cogollo
de la verde limón?
El Niño Chiquito,
rosita en botón.

De los aguinaldos
si nos han de dar,
que la noche es corta
y tenemos que andar.

Will you give us
some New year's gifts,
for the night is short
and we have far to go.

All the way from Puente Piedra
we have come walking;
we have come looking
for the Little Christ Child.

Who will cut off the top
of the green sugarcane?
The Little Christ Child,
the Prince of Spain.

Who will cut off the top
of the green lemon tree?
The Little Christ Child,
rose in the bud.

Will you give us
some New year's gifts,
for the night is short
and we have far to go.

ACTIVITY—*AGUINALDOS* (LITTLE CHRISTMAS GIFTS)

Materials

Large round dinner plate for tracing
Large sheets of brightly colored construction paper
Brightly colored sheets of crêpe paper
Scissors
Tape
Pencil, colored markers, crayons
Brightly colored ribbon
Glue

Instructions (makes two cones)

1. Place plate on construction paper and trace circle.

2. Cut out circle.

3. Fold circle in half, then cut circle into two pieces along folded line.

4. Decorate both halves of the circle with drawings .

5. Roll each half into a cone and tape securely along the edge.

6. Cut crêpe paper into wide strips.

7. Glue crêpe paper into paper cones. Let glue dry so crêpe paper is securely attached. Have enough crêpe paper above the rim of the cone to cover treats.

8. Place candy, treats or small gifts inside the cone.

9. Cover the treats with the crêpe paper and tie off with ribbon.

10. Attach a handle.

FAROLITOS/LUMINARIAS

Farolitos and *luminarias* are one of the most common Christmas holiday decorations in the Southwest, especially in New Mexico. Simple to make, they add a light-filled festive element to any house, building or driveway.

In New Mexico the tradition of lighting *luminarias* and *farolitos* is, to this day, a widely observed practice for the Christmas season as well as other festive occasions. Its origins are in the folk practice of lighting small fires outside the home to light the way for the Christ Child to homes on Christmas Eve. Because the homes were built of *adobe*, bricks of dried mud and straw, and had flat roofs another tradition evolved of building a fire on the roof.

Traditionally, *luminarias* are small fires built outside homes, and *farolitos* are candle-lit paper bags. *Farolito* is Spanish for "small lantern." Over time, however, the two terms have become interchangeable, as families began to concentrate on decorating with votive candles set in sand in paper bags and not build the small fires anymore. It is common now to hear the candle-lit paper bags referred to as *luminarias*. Today, homes, driveways, walkways and even businesses are lined with the small paper bags with candles in them lighting the crisp Christmas air.

> *Farolitos'* origins are in the folk practice of lighting small fires outside the home to light the way for the Christ Child to homes on Christmas Eve.

ACTIVITY GUIDE FOR *FAROLITOS/LUMINARIAS*

Materials

Brown lunch bags
Sand or dirt
Small candles
Markers
Hole punch
Scissors

Instructions

1. Fold a flap at the top of the paper bags.

2. Decorate the paper bags with designs drawn on with the marker and punched out with the hole punch or cut out with scissors.

3. Decorate the paper bags by cutting a decorative border with the scissors.

4. Fill the bottom of the bags with sand or dirt.

5. Place the candles in the sand or dirt.

6. Light the candle and place the bags where desired.

CAROL KIMBALL

THE POINSETTIA

The poinsettia, the favorite decorative plant of the Christmas season, is the central image in the miracle legend *La Flor de la Noche Buena*. The literal translation is "The Flower of the Good Night," with *La Noche Buena* being Christmas Eve.

The plant is native to Mexico and was called *Cuetlaxochitl,* the flower of purity. The Spanish associated the plant with the Christmas season because Christmastime is the plant's most colorful period.

The U.S. ambassador to Mexico from 1825 to 1830, Joel R. Poinsett, introduced the plant to the United States. As a botanist, Poinsett was attracted to the plant and its colorful leaves, calling the plant "painted leaves." He took cuttings of the plant to his plantation in South Carolina, and eventually the plant became known as the "poinsettia" (after Poinsett). Its association with the Christmas season continued, with the green leaves symbolizing the continuation of life, and the red leaves the blood shed by Christ.

The legend of *La Flor de la Noche Buena* tells the miracle story of a poor child with no gifts for the Christ Child. Deeply wanting to give the Christ Child a gift, in desperation on the way to the church, she picks the common Mexican plant from the fields. Because the child's gift was a pure and true gift of love to the Christ Child, the plant's green leaves miraculously turned red before all gathered at the church for Midnight Mass. Families remember the story of *La Flor de la Noche Buena* and tell it to children as a lesson about the true meaning of the Christmas season.

The play, *La Flor de la Noche Buena*, a dramatic retelling of the legend of the poinsettia, is available in my book, *¡Teatro! Plays from Hispanic Culture for Young People,* Libraries Unlimited, P.O. Box 6633, Englewood, CO 80155-6633; (800) 237-6124.

The Spanish associated the poinsettia with the Christmas season because Christmastime is the plant's most colorful period.

Part IV

Curanderismo:
The Healing Arts

Al enfermo que es de vida, hasta 'l agua le es medicina.
For the sick person who is destined to live, even water is medicine.
Medicine sometimes works in unknown ways.

The word *curandera* comes from the Spanish word *curar,* which means "to cure." In traditional Hispanic culture the *curandera*, or *curandero* if a man, was a folk healer who had the gift of healing. With knowledge and skill in the healing arts, the *curandera* was a health resource to communities, which, because of their rural isolation, had little access to health care professionals.

The role of *curanderas* and their art of herbal healing was widespread throughout the Hispanic Southwest. Their knowledge of the uses of natural herbs as *remedios* (remedies) allowed them to practice a folk medicine that was a hybrid of two cultures—Hispanic and Native American. The herbal knowledge of these folk practitioners was based upon the accumulated learning of generations of healers who had passed on the knowledge of the curative powers of herbs.

Figure IV.1. Zábila, aloe vera, was used to sooth and heal burns.

11

La Curandera—The Healer and Remedios—Remedies

LA CURANDERA

The *curandera* practiced a form of healing that was remarkably similar to the modern system of holistic medicine. Health for the *curandera* was a state of balance, a life in harmony. The *curandera* treated the social, psychological and physical health of the sick and infirm. By combining the knowledge of herbal, natural treatments with the attention given to the patient's psychological health, the *curandera* affected a physical and mental healing, which contributed to both an individual's and a community's health. In its most positive aspects *curanderismo* represented a self-reliant practice, which was grounded in the strengths and support of family and community.

Today the practice of *curanderismo* is still a part of many Hispanic communities. The system of *curanderismo* is evolving new forms of practice that allow it to contribute to a health care system with modern medicine. The traditional successes of the *curandera* in physical health were based upon the folk knowledge of herbal remedies. Today, the work of the *curandera* in mental health treatment is also a continuing aspect of mental health care in Hispanic communities.

In the state of Colorado, the Colorado State Mental Health Services has sanctioned a *curandera* who is also the director of a clinic for the mentally ill that is culturally focused. The University of Colorado Health Sciences Center in Denver has also established an advisory board to form a section on *curanderismo*. These bold initiatives by modern health professionals speak to the recognition that *curanderismo* can make worthwhile contributions to the field of mental health.

REMEDIOS

The Spanish brought to the New World their knowledge of such traditional herbs as *rosa de castilla* (rose), *manzanilla* (chamomile) and *alhucema* (lavender). From the Native Americans they learned about *inmortal* (antelope horns) and *oshá* (porter's lovage, wild celery).

The use of *remedios* usually relied upon the plants that grew wild and were native to the local region.

The use of herbs from other regions, however, was possible because almanacs existed that featured advertisements for folk medicines and herbs, and herb traders traveled the Southwest dispensing herbs to restock family cupboards. In *Hispanic Culture in the Southwest*, Arthur L. Campa describes these herb vendors in an especially colorful manner:

> The use of *remedios* usually relied upon the plants that grew wild and were native to the local region.

The herb vendor made a good living. He carried a supply of everything from *yerba de la golondrina* for skin infections to *canagria* or *lengua del toro* for loose teeth. All the housewife had to do was name an ailment, and the herbalist could rattle off half-a dozen herbs, brewings, or salves, including such rubefacients as rattlesnake oil and skunk fat, which were "sure cures." (1979, p. 51)

Even though Campa's herb dealers conjure up images of the Wild West and the snake oil peddler and huckster, traditional folk healers were an integral and important part of the community fabric. While the traveling herb dealer could possibly be seen in the same light as the unscrupulous traveling salesman, the traditional healer was a part of the community.

Being a *curandera* was a calling taken very seriously in Hispanic culture. The knowledge of *remedios* was usually passed down through families, usually in an apprentice fashion between an elder *curandera* and a younger student of *remedios*. Also, any person misusing the knowledge of *remedios* was quickly suspected of being a *bruja* (witch). Most importantly, in the days when medical doctors were not readily available, the knowledge and services of the *curandera* were indispensable to the health of a community.

In traditional Hispanic culture, healers were categorized according to general specialties. A *partera* was a midwife. Her use of *remedios* was applied to the needs of a woman giving birth. A *médico* was a person who combined the knowledge of *remedios* with religious practices. In addition to the use of *remedios* they would call for divine or saintly in-

tervention to aid the healing of the sick person. Their use of prayer often would give the patient greater faith in the powers of the *remedio*. An *arbolario* was originally an herb dispenser. The *arbolario* later became a specialist who did not usually use *remedios,* but instead used personal powers and knowledge to cast out evil spells and reverse the work of *brujas*. A *sobadora,* similar to today's chiropractor, was skilled in physical manipulations.

Most herbal remedies have uses for more than one ailment and in various preparations depending upon the ailment being treated. They are used in pastes as poultices, salves and compresses. Another common practice is for the *curandera* to use the natural herbs in special brews.

Figure 11.1. Manzanilla *(chamomile) was used as a tea for fever.*

Table 11.1 presents examples of common plants and their primary uses. The chart is for illustrative purposes only and in no way is meant to be a prescription for ailments.

Spanish Name	English Name	Use
ajo	garlic	constipation, cough
ajenjibre	ginger	unsettled stomach
álamo sauco	poplar	bark used for fever
albácar	basil	menstrual and labor pains
alcanfor	camphor	external use as a liniment for rheumatism
alfalfa	alfalfa	stomach pains
alhucema	lavender	colic, gas and indigestion
amole	yucca root	hair shampoo
anís	anise	coughs, anxiety
barba de maiz	corn silk	urinary tract infections
canela	cinnamon	nausea
cebolla	onion	coughs, burns, sores
capulín	wild cherry	viral infections
cilantro	coriander	inflamed gums
clavo	clove	toothache
flor de Santa Rita	Indian paintbrush	water retention
inmortal	antelope horns	asthma
lecheros	milkweed	skin infections
manzanilla	chamomile	colds and fevers, colic
nuez moscada	nutmeg	indigestion
nopal	cactus	rash
oshá	root of wild celery	antiseptic
orégano	oregano	cough, sore throat
romero	rosemary	indigestion, baldness
ruda	rue	earache
salvia	sage	diarrhea in babies
toloache	jimson weed	external analgesic
yerba buena	mint	stomach ills
zábila	aloe vera	wounds and burns

Table 11.1. Plants and their medicinal uses in the Hispanic Southwest.

ACTIVITY—HERBAL REMEDIES

1. Ask your parents or grandparents if they remember any folk remedies and practices from their childhood.
2. Research traditional folk remedies that use natural plants and foods. Develop a list of natural remedies that you can find at the supermarket.
3. Take a trip to a health food store and develop a list of natural remedies that are available at that store.
4. Interview the manager of a health food store about what type of modern products customers buy for illness remedies.
5. Interview a doctor, a chiropractor and an acupuncturist about herbal treatments. Write a report comparing their views.
6. Do research on the Native American and Chinese cultures and their uses of herbal remedies. Write a report comparing these cultures' use of herbal remedies with the Hispanic culture's.
7. Organize a debate on the topic of "Herbal Remedies: Fact or Fiction?"
8. Review newspapers and magazines for articles on modern and non-traditional healing practices. Write letters to the experts mentioned in the articles and ask them to send you additional information supporting their viewpoint or work. Prepare a report on the information you receive.
9. Seek out and interview people who have utilized natural remedies for their illnesses. Write a report on their experiences. Make an effort to write a report presenting both the pros and cons of natural remedies and treatments.

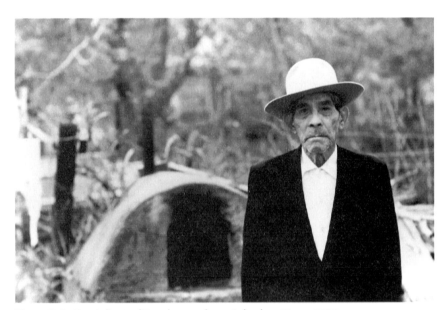

Figure 11.2. Don Julio, traditional curandero, Columbus, Texas, 1978.

Part V

Las Artes:
The Arts

Quien bien baila, de boda en boda anda.
The good dancer goes from wedding to wedding.
(The artist is welcome everywhere.)

Hazte el tonto y come con dos manos.
Act the fool and eat with both hands.
(Live life to the fullest.)

The traditional folk arts of the Hispanic people have been a source of cultural pride and artistry for centuries. Artisans and craftspersons have used the materials, techniques and knowledge passed down through generations to provide beautiful secular and religious objects for families and communities. These artistic objects fulfilled both utilitarian and spiritual needs for Hispanic people.

As in so many other areas of Hispanic culture, folk arts contribute abundant examples of the influence of indigenous and Spanish colonial culture in the work of Hispanic artists. This area of folk culture also has many examples of the effect and influence of American culture on the evolution of Hispanic traditional practices. With stores often a far distance away and visits from the clergy infrequent, the often-mentioned geographic isolation of the southwestern Hispanic people was a further influence on the path their artistic practices followed.

As a rural, agricultural and religious people, traditional artisans had the task of creating both utilitarian objects for everyday use and spiritual objects for religious practices. As part of a proudly self-reliant culture, the traditional Hispanic people used the conditions of their lives to create a strong tradition of expressive arts, which has persevered for centuries through four distinct periods: cultural establishment, cultural expansion, cultural decline and cultural Renaissance.

As has been the experience of all traditional cultures in the world, the southwestern Hispanic cultural arts prospered for centuries before they experienced a period of decline. Cultural decline in this sense has several clear indicators:

As part of a proudly self-reliant culture, the traditional Hispanic people used the conditions of their lives to create a strong tradition of expressive arts.

- A period of time in which people lose touch with traditional practices.
- The advent of manufactured products replacing formerly handcrafted products.
- Society evolving from an agricultural to industrial economy.
- Families move from rural to urban settings.
- Work changes from a trade-and-barter system to a wage-and-cash economy.
- Markets demand for handcrafted traditional products decreases.
- Assimilation becomes a painful process of cultural loss.

Each of these changes places inevitable stresses on the cultural fabric to the extent that generations drift away from the traditional practices of their heritage.

Hispanic culture has not been immune to these societal forces. The recent experience of southwestern Hispanic culture, however, has seen a Renaissance and rebirth of cultural awareness, cultural pride and traditional practices. Led by its artists, teachers and scholars, Hispanic culture is in the process of rediscovering its traditional heritage. As families reaffirm the activities of the past, they build a stronger foundation for the future. Throughout the Southwest people are painting murals, producing plays, carving *santos*, forming dance companies, opening art galleries and baking traditional foods. A new generation has realized the importance of traditional artistic practices in maintaining and preserving culture for future generations. The traditional arts described in this section are the foundation of the next period of cultural development in the Hispanic Southwest, the cultural Renaissance.

The folk arts described in this section are meant to be representative and not definitive. There are many different folk arts practiced by Hispanics throughout the Southwest. Modern and traditional artists work in many different art forms, all with their own artistic heritage and vision. Hispanics, however, recognize the folk arts presented below as primary folk arts because of their strong traditional origins, wide prevalence in artistic practice and their continuing influence in the Renaissance of Hispanic culture in the Southwest.

> Hispanic culture has seen a Renaissance and rebirth of cultural awareness, cultural pride and traditional practices.

12

Traditional Arts

WEAVING

Weaving has long been one of the essential folk arts in the Southwest. It was a basic necessity of Hispanic settlers because of their need to make their own cloth for clothing, blankets and rugs.

The cultural traditions of both the Native Americans and the Spanish contributed to the development of weaving as a textile art in the Southwest. When the Spanish arrived in the Southwest, the Pueblo Native Americans had a long-established and advanced technical ability in weaving. The Pueblo weavers grew cotton and used cotton yarn in their weaving. For their weaving they also used the vertical loom. The vertical loom consisted of two poles set in the ground with horizontal poles at the top and bottom of the loom structure, forming a rectangle. The Pueblo weavers strung the cotton yarn warp vertically and worked the weft yarn horizontally. The Spanish called the Native American weaving *mantas*, which was a general term for cotton cloth. In the early period of Spanish colonization, weaving remained an important activity in Native American pueblos.

The Spanish changed the nature of southwestern weaving when they introduced sheep, and with these animals, wool as a material for weaving. Sheep raising became a major occupation and wool became an abundant material for weaving. By the seventeenth century wool had replaced cotton as the source of the yarn used in weaving. The Spanish also brought the horizontal or treadle loom from Europe and introduced it to the New World. Because of their massive size the looms themselves were not imported from Spain but rather were constructed new in the New World. E. Boyd, in *Popular Arts of Spanish New Mexico*, describes the elementary construction of the loom:

Figure 12.1. Weaver using the traditional horizontal loom, Gans Store, Chimayó, New Mexico, ca. 1935.

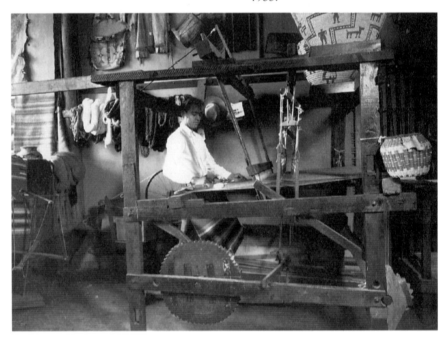

Traditional weavings were the result of a laborious process of hand spinning and dying.

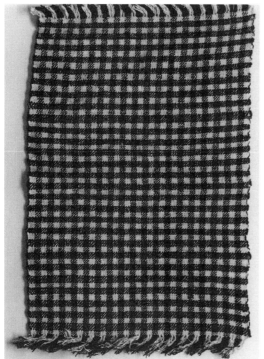

Figure 12.2. Jerga weaving, handspun wool, natural colors, by David Salazar, Ribera, New Mexico, 1977.

The New Mexican loom was massive, hewn from tree trunks with no more shaping than could be done with the ax and adz, but it was basically of European design—the same horizontal loom which had been used for centuries in Spain and Arabic North Africa. The tall four corner posts support a frame like a large four-poster bed and canopy. (1974, p. 173)

During the Spanish colonial period it was common for Spanish families to have *criados*, Native American servants. These servants, many of them children, assisted with the family's weaving. The *criados* usually performed the tedious tasks of washing, carding and spinning the wool. A clear example of cultural cross-fertilization occurred when these *criados* returned to their tribes after living with a Spanish family. They took with them the skills of Spanish weaving with wool and transferred this knowledge to their native vertical loom.

The Pueblo weavers in turn influenced the Navajo. The Navajo became adept at sheep raising and wool processing, eventually developing their highly prized woolen blankets.

The Spanish, however, were little influenced by Native American weaving. The Hispanic weavers were more influenced by Mexican designs. The rugs Spanish merchants brought to Mexico from Turkey and Asia also were a greater influence on the design of Hispanic weavings.

The three most common types of weaving were the *jerga, sarape* and the *sabanilla*. The *jerga* was a coarse woolen cloth with many domestic uses, two being horse blankets and rugs. The word *jerga* derives from the Arabic *xerca*, the word for a sack cloth, which reflects the material's rough and humble uses. The *jerga* usually had a simpler design, often a checkerboard or striped weave. It was woven in strips about 2 feet wide with a thick yarn and then sewn together to fit the area to be covered.

The *sarape* was a finer weaving used for blankets and poncho-like jackets. Its design was more colorful, striking and intricate than the *jerga*. The traditional Mexican *sarape* is a poncho with a slit in the middle for the wearer's head to go through.

The *sabanilla* was a light woolen cloth used for clothes, mattress ticking, sheets and as the backing for another prevalent folk art—*colcha* embroidery. The word *sabanilla* derives from the Spanish *savana*, meaning sheet or plains. A *sabanilla* was a loosely woven white material with a plain weave. The activity guide for *colcha* embroidery lists a source for hand-woven traditional *sabanilla* cloth.

Traditional weavings were the result of a laborious process of hand spinning and dying. The dying of the yarn was a multistep process using vegetable and plant dyes. The Spanish brought a knowledge of wool treatment and dying from Europe. They also learned from the knowledge Native Americans had developed over the centuries of using natural dyes native to the New World to color their fabrics, basketry and paints.

Examples of vegetable and plant natural dyes are abundant. Flowers, barks, plants and roots all contrib-

uted to the coloring of woolen yarns. The golden flowers of the rabbit bush made yellow dye. Wild plum roots made rust red. Mountain mahogany made red. *Canaigra*, the roots of a desert plant, produced yellows and tans. Apple bark gave reddish yellow. Sumac was part of a process producing black. Dahlia blossoms made yellow-orange.

Cochineal, brazil wood and indigo were imported natural dyes. Cochineal, a red dye ground from an insect living on the prickly pear cactus the Mexicans call *nopal*, came from Mexico and Central America. *Brasil*, or brazil wood, producing a beautiful rose and red color, came from the tropical hardwood that gave Brazil its name. Indigo, a deep blue dye derived from a plant known as anil, came from the West Indies.

The centuries-old and sophisticated knowledge of the gathering, preparation and use of natural dyes eventually fell victim to the advances of science and industry. The introduction of commercial, synthetic aniline dyes in the 1860s, with their bright range of colors and ease of use, led to the decline of the use of natural dyes. These commercial dyes eliminated the work of gathering and preparing dyes. Also, the introduction of commercial, machine-made yarn ended the tedious labors of washing, carding and spinning wool. While the production of wool textiles continued, the late nineteenth century saw the abandonment of the traditional methods for the ease of use and ready availability of commercial fabrics used for weaving.

Three primary styles identify the designs of Hispanic weaving: *saltillo*, *Rio Grande* and *Chimayó*. The *saltillo* design originated in Saltillo, Mexico, and was brought to New Mexico in the 1830s. This design was probably influenced by the rugs imported to Mexico from Asia. The *saltillo* design features a large diamond shape in the center of the weaving with interlocking, radiating diamond patterns repeated inside it. Diamonds and zigzag designs form a complex background design, with stripes at the top and bottom of the weaving.

The *Rio Grande* pattern is a variation of the *saltillo* design. It consists of detailed geometric patterns. The pattern is named after the region of the Upper Rio Grande River in New Mexico. One version is a zigzag striped pattern. A simpler version consists of bands or stripes.

The *Chimayó* weaving is a very identifiable version of the *Rio Grande* blanket.

Two Mexican master weavers from Saltillo, the Bazan brothers, were commissioned to observe and teach weaving in Santa Fe in 1805. The governor of the province brought the Bazan brothers to New Mexico because of a perceived decline in the quality of the weaving craft in the area. The Bazen brothers' influence reached north to the village of Chimayó, which in time became a center for New Mexican weaving and the namesake of the well-recognized *Chimayó* style.

Southwestern Hispanic weaving has continued through the centuries accommodating many challenging changes. The ending of the use of *criados*, Native American servants, as a source of labor caused changes in the production of weavings. Another change in the weaving tradition was the introduc-

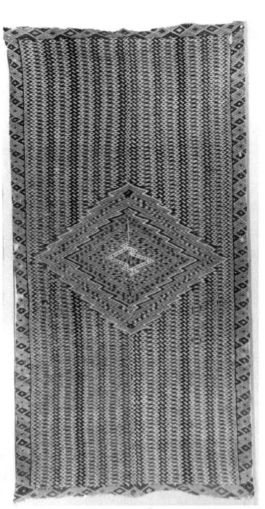

Figure 12.3. Saltillo *weaving*.

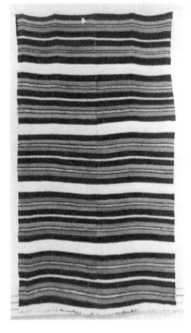

Figure 12.4. Rio Grande *weaving*.

tion of commercial manufactured wool as weavers adopted the new yarns because of their ease of use and brighter colors.

The coming of the railroad and the influx of Anglo settlers changed the sheep used for producing wool. This influx of new settlers to the Southwest also changed the market using sheep as wool producers to a market needing sheep as meat producers. The Spanish had introduced the *churro* sheep, the common sheep of southern Spain, which had a long, fine, strong, silky yarn allowing for a high-quality weaving product. The new settlers introduced the Rambouillet sheep to meet the increased need of

sheep for meat. The Rambouillet eventually became the major sheep strain in the Southwest. The Rambouillet was preferred because its shorter hair suited the grazing of sheep better. But its short, oily wool, with its harsher texture, produced a decline in the quality of wool textiles.

Despite the changes in the traditions of Hispanic weaving, the production of weaving textiles continues to be part of the Hispanic experience. The weaving of traditional products using modern methods and the development of new markets have resulted in a Renaissance and revival of Hispanic weaving in the Southwest.

Figure 12.5. Chimayó *weaving. The* Chimayó *design consists of a series of repeating triple cone designs in a horizontal row, with the middle being the largest.*

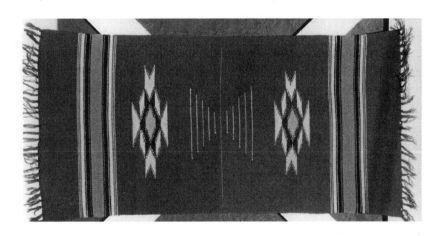

ACTIVITY—WEAVING

Research weaving styles, dye colors and weavers.

- Go to your local library and check out books on weaving. Research the various types of weaving in the world by looking for examples of vertical and horizontal weaving.

- Write a report explaining the differences between the vertical and horizontal loom. Be sure to include examples of which cultures use which type of loom. Present your report to your class or youth group.

- Use craft Popsicle sticks and yarn to build models of the vertical and horizontal looms. Include these models in your report.

- Research the three primary types of Hispanic weaving styles and learn to identify the styles by design. Go to a local museum that has a textile collection and learn if the three Hispanic design styles are represented in the collection. Examine the museum weaving collection. Make a game out of seeing if you can identify and name design styles without looking at the identifying labels.

- Research the weaving styles of the Native American tribes. Compare the design styles with the Hispanic culture and determine if any are similar to the three main Hispanic styles. In a report, compare and contrast the design styles of the Hispanic and Native American weavings. Share your findings with your class.

- Research the use of natural plants and minerals to make dye colors found in the Hispanic and Native American cultures. Collect sample materials from mineral supply stores and weaving arts and crafts centers. Try to make the natural dye colors with the materials you have collected.

- Test your homemade dye colors on cotton, wool and synthetic fabric. Record your results and form conclusions about which dyes work best on which fabrics.

- Locate local weavers through weaving arts and crafts centers or community arts organizations. Arrange to meet the weavers and interview them about their weaving styles. Ask them how they learned to weave and why they work in their particular design style.

- Examine the design styles of the weavers you have met. Determine if their design styles are similar to any in Hispanic and Native American culture.

- Write an artist profile about the weavers you have met. Share the report with the weavers you interviewed and your class. After you have shared your report with your class, arrange for the weavers to visit your class and talk about their weavings.

The worshipping of religious images has long been part of the Hispanic experience in the Southwest. The act of supplicant prayer has always been aided by physical representations of Catholic religious personages, especially the saints of the church. These religious images were valued as powerful mediators between God and human beings. The deeply devout people of the Hispanic Southwest, and their religious practices, created a large demand for religious images for their churches, chapels and homes. The development of the folk art of painted and carved Catholic religious icons to meet this need follows a well-recognized path beginning with the indigenous people of ancient Mexico.

The Aztecs had a highly developed cosmology and a profoundly religious society. They had developed the art of religious representation to a high degree, the most striking being their intricately detailed stone-carved images of their gods.

After the conquest of the Aztec people, the Spanish immediately began the process of converting the Aztecs and other indigenous tribes to Christianity and Catholicism. One of their first tasks was the replacement of the indigenous gods with Catholic religious personages. The Spanish had brought to the New World their Catholic practices and its images of God, Christ, the Holy Family and the church's numerous saints. The Spanish transplanted their Catholic images on the Aztec's existing image-worshipping traditions to facilitate the work

of conversion from pagan practices to Christian religion.

The success of the Spanish in establishing the Catholic religion in the New World reached as far as its northern frontiers. In the three hundred years of New Spain, the Spanish settlers of the northern frontiers placed the Catholic religion at the center of their life.

The geographic isolation of the northern frontiers resulted in the development of a folk art of *santos*, carved and painted religious images. As they settled new regions, the Spanish colonists brought with them religious statues, canvas and tin paintings and missals with engraved prints. The religious images new settlers brought with them, however, were not sufficient in number to fill the religious needs of the Hispanic populace. Also, because it was difficult for the Hispanics in the northern frontiers of New Spain to acquire new religious images from traders, they began to create their own images for their religious practices. And because it was difficult to acquire basic materials, the Hispanics of the northern regions learned to utilize locally available materials in the creation of their religious images.

The name *santo* means "holy" and is an appropriate description of the purposes of the *santero*, or religious artist, in creating their religious or devotional art. The *santo* art consists of three primary forms: *retablos, bultos* and *reredos. Retablos* are devotional icons of saints and biblical scenes painted on pine board. The *bulto* is a carved statue of saints or Christ figures. The *reredos* is a large freestanding altar screen, placed behind the altar and containing multiple images of saints painted on pine board. They are

Religious images were valued as powerful mediators between God and human beings.

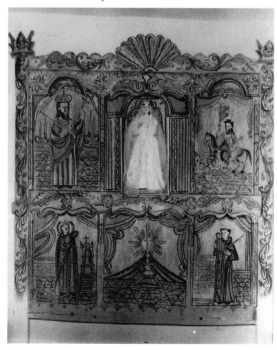

Figure 12.6. Reredo altar screen, made in 1828, Talpa, New Mexico.

used to decorate church altars. Smaller *reredos* are used to decorate family devotional shrines. The *reredos* had the appearance of an arrangement of *retablos* grouped together to form a large multi-paneled religious backdrop.

The *retablo* ranged in size from large 4- to 6-foot images used for church decoration to small 4- to 6-inch images for home and personal use. The *retablo* from the Spanish colonial period was painted on wood or canvas. With the introduction of tin in the 1800s, the Mexican *santeros* began to paint their *retablos* on this durable and inexpensive metal. Since tin was scarce in Mexico's northern frontiers, however, the artisans of the Hispanic Southwest painted *retablos* on locally available wood, usually pine or cottonwood.

The subject matter for the *retablo* consisted of images of the Holy Family (Jesus, Mary, Joseph), the Holy Trinity (God, Christ, the Holy Ghost), biblical figures, the Christ figure and saints of the Catholic Church. An especially popular saint in both the traditional and modern *retablo* is *el Niño de Atocha*, the patron saint of travelers and prisoners.

The *santero* would begin the creation of the retablo by selecting and carving a flat piece of wood. The *retablo* was predominantly rectangular in shape. The *santero* would then prepare the surface with a gesso mixture made from animal-hide glue and gypsum rock, ground and mixed with water. The next stage consisted of outlining the figures. The final stage was the painting of the religious image. For paint the *santero* used powdered natural materials, mixed in egg yolk to make a tempera paint, as well as charcoal for black, clay for creams and reds and ground minerals and earth materials for other colors. Examples of other natural sources of color were walnut hulls for brown, charred bones, honey and water for black, beetle larva skins for red, rabbit brush for yellow and azurite for light blue. Piñon sap mixed with grain alcohol provided a varnish. For a brush, the *santero* would use a yucca fiber chewed on the end to produce a frayed brush-like tip.

A typical design for a *retablo* had a semicircular "lunette" resembling a fluted shell or a scalloped half-wheel on the top of the wood panel. The *santero* often carved a frame into the wood to border the central religious image.

The second type of *santo*, the *bulto*, was a three-dimensional sculptural statue of saints and holy personages. The *santero* would use the same materials as in making a *retablo*. *Bultos* range in size from small figures for a home shrine to life-size figures, with attached and movable arms and legs, used in religious processions and altars. *Bultos* are painted and frequently clothed to increase realism.

The subject matter of the *bulto* was a varied as the saints of the Catholic Church. *Santeros* also created group sculptures of the Holy Family. A popular group sculpture depicted the Holy Family, with Joseph leading a horse carrying Mary seated on it holding the Christ Child. Another had Saint Ysidro de Labrador leading his cattle, with an angel hovering nearby.

The traditional art of the *santero* flourished during the early to middle part of the 1800s. As with other traditional arts, the art fell into decline with the arrival of manufactured

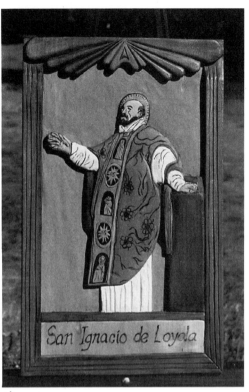

Figure 12.7. Retablo of San Ignacio de Loyola by José Raul Esquibel, Denver, Colorado. The founder of the Jesuit order, San Ignacio is shown as bald after a contemporary portrait and, in this modern interpretation, has the letters IHS on his robe instead of the traditional plaque.

products. Lithographs and commercial paintings replaced *retablos*. Ceramic and plaster of paris commercial statues replaced *bultos*.

Today, however, as with other traditional arts, Hispanic artists are leading a revival of the work of the *santero*. Modern artisans are studying and learning the traditional arts, often dedicating themselves to using traditional materials as well. Throughout the Southwest, Hispanic artists are creating *santos* for personal and religious uses, museums, art centers, as well as the tourist market. These artists are also dedicated to passing on their knowledge and skills to a younger generation in schools and community centers.

Figure 12.8. A traditional bulto of *San Miguel defeating Lucifer. San Miguel is identified by the scales he will use to weigh souls on Judgment Day. He is also depicted with a sword to defeat Lucifer, a helmet and leggings.*

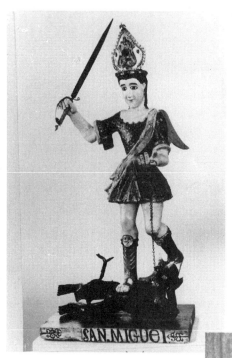

Figure 12.9. A modern bulto of *Our Lady of Guadalupe by Juan D. Martínez, Española, New Mexico. This* bulto *follows the traditional depiction of the Virgin wearing a gown, surrounded by a rim of flames, with a cherub and crescent moon at her feet.*

ACTIVITY—*SANTOS*

Make a traditional *retablo*.

Materials

Flat wood board (4 inches by 6 inches is a good beginning size), $^1/_4$- to 1-inch thickness.
Baltic birch plywood ($^1/_4$- to $^1/_2$-inch thickness is best for this project, though regular pine is fine).
Water-based acrylic paints, various colors depending on artistic choice
Carbon paper
Image to be transferred to board
220- or 300-grit sandpaper
Drawing pad
Colored pencils
Black marker

Instructions

This carbon paper–image-transfer method is an easy beginner's project. It requires that you have images available that can be cut out of books and you do not mind getting a little carbon paper ink on you. If you cannot cut images out of books, copy the image on a copy machine and use the copy. Two *santo* images, *San Miguel* and the Virgin of Guadalupe, are provided to get you started.

Figure 12.10. San Miguel.

1. Begin this project by going to the library or a bookstore and looking at several books on *santos*. You can also go to your art museum if it has a Mexican/Spanish colonial section. Look at the *retablos* and examine how they were painted. Especially notice the colors traditional *santeros* used.

2. Use the drawing pad and colored pencils to draw colored pictures of *retablos* for future reference.

3. After you have completed your research, you are ready to begin.

4. Sand your board with the sandpaper. Remove all roughness and nappy surface. The image transfer requires a perfectly smooth surface.

5. Place a piece of carbon paper, ink side down, on the board surface.

6. Place your image, image side up, on top of the carbon paper.

7. Trace the outline of your image on the carbon paper on the board.

8. Remove the image and carbon paper from the board. (Even though the image supposedly never touched the ink side of the carbon paper, it is inevitable that children will somehow dirty their fingers and the paper image with carbon ink.)

9. The image on the board is now a template for painting. Darken the carbon outline with the black marker.

10. Take out your research drawings. Evaluate them for color and use them to help you select which colors to use.

11. Paint your *retablo*, using the template as a guide. For a special effect, dilute the acrylic paint with water. This will give your *retablo* a water-colored look and will allow the grain of the wood to show through. As with any traditional art, you can adapt the traditional to your own personal tastes.

12. You can leave the *retablo* painted as is or you can put a final clear acrylic finish on it, after it has dried, to seal and protect it.

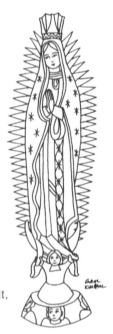

Figure 12.11. The Virgin of Guadalupe.

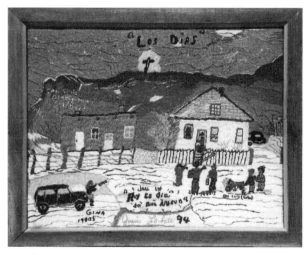

Figure 12.12. A traditional Mexican colcha.

Figure 12.13. A modern colcha *by Josephine Lobato, Chama, Colorado, depicting the traditional* Los Días *celebration.*

Colcha embroidery is one of the most beautiful and delicate of the Hispanic folk arts. The word *colcha* means bedspread. A traditional *colcha* was a covering or hanging, embroidered with geometric or floral designs using the distinctive *colcha* stitch.

E. Boyd, in *Popular Arts of Spanish New Mexico*, states that the *colcha* stitch is probably of Asian origin. The *colcha* stitch does not occur in either Spanish or Mexican needlework. In the eighteenth century, however, Chinese silk embroideries were imported to Mexico by the Manila Galleon trade and transported to New Mexico as altar frontals. The basic *colcha* stitch occurs on these intricate Chinese silks, and it's likely that New Mexican women developed their use of the *colcha* technique after being influenced by the Chinese embroidery.

The basic *colcha* stitch is a long wool stitch. Marianne Stoller, in Wroth's *Hispanic Crafts of the Southwest*, describes the stitch in these words:

The stitch is made by pushing the threaded needle through from the underside of the cloth, passing it across the surface of the material for the desired length, and pulling it through again, leaving a long straight line of thread; then the needle is brought up again from the underside in the middle of the stitch and passed over it at right angles in a short "step-over" stitch to hold the long flat one. (1977, p. 86)

Another version of the stitch has a long stitch with smaller tying stitches crossing it at regular intervals. The stitch usually lies close and parallel to the previous stitch, resulting in long, colorful and lyrical patterns.

The *colcha* stitches were applied to a *sabanilla* backing. This white, light, wool backing provided a secure support for the colorful patterns of the *colcha*. Cotton backing was occasionally used, but it did not provide the durability or strength of the *colcha* .

There are two basic types of *colcha* embroidery. The simplest is a white background covered with geometric or floral designs. This style produces lyrical, beautiful, artistic, light and fluid *colcha* designs.

A more complicated, and more visually striking, *colcha* is densely stitched, with stitched embroidery covering the entire base material. This style is often pictorial and realistic, with both religious and secular images occurring.

Religious images are most often of saints or religious icons, with floral borders decorating the piece. This use of *colcha* for religious purposes continues in traditional churches. The secular images can include animals, people, houses and other southwestern and personal motifs.

Colcha embroidery pieces were used as wall hangings, table covers, bed covers and altar coverings. The largest *colcha* could be several feet in length and could cover a bed or large altar.

ACTIVITY—*COLCHA* EMBROIDERY

The making of a *colcha* embroidery is an activity requiring the careful learning and practicing of the two basic *colcha* stitches. Once learned, the stitches are very easy to do and, like all needlework, will give hours of crafting pleasure as well as a beautiful artistic product.

An artist's individual choices determine the *colcha* design. The two primary categories are secular and religious. Geometric and scrolling designs, animal images and images of people, homes, family scenes or almost any image important to the artist characterize the secular *colcha*. Secular *colcha* have realistic images filling the complete *colcha* surface. Religious *colcha* can have any type of religious imagery reflecting the artist's religious beliefs.

The following activity guide for a *colcha* blanket is adapted from the work of Marie Risbeck, a fabric artist proficient in the *colcha* tradition. The activity guide for a *colcha* picture is adapted from the work of Josephine Lobato, a Hispanic folk artist from the San Luis Valley in Colorado who is active in keeping the *colcha* tradition alive. She is recognized for her full-image *colcha* embroideries depicting scenes from the religious and daily life of Hispanic culture. Her *colcha* of *Los Días* (see Fig.12.13) is typical of her work. She is also active as a teacher of *colcha* workshops and is dedicated to teaching new generations about the *colcha* heritage.

The *colcha* stitch traditionally has no knots, so thread is anchored with running knots. Two simple stitches, a large and a small stitch, create the *colcha*'s characteristic texture. Two other qualities define the *colcha* stitch. One is its random quality. The *colcha* artist can easily vary its length and direction, which lets the artist "paint" with the yarn. The second is the effect of the needle's occasionally splitting the strand of yarn (but only some of the time). Coming up through the strand actually helps create the dynamic textured look of *colcha* embroidery.

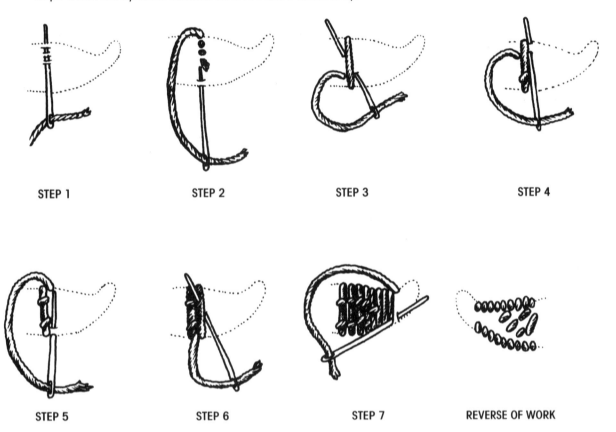

STEP 1 STEP 2 STEP 3 STEP 4

STEP 5 STEP 6 STEP 7 REVERSE OF WORK

Figure 12.14. The traditional colcha stitch.

The following figures are design templates, based on traditional patterns, to use in your *colcha* embroidery. (See Figs. 12.15, 12.16 and 12.17.)

Figure 12.15. Traditional colcha *design.*

Figure 12.16. Traditional colcha *design.*

Figure 12.17. Traditional colcha *design*

ACTIVITY—*COLCHA* BLANKET

Materials

1 ¼ yards of off-white lightweight wool twill fabric. Twill worsted fabric (catalog #211) is available from Textile Reproductions, Box 48, West Chesterfield, MA 01084; (413) 296-4437. Another choice of fabric, for a more traditional blanket, is a custom-made, open-weave, hand-woven *churro sabanilla*, available from Glenna Dean, 7495 Sagebrush Rd., Santa Fe, NM 87505; (505) 438-9771.

Crewel embroidery needle, sharp with a large eye

Oval embroidery hoop 5 x 9 inches

100% wool yarn (Synthetic yarn will cause your *colcha* to shrink and lose its shape.)

Fabric scissors

Cotton thread to match the background cloth

Carbon paper

Fabric marking pencil, black, such as Washable Wonder Marker (A pen-fax laundry pen is also suitable.)

Sheet of paper, 11 x 17 inches

Black marker that will not bleed into the paper

Tape measure

Instructions

1. Determine what type of *colcha* you wish to make.

2. Gather or draw the images you want to embroider on your *colcha*.

3. On a piece of paper, rough sketch an image plan for your *colcha*. Determine your color scheme at this time also.

4. Cut the fabric into a square 37 x 37 inches and pull a few edge threads to mark the grain on each side. Recut the fabric if necessary to align it with the grain and cross grain.

5. Trace your images onto the fabric. If using template designs or a drawing, use the carbon paper to trace the image on the fabric. After the image is traced, use the fabric marker to darken your embroidery lines. Another method of transferring the image to the fabric is to outline each image with the black marker, place the fabric over the image and then trace the image onto the fabric with the fabric marking pencil.

6. With the fabric held fastened in the embroidery hoop, thread your needle with one of the yarn colors and select a starting point.

7. Take three running stitches within the outlined image area to anchor the thread.

8. Single close stitches will fill some areas of the design completely, reaching from one edge of the image to another. In other areas, you will use both large and small stitches to cover a larger image, often couching the large stitch at an angle. To add to the motif's texture, occasionally bring your needle up through a strand of yarn, splitting it.

9. With your sewing machine and off-white thread, sew a straight stitch border ½ inch from the edge of the blanket all the way around. Pull the outside ½ inch of threads from the fabric to make the fringe.

ACTIVITY—*COLCHA* PICTURE

Making a *colcha* picture is a very similar activity, using most of the same materials, to making a *colcha* blanket. Because the complete ground cloth will be covered with an embroidered image, it is more important to brainstorm the ideas for the picture. Traditions, folklore, legends and family and community life are all good areas of discussion when creating a picture image. Draw your complete image on paper first, then transfer its outlined image to the fabric.

With a *colcha* picture, a good choice for the background fabric is muslin. Before cutting the muslin, wash, dry and iron it. Next, use a sewing machine to sew the edges of the muslin.

Materials

Sufficient muslin to complete activity (The size of the image is the *colcha* artist's decision.)
100% wool yarn
Carbon paper
Fabric marking pen
Paper
Non-bleeding black marker pen
Crewel embroidery needle
Frame board, medium quality, non-warping board, cut to desired size

Instructions

1. Follow directions in *colcha* blanket activity for transferring image to fabric.

2. Follow directions in *colcha* blanket activity for using the *colcha* stitch to embroider your image onto fabric.

3. When the piece is finished, wash it in cold water.

4. Measure both length and width of the fabric and cut a wooden frame board to its dimensions.

5. Cover the frame board with acid-free tissue (available at a good art supply store).

6. Cut a piece of muslin 3 inches larger on all four sides than your image.

7. Baste or sew the larger muslin onto the back of your *colcha*.

8. Cut a large T opening into the back of the basted muslin to allow air for the yarn.

9. Pull the basted muslin over the edges of the frame board, stretching and pulling so that the yarn is on the edge of the frame.

10. Staple it down.

11. Cover the back with another piece of muslin so that it covers the back neatly, then staple this last piece of muslin to the frame board.
 Note: Do not frame the colcha behind glass or Plexiglass because trapped moisture eventually rots the wool.

TINWORK

Tinwork first appeared in the Southwest in the 1840s. Artisans had previously used tin from Mexico to fashion trinkets and ornaments. Mexico has had well-developed metalwork traditions dating from the time of the Conquest, and the Hispanics of the Southwest were aware of this work. (In Mexico, tin artists are called *hojalateros*.) Metalworkers, of course, had long been using iron and copper to make utilitarian goods. The use of tin as an artistic metal evolved soon after the introduction of tin containers after the opening of the Santa Fe Trail. Previously, tin had come north from Mexico in sparse amounts. After the annexation of the Southwest from Mexico, the area experienced immigration from the East and an influx of new consumer products in large numbers.

Merchants and American soldiers were the first to bring tin cans to New Mexico (their perishable goods were stored in them). Tinwork from this period sometimes reveals the use of tin labeled "Pure Lard." E. Boyd, in *Popular Arts of Spanish New Mexico*, relates an interesting side story for the origins of the tin can. According to her version of history, Napoleon was responsible for the creation of the tin can. He commanded its development to answer the need of his nomadic armies to transport perishable food long distances. The product was later perfected in England.

With the introduction of tin in larger and more available quantities, Hispanic artisans began to use the metal to fashion picture frames, boxes, candle sconces (because tin charred less than wood), crosses, *nichos* (holders) for *santos* and other religious objects and extralarge candelabras and chandeliers. The artisans created ornamental and functional objects for both secular and religious uses. The needs of the Hispanic people for religious items for their churches and chapels created a preponderance of religious tinwork.

The creation of tinwork was relatively simple. The artisans would roll out the tin, pound it flat, cut it to shape and punch decorative dotted patterns into it. Tools similar to those used in leatherwork were also used in tinwork: nails, hammers, cold chisels, dies and snips. Coulter and Dixon, in their magnificent *New Mexican Tinwork*, dispel the suggestion, however, that tinworkers used actual leatherworking tools. The punching and stamping tools of the tinworker were larger, with a coarser detail better suited to tin decoration. An additional tool particular to tin work was the soldering iron. One of the wonders of tinwork from the nineteenth century was the creation of small intricate solder points with a thick copper bar embedded in an iron shaft and heated in an open fire or burning coal.

These punched tin designs are the distinctive element of this type of tinwork. The punched designs consisted of geometric patters of dots, crescents, circles and lines. Recognizable icons, especially shell and flower designs, also decorated the tin cans.

Three other products that came into the Southwest in large quantities after the establishment of trade routes from the East and Anglo settlement were glass, wallpaper and commercial paints. Artisans

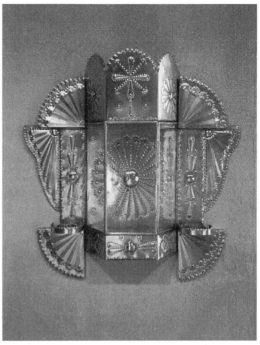

Figure 12.18. Modern tin nicho by Paul Zamora, Denver, Colorado. The doors of the nicho open so that a religious figure may be placed inside.

The use of tin as an artistic metal evolved soon after the introduction of tin containers after the opening of the Santa Fe Trail.

Figure 12.19. Francisco Delgado, master tinsmith, Santa Fe, New Mexico, ca. 1935. Señor Delgado was the grandfather of Lucy Delgado, the master cook whose traditional recipes are included in Chapter 21. He also was the patriarch of what would become a five-generation family of tinsmiths. Another granddaughter, Angelina Delgado, is a New Mexico heritage artist tinsmith.

adopted all three of these products into their creation of tin products. Tin frames, surrounding panes of glass covering decorative wallpaper, became a common piece of tinwork. Later artisans used commercial paints to retard the rusting of the metal as the tin detached from the iron base.

As with other traditional arts, tinwork had a period of decline around the turn of the century. As commercial frames became available, gas and electrical lighting reduced the need for candle sconces, and even the need for religious objects declined. Tinwork recently has been revived in the Southwest as Hispanics learn again of its delicate reflective beauty. The Renaissance in the creation of religious traditional art has included the renewal of the art of tinwork to create religious objects.

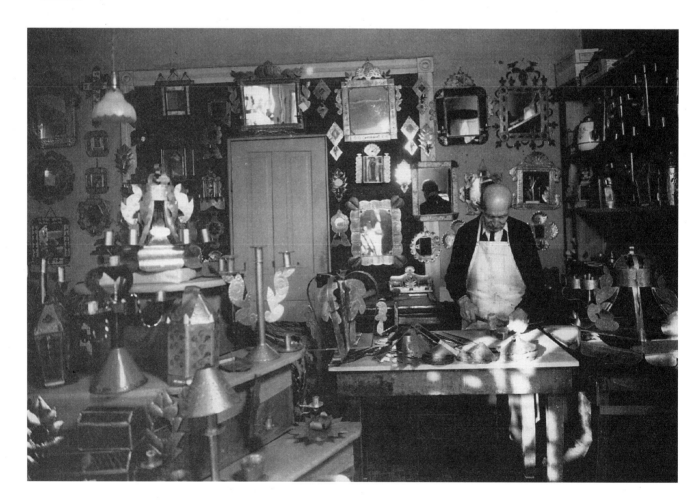

ACTIVITY—TIN LANTERN

Advanced tinwork requires acid-core soldering and tin cutting, which is beyond the scope of these simple children's projects. For readers wishing to undertake more challenging projects, *Tin Craft*, a workbook by Fern-Rae Abraham, is an excellent resource. Even though it is an old and out-of-print book (1935) and you will probably only be able to find it in a large library, *Tin Craft as a Hobby*, by Enid Bell, is another excellent resource. It has many traditional Hispanic tin projects and is worth the effort to find it.

The company Valencia Tin/Rita Martinez sells a tin-making kit designed for children over age six working with adult supervision. It contains all the necessary materials and instructions for four or more projects. The company's address is Tin Making Kit, Valencia Tin/Rita Martinez, 336 Oñate, Espanola, New Mexico 87532; (505) 753-5166.

The following figures are design templates based upon traditional patterns to use in your tin projects.

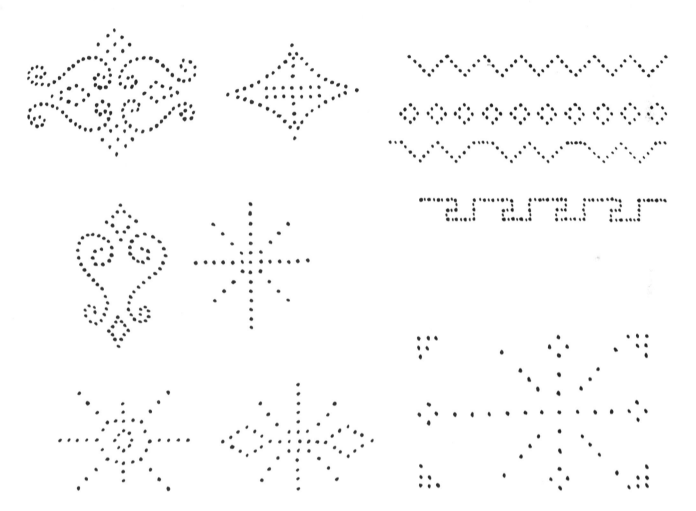

Figures 12.20 and 12.21. Traditional tin designs.

Tin lanterns are easy to make and add a festive decoration to any event. Use them as table lanterns, floor decorations, fence decorations or lighted path markers.

This is an adult-supervised activity with special caution being given to the sharp edges of the tin.

Materials

An empty can, the smoother the better
Can opener
Masking tape
Design templates
Various size nails
Hammer
Votive candles
Heat-resistant spray paint, various colors
A wooden post, smaller in diameter than the can
Sandpaper

Instructions

1. Remove outside wrapper from can and wash can.

2. Remove any glue from the side of the can by scraping it off with a dull knife or a wooden straightedge. Be careful not to scratch the tin.

3. Cut both ends out of the can. A can opener, either manual or electric, works best. *Be careful, the edges are sharp and can cut you.* Hammer down or sand off any slivers of tin sticking up (Fig. 12.22).

4. Tape a design template on the outside of the can.

5. Slip the can on the wooden post.

6. Support the post between two tables or other secure surfaces.

7. Use nails and the hammer to punch holes in the can through the template.

8. Use nails of different sizes to vary the pattern made by the holes.

9. Repeat the design on the can in order to allow more light holes on the surface of the can (Fig. 12.23).

10. If desired, lightly spray paint the can, but be careful not to close the holes.

11. Place the tin lantern on the ground or other selected surface.

12. Place the votive candle inside the can, and light the candle. The tin lanterns are especially enjoyable at nighttime (Fig. 12.24).

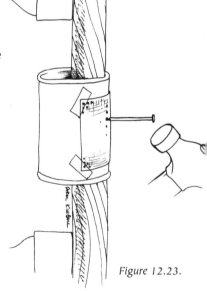

Figure 12.22.

Figure 12.23.

Figure 12.24.

ACTIVITY—TIN FRAME

Tin picture frames are also easy to make. As with tin lanterns, this is an adult-supervised activity, with special caution being given to the edges of the cut tin. This activity is for a simple tin frame (the image is pasted on).

Materials

Tin cans. Cans come in all sizes so select an appropriate can size for the size of frame you want. For your first frame, practice using a large fruit or juice can. If you do not want to use tin can metal, you can order sheets of turneplate tin from a hardware store.

Galvanized wire, size 16 gauge

Tin snips

Wire cutter

Nails, various sizes

Hammer

Flat wooden board

Hole punch suitable for metal (nails work too)

Design templates

Marker pen

Strong adhesive glue, spray-on adhesive or contact cement (rubber cement is adequate but less permanent)

Ruler

Masking tape

Sandpaper

Picture or mirror to be framed

Instructions

1. Follow instructions 1 through 3 (page 86) for making a tin lantern.

2. Cut open the can along its side. This is best done by using the tin snips to remove the seam from the can.

3. Carefully, so as not to cut yourself on the metal, roll the curve out of the can. Flatten the metal as best as you can. (This is the hardest part of the whole project.) This step takes time because the metal retains its shape memory. Also, the thicker the metal the harder it is to flatten out. Roll the metal concave side up over your knee to flatten it. Be careful not to bend any sharp angles into the metal. Be careful not to cut yourself. If necessary, wear gloves. This is the step in which turneplate tin from the hardware store makes things a bit easier (and safer).

4. After the metal lies flat on its own, place your picture on the tin. You now have a choice of using either the outside or inside of the tin. The outside usually has a silver finish. The inside will usually have a silver or slightly golden or colored finish.

5. Center the picture or mirror in the frame. Make sure the top and bottom edges are the same width. Make sure the sides of the frame edge are the same width. Use the ruler to measure.

6. Use the marker pen to outline the edge of the picture after it has been centered in the frame area. Do not glue the picture down yet.

7. Tape the design templates around the edge of the frame.

8. Place the tin frame on the flat wooden board.

9. Using the hole punch (or nails and hammer), punch holes in the frame in the pattern of the template. You can either punch holes completely through the tin or just dimple the holes into the tin.

10. After the frame designs are punched in, glue the picture onto the tin.

11. If you are making a mirror frame, glue the mirror onto the frame.

Figure 12.25. Tin mirror or picture frame.

13

Folk Crafts

Folk crafts are enjoyed by people all over the world. Because of their simple techniques, children, as well as adults, can enjoy these craft activities. Also, because of their easy-skill needs and low materials requirements, they are quickly learned and readily affordable. Folk crafts are as varied as the cultures of the world, for every culture has an abundance of these crafts in their folk traditions. The people of the Hispanic Southwest have three folk craft traditions that can provide hours of creative activity as well as create beautiful folk objects to add to many cultural and family celebrations.

LA PIÑATA

The *piñata* is one of the most delightful and playful Hispanic traditions. Enjoyed by Hispanics and non-Hispanics alike, the *piñata* has evolved from its Spanish Lenten season origins to a year-round celebration activity. A *piñata* party typically includes a gaily decorated papier-mâché sculpture in the shape of an animal, or some fanciful shape, suspended from a tree limb or the ceiling by a rope. The *piñata* is filled with candy or other special treats. An adult controls the *piñata* while blindfolded children strike at the *piñata* with a stick trying to break it. When one child succeeds and breaks the *piñata*, a mad scramble occurs as children try to fill their hands with the *piñata*'s treats.

The origins of the *piñata* are lost in legend. Some say Marco Polo brought it from China to Italy in the twelfth century. The Chinese used a *piñata*-like object in their spring agricultural ceremonies to scatter seeds for planting. Others point to an old Roman game played at the end of the harvest, with blindfolded workers breaking a clay pot hanging over a branch and filled with nuts and fruits. The armies of Julius Caesar later spread this game to the Iberian Peninsula.

In sixteenth-century Italy, the Italians played a game called *pignatta*, which means cone-shaped. The *pignatta* was a cone-shaped clay pot used in games played by the nobility. These wealthy Italians would try to break the jewel-filled *pignatta* while blindfolded.

The Spanish borrowed this Italian game, decorated the clay pot with bright colors and transformed it into a Lenten season activity. The Spanish designated the first Sunday of Lent as *Piñata* Sunday, on which they would break clay pots filled with candies. They called the game *piñata*.

The Spanish brought the *piñata* game to the New World, where it continued to evolve. As was their

The Spanish designated the first Sunday of Lent as *Piñata* Sunday, on which they would break clay pots filled with candies. They called the game *piñata*.

usual practice to use everything for a religious purpose, the Spanish missionaries used the *piñata* to teach the tenants of Christianity. The *piñata* symbolized the devil dressed in his finest attire to trick humanity. The blindfold represented the human difficulty of recognizing sin. Breaking the pot symbolized the triumph of good over evil. The treats were God's blessings falling on the Earth.

Over the years the *piñata* game evolved away from such religious purposes to its present enjoyment as a party game. While it is still played as part of the Christmas season *Las Posadas* celebrations, the *piñata* has become a favorite child's birthday party game as well as a part of many other cultural celebrations.

Piñatas also have become a large item in the tourist trade. Brightly and imaginatively decorated *piñatas* of all shapes and sizes are available for purchase.

Today, in Mexico, the *piñata* can be filled with candies and treats as well as fruit and nuts. In America, the *piñata* is mostly filled with candy or small toys.

During the hitting of the *piñata*, children often encourage the hitter with shouts of "¡*Dale!* ¡*Dale!*" ("Hit it! Hit It!").

No matter what the occasion, it can always be improved with a joyful game of the *piñata*.

A wonderful children's book about the *piñata* is *El Piñatero, The Piñata Maker* by George Ancona. It tells the story of an old *piñata* maker who makes the *piñata de pico*, the traditional star *piñata*. The book is filled with pictures of the old ways of constructing a *piñata*.

ACTIVITY—STAR *PIÑATA*

Materials

Newspapers (several days worth for construction and protecting work surfaces)
3 to 4 cups flour
Water
2 large bowls
Something to stir with
Compass
Ruler
Scissors
Stapler
Marker
Round 11-inch-diameter balloon
Large jar of rubber cement
20-x-30-inch tissue paper (4 sheets red, 4 sheets green, 4 sheets white)
12-inch square of aluminum foil
Masking tape
10-foot cord for hanging the *piñata*
Candies and special treats to fill the *piñata*

Instructions

1. Cover work surface with newspaper. Be sure to wear a long smock or clothing you don't mind getting messy.

2. Inflate the balloon and tie end. Draw a circle that is 3 inches in diameter around the knot to mark the opening of the *piñata*.

3. Prepare five cone-shaped points for star: With compass, draw two 8-inch circles on three layers of newspaper. Cut circles into quarters and staple the three layers of each one together for easy handling. Roll five newspaper cones from quartered circles, cementing ends together. To make shiny tips of star, cut two 4-inch circles of foil and quarter. Cement foil onto cone tips.

4. Mix 1 cup flour and 2 cups water for a thin paste. Repeat as needed.

5. Tear or cut newspaper into strips, approximately 2 inches wide and 14 inches long.

6. Dip newspaper strips into paste. Starting just below opening you have marked, cover balloon in four layers of paper. (It is not necessary to let a layer dry before applying the next one.)

7. While the *piñata* is still wet, attach five star points by cutting 1-inch notches around the bottom edge of each cone, folding as shown, and pasting them in place.

8. Allow 24 to 36 hours for the *piñata* to dry.

9. Pop balloon. Attach cord by looping around two star points nearest the opening and weaving around each of the other three points. Use masking tape to secure cord to form, leaving about 3 feet to thread through top loops for later suspension.

10. For ruffles, stack four sheets of red tissue paper, cut strips 3 x 30 inches, then cut in half so strips measure 3 x 15 inches. Fold in half lengthwise and cut slits about $^3/_4$ inch deep and $^1/_4$ inch apart all along the folded edge, leaving about $^1/_2$ inch of uncut tissue on each end. Separate ruffle strips, refold each inside out and cement together along the long edge. Ruffles should puff out. (Young children may make simple fringed strips instead.)

11. Cement ruffles around star's points, just above foil tips. Add each layer of ruffling close to last layer, covering portion cemented to the *piñata*. When you have covered each point in red ruffles, make five white ruffles and cement just above the red ones where cones meet body. Attach ruffling over cord as necessary. Now make enough green ruffles to cover body, exposing only opening at top.

12. Fill the *piñata* with candies and special treats. Be creative and have fun with the *piñata* on celebrations throughout the year. On New Year's fill it with streamers and noisemakers; on Valentine's Day fill it with valentines and heart candies; on St. Patrick's Day fill it with shamrocks and green treats; on Fourth of July fill it with firecrackers. You get the idea!

13. Cover the hole with paper and flour strips. Finally cover the hole with green tissue.

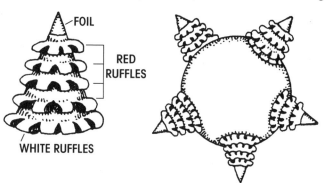

FOIL
RED RUFFLES
WHITE RUFFLES

ACTIVITY—*PIÑATA* GAME

Materials

Blindfold
Stick (broom handle, small baseball bat, tree branch)
Rope
Piñata

Instructions

1. Assemble the *piñata* players in a large open space.

2. Suspend the *piñata* from a high spot, a branch, a rafter or a roof suspension. Suspend the *piñata* with a rope that allows the *piñata* to be moved up and down as the game is played.

3. Blindfold each player, spin the player around three times and allow each player to take three swings at the *piñata*. It is best to begin with the younger players and work up to the older, more capable, players. A word of caution: Be careful that children stay out of the way of the swing!

4. As each player swings, control the *piñata* by moving it up and down with each swing, keeping it just out of reach for the first round.

5. Have the players shout "¡Dale! ¡Dale!" ("Hit it! Hit It!") as each player swings.

6. As play progresses use your own judgment as to when to allow the *piñata* to be broken.

7. Another word of caution: If the game is played with a wide age range of children, protect and help the younger children as they will be trampled by the older children in the rush to gather the candy after the *piñata* breaks.

PAPEL PICADO

Papel Picado, meaning "perforated paper," are colorful paper cutouts. In some parts of the Spanish-speaking world they are called *Papel de Seda*, "paper silk," because of their delicate nature. In Mexico they are called *Papel de China*, "Chinese paper," because the practice of decoratively cutting images into paper originated in China. Traders brought tissue paper from Asia to Mexico in the 1500s.

These tissue-paper cutouts are used to decorate many different celebrations. They can be seen decorating rooms in homes, hallways in churches as well as city streets. One particular use of them is to decorate the *ofrenda*, "the altar," for the Day of the Dead celebration. The pictures on them can be seasonal such as Christmas angels or Easter eggs. The cut images also can be simple geometric or floral designs and can decorate any festive occasion.

Usually they are draped over string and hung in the air to create a large decorative banner of *Papel Picado*.

One particular use of them is to decorate the *ofrenda*, "the altar," for the Day of the Dead celebration.

ACTIVITY—*PAPEL PICADO*

Materials

12-x-18-inch sheets of tissue paper
Scissors
String
Glue, glue stick or stapler

Instructions

1. Take a sheet of tissue paper and fold a 1-inch edge down the 18-inch side of the paper. This is the string side.

2. Fold the 18-inch side in half.

3. Fold the paper diagonally so that the AB fold is at the bottom of the string side.

4. Fold diagonally again so that the AZ fold is at the bottom of the string side.

5. Cut a wavy or scalloped line from P to Z to add a fancy edge. This edge can be cut more intricately if you like.

6. Cut out a variety of shapes along AP.

7. Unfold the sheet and insert string under flap, and glue or staple down.

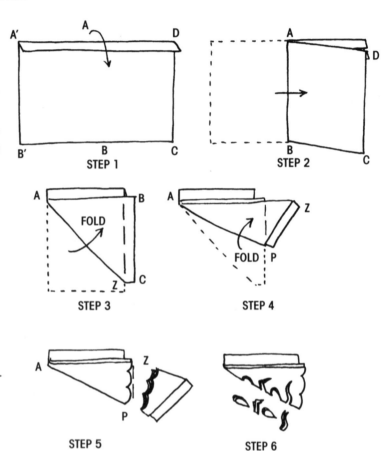

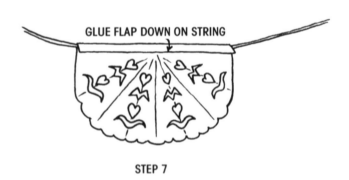

OJOS DE DIOS

Ojos de Dios, "god's eyes," are ritual objects made by the Huichol people of Mexico. The Huichol Indians of the state of Jalisco live in the rugged and inaccessible mountains of the western Sierra Madre. They were one of the last native tribes to fall under Spanish rule, and they never completely adopted the Spanish ways. Of all the Mexican native people, they most closely live the indigenous life of pre-Conquest Mexico. They still live in their traditional ways and practice their own religion.

The Huichol use *Ojos de Dios* as revered religious objects in their prayer ceremonies. Their yarn and bamboo creations symbolize the eyes of the gods invoked in their prayers. These eyes allow the gods to view human life and thereby grant people health and a good life. They call their god's eyes Tsikuri and their shaman holy men weave them to use in their religious prayers.

The Huichol symbolism of the god's eyes is primarily associated with their prayers for their children—prayers for a good and long life. They pray that the god's eyes look down with favor on their children. For their prayers they place their god's eyes on their altars, attach them to their prayer arrows or have their children wear them.

Fathers dedicate god's eyes to their children, with one god's eye for each year of the child's life, up to age five. After that, children are responsible for their own religious obligations and must make their own god's eyes.

The Huichol also place god's eyes in the frameworks of new houses and in their mountain shrines for protection of people and to ensure abundant crops and a long life.

Figure 13.1. This Huichol man is fashioning a sacred "god's eye," a ceremonial object. La Mesa, Nayarit, 1937.

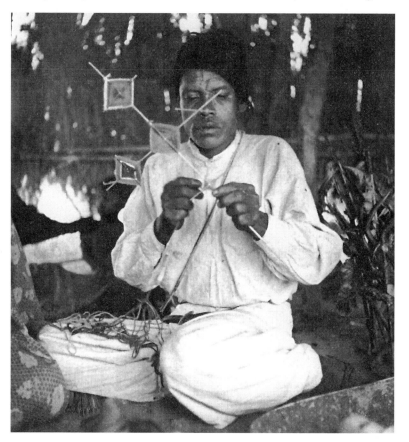

ACTIVITY—OJOS DE DIOS

Materials

Popsicle sticks, small dowel sticks or small tree sticks
Glue
Colorful yarn

Instructions

1. Glue or tie two sticks together in the shape of a cross, with the sticks crossing in the middle.

2. Wind the yarn around the sticks, either clockwise or counterclockwise as desired, in the following rhythm: behind the stick, looped completely around the stick and on to the next stick, repeat.

3. Change the color of the yarn by tying on a new color to the old color yarn when desired and continue the wrapping rhythm.

Here are some suggestions to stimulate your imagination:

Contrast colors. Use a color wheel to select from the primary (red, yellow, blue), secondary (orange, green, purple) and six intermediary colors (red-orange, etc.).

Put light colors next to dark colors.

If using only one color, use several shades of the color and change color in gradations, moving from light to dark and dark to light.

Use like colors together: earth tones, sun colors, night colors.

Make one color dominate. Have a color theme.

Make complicated multieye god's eyes.

Make a god's eye mobile.

14

Oral Traditions

Buenos Cuentos, Buenos Amigos.
Good stories, good friends.

CUENTOS: STORIES AND LEGENDS

The oral traditions of the Hispanic Southwest comprised a literary heritage for Hispanic families.

The origins of Hispanic Southwest oral traditions are found in history and in cultural memory. When the Spaniards came to the New World, they brought with them the rich oral traditions of sixteenth-century Spain. Spanish culture at the time was a mosaic of varied influences. The Iberian Peninsula had experienced Greek, Roman, Arab and Jewish cultures over many centuries; the Asian and Indian cultures also had passed on their influences to the Spanish people. In addition, the Catholic Church was a primary and powerful influence on Spanish life, thought and cultural practices. This fertile cultural environment produced oral traditions with an immense scope in style and subject.

Folklorists have traced the roots of traditional *cuentos* as far back as the magical tales of *The Thousand and One Arabian Nights* and the fables of medieval Europe. Juan B. Rael, in the introduction to his two-volume collection, *Cuentos Españoles Colorado y Nuevo Méjico,* describes similarities between stories he collected and the fabliaux of Medieval French literature as well as Boccaccio and Marguerite de Navarre. In *The Folklore of Spain in the American Southwest,* Aurelio Espinosa reports that 90 percent of the folk literature of the Hispanic Southwest can be traced to Spain. In his book he tells

several anecdotes about a research trip to Spain during which he finds exact versions of stories he had collected in the Hispanic Southwest. Many folklorists consider the Hispanic Southwest to be the richest store of folktales in the United States. Stanley Robe, in the introduction to *Hispanic Folktales from New Mexico,* states:

> Folklorists have long been aware of the wealth of oral narratives that is available among New Mexican Hispanics. It is doubtful that any comparable area in the United States has contributed as many narrative texts for study. (1977, p. 5)

The oral traditions of the Hispanic Southwest comprised a literary heritage for Hispanic families. Often the only book in the home was the Bible, and many members of the family were unable to read. The stories they told were their way of passing on their culture from one generation to the next. The stories allowed older generations to pass on their wisdom. The stories allowed communities to share and sustain their religious faith between the infrequent visits from the clergy. And finally, the stories provided a way for families to pass the time after the work of the day was finished.

The stories were alive with the traditions of the family. The stories' natural context was family gatherings: weddings, birthdays, funerals, harvest celebrations or the simple gathering of the family around the winter fire. The traditional storytellers were not in any way similar to the professional storytellers we know today. They were farmers, miners, sheepherders, weavers, cooks, brothers, uncles, aunts and grandparents. They were family members who loved telling a good story and who held a special reputation in the family as a *cuentista*, a storyteller.

Traditional Hispanic culture has a vast variety of stories. Folklorists have categorized these stories with detailed indicators of tale-type and origin. But most of the stories can be categorized under several general headings. A representative *cuento* from each of these primary categories is presented following this introduction.

Moral and religious tales were important to the Hispanic people as an aid in maintaining their Catholic religion. During the Spanish colonial years, it took weeks and months for priests to make their infrequent visits from the interior of Mexico to the northern frontiers. Isolated geographically, the Hispanic people used moral and religious *cuentos* to sustain their religious beliefs. The stories centered on struggles with temptation and the search for the moral life on Earth. The stories had God, the devil, death and the saints as major characters. And each story contained a strong moral teaching from the Catholic Church.

Chistes were short, anecdotal tales, usually with a comic twist at the end. The Hispanic people greatly enjoyed *chistes*. Over time the *cuento* tradition has changed from favoring long, fully developed, detailed narratives to favoring shorter stories, especially *chistes*.

Animal stories are especially common. As in Aesop's fables, the stories feature animals who speak and act as humans. The stories always contain a subtle moral lesson.

Traditional stories existed with the context of a larger oral tradition. Along with *cuentos*, the Hispanic people enjoyed a large repertoire of *dichos*, folk proverbs, and *adivinanzas*, riddles.

For further information on Hispanic oral traditions, my book, *The Corn Woman: Stories and Legends of the Hispanic Southwest*, contains forty-five traditional Hispanic stories. Fifteen of them are translated into Spanish. There are also two audiotapes available featuring stories from *The Corn Woman*, a ninety-minute tape in English and a ninety-minute tape in Spanish. The book and tapes are available from Libraries Unlimited, P.O. Box 6633, Englewood, CO 80155-6633; (800) 237-6124.

> The stories centered on struggles with temptation and the search for the moral life on Earth.

THE THREE BRANCHES: A MORAL AND RELIGIOUS TALE
Retold by Angel Vigil

*Excerpted from The Corn Woman:
Stories and Legends of the Hispanic Southwest*

Deep inside the forest, on the other side of the mountain, lived a hermit. The hermit had once been a man of the world, but he had left the world to live by himself in his small house in the forest, enjoying the company of nature. Living far from the troubles of the world, the hermit

was happy with his life. He had chosen the life of solitude because he had dedicated himself to following the path of the Lord here on this earth. He spent his days praying, fasting and reading the Bible. Often travelers would seek him out trying to find the answers to their daily problems and he would always give them the same answer, "The answer to your problems is to follow the path of the Lord. There is no other way, but the teachings of the Lord."

The Lord was pleased with the hermit and every day an angel came to the hermit and brought him food and water. The angel would place the food and water outside of the hermit's door, and when the hermit got up in the morning he often could hear the beating of the angel's wings as it flew back to Heaven. In this way, the hermit knew that he lived in grace in the eyes of the Lord.

One day a troop of soldiers was traveling through the forest by the hermit's house. They were transporting prisoners. The hermit could tell that these must be especially bad prisoners, because they were under such heavy guard. He imagined all the terrible crimes they must have committed. As they passed his house the hermit called out, "Their souls should be taken by the devil for their sins have offended the Lord."

When the Lord heard what the hermit had said, the Lord was unhappy with him. He felt that the hermit had committed the sin of pride. The hermit had started to believe that he was more holy than anyone else.

The hermit had forgotten that only the Lord decides who is a sinner. For each person's sins are hidden inside their heart. The hermit was wrong to wish any person's soul to the devil. As long as there is a chance for repentance, there is a chance to be forgiven one's sins. To teach the hermit a lesson, the Lord no longer sent the angel with food and water.

The first day that the angel didn't deliver the food, the hermit decided he must have committed some small sin, so he said extra prayers that night. The second day that the angel didn't deliver any food, the hermit was more worried. But once again he said extra prayers at night. Finally, the hermit realized that the angel had stopped delivering food, and he realized that the Lord was punishing him.

The hermit went to the priest and asked why the Lord was punishing him. The priest heard his confession and told him, "You have committed the sin of pride, and you have sinned by wishing the prisoners' souls be taken by the devil."

Anguished by the thought that he had sinned, the hermit asked the priest, "I have sinned in the eyes of the Lord. What is my penance to be? Tell me Father."

The priest gave the hermit his penance. "Take this dead branch. When the branch sprouts three green branches, then the Lord has forgiven you."

The hermit left the church carrying the cane the priest had given him. He traveled through the land wandering from village to village. At each village he would ask for food and shelter. In some villages, the people would take pity on such a miserable looking man, and they

would give him food and shelter. In other villages, the people would see him coming and would chase him away. The children would throw rocks at him, and the dogs would bark after him as he left. The hermit wondered to himself, "When will my penance be over? I have traveled through the land and still my branch shows no sign of sprouting even one leaf."

One evening the hermit came to the house of a little old woman. He knocked on the door of the house, and when the little old woman answered he asked her, "I am an old hermit. Would you please show me the kindness of giving me some food? I have traveled long and I have not had any food for several days."

The old woman looked at the hermit and realized that the man was suffering from some penance, and she took pity on him. She invited him into her house and fed him some warm soup. As the hermit was eating, she asked him, "Old man, why do you suffer so much? What have you done to displease the Lord that he would punish you in this way?"

The hermit told her his story. As she listened, the old woman found the hermit's story so sad that she offered to give him shelter for the night.

"But when my three sons return home you must hide. They have turned into very bad men, and I fear that they will harm you if they see you here." She then showed the hermit a place where he could hide in a barn by the house.

Later that evening, the old woman's sons came back. The sons were thieves and had brought back the things they had stolen that day. As soon as they had returned to their house they went directly to the barn to hide what they had stolen. As they were hiding their loot, they discovered the hermit.

When they had dragged the hermit out of the barn, they argued over who was going to get to beat him up first. The hermit was very scared that they would kill him. On the one hand, the hermit was glad his life might be over, because he was tired of suffering so much. But on the other hand, he did not want to die before his penance was finished, because he knew that then he would never have eternal salvation.

The old woman came out of the house and stopped the thieves from beating the hermit. Her sons asked her, "Why should we do this old man any favors? He looks so miserable he deserves to die."

The old woman admonished her sons, "Leave him alone! This poor man has suffered enough. He is being punished by the Lord for the sin of pride, and he must travel as a hermit until his penance is done."

The sons took their hands off the hermit and one said, "This is how the Lord punishes a man for the sin of pride. What will the Lord do to us? We are murderers and thieves."

When the sons thought about what their punishment might be, they decided to change their ways and to follow the ways of the Lord for the rest of their lives. They thanked the hermit for coming to their house and showing them their sins while there was still time to change. The thieves asked the hermit to show them how to pray to the Lord for forgiveness. After they had prayed they told the hermit he could stay with them until he was finished with his penance.

The old woman admonished her sons, "Leave him alone! This poor man has suffered enough. He is being punished by the Lord for the sin of pride, and he must travel as a hermit until his penance is done."

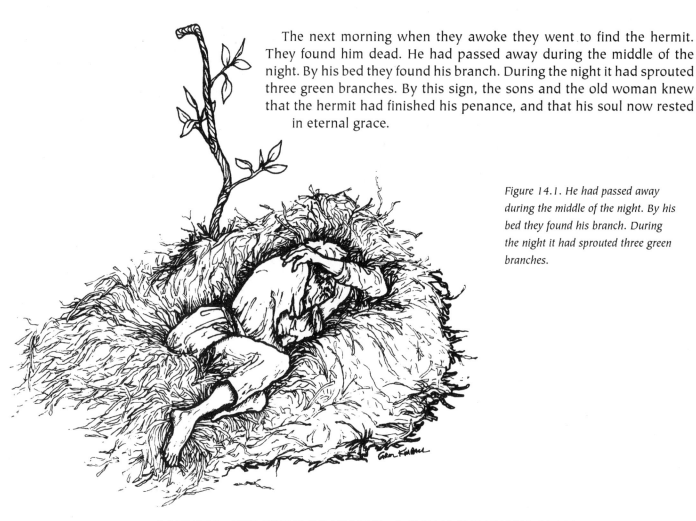

The next morning when they awoke they went to find the hermit. They found him dead. He had passed away during the middle of the night. By his bed they found his branch. During the night it had sprouted three green branches. By this sign, the sons and the old woman knew that the hermit had finished his penance, and that his soul now rested in eternal grace.

Figure 14.1. He had passed away during the middle of the night. By his bed they found his branch. During the night it had sprouted three green branches.

ACTIVITY—THE THREE BRANCHES: A MORAL/RELIGIOUS STORY

Create a "grateful dead" story. "The Three Branches" is an example of a special category of story—a grateful dead story. The Grimm brothers first collected this tale-type, which is common in European folklore.

The structure of this type of story is simple, but it allows for the telling of a profound story. The core of the tale-type is a person's soul that cannot go to its eternal rest in Heaven until it does one last good deed on Earth. The soul wanders the Earth searching for an opportunity to perform this last good deed. The important part of the story is the soul's discovery of another person who is in need of help. When the soul performs this final act of help it is finally free to leave this Earth. The dead soul is free and grateful for the opportunity to do this final good deed.

An interesting bit of popular culture legend is that the band The Grateful Dead took its name from this tale-type and dedicated itself to doing its good deeds on Earth through its music and the good it brought to people.

Instructions

1. Reread "The Three Branches" and answer these questions:

 * Why is the hermit being punished? What sin did he commit?

 * What is his punishment?

 * Why is it so hard for him to do his good deed?

 * Who finally helps him?

- What is his final good deed?

- Why is this final good deed so important?

- Who deserves the thanks in the story?

2. Write your own grateful dead story. Use the following outline to help you organize your ideas.

 - First decide on your main character. Boy, girl, adult, child?

 - Next, decide on a way for your character to get into trouble. Your character needs to break some important rule of society or religion. For your version of this type of story, you do not need to have your character actually die. Your story could be about how your character finds redemption and rights a wrong he has committed. It could be about how a person realized that she did something wrong and how she makes up for it.

 - It is important that your character realize that he has done something wrong. Then he must want to fix it. It is important that he know that it is his responsibility to right his wrong.

 - In order to make your story interesting and give your character more nobility, you need to show her having to struggle to right the wrong. If you make it too easy for your character, then the final good deed will not be as powerful.

 - Decide upon some obstacles that keep your character from completing the good deed.

 - Decide upon a person who needs help. This is the person who will provide the opportunity for your character to do a final good deed. Your story will be more powerful and interesting if you can think up a person who needs help and a problem to be solved that are in some way related to the original problem of your character. This is the trickiest part of your story.

 - At the end of your story, when your character finally does the good deed and rights her wrong, have your character realize how she could have avoided the problem in the first place. This final part is what makes your story into a powerful moral tale.

3. Read or tell your story to your family, friends or class.

LOS TRES RATONCITOS: A CHISTE
Retold by Angel Vigil

Once there were *tres ratoncitos,* "three little mice," who lived with their mother. The mice lived in a small hole under a big fancy house.

Every day the mother mouse would leave the hole to go and search for food for herself and her children. The *ratoncitos* would cry out, "Mamá, why can't we go out and look for food too. It's always so boring just sitting here in our little hole."

The mother mouse would patiently answer, "Because the world is full of dangers. The big *gato* is always waiting outside, waiting to catch a nice little mouse and eat him up!"

The three *ratoncitos* pleaded even more, "Ah, Mamá, you're just trying to scare us. And besides, we're too smart and too fast for any old *gato* to catch us. Please let us go with you."

"No, you may not go and that's final. Now stay here until I get back. And wish me luck in finding some food for us."

The *ratoncitos* grumbled, "Oh, OK, Mamá. We'll stay here and be good. Good luck."

As soon as the mother mouse had left, one of the *ratoncitos* said, "You know, Mamá always has such a hard time finding food. Why don't we sneak out and help her? I know she is just trying to protect us, but we're almost grown up now, and it's time we started helping out."

Another *ratoncito* agreed and piped in, "Yeah! Let's sneak out, find some food, bring it back and have it waiting for Mamá when she gets back."

The third *ratoncito* agreed, "Good idea! Mamá will be so proud of us."

So the three *ratoncitos* crept out of their hole and cautiously went looking for food. Very soon they were lucky and found some cheese that had been swept in a corner. As they struggled to carry it back to their hole, they did not notice a big mean *gato* sneaking up on them. When they did notice the *gato* it was too late—the *gato* had trapped them and was snarling with his big teeth and getting ready to eat them!

Suddenly, the mother mouse leapt between the *gato* and her baby *ratoncitos.* The *gato* was ready to pounce on the mother mouse when she reared up on her hind legs and began to bark like a dog, "Woof! Woof! Grrrr! Woof! Woof!"

Figure 14.2. They did not notice a big mean gato *sneaking up on them.*

As soon as the *gato* heard the sound of a dog barking it turned around and quickly scampered away.

Later, when they were all safe back in their hole the mother scolded the *ratoncitos,* "Do you see why I asked you to stay in the hole?" The three *ratoncitos* sheepishly answered, "Yes, Mamá."

The mother mouse held her baby *ratoncitos* close to her and lovingly told them, "One day you'll be big enough to look for food on your own. There are still many more things you need to learn about the big world outside our hole. And one more thing about the lesson you learned today—now do you see why it's good to know how to speak more then one language?!"

ACTIVITY—*LOS TRES RATONCITOS*: A *CHISTE*

Create a story with a surprise twist ending. In the Hispanic oral tradition, *chistes* are some of the most popular and frequently told stories.

Their structure is simple. They are short, simple in plot and have a comic twist at the end. Their intended comedy is not the knee-slapping, hearty-laugh type of comedy. Their humor is much more a wry, humorous awareness of the foibles of people and situations. They are a wink of the eye, a chuckle of self-awareness and the discovery of a common, but overlooked, truth.

Instructions

1. Reread *"Los Tres Ratoncitos"* and answer these questions:

 * Who was the wise character in the story?

 * Who was the foolish character in the story?

 * What is the unexpected twist at the end of the story?

 * What is the lesson to be learned in the story?

 * Why would someone find this story humorous?

 * Do you get the joke? Can you explain it to someone else?

2. Read the section on *chistes* in *The Corn Woman: Stories and Legends of the Hispanic Southwest* by Angel Vigil. This book contains a large selection of various types of *chiste* tales. Read these *chistes* and try to answer the questions in item #1 for each story in order to understand this story-type better.

3. Write your own *chiste* story. Use the following outline to help you organize your ideas.

 * A good start for this type of story is to read the section on *dichos*, folk proverbs, in this book. Find a *dicho* that you like, has a truth to it that appeals to you and has a meaning you understand.

 * Try to imagine a situation in which a person would say the *dicho* in order to make a point to someone else. This situation will be the beginning of your story.

 * First decide on who will be the wise character in your story.

 * Next decide on who will be the foolish character in your story.

 * Put your foolish character in a situation in which their foolishness causes a problem.

 * Have the wise character solve the problem for the foolish character.

 * At the end of your story, have the wise character say the *dicho* to the foolish character. Have the foolish character learn a lesson from the wise character.

 * Remember, keep your story short.

4. Read or tell your story to your family, friends or class.

'MANA ZORRA Y 'MANO COYOTE
AN ANIMAL TRICKSTER TALE
Retold by Angel Vigil

Once, Hermana Zorra had been secretly watching a farmer's chicken coop to find a time when the chickens were left unguarded. Day and night she waited in the bushes for her chance to steal a nice fat chicken. But the farmer knew that 'Mana Zorra was nearby, and so he set a trap for her. He had lost too many chickens to foxes and coyotes, and he was determined not to lose anymore.

The next night 'Mana Zorra noticed her perseverance and patience was finally going to pay off. She saw the farmer get in his truck and set off for town. The chickens were unguarded!

Quickly she bounded over the fence that protected the chicken coop. She could hear the chickens cackling as she approached the coop. She could almost taste one of them already. As she crept closer she thought, "As I'm here, I might as well take two chickens. Who knows when I'll have this chance again."

As she got to the door of the chicken coop, she saw a little man guarding the coop. She had not noticed the little man at the farm before and couldn't imagine who he was. "Drat," she said. "The farmer has tricked me and left someone guarding the coop while he is away. The man is so little I didn't see him from the bushes."

But she realized that she had come this far, and she was so close that she was not leaving without a chicken. She made up her mind to overcome the little man and get a chicken anyway.

She went up to the little man and said, "Who are you and why are you here?"

But the little man didn't answer. So she asked again, "Do you think you are going to stop me from getting a chicken? Well you are mistaken." And with that she hit the little man on the head with one of her paws.

Immediately she realized that the little man was indeed a trick of the farmer's. The little man was a little scarecrow covered with tar pitch. Her paw was stuck fast to the head of the tar man. The more she struggled the more stuck she became. Eventually she was totally covered with tar with no chance of escaping.

As she tried in vain to set herself free, she thought to herself, "Now I am caught for sure. When the farmer returns he will have my hide for a souvenir. Oh, how did I ever get stuck like this?"

As she was trying to free herself, Hermano Coyote leapt into the yard by the chicken coop. He also had been waiting for a chance to steal a chicken or two. As he approached the coop he came upon 'Mana Zorra stuck to the tar man. He laughed at her predicament and asked her, "'Mana Zorra, what has happened to you?"

Thinking quickly 'Mana Zorra answered, "Oh, 'Mano Coyote, how glad I am to see you. I was here trying to get some chickens for the two of us when I was attacked by this man. He has a fast hold on me, and if you could help me get loose, then I could get the chickens for us."

'Mano Coyote thought that it was kind of 'Mana Zorra to be getting some chickens for him, so he decided to help her. He grabbed onto the

She could hear the chickens cackling as she approached the coop. She could almost taste one of them already.

tar man and tore him way from 'Mana Zorra. Of course now he was the one stuck to the tar man.

As soon as she was free, 'Mana Zorra stole two chickens and bounded off into the night, leaving 'Mano Coyote stuck to the tar man. He was furious as soon as he realized he had been tricked by 'Mana Zorra. The more he struggled to get free, the more stuck he became to the tar man.

When the farmer returned, he immediately went to the chicken coop to see if his trick had worked. Imagine his surprise when he saw 'Mano Coyote instead of 'Mana Zorra. He went up to 'Mano Coyote and said, "So it has been you stealing my chickens. I hope you have learned a lesson. Because if you haven't there is even worse waiting for you."

'Mano Coyote desperately pled his case to the farmer. "Yes I have learned my lesson. Just let me go and you will never see me around your farm again."

The farmer answered, "If you have learned your lesson then all this trick was for the good. Now I am going to let you go, but you must stay in the shed until I tell you the coast is clear. If you try to leave now the dogs will get you. As soon as I tell you the coast is clear just jump out the back window and the dogs won't know where you are. Then you are free to leave."

'Mano Coyote did as he was told. He was overjoyed to be free, and he did vow never to return to that farm again.

As soon as 'Mano Coyote was in the shed, the farmer put a tub of boiling water under the window, for he had one last lesson he wanted to teach 'Mano Coyote. As soon as the tub was in place he called out, "'Mano Coyote, it's all clear. You are free to go now."

'Mano Coyote leapt out of the window right into the tub of boiling water. Howling, he ran out of the farmer's yard never to return again. As he suffered his wounds he thought, "'Mana Zorra is to blame for all my suffering. As soon as I find her, she will be the one suffering."

He spent the rest of the night looking for 'Mana Zorra. Finally, he found her sitting by a pond intently watching a reflection in the water.

He rushed up to her, and before he could even say a word, she told him, "'Mano Coyote, I am really glad you have arrived. I'm sorry about what happened at the farmer's house, but I thought it would be better if I took the chickens right away before he caught both of us. I have hidden the chickens in a safe place not far from here. But I need your help now so we can have an even more enjoyable meal."

Even though he was suspicious, 'Mano Coyote was glad that she still had the chickens. And he was curious about what could make an even better meal. He told her, "This had better not be another one of your tricks 'Mana Zorra. Now tell me about the even better meal."

Figure 14.3. The cheese in the pond was really the reflection of the full moon on the water.

As she pointed to the reflection in the pond, 'Mana Zorra said, "Look. There in the pond. There is a big round of cheese. I am waiting for the cheese to come closer so I can grab it. Then we will eat both chicken and cheese tonight. You can help by waiting here while I go get the chickens. As soon as the cheese is close enough, grab it, and by then I will be back."

'Mano Coyote could almost taste the chicken and cheese already. As soon as 'Mana Zorra had left to get the chickens, he turned and watched the cheese in the pond.

Of course this was another trick of 'Mana Zorra's. The cheese in the pond was really the reflection of the full moon on the water. As the moon sank in the sky the cheese came closer and closer to 'Mano Coyote. When it was close enough he grabbed out at it, fell head first into the water and got totally soaked.

"This is another trick of 'Mana Zorra's!" he yelled. He jumped out of the pond and raced to find 'Mana Zorra before she got too far away.

He searched and searched until he finally found her in a cave sleeping with her legs up in the air touching the low roof of the cave. As soon as he entered the cave she woke up and once again immediately began talking.

"'Mano Coyote, where have you been? Some men were chasing me. I think one of them was the farmer. I came into this cave to hide and the bear who was here took the chickens to hide them until we could come and get them. He asked my to lie here with my legs holding up the roof of the cave so it doesn't collapse while he is gone with our chickens. But to tell you the truth, I don't trust him with those chickens. Why don't you take the job of holding up the roof while I go search for the bear. It is our only chance to get our chickens back."

By now 'Mano Coyote was so hungry he couldn't think of anything but the chickens. He agreed to the job of holding up the roof, but he made 'Mana Zorra promise that it wasn't a trick this time, and that soon he really would be eating chicken.

Of course 'Mana Zorra promised. She even took special time to show 'Mano Coyote just the right way to hold up the roof. On her way out, she assured him that she would be back as soon as she found the bear.

'Mano Coyote did his duty. No matter how fatigued his legs became he kept holding up the roof. So much time had passed that he couldn't tell if it was day or night. The darkness in the cave didn't help either. Finally he began to suspect that 'Mana Zorra was never coming back. He carefully removed one leg at a time from the ceiling. As he removed each leg, he became more sure that the roof was not going to fall down. As he removed his final leg, he knew that once again 'Mana Zorra had tricked him. He began to give up all hope of ever eating chicken, but he vowed to find 'Mana Zorra and get his revenge.

As he searched the forest, he heard a loud buzzing sound behind a particularly large tree. When he came around the tree he saw 'Mana Zorra poking a stick into a round, gray object. He definitely had surprised 'Mana Zorra because she was very startled to see him.

As soon as he saw 'Mano Zorra, he rushed to capture her, but stopped when he saw that she was crying. Momentarily forgetting his vow for revenge, he asked her what was wrong. Through deep sobs she told him, "'Mano Coyote, you won't believe what has happened. Trapped in

By now 'Mano Coyote was so hungry he couldn't think of anything but the chickens.

here are small children whose mother has died. I am trying to free them so they can fly home to their father. I am so glad you arrived. Now I can go find the father, and he can come and save his children."

Touched by this sad story, 'Mano Coyote asked what he could do to help. 'Mana Zorra gave him these simple directions, "Just keep doing what I am doing. Poke this stick into this object. If the children inside get very quiet, stir the stick hard to keep them alive until I return with their father. Thank you 'Mano Coyote. Only you can help now."

With those final words she turned the stick over to 'Mano Coyote and raced off.

Soon the children inside the gray object did become very quiet. Fearing for their lives, 'Mano Coyote began to stir the stick harder. He stirred the stick too hard because the gray object broke open. Only then did he learn that the gray object was a bees' nest, and the children inside were angry bees. 'Mana Zorra had been trying to steal some honey, and now he had to suffer the stings of the furious bees. He ran to the river and jumped in, but not before he was covered with bee stings. When the cool water had soothed his stings, he dried off and renewed his search for 'Mana Zorra.

Searching throughout the forest and open land, he could not find 'Mana Zorra anywhere. Tired of his futile search, he sat under a tree in a field of tall grass to rest, when who walked by but 'Mana Zorra.

Immediately he grabbed her and said, "Now you are mine, and you will pay for those tricks you have played on me. And where are those chickens?"

The mention of those chickens gave 'Mana Zorra the opening she was desperate for.

She pleaded with 'Mano Coyote. "Oh 'Mano Coyote, I know that my tricks have not been kind to you. But please know that the chickens are still waiting for you. But I must confess, that while I was not looking, some servants to the king took them from my hiding place and they have prepared them for a wedding feast. As we talk the feast is on its way to the castle."

The coyote could not stand the thought of his chickens being gone for good. He asked 'Mana Zorra, "Is there anything we can do? Those chickens belonged to me. I can still see their fat little bodies."

'Mana Zorra continued, "If you wait here, the wedding procession will pass by this way. You will know that it is near when you hear the popping of the celebration firecrackers. Now just let me go so I can find a position to help you with the attack. Together we can recapture our chickens."

'Mano Coyote released 'Mana Zorra and hid low in the tall grasses waiting to attack the wedding procession. As he waited 'Mana Zorra crept to the outside of the field in which 'Mano Coyote was hiding.

Once outside the field she lit the tall grasses on fire. As the field caught on fire, the burning of the tall grasses did sound like popping of firecrackers to 'Mano Coyote. As he jumped up to attack the wedding procession, he realized that the field was on fire, and he had been tricked by 'Mana Zorra again.

He barely escaped from the fire with his life, and to this day he is searching for 'Mana Zorra and planning his revenge on her.

The coyote could not stand the thought of his chickens being gone for good. He asked 'Mana Zorra, "Is there anything we can do? Those chickens belonged to me. I can still see their fat little bodies."

ACTIVITY—'MANA ZORRA AND 'MANO COYOTE: A CHILDREN'S ANIMAL TRICKSTER TALE

Create an animal trickster tale. Animal trickster tales are one of the most common tale-types in children's literature. Every culture has them, and children all over the world enjoy them. A quick trip to the library provides numerous individual stories as well as folktale collections.

The animal trickster tale has several definite characteristics. First, the characters are all animals who act like humans. They talk, have emotions and experience wild adventures. Second, a tale usually contains a subtle moral, a lesson to be learned. The tale teaches about life, the ways to understand people and what they do and how to get along in life. It especially teaches one to pay attention and not be easily tricked.

A trickster can be a hero, a scoundrel or a clown. Sometimes the trickster creates something good for people. Sometimes the trickster creates mischief just for the fun of it.

In the Native American oral tradition, the coyote is often the trickster. The African tales of Anansi the spider are trickster tales. The Northwest Coast tribes have the raven as their trickster. The well-known Brer Rabbit stories are also prime examples of this tale-type.

Hispanic culture has numerous trickster tales. Adult stories tell of Pedro de Urdamalas and his exploits. Children's tales feature the Tar Baby characters similar to the Brer Rabbit tales and the common story of the fox outwitting the coyote. In southwestern Hispanic oral tradition, the coyote is not the trickster but is the tricked.

Instructions

1. Reread "'Mana Zorra and 'Mano Coyote" and answer these questions:
 - Who is the trickster?
 - Why does Fox do what she does to Coyote?
 - Why doesn't Coyote wise up and see what Fox is doing?
 - In what way does Coyote cause his own problems?
 - Does Coyote deserve what happens to him?
 - How is Fox clever?
 - What are the results of Fox's tricks?

2. Read other trickster tales and use the questions in item #1 in order to understand the tale-type better. Recommended readings are *Tales of Uncle Remus* and *The Knee-high Man and Other Tales*, both by Julius Lester. *Favorite Folktales from Around the World* by Jane Yolen has a very good selection of trickster tales for the more mature reader.

3. Write your own animal trickster story. Use the following outline to help you organize your ideas.
 - A trickster story is usually short and direct.
 - Decide upon the animal character who will be your trickster. You can use a traditional animal trickster from your own or another culture, or you can use your own original animal trickster.
 - Decide upon the animal who will be tricked. This animal usually is somewhat responsible for its own problems.
 - Create a problem that the trickster needs to solve, a problem caused by the character who will be tricked.
 - The most creative part of your story is thinking up the trick the trickster uses to solve the problem.
 - The ending of your story is the surprising and clever trick the trickster plays.

4. Read or tell your story to your family, friends or class.

DICHOS: FOLK PROVERBS

Los dichos de los viejos son evangelios chiquitos.
The saying of old people are little gospels.

Dichos were part of the everyday experience of Spanish settlers. Their wide familiarity with *dichos* was in large part grounded in their Spanish heritage. Spain in the sixteenth century had a well-developed tradition of folk proverbs. The greatest Spanish novel, *Don Quixote* by Don Miguel de Cervantes, with its ample expression of folk proverbs, is the most significant literary example of the extent and importance of dichos in Spanish culture.

Dichos are an expression of personal philosophy and folk wisdom. They serve as guidelines for moral values and social behavior, and they often offer a clever insight into a person's character. The older generation often uses them to help younger people understand the subtleties of a situation or conflict. And often they end a conversation with a pithy, final observation. There are literally hundreds of recorded *dichos*. Many have an untranslatable, idiomatic quality. And they vary family to family, region to region.

There is even a *dicho* about *dichos*—*Para todo hay dicho:* There is a *dicho* for everything. Also, each section of this book begins with a *dicho* reflecting its theme.

Aquellos son ricos,
que tienen amigos.
They are rich,
those who have friends.

A buen entendedor, pocas palabras bastan.	To a good listener, a few words are enough.
A buey viejo, cencerro nuevo.	An old ox, a new cowbell. (An old man with a young woman.)
Adonde va el violin, va la bolsa.	Wherever the violin goes, the case goes. (Said about mothers who always chaperone their daughters.)
Al decir las verdades se pierden las amistades.	In telling the truth, friendships are lost.
Al mal paso, darle prisa.	With a bad road, hurry over it. (The sooner, the better.)
Al que le duela la muela, que se la saque.	If your tooth hurts, pull it out. (Solve your own problems.)
Aquellos son ricos, que tienen amigos.	They are rich, those who have friends.
Cada cabeza es un mundo.	Each head is a world. (To each his own.)
Cara de santo, uñas de gato.	Face of a saint, claws of a cat. (Said of people who pretend to be righteous.)

Caras vemos, pero corazones
no sabemos.

We see faces, but we do
not know hearts.
(Do not judge a book by its cover.)

Como es la vida, así es la muerte.

As life is, so is death.

Cuando el gato no está,
el ratón se pasea.

When the cat is gone,
the rat takes a walk.
(When the cat's away,
the mice will play.)

Cuando el gato no está,
el ratón se pasea.
When the cat is gone, the rat
takes a walk.
(When the cat's away,
the mice will play.)

El que al cielo escupe en
la cara le cae.

He who spits at Heaven has it fall
in his face.

El que al pobre le cierra la puerta,
la del cielo no halla abierta.

He who closes the door to the
poor, will find the door of
Heaven closed.

El que madruga, Dios le ayuda.

He who gets up early, God helps.
(The early bird gets the worm.)

El que no habla, Dios no lo oye.

He who doesn't speak,
God doesn't hear.
(The squeaky wheel gets
the grease.)

El que no quiere ruido
que no críe cochinos.

He who doesn't want noise
shouldn't raise pigs.
(Don't cause trouble if you
don't want trouble.)

El que todo lo quiere, todo lo pierde.

He who wants everything
will lose everything.

En boca cerrada no entran moscas.

Flies do not fly into
a closed mouth.
(Keep quiet and mind
your own business.)

Entre menos burros, más elotes.

Among fewer donkeys, more corn.
(The fewer the better.)

Fue por lana y lo tresquilaron.

He went for wool and
came back shorn.
(It backfired on him.)

Gato llorón no caza ratón.

A crying cat does not
catch a mouse.
(Complaining will get
you nowhere.)

¡Hasta los gatos, quieren zapatos!

Even the cats want shoes!
(He wants more than he deserves.)

Largo de uña.	Long of nails. (Describes a thief.)
La verdad es como el maíz, solita sale.	Truth is like corn, it comes out by itself.
Lo que volando viene, volando se va.	What comes flying, leaves flying. (Easy come, easy go.)
No hay rosa sin espina.	There is no rose without a thorn. (Something beautiful requires effort.)
No hay una cosa tan quieta como una bolsa sin dinero.	There is nothing as quiet as a purse without money.
Panza llena, corazón contento.	Full stomach, contented heart.
Perro que no sale no encuentra hueso.	The dog that doesn't go out won't find a bone. (If you don't try, you won't get anything.)
Poco a poco se anda lejos.	Little by little you walk a long ways.
Poderoso caballero es don Dinero.	Don Dinero is a powerful gentleman. (Money talks.)
Sin padre ni madre, ni perro que le ladre.	Without a father or a mother, or a dog to bark at him. (All forlorn and alone.)
Vale más tarde que nunca.	It is better late than never.
Vale más hoy que mañana.	Better today than tomorrow. (A bird in the hand is worth two in the bush.)
Ya va otra vez la burra al maíz.	The burro is in the corn again. (There he goes again.)

No hay rosa sin espina.
There is no rose
without a thorn.
(Something beautiful
requires effort.)

ADIVINANZAS: RIDDLES

Adivinanzas are also part of the oral tradition in Hispanic families. As with *dichos*, there are hundreds of collected *adivinanzas* giving testimony to the widespread practice of families sharing riddles with each other.

Adivinanzas vary from the simple question with a clever answer to the complex challenge requiring a knowledge of or familiarity with Hispanic culture and religion. Some are in poetical form. Some are brainteasers requiring thoughtful analysis. And some are simple children's ditties. Many traditional stories have *adivinanzas* as part of the plot and the hero's quest. But all are part of the family experience and a common social pastime.

> **Adivinanzas** vary from the simple question with a clever answer to the complex challenge requiring a knowledge of or familiarity with Hispanic culture and religion.

Anda y no tiene pies
Habla y no tiene boca
¿Qué es?
(Una carta)

It travels, but has no feet.
It talks, but has no mouth.
What is it?
(A letter)

Arca monarca de buen parecer
ningún carpintero le puede hacer.
¿Qué es?
(La caja del cuerpo)

A royal box so beautiful-looking
no carpenter could ever make it.
What is it?
(The human body)

Blanco fue me nacimiento,
Me pintaron de colores,
He causado muchas muertes,
Y he empobrecido señores.
¿Qué es?
(Barajas)

White was my birth,
They painted me with colors,
I have caused many deaths,
And impoverished many men.
What is it?
(Cards)

Cajita de Dios bendita
que se abre y se cierra
y no se marchita
¿Qué es?
(El Ojo)

A little box, blessed by God,
that opens and shuts
but never wears out.
What is it?
(An eye)

Chiquito como un ratón
cuida la casa como león
¿Qué es?
(El candado)

Little like a mouse
but I guard the house like a lion.
What is it?
(A padlock)

¿Cual es la santa mas olorosa?

(Santa Rosa)

What is the saint that
smells the best?
(Saint Rose)

Dos amigos muy queridos
andan con la boca por delante
y los ojos por detrás.
¿Qué es?
(Las tijeras)

Two close friends walk
with the mouth to the front
and the eyes to the back.
What is it?
(Scissors)

En el agua y no me mojo
En brazos y no me abrazo
en el aire y no me caigo
¿Qué es?
(La letra A)

I am in water but I am not wet.
I am in arms but I do not hug.
I am in the air but I do not fall.
What is it?
(The letter A)

Entre dos paredes blancas
hay una cuenta amarilla
¿Qué es?
(Un huevo)

Between two white walls
there is a yellow bead.
What is it?
(An egg)

Mi comadre
se come todo
lo que hay en la loma
¿Qué es?
(Una estufa)

My good friend
eats everything
there is in the mountains.
What is it?
(A stove)

Que cosa nunca puedes alcanzar
y siempre anda contigo?
(Tu sombra)

What thing can you never grab
but always walks with you?
(Your shadow)

¿Qué es que te lo tragas
y no lo ves?
(Aire)

What is it you can swallow
but can not see?
(Air)

¿Qué tiene boca y no puede comer?
(El rio)

What has a mouth but can't eat?
A river

Rita, Rita
que en el monte grita
y en su casa calladita.
¿Qué es?
(La hacha)

Rita, Rita
screams in the mountains
and is quiet at home.
What is it?
(An ax)

Sube el cerro y baja
y siempre está
en el mismo lugar.
¿Qué es?
(El camino)

It goes up the hill
and comes down the hill
but is always in the same place.
What is it?
(The road)

Una vieja
con un solo diente
recoge a toda su gente
¿Qué es?
(Una campana)

An old woman
with only one tooth
gathers all her people.
What is it?
(A bell)

Dos torres altas
dos miradores
un espantamoscas
y cuatro ansadores.
¿Qué es?
(La vaca)

Two tall towers
two lookouts
a fly swatter
and four walkers.
What is it?
(A cow)

Sube el cerro y baja y siempre
está en el mismo lugar. ¿Qué es?
(El camino)
It goes up the hill
and comes down the hill
but is always in the same place.
What is it? (The road)

¿Qué es lo que hacemos todos
con el tiempo? (Envejecer)
What is it
that we all do
in time?
(Grow old)

Vestidos de cuero negro
venían dos caballeros
uno al otro se decía
¡Yo primero! ¡Yo primero!
¿Qué es?
(Los pies)

¿Qué es
lo que hacemos todos
con el tiempo?
(Envejecer)

¿Qué es
que entre mas le quitas
mas grande es?
(El poso)

Guardada en estrecha carcel
por soldados de marfil
está una roja culebra
que es la madre del mentir.
¿Qué es?
(La lengua)

Me acuesto blanca
Me levanto pinta.
¿Qué es?
(La tortilla)

Two gentlemen come
dressed in black leather
one says to the other
I'm first! I'm first!
What is it?
(The feet)

What is it
that we all do
in time?
(Grow old)

What is it
the more you take away from it
the larger it gets?
(A hole in the ground)

Guarded in a narrow jail
by ivory soldiers
there is a red snake
that is the mother of the lie.
What is it?
(The tongue)

I lie down white
I get up spotted.
What is it?
(A tortilla)

ACTIVITY—*DICHOS* AND *ADIVINANZAS*

- Look up the definition of the word "proverb" in the dictionary. Put the definition in your own words and try to explain its meaning to your class or a friend.

- Go to the library and check out a book on proverbs. Make a list of your favorite ones and share them with your family, class and friends.

- Do research on proverbs from different cultures. A good place to look is in the folk culture and storytelling sections of the library. Can you find any proverbs that appear in more than one culture?

- Ask adults if they know any proverbs. If you can get in contact with any, storytellers are usually a good source of proverbs. Make a list of proverbs they tell you. Share the list with your family, class and friends. Can you recognize what culture their proverbs come from?

- Become an expert on proverbs. Learn as many as you can and see if you can use at least one a day to describe a situation you are in at home or school.

- Pick your favorite proverb and write a story using your proverb as the moral of the story. Construct your story so your main character learns the true meaning of your proverb by the end of the story.

- Go to the library and check out a book on riddles. Make a list of your favorite ones and share them with your family, class and friends.

- Organize a riddle contest in your class. Collect riddles and see who can guess the most correct answers.

- Research riddles from different cultures. Can you find any riddles that appear in more than one culture?

- Write a story in which the main character must answer riddles as part of the challenges in the story. Read your story to your family, class and friends, and see if they can answer the riddles in order to help the main character in your story.

15

MUSIC

Music is one of the most accessible paths into the heart of a culture. The songs a people sing spring from their deepest emotional centers. Songs pass from generation to generation, creating powerful cultural bonds and lasting cultural memory. Within the family, one generation passes musical talent, knowledge and skills to another generation. The music people play to entertain themselves gives meaning to their life, for their songs help celebrate the greatest joys and bring comfort to the deepest grief. The instruments people play are their tools of cultural expression. Most important, the occasions of traditional music are centered in the experiences of family life—weddings, funerals, birthdays, celebrations and reunions.

Many of the events that mark a full and rich life on this Earth are accompanied by music.

One of the most enduring characteristics of the Hispanic people is their great love of music. Just as with other cultural traditions, the Hispanic people have evolved forms of music that are widely varied and particular to each region of the Southwest. For the Hispanic people, their music is a constant reminder of the riches that result from the infusion of musical culture into all aspects of daily life, both secular and religious.

The music of the Hispanic Southwest is the result of centuries of cultural evolution, beginning with the historically momentous collision of Spanish and Aztec cultures. The history of the Spanish colonization of the New World, beginning with the conquest of the Aztec empire, includes the supplanting of Aztec musical traditions with those of the Spanish.

At the time of the Spanish arrival in the New World, the Aztecs had developed a sophisticated ceremonial and religious system that fully dominated their life. During the time of their consolidation of power and the establishment of their dominance in central Mexico, the Aztec people had also developed sophisticated literary, artistic and musical traditions. Music especially was a central part of their cultural practices.

Figure 15.1. Three Musicians of the Baile.

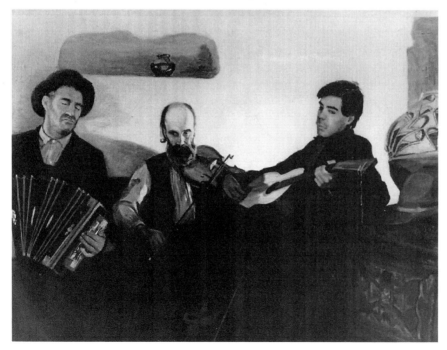

Music, singing and indigenous instruments were part of Aztec religious and ceremonial rituals. The Aztecs' instruments included drums, reed or clay flutes, shells, bones, gourd rattles, wooden rasps and stringed instruments made with animal shells.

The *conquistadores,* and the missionaries who followed them, brought the instruments and the musical traditions of the Golden Age of Spain to the New World. The Spanish soon used their musical traditions in their efforts to convert the indigenous natives to Spanish culture. During the early period of colonization, the missionaries were intent on replacing all aspects of Aztec life, including the music and instruments of the Aztec people, with Spanish cultural practices. Soon Spanish violins, harps and guitars replaced the Aztec drums and flutes. The Aztec musical repertoire eventually gave way to European-Spanish musical forms.

The native musical traditions and instruments, however, were never completely eradicated. The indigenous populations were successful in maintaining many aspects of their culture. The Deer Dance of the Yaqui Indians, with its characteristic sound of gourd rattles and wooden rasps, is one of the most well known and famous indigenous dances performed by modern Mexican dance companies. Another example of the continuing influence of native culture is the common sight of fabulously costumed *conchero* dancers performing the traditional and sacred Aztec dances at community festivals throughout the Southwest.

The people of the Hispanic Southwest have a varied and wide-ranging repertoire of songs and musical styles. Many of the songs are directly descended from the tra-

ditions of Spain, while many evolved in the fertile mix of indigenous and Spanish cultures in the New World. *Romances, rancheras, sones* and *corridos* are a few of the primary musical styles heard in the Hispanic Southwest.

The *romance* is a narrative ballad of Spanish origin, with songs dating from late Medieval and Renaissance Spain. They are the oldest type of folk song known in the Southwest, telling the common and eternal stories of love, betrayal, desire and honor. Romances often tell the stories of nobility and the upper class. The *romances* found in the Hispanic Southwest often share text, titles and subject matter with the *cancioneros* of Spain, the songs of the Spanish Renaissance court.

The *ranchera* is the rural "ranch" folk music of Mexico. Like the *romance, rancheras* often sing about lost love and powerful emotions. They also have lyrics telling of personal and regional pride. Their musical style can vary from the 3/4 meter of the waltz to the fast 2/4 of the polka. Well-known *rancheras* are "El Rancho Grande," "La Cucaracha," "De Colores," the anthem of the United Farm Workers and the all-time great Mexican love song, categorized as a *ranchera romantica,* "Volver, Volver." Another is the lovely birthday song "Las Mañanitas."

The *son* is a characteristic musical style played by mariachis. It is a basic Mexican dance form with many regional variations and is associated with the Mexican dance style *zapateado,* a heel-toe dance step known for its complex rhythms. The distinctive sounds of the *zapateado* are made by the stamping of the foot and clicking of the heels on the floor. The basic *son* rhythm is characterized by rhythmic variations and its development of

The *conquistadores,* and the missionaries who followed them, brought the instruments and the musical traditions of the Golden Age of Spain to the New World.

theme and variations. The *son* form appears in regional styles throughout Mexico. One of the most well-known examples is the song *"La Bamba,"* a *son jarocho* from Veracruz.

Corridos are one of the most popular Hispanic musical styles. They are narrative ballads that tell the story of ordinary people and their adventures. Often *corridos* tell a very dramatic story and have death or some tragic event as their primary theme. A *corrido* often was a quickly improvised song reporting the facts of a dramatic event. Originating in Mexico, *corridos* have spread throughout the Hispanic Southwest. *Corridos* have generally been written in the last century and a half, as opposed to the *romances*, many of which are centuries old.

Corridos consist of the most common Hispanic verse form, the *copla*, the rhymed four-line verse, with eight syllables to a line. Two main features of the *corrido* are the opening verses, which present a detailed description of the time and place of the narrative, and the closing verses,

the *despedida*, or farewell, in which the singers bid a farewell to the song. The *despedida* often begins with the lines "fly, fly, little dove," and can add a light ending or a moral to a tragic tale. Many *corridos* came from the events of the Mexican revolution in 1910. *"Adelita"* is one of the most famous from this period, telling the story of a revolutionary heroine.

It is impossible to identify one dominant Hispanic musical tradition, for the musical map of the Hispanic Southwest is a combination of many musical traditions. Three musical forms, however, are especially prevalent in the Southwest: Mexican mariachi, northern New Mexican and southern Coloradan colonial music and Texan-Mexican *conjunto*.

Each of these forms represents the cross-fertilization of European and Mexican musical influences. As the colonial population spread throughout the frontiers of northern Mexico, the land that would eventually become the American Southwest, they established the musical traditions that are expressed in these three dominant musical forms.

> It is impossible to identify one dominant Hispanic musical tradition, for the musical map of the Hispanic Southwest is a combination of many musical traditions.

MEXICAN MARIACHI

Mariachi music is the most recognizable and popular Mexican musical style. In fact, as experienced in the southwestern United States, mariachi music has become the national music of Mexico. A broader perspective, however, recognizes that as little as fifty years ago, mariachi music was no more popular than a dozen or so other regional Mexican musical styles. Many states in Mexico had their own regional music and the state of Jalisco, with its mariachi music, was one of these.

Mariachi music began to rise to prominence in the 1930s as Mexican folk music became more commercialized and part of popular

mass media entertainment. The professionalization of folk music and musicians was a result of the national exposure radio gave to regional folk musicians. Mariachi music soon separated itself from being one of many regional folk music styles to being recognized as a commercial success. Gaspar Vargas, who founded the famed Mariachi Vargas de Tecalitlán, and his son Silvestre were two mariachi musicians who brought the music of Jalisco to the forefront of Mexican culture. By the 1930s and 1940s mariachi music had moved beyond just being one of many regional music styles and was becoming the

musical style representing Mexico as a whole.

There are several theories about the origin of the word "mariachi." The word "maria" is at the heart of the word "mariachi," and one theory cites the origin of the word to be in the Catholic veneration of the Blessed Virgin Mary. However, this theory has little support in the academic world beyond a recognition of the coincidental similarity of the words. A second and widely believed popular legend about the word is that it is derived from the French word for marriage, *mariage*. It was common practice during the French occupation of Mexico under Maximilian for the French to hire Mexican bands, including many Jalisco folk musicians, to play at social events, especially their weddings. According to this theory, the Spanish soon adapted the French word *mariage* into the term mariachi. The French phrase *c'est un mariage* (it is a wedding) became the Spanish phrase *es un mariachi* (it is a mariachi). This theory, however, does not recognize the great resentment the Mexicans had for the establishment of French culture, which weakens the likelihood of this explanation.

Steven Pearlman, in "Mariachi Music in Los Angeles," presents a third theory that has growing academic support. This theory gives the word an indigenous origin from the Nahautl language of the Coca, a native group from the area of Cocula, near Guadalajara, in what is now southern Jalisco. The supporters of this theory see the origins of the mariachi in indigenous music, which, as in so many other aspects of the merging of native and Spanish cultural elements in Mexico, later adopted and evolved the traits of Spanish culture, in this instance Spanish musical culture. Further support for this theory is the occurrence of the word *"mariachitos,"* which is used to describe modern indigenous performers who are Nahautl speakers in a region close to Jalisco.

Dr. Brenda Romero, ethnomusicologist at the University of Colorado, presents another origin of the word mariachi. She cites Juan Guillermo Contreras, curator of the Museum of Musical Instruments in Mexico City, in describing "mariachi" as the name of a wood in southern Mexico. Mexican Indians used this wood to make stringed musical instruments, and the musical ensembles who used these wooden instruments became identified as "mariachi."

The modern mariachi group consists of violins, the *vihuela* (a small rounded-back, five-string guitar), a *guitarrón* (a six-string bass guitar), the regular six-string guitar and, of course, the trumpet. The trumpet is the most recent instrument to join the mariachi sound, but it has quickly become a dominant part of mariachi music. The size of mariachi groups can vary from as few as four musicians to as many as eight. One of the most identifying aspects of a mariachi group is their *traje de charro* outfits, adopted from the *charro*, or rural landowner-horseman in Jalisco: wide sombrero, boots and silver-plated decoration on the jackets and pants.

Traditional mariachi music consisted of *sones* and *jarabes*. The musical repertoire of the modern mariachi has expanded to include *rancheras*, *corridos* and other popular Mexican musical styles.

Mariachi music has become so widespread throughout Hispanic culture that it can be heard at weddings, birthdays, political functions and community celebrations. Mariachi music's great popularity is even evidenced in the mariachi Mass, which is becoming a common event at southwestern Catholic churches with large Mexican congregations.

Mariachi music has become so widespread throughout Hispanic culture that it can be heard at weddings, birthdays, political functions and community celebrations.

NORTHERN NEW MEXICAN AND SOUTHERN COLORADAN SPANISH COLONIAL MUSIC

The Hispanic people of northern New Mexico and southern Colorado have retained aspects of Spanish colonial culture longer than others in the Hispanic Southwest. It is the one area of the region in which people still proudly refer to themselves as "Spanish."

The first Spanish settlement in the northern reaches of New Spain was in 1598, under the leadership of Don Juan de Oñate. Soon after his expedition came clergy and military, further settling the northern frontier of New Spain. In 1610 Santa Fe was established as the administrative outpost of this area.

These communities were far from the centers of culture, population and political power of New Spain, which were 1,000 miles to the south across a vast and barren frontier. This geographical isolation produced an exemplary self-reliance in the Hispanic people of these early southwestern villages. One aspect of this self-reliance was the development of independent artistic traditions. Left to themselves for generations, these people sustained the original Spanish culture of the first settlers. Their musical traditions especially continued to reflect their Spanish colonial heritage. To this day it is common to find centuries-old Spanish *romances* and the Spanish colonial *entriega de novios* existing along with a Mexican *corrido*.

The primary instruments of this area's Spanish colonial music are the violin and guitar, which were imported to Mexico and the Southwest from Spain. Musical duos will have the violin playing the melody line and the guitar playing the bass or rhythm line, and it is traditional to have one or both of the musicians sing as they play such Spanish colonial favorites as *romances*, *rancheras* and *valses*.

A particularly unique song to this area is the *alabado*. A religious hymn, the *alabado* was sung by the religious brotherhood of *Los Hermanos*, or *Penitentes*. The songs resemble the chanting of the plainsong, or Gregorian chants of the Medieval church. Sung in unison, *alabados* had simple accompaniment, usually the *pito* (reed flute) or *matraca* (rattle). They were deeply religious songs and helped the Hispanic people of this area maintain their Spanish Catholic religious practices, as visits from the clergy to this distant and isolated area were infrequent.

Conjunto emerged as a dominant form of music in the region during the early part of the twentieth century.

TEXAN-MEXICAN *CONJUNTO*

Conjunto, or as it is also known, *norteño*, music is very popular among the Hispanic people of Texas. Its joyful, polka-dance rhythms and bright accordion sound are its primary musical characteristics. Throughout southern Texas one hears this most identifiable sound at family and community celebrations.

Conjunto emerged as a dominant form of music in the region during the early part of the twentieth century. During the last quarter of the nineteenth century, the violin was the primary instrument for dance bands. In the 1860s, however, German immigrants introduced a new instrument, the accordion, into Mexican-Texan culture. In addition to the accordion, German musicians popularized dances such as the polka and the schottische. Bands that played this type of music were called *conjunto norteño*. *Conjunto* means "ensemble" when referring to musical groups, and *norteño* refers

to the northern parts of Mexico as the source of the music. By the end of the nineteenth century, *conjunto* bands were popular and in demand at weddings and other Mexican-Texan celebrations.

One theory about the source of this German influence on Mexican music is that German settlers in and around central Texas (San Antonio specifically) were the musicians who influenced the music of the Rio Grande Valley. Manuel Peña, in his book *The Texas-Mexican Conjunto*, however, presents a better case by arguing that German brewery workers in Monterrey, Mexico, were the musicians who introduced the accordion and the polka to northern Mexico around the 1860s. He supports his argument by describing the strong commercial link that existed between Monterrey and Mexican Texas up until the 1920s. Another point he makes is that the path of cultural influence historically was from south to north, from Mexico to the American Southwest. It is this cultural influence from northern Mexico, specifically Monterrey, and *el norte*, Mexican Texas, that resulted in the development of what is now known as *conjunto* music.

The commercialization of northern Mexican music in the 1920s and 1930s resulted in the popularization of *conjunto* music in *tejano*, or Mexican Texas, culture. The godfather of *conjunto* music, accordionist Narciso Martínez, began to record during this time and greatly influenced the acceptance of *conjunto* music by the *tejano* working class. During this time, the instruments of early *conjunto* music were the accordion, the twelve-string *bajo sexto* and the *tololoche*, or stand-up string bass.

From the 1920s to the 1960s *conjunto* music became more established

in *tejano* culture. The instrumentation evolved to include drum sets and the electric bass. In addition, its repertoire expanded to include many popular Mexican song types, while the central musical characteristic of *conjunto* music continued to be its dance-oriented polka rhythm.

Today, *conjunto* music is an established part of *tejano* culture. On the radio, in dance halls, at family celebrations and at community events it is common to find a *conjunto* band entertaining dancing crowds. Successful bands of all types include *conjunto* music as part of their repertoire. While hard to find, the notable film *Chulas Fronteras* is a

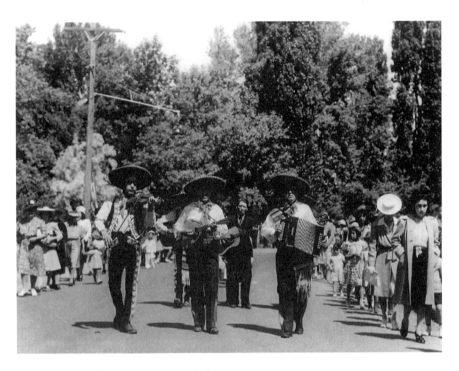

remarkable documentary of the importance of *conjunto* music in *tejano* culture. Modern musicians including the Mexican *Tigres del Norte*, the legendary accordionist Flaco Jiménez and the Texas Tornados with Freddy Fender continue to infuse creative energy into *conjunto* music and truly make it a music of the *tejano* people.

Figure 15.2. Corpus Christi procession, Santa Fe, New Mexico, 1942.

LAS MAÑANITAS

Las Mañanitas (a morning song) is a *ranchera* with a beautiful and romantic Mexican tradition. The romantic tradition has it sung at the beginning of daybreak, when young men serenade their girlfriends as an expression of love and admiration. The singer can be accompanied by his friends or musicians to add harmonies to the occasion.

Another popular tradition is for *Las Mañanitas* to be sung on special days, saint's days and especially birthdays. *Las Mañanitas* is one of the most well-known songs in the Hispanic Southwest. It is sung at birthdays, parties and family reunions. Many varieties of verses exist, and often communities and families have their own versions.

LAS MAÑANITAS
Transcribed by Brenda Romero

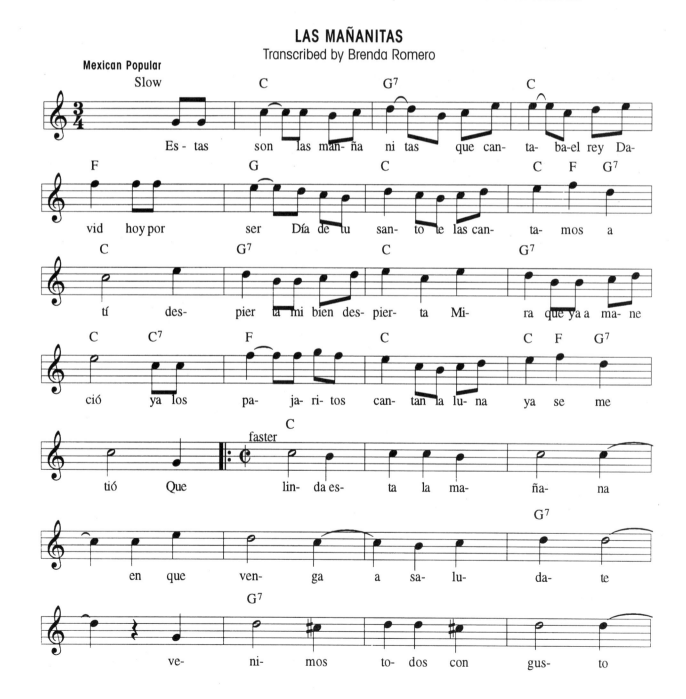

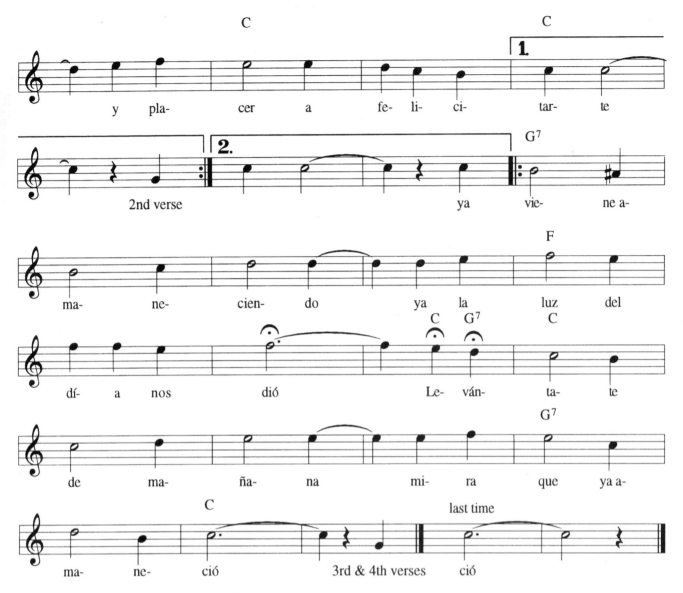

LAS MAÑANITAS

Estas son la mañanitas	These are the morning songs	
Que cantaba el rey David.	That King David sang.	
Hoy por ser día de tu santo	Since today is your birthday (saint's day)	
Te las cantamos a tí.	We sing them to you.	

Despierta, mi bien, despierta, — Awaken, my love, awaken,
Mira que ya amaneció, — See that the day has dawned,
Ya los pajarillos cantan, — The little birds are singing
La luna ya se metió. — And the moon is gone.

Qué linda está la mañana — How beautiful is the morning
En que vengo a saludarte — When I come to greet you.
Venimos todos con gusto — We all come with joy
Y placer a felicitarte. — And pleasure to congratulate you.

Ya viene amaneciendo,
Ya la luz del día nos dio.
Levántate de mañana,
Mira que ya amaneció.

El dia que tu naciste
Nacieron todas las flores,
Y en la pila del bautizmo
Cantaron las ruiseñores.

De las estrellas del cielo
Tengo que bajarte dos.
Una para saludarte,
Y otra para decirte adiós.

Here comes the dawn,
The light of day is here.
Get up in the morning,
And see what has dawned.

The day you were born
All the flowers were born,
At your baptism
The nightingales sang.

Of the stars in heaven
I want to give you two.
One to greet you,
And the other to tell you good-bye.

DE COLORES

De Colores, a traditional Mexican *ranchera* sung on special occasions and celebrations, has its origins in sixteenth-century Spain. Kurt Schindler, in *Folk Music and Poetry of Spain and Portugal*, presents a short transcription of the song he collected in the Spanish province of Soria in 1928, which reveals the song's Spanish rural origins. In the United States, it is a Chicano favorite and is well known as the anthem of the United Farm Workers of America, the farmworkers' union founded by César Chavez.

DE COLORES

Traditional
Arranged by Jerry Silverman

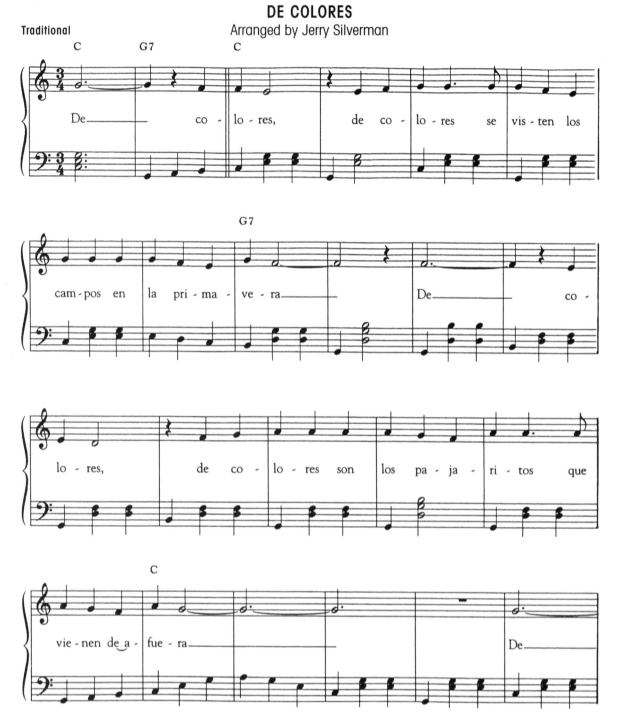

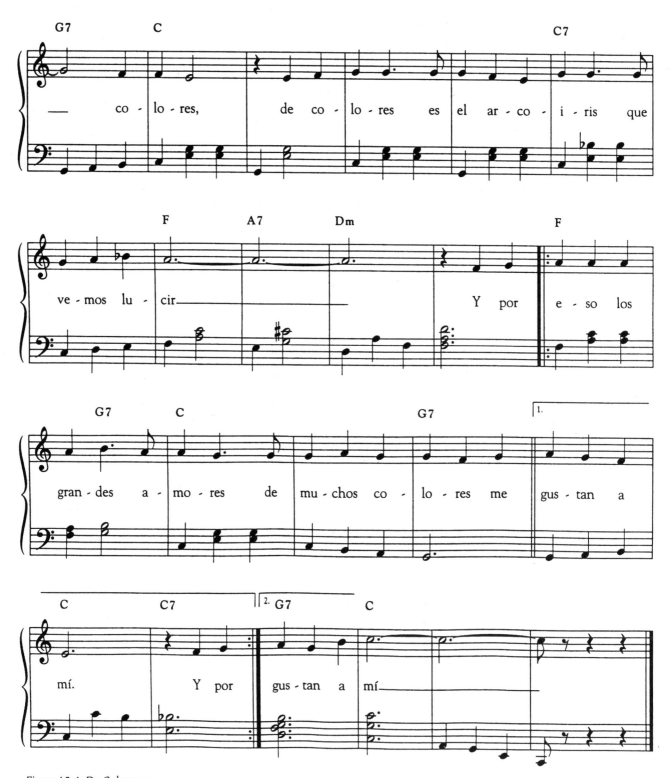

Figure 15.4. De Colores, *a traditional Mexican ranchera.*

DE COLORES

De colores,
de colores se visten los campos
en la primavera.

De colores,
de colores son los pajaritos
que vienen
de fuena.
De colores,
de colores es al arcoiris
que vemos
lucir.

Coro
Y por eso los grandes amores
de muchos colores me gustan
a mi. (Cantar dos veces.)

Canta el gallo,
canta el gallo con el quire, quire.
La gallina,
La gallina con el cara,
cara, cara, cara.
Los pollitos,
Los pollitos con el pío, pío, pío, pí.

Coro
Y por eso ...

In bright colors,
in bright colors the fields
dress up in the
beautiful springtime.
In bright colors,
In bright colors are all the
little birds
that come from far off.
In bright colors,
in bright colors is the rainbow
we see
shining clearly.

Chorus
And that's why the many
colored loves, they are pleasing
to me. (Sing twice.)

The rooster sings,
the rooster singing quiri, quiri.
The hen,
the hen sings cara, cara,
cara, cara.
The baby chicks,
the baby chicks sing pío, pío, pío,
pí.

Chorus
And that's why ...

16

Dance

The dances of the Hispanic Southwest, as with so many other cultural practices, have their roots in the dances of the indigenous people of Mexico and the Spanish colonialists who settled the New World.

One of the most immediate and most enjoyable experiences in Hispanic culture are the movements and rhythms of its dances. Just as with music, the people of the Hispanic Southwest have an old and joyous tradition of dance as part of their living heritage. There is not a wedding, a *quinceañera* (a fifteenth birthday celebration) or a community celebration without that exuberant moment when families and individuals express their great shared happiness by dancing. Sandra Myres, in W*estering Women and the Frontier Experience, 1800–1915*, describes the extent of dance as a popular activity in the southwestern Hispanic culture.

> Parties, fiestas, and dances or *biales* were also popular on the Hispanic frontiers. Like other pioneer entertainments, these were usually community affairs in which everyone participated and which often lasted for several days. Any occasion—a wedding, a baptism, a major saint's day—provided an excuse for a fiesta and dance. So frequent were such occasions among the rancheros of Southern California that one woman remarked that "dancing, music, religion and amiability were the orthodox occupations" of the area. (1982, p. 176)

The dances can range from the free-spirited modern movements of the young to the traditional dances of the elder generation. The dances can be as spontaneous as family members joining in a wedding march, as informal as observing Aztec *conchero* dancers at a community fair or as formal as a professional dance troupe presenting an evening concert of Mexican dance. But no matter what the style, the meaning is the same—dance is a central expression of joy and pride for Hispanic people throughout the Southwest.

The dances of the Hispanic Southwest, as with so many other cultural practices, have their roots in the dances of the indigenous people of Mexico and the Spanish colonialists who settled the New World. This discussion of Hispanic dance will examine these roots and present the origins of the dances enjoyed throughout the Hispanic Southwest today. It will also describe several representative dances from both Mexican and Southwest Hispanic traditions. The purpose of this chapter is to introduce the reader to the background and traditions of the dances as well as to place the dances in their proper social context. Its educational purpose is to give the reader an appreciation of the history of traditional dances and an ability to

recognize and understand several of the primary dances that might be encountered in the Hispanic Southwest. Any occasion providing the opportunity to witness or participate in any of the described dances will give the reader a heartfelt and fun experience of the beauty of Mexican and southwestern Hispanic dance.

AZTEC, SPANISH AND MEXICAN ROOTS

The Aztecs of ancient Mexico had a highly developed ritual and ceremonial life. Their calendar was marked by festivals called *veintenas,* which were festivals in honor of their gods. Singing, music and dance were important parts of their ceremonial life. The demands of a strict and rigorous religious cosmology dictated that all aspects of the people's lives reflect their profound religious practices, and dance was one aspect of this ceremonial life that served the Aztecs in both their religious and secular practices.

The Aztecs had houses of song and dance called *cuicalli* near their temples. These houses were schools for students who began their dance studies at the age of twelve. Both men and women danced in Aztec ceremonies, usually separately. Large-scale dances were performed in the temples or main *plazas* for major religious observances; smaller dances were for private occasions for nobles—a wedding, for example. Their simple instruments were derived from the natural world: the drum, the clay ocarina, the gourd rattle, the wooden flute, the scored bone scraped with a stick.

The most common Aztec dances were both religious and military in function. As a warrior society, the Aztecs used dance to celebrate their warriors, to prepare warriors for battle and to fortify the spirits of young recruits. The strong percussive beat of the drum was a perfect sound for the dances of this warrior society.

In contrast to this warrior aspect of their society, the Aztecs also had a deep appreciation of beauty and the natural world. Many of their festivals were dedicated to the beautiful flowers and feathers that decorated their world. Their dances to Xochiquetzal, the Flower Goddess, and Macuilxochitl, also known as Five Flowers, the god of music, were performed at two of their more popular festivals. As an agricultural society, they also had dances to the gods to ensure a good harvest and give thanks for a bountiful year.

The Spanish had a profound effect on the religious and ceremonial life of Aztec society. Of course, the primary goal of the Spanish was to destroy all cultural aspects of Aztec society and supplant it with Hispanic religious and secular practices. While they were successful in this effort in almost all areas of Aztec life, the Spanish recognized that the ceremonial and dance traditions of the Aztecs would be next to impossible to totally extinguish. The Spanish therefore took the tactic of encouraging music, dance and *fiestas* among the Aztec population, but with the substitution of Christian symbols and the Christian God for pagan motifs and gods.

The Spanish also introduced European musical instruments, especially the guitar and other stringed instruments. In time, the guitar became a popular folk instrument, and a *mestizo* folk music evolved containing elements of both Aztec and Spanish musical traditions. Accompanying this musical evolution was a similar transformation in dance, for the Spanish also brought to the

> The most common Aztec dances were both religious and military in function.

New World the dances of Spain and Europe. By the 1800s both the waltz and polka had became very popular in Mexican society.

In time, Mexican dance traditions became a rich mix of dances reflecting both its indigenous and Spanish roots. Dancers today refer to the traditional folk dances of Mexico with the generic term *folklórico*. This term has come to represent the dances of Mexico that are the result of the centuries of evolution of dance as both a popular and traditional art form in Mexican and southwestern Hispanic culture.

LOS CONCHEROS

Los conchero dancers are the most dramatically and brightly costumed dancers of the *folklórico* tradition. *Conchero* dances are ancient Aztec dances that reflect the dancers' pride in their Aztec heritage. An important purpose of modern *conchero* dancers is to keep alive the Aztec dance traditions. An additional purpose is to educate communities about the wisdom of the traditional ceremonies and to maintain a spiritual life based on ancient practices.

In Mexico the dancers are also called *Chichimecas*, after a tribe from the region of Queretaro. After the conquest, the *Chichimecas* originated the dances that are today the heritage of the *conchero* dancers. The dances are characterized by theatrically dramatic costumes, percussive and rhythmic drum beats and fancy footwork.

Conchero dances have a ritual and religious symbolism as part of their purpose. Many dancers consider their dances to be sacred prayers, much as the Aztecs used dance to honor their gods. The dance ceremony begins with a blessing to the four corners of the Earth with the *incensario* burning *copal*. The *incensario* remains at the center of the dance with the pungent fumes of the *copal* enveloping the dancers as they dance. Usually the dances follow a circular pattern on the floor.

Another aspect of the *conchero* tradition is its embracing of the family as an important part of its dance practices. It is common to see children dancing along with the adults in *conchero* dances. Often children too young to dance will be sitting at the feet of the drummer, mesmerized by the sound of the drums, or they will be dressed in miniature costumes wandering through the dancers.

One of the most recognizable aspects of the *conchero* costume is the immense feathered headdresses worn by the dancers. The dancers pattern their costumes after ancient native dress and decorate them with long colored feathers, bright fabric, beads, mirrors and shells. The shells around the knees and ankles serve as rhythm instruments complementing the persistent percussive sound of the drums.

Groupo Tlaloc is a traditional Chicano/Mexicano/Indio cultural dance group comprising adults and children dedicated to the preservation, education and promotion of the indigenous dances of their ancestors, the Mexica, for future

One of the most recognizable aspects of the *conchero* costume is the immense feathered headdresses worn by the dancers.

Figure 16.1. Groupo Tlaloc, Denver, Colorado.

generations. The group was established in 1980 by a handful of college students and Chicano activists seeking to rediscover their Mexican-Indian heritage. Their commitment is to the spiritual teaching of the dances and the cultural identity fostered by their performance. Their other goals are to provide positive alternatives for youth activity and to demonstrate the necessity of retaining cultural traditions.

LA DANZA DEL VENADO

One of the most famous Mexican dances reflecting its indigenous origins is *la Danza del Venado*, the Deer Dance of the Yaqui Tribe of northern Mexico. *La Danza del Venado* is one of the best preserved native dances in Mexico. The dance depicts the chase, hunt and capture of a wild animal, in this instance a deer. It is an example of the native use of dance to address the people's experiences in the natural world. For the Yaqui, the dance is a ritual sacred dance.

In *la Danza del Venado*, the dancer wears only a loincloth. He carries two gourd rattles in his hands and wears shells tied around his legs and ankles. The most identifying element of the costume—and most famously recognized—is the stuffed deer head with antlers the dancer wears on top of his head, very much like a headdress.

The music for the dance is a high-pitched flute, accompanied by the beating of a small drum. A bone rasp completes the sound of the dance. Of course, the dancer contributes his owns rhythmic emphasis to the dance with his gourd rattles and shell leggings. The music is a haunting melody that gains in intensity as the chase quickens, and the hunt reaches its inevitable climax with the capture and killing of the deer.

The dance begins by portraying the grace of the deer in the natural world. It then continues to the chase of the deer by hunters. As the hunters close in on the deer, the music quickens and builds in intensity. Finally, with a climatic crescendo of percussive and rhythmic accent, the deer is captured and dies.

The dance is an opportunity for strong, virtuoso dancing, with its opening graceful movements, following with its quick, nervous darts and desperate leaps about the stage, ending with a poignant stage death that rivals the Dying Swan of classical ballet in dramatic intensity. The dance ends with a melancholy recognition of the triumph of humans over nature and the lament that such a noble animal as the deer has to die at our hands.

Figure 16.2. The Deer Dancer.

LOS VIEJITOS

Los Viejitos is a comical dance from the state of Michoacán, especially in the villages around Lake Pátzcuaro in the southwestern region of Mexico. The title literally means "little old men," but the dance typically is performed by the agile and athletic young men in the village. The dance is an example of the hybrid nature of many Mexican dances: It appears to be of native origin because of its style and its common performance at village *fiestas*, but its use of *zapateado* steps is clearly Spanish derived.

Zapateado is a characteristic heel and foot rhythmic brushing and stamping of the feet in Mexican dances. The emphasis in *zapateado* is on the rhythmic sound of the feet during the dance. While *zapateado*'s similarity to Spanish flamenco suggests common origins, the two dance styles are very different in body carriage, musical style and footwork rhythms. The classic *zapateado* for *los Viejitos* dance is an alternating series of right-left-right-left-right-step rhythms.

The emphasis in *zapateado* is on the rhythmic sound of the feet during the dance.

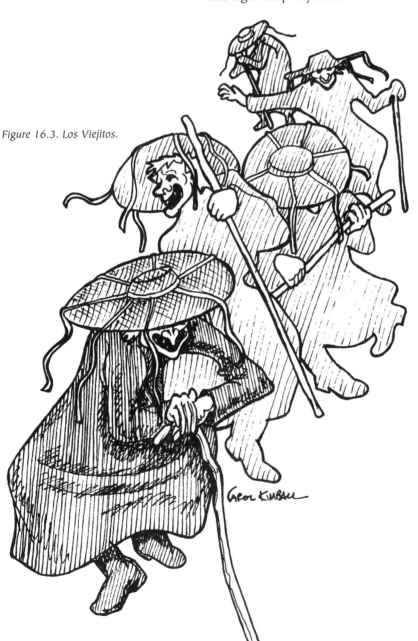

Figure 16.3. Los Viejitos.

The dance begins with the "old men" entering the stage, feeble and tottering on their canes. The tapping of the canes on the stage adds an additional rhythm to the dance. The beginning of the dance is punctuated by the leader tapping his cane at each dancer to see if he is ready to begin. After this start, the leader then taps his cane for the music to begin. The music is played on a guitar-like stringed instrument called a *jarana*.

During the dance the men remain hunched over their canes, but their steps are transformed into agile, athletic and startling step variations as youth temporarily returns to the old men. This comic transformation is the heart of the dance and it is the part audiences most anticipate and appreciate. At the end of the dance, the performers return to their weary and feeble condition and hobble off the stage.

The dancers' costumes add to the dance's comic portrayal. The dancers wear wide-brimmed palm hats with brightly colored ribbons attached to and streaming down from the brim. A white wig usually completes the headpiece. The dancers also wear a red handkerchief at the collar, a bright poncho, white peon pants and usually a Mexican blanket draped over the shoulders. They wear shoes with pronounced heels that are used to accent the sound of the *zapateado*.

The most identifying image of the dance are the masks. They have snaggle-toothed grins, rosy but wrinkled cheeks and a bright, cheery disposition. The masks complete the comic look of the costumes, enhancing the nature of the dance.

EL JARABE TAPATÍO

El Jarabe Tapatío, also known as the Mexican Hat Dance, is the best known and most popular of Mexican dances. Also recognized as the national dance of Mexico, it originated in Guadalajara, the capital city of the Mexican state of Jalisco. There are many different *jarabes*, but the word *tapatío* identifies this *jarabe* as being from Jalisco. *Tapatío* is the adjective used to describe dances as well as other parts of culture from Jalisco.

The *jarabe* is a generic name for a collection of popular dance forms. Mariachi musical groups typically play *jalisciense*, the *son* music from Jalisco, which forms the basis of traditional *mariachi* repertoire. The *son* is the musical form most often associated with *zapateado* dances.

The steps of *el Jarabe Tapatío* are the *zapateado* brushing and stamping of the heel and toe characteristic to many Mexican dances. The Mexican *jarabe* has been traced to the *seguidillas manchegas*, the step dances of the *La Mancha* region of southern Spain. There are over seventy *jarabe* steps and combinations, which vary in the dance according to the skill and talent of the dancer.

El Jarabe Tapatío has had an interesting history in Mexico. It was first danced in Mexico City in 1790, and the dance quickly became popular in general Mexican culture. In the early 1800s the viceroy, Don Felix Berenguer, banned the dance and music because of the perceived indecent words in the song. Another theory about the banning of the dance and song is that the Mexican government was attempting to repudiate anything Spanish in the country, as Mexico wanted to be an independent country. The court of Maximilian and Carlota revived *el Jarabe Tapatío* during the pe-

riod of the French occupation of Mexico, and the dance regained its popularity.

El Jarabe Tapatío represents the courtship of a young maiden by a gallant young man. The young man, the *charro*, a horseman from Jalisco, courts the maiden, the *china poblana*, a Chinese girl from Puebla, through the dance. At the beginning of the dance, the *charro* attempts to gain the attention of the *china poblana*, who is flirtatious and coquettish. In order to impress her with his love, the *charro* throws his hat on the floor between them and dances with his hands behind his back. In traditional versions of *el Jarabe Tapatío*, the *charro* holds his pistol behind his back as a gesture of respect for the *china poblana*. The two dance around the brim of the hat until the *china poblana* accepts his love by reaching down and putting on his hat. The two then joyously dance together facing the audience while a *diana* plays to end the dance. A *diana* is a triumphant musical flourish played at the end of *el Jarabe Tapatío*.

The costumes of *el Jarabe Tapatío* are beautiful in their splendor and folk style. The *charro* wears a riding costume consisting of tight-fitting trousers decorated with silver buttons or braiding down the sides of the legs. The costume also includes a short jacket that matches the pants and is also trimmed with silver

Figure 16.4. El Jarabe Tapatío.

El Jarabe Tapatío represents the courtship of a young maiden by a gallant young man.

buttons or braiding. The shirt is of embroidered silk, and a wide-brimmed hat, also decorated with silver or gold braiding, completes the costume along with boots and spurs. If a jacket is not worn, then a Saltillo *sarape,* a brightly woven blanket draped over the shoulder, is the final touch to the *charro* costume.

The costume for the *china poblana* consists of a white embroidered blouse and a full red skirt richly embroidered with sequins in designs of flowers and fanciful geometric patterns. She also wears a *rebozo,* a silk shawl worn by the majority of Mexican women. The *rebozo* is crossed around her waist, over her back and draped over her shoulders in front. Traditionally, the *china poblana* wears her hair in brightly ribboned braids down her back.

A charming legend exists about the origins of the *china poblana*

costume. In one version of this legend, a Chinese princess was brought to Acapulco as a slave. She was then sold to a wealthy family in Puebla, who adopted her as a daughter. She had a gentle disposition and became known for her virtue and charity. When she died, all the young women of Puebla wished to be like her and so they adopted her style of dress—a simple red dress, white blouse and *rebozo.* In her memory they named this style of dress after her: *China* for Chinese and *poblana* for Puebla.

As with all legends, there are scholars who dismiss the legend. Mela Sedillo, in *Mexican and New Mexican Folkdances,* refers to Andulucía and its Arabian influence as the origin of the *china poblana* costume. But the legend is much more engaging and is the popularly believed origin of the costume.

LOS MATACHINES

Los Matachines is one of the oldest and most unique dances in the Hispanic Southwest. It is unique in that folklorists and musicologists consider it both a dance and folk drama. Also, it is still performed throughout the Southwest and northern Mexico. The word "*matachine*" has several obscure meanings, one of which is "masked sword dance." *Los Matachines* performances can be found in New Mexico in both Hispanic communities and Native American pueblos. In northern and central Mexico, one of the traditional native ceremonial dances is *los Matlanchines,* a dance related to *los Matachines* of the Hispanic Southwest. As with all folklore, each community has its own variation of the dance, but they all share identifiable common characteristics.

The dance/drama traditionally was performed in association with the feast of the Virgin of Guadalupe

on December 12. In modern practice the dance is performed on other church holidays and community celebrations as well.

A performance of *los Matachines* is a dance/drama presenting the eternal battle between good and evil. It is descended from sixteenth- and seventeenth-century Spanish pageants and dramas that were used to teach Catholic ideology. Aurelio Espinosa, in *The Folklore of Spain in the American Southwest,* describes several of these Spanish plays that were dramatic representations of the battles between the Moors and the Christians. The Spanish brought these plays to the New World, and eventually the plays were well known throughout Spain and New Spain. In the New World the dance/drama evolved to contain two distinct elements: the *matachines* dance and a mock battle between the forces of good and evil.

A performance of *los Matachines* is a dance/drama presenting the eternal battle between good and evil.

Espinosa also describes a seventeenth-century Spanish dance of *los Matachines* that was a mock battle with musical accompaniment. It was performed during Carnival season and had a comic and burlesque quality to its performance. The shared elements with its New World versions are the dance of the *matachines* and the mock battle within the ceremonial dance. The Indio-Hispanic version performed in New Mexico appears to be a variant descendant of the Spanish dance with native elements incorporated into it.

Arthur Campa, in *Hispanic Culture in the Southwest*, relates *los Matachines* to the sword dances of the Middle Ages, known as Morris Dances in England and *Danzas de Espades* (Sword Dances) or *Moros y Christianos* in Spain. Campa further describes the dance's evolution in the New World:

> It is likely that the dance was further dramatized in Mexico by the addition of such characters as *el Monarca*, representing Moctezuma, to give it significance to the Aztecs, and that the allegorical characters *el Abuelo*, *el Torito*, and *la Malinche* were representatives of the forces of evil against virtue, as in so many religious folk plays. (1979, p. 231)

In the New World, the Spanish Franciscan missionaries introduced and developed *los Matachines* in both Hispanic and native communities, retaining its primarily Spanish elements. The dance served one of the missionaries' purposes, converting indigenous populations to Christianity, by telling the story of the Spanish *conquistadores'* quest to bring Christian beliefs to the Aztec people.

The dance exists with enough variations as to include such diverse interpretations as the conversion of the Aztecs to Christianity and the conquest legends of the Aztecs and Spanish. The dance can also represent a dedication to the Virgin of Guadalupe and the celebration of the birth of Christ during the Christmas season.

The traditional version of *los Matachines* consists of eight to ten dance/drama sequences. The number of dancers can vary from six couples or more as determined by local practice and needs. Usually twelve dancers represent the twelve apostles. The dance begins with the entry of *los Matachines* dancers. The leader is *el Monarca*, representing Moctezuma, the Aztec ruler who is Christianized during the dance. The *Matachine*

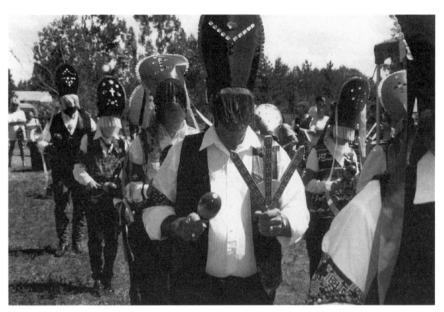

dancers follow, representing the arrival of the Spanish in the New World. In their right hands they carry *guajes*, rattles, and in their left a *palma*, a three-pronged fan that represents the Holy Trinity.

Los Matachines includes *la Malinche*, the Indian maiden who was translator and consort to

In the New World, the Spanish Franciscan missionaries introduced and developed *los Matachines* in both Hispanic and native communities, retaining its primarily Spanish elements.

Figure 16.5. Matachine *dancers wearing the* cupils *and carrying the* guajes *and* palmas.

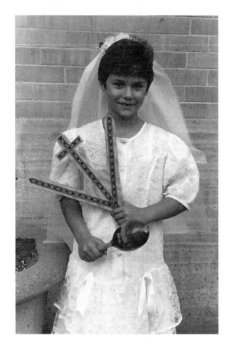

Figure 16.6. A young girl plays la Malinche. *Dressed in a communion dress, she represents the first convert to Christianity.*

The dance steps of *los Matachines* are those common to folk and indigenous dance: kicks, do-si-does, *pas de basques,* polka steps, hops, skips and runs.

Cortés, transformed in *los Matachines* to the symbol of innocence and purity. The part is usually played by a young girl representing the first convert to Christianity, and her dance symbolizes the arrival of Christianity in the New World.

The dance/drama's Spanish origins are further reflected in a mock bull fight between the grandfather, *el Abuelo,* and the bull, *el Toro,* over the purity of *la Malinche. El Abuelo* serves as the protector of *la Malinche* and *el Toro* represents temptation and evil. For a portion of the dance *el Abuelo* and *el Toro* play comic characters by playing pranks on the spectators. Some versions have the grandmother, *la Abuela,* joining *el Abuelo* in the battle of good over evil.

The primary dramatic event is the temptation of *la Malinche* by *el Toro,* and the battle, defeat and killing of *el Toro* by *el Abuelo.* At the end of the dance *la Malinche* retains her purity and sets an example for *el Monarca's* conversion to Christianity.

The dance steps of *los Matachines* are those common to folk and indigenous dance: kicks, do-si-does, *pas de basques,* polka steps, hops, skips and runs. The music in tradi-tional Hispanic productions is played on guitar and violin. In Native American pueblo ceremonies the drum is added.

The costumes of the dancers are especially unique and theatrical. Most notable are the masked headdresses worn by the dancers. The masked headdress is called a *cupil* and resembles a bishop's miter at the top. The masks cover the faces of the dancers and are decorated with beads, jewels and ribbons topped with crown-like headdresses. A 6-inch fringe of beads or fabric hangs in front of the headdress, covering the face of the dancer. The dancer's costumes are bright and festive, also heavily decorated with ribbons, beads and jewels. Long drapings of ribbons or fabric, called *listones,* hang from the back of the headdress to the knees. Another unique part is the silk bandannas worn across the face covering the mouth in the style of the Wild West bandit. The girl playing *la Malinche* wears a white communion dress with a lace veil on her head.

As in all folk dance and drama, the messages of *los Matachines* are

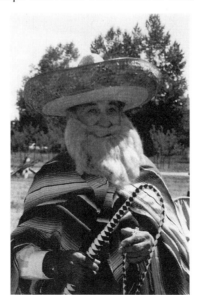

Figure 16.7. El Abuelo.

Figure 16.8. El Toro.

cloaked in the symbolism of its various elements. *Los Matachines* remains a wonderful example of how the Hispanic people of the Southwest use their cultural traditions to maintain and preserve their history and beliefs.

The pictures presented here are of *Los Matachines de Pueblo*. This *Matachine* dance company, from Pueblo, Colorado, is under the direction of José L. Baca and Mario Medina. Señor Baca is a master folk artist of *los Matachines* tradi-tions. The directors' dedication is to keep the dance alive in Hispanic culture and to train future generations to carry on the tradition. In addition to ceremonial performances of *los Matachines*, the dance company is active in the educational aspects of teaching communities and audiences about the symbolism of this ancient dance ritual and its importance as part of the preservation of the culture and beliefs of the people of the Hispanic Southwest.

The Hispanic dances of southern Colorado and northern New Mexico especially reflect the area's Spanish heritage.

LOS BAILES DE LOS MANITOS

The land of southern Colorado and northern New Mexico was the first area in the northern frontiers of New Spain colonized by the Spanish when they began their fabled explorations for gold, honor and glory in the sixteenth century. For the following centuries, this area, because of its geographic and cultural isolation, retained its Spanish colonial traditions more than other areas of the Hispanic Southwest. The term *mani-to* describes the descendants of the Spanish colonials of southern Colorado and northern New Mexico. *Manito* is the diminutive form of the Spanish word for brother, *hermano*, and it expresses a tender caring and warm brotherhood.

Manito culture has maintained many aspects of Spanish colonial society. The Hispanic dances of southern Colorado and northern New Mexico especially reflect the area's Spanish heritage. The folk dances of this area are from the Spanish colonial period and are mostly of European origin. The dances evolved from the European court dances brought to Mexico during the brief rule of Emperor Maximilian. In social gatherings called *"bailes,"* it is common to find the polka, the schottische, the waltz and the *varsoviana*. Marta Weigle and Peter White, in *The Lore of New Mexico*, describe the origins of these dances in New Mexico:

> It is generally believed that these Eastern and Western European dance forms were carried across the European continent by Napoleon's nomadic troops to Spain. Then the dances were brought to Mexico, adopted and later spurned by the aristocracy, and finally survived and prospered in the more remote provinces. (1988, p. 191)

The *varsoviana*, also known as the Spanish two-step, is a dance introduced to Mexico by Polish nobility during the time of Emperor Maximilian. It is similar to the American "Put your little foot in, put your little foot out" folk dance. *El Chote* is the New Mexican version of the American barn dance, the schottische. *La Cuna* (the cradle) is a dance of four couples similar to a square dance in which a cradle is formed by the linked and rocking arm movements of the dancers.

The *Valse de la Escoba* (the waltz of the broom) is another popular

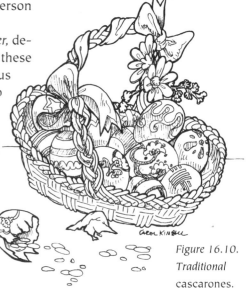

dance game with similarities to musical chairs. In this version of the game, the dancers use a broom to determine who is leftover after the music stops.

The *marcha* is the traditional introductory dance at wedding *bailes*. It follows the pattern of a march through the dance hall, ending in the dancers forming an arch with their arms. The dancers and the bride and groom march under the arch and they then begin the wedding dancing. Chapter 5 includes the music and dance instructions for the *marcha*.

An especially enjoyable dance is *el Baile de Cascarones* in which the dancers break confetti-filled eggshells over each other's heads during the dance. *Cascarones* are another Mexican tradition appearing in the customs of the Hispanic Southwest.

To prepare for the dance, the dancers drained eggs through small pinholes, filling the shells with cologne-sprinkled confetti. The dancers then painted the eggshells with both simple and artistic designs. At the *baile*, the dancers would break the shells over the head of the person they wanted to dance with.

V. Newall, in *An Egg at Easter*, describes the Mexican version of these eggs, suggests their indigenous origins and compares them to the *piñata*.

> In Mexico, empty egg-shells are an important feature of Carnival. These *cascarones*, whether coloured or gilded ... are filled with scraps of coloured paper, ashes or eau-de-Cologne, and broken against heads of woman and children.

Sometimes sweets called *colacion* are mixed up with the paper. These are sold in all the markets. Women bring them in great baskets and sit, colouring the shells with paint daubed on from rags, or sometimes just from their fingers. Elaborate creations, covered with tin-foil, wax or coloured tissue, are more costly and presented as gifts to friends *Cascarones* appear at weddings, and indeed at any major festival. They resemble miniature versions of the great clay pot, traditionally broken at Christmas, emitting a stream of gifts and sweets. (1971, p. 189)

In New Mexico, Hispanics save eggshells during the Lenten season. As religious Catholics often give up meat during Lent, the period of sacrifice before Easter, eggs are a meat substitute providing an abundance of available shells. By carefully blowing the egg out of the shell, people are able to preserve the shell for decoration. The eggshells are decorated and used at dances after Lent is over.

Figure 16.9. Valse de la escoba, waltz of the broom.

Figure 16.10. Traditional cascarones.

Sandra Myres offers another colorful description of *el Baile de Cascarones:*

> A favorite custom at Mexican-American festivals and dances was the breaking of c*ascarones*, eggs filled with gold and silver confetti and cologne or different colored liquids. Often, as a young woman Mexican woman remembered, "the ladies' dresses and faces suffered, but we all took it in good part." (1982, p. 176)

Dr. Lorenzo Trujillo describes the symbolism of one of the best examples of Spanish tradition surviving in the *manito* popular traditions of Colorado and New Mexico.

> The *valse de los paños* means the waltz of the scarves. During the dark ages and early renaissance in Spain it was forbidden for physical contact to occur between a man and a woman. Therefore an acceptable way for a man to dance with a woman without touching her was to have a material scarf bond the dancers together. ...The scarf of a woman was symbolic of her honor. (1992, p. 9)

During the *Valse de los Paños* a man and two women dance, with the man between the two women. One man and one woman can also dance the *valse*—instead of holding hands, the dancers hold scarves between them. The dance consists of waltz steps and arches formed by the dancers' linked arms and the scarves under which other dancers waltz. The dance is visually beautiful and graceful and is a reminder of the passed beauty of Spanish colonial culture.

A cassette recording of music for the Spanish colonial dances described in this section is available from the Southwest Colonial Musicians, 1556 South Van Dyke Way, Lakewood, CO 80228.

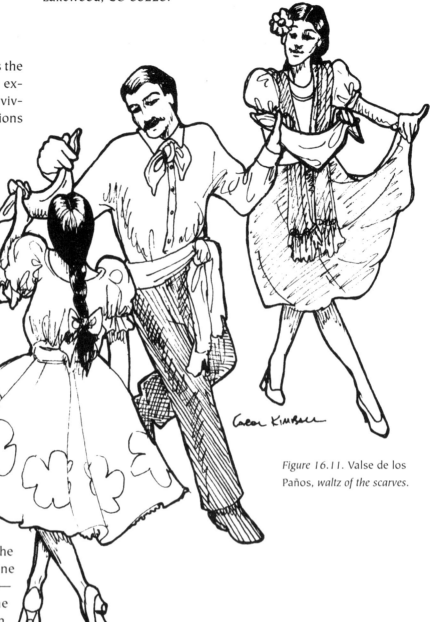

Figure 16.11. Valse de los Paños, *waltz of the scarves.*

ACTIVITY—*EL VALSE DE LA ESCOBA:* WALTZ OF THE BROOM

This is a group folk dance similar to musical chairs. Any number can participate, but there must be one extra person who dances with the broom. Traditionally, the extra person is a male and the men choose partners, but the dance is just as enjoyable with the extra person being female and the women choosing partners.

EL VALS DE LA ESCOBA
Transcribed by Eunice Hauskins

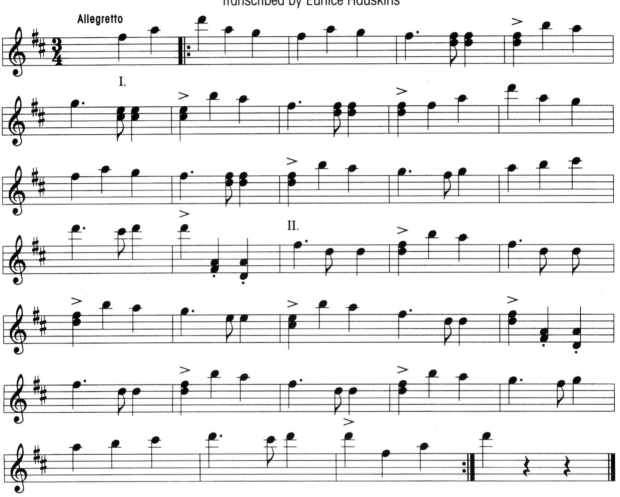

Figure 16.12. *Music for* el Valse de la Escoba.

Instructions

1. Dancers line up in two lines, males on one side, females on the other, facing each other. The lines are several feet apart to allow room for the broom dancer between them.

2. The extra person dances with the broom between the two lines. Music I plays while the broom dancer waltzes alone with the broom.

3. The music stops suddenly and the broom dancer drops the broom and grabs a partner.

4. All other dancers also grab partners.

5. The musicians play Music II as the new partners dance the waltz.

6. The leftover person picks up the broom and the dance sequence begins again.

ACTIVITY—*EL VALSE DE LOS PAÑOS:* WALTZ OF THE SCARVES

This dance traditionally is done by trios consisting of one man and two women. The man holds two scarves, one in each hand, and stands between the two women. The two women hold on to the scarves in the man's hands, one on each side of the man. They all face the same direction.

At the beginning they all dance a simple waltz step together. They weave under each other's arms to face a new direction and begin the sequence anew. The dance consists of repeating this simple pattern.

The dancers hold on to the scarves throughout the dance.

VALSE DE LOS PAÑOS

Traditional Arranged by Lorenzo Trujillo, Jenny Baca and Brenda Romero

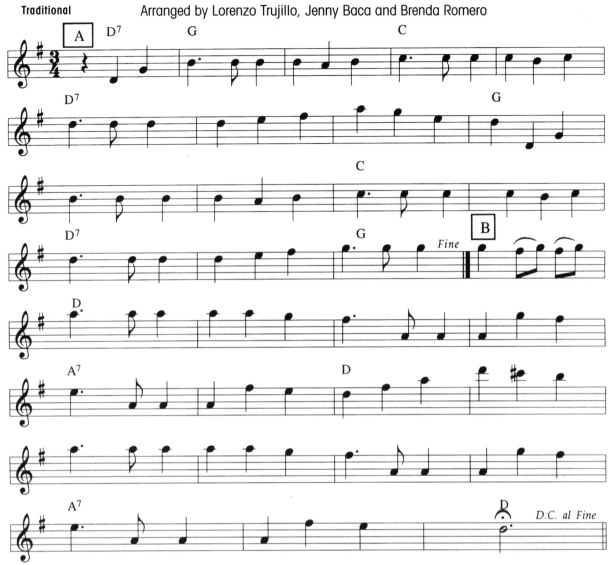

Figure 16.13. Music for el Valse de los Paños.

Instructions

1. The trio dances forward for four measures.

2. They then dance back for four measures. The step is a simple waltz step counted 1-2-3, 1-2-3 and stepped off in a left-right-left, right-left-right waltz pattern. In each step pattern, the steps are to the side with the middle step going behind the first step of the pattern.

3. The dancers hold their arms up high.

4. The woman on the left side of the man crosses in front of the man and dances under the arch formed by the linked and raised arms of the man and the woman on the right side of the man.

5. As the woman on the left is dancing under the arch of the man and the woman on the right, the woman on the right continues to cross over the woman on the left, in front of the man, and then dances in a circle around the back of the man until she ends up back on the right side of the man.

6. During this cross-step the dancers never let go of the scarves.

7. After the dancers have completed their turns, the trio ends up facing a new direction and the dance begins again with the first sequence.

This spelling of the word *valse* represents a linguistic anachronism typical of Middle Age Spanish. It also appears in the Spanish of New Mexico. The "e" at the end of the word is called an "*e paragójica*," and it was a linguistic device used to add another syllable to a word.

ACTIVITY—*EL BAILE DE CASCARONES*
These eggs are very simple to make and are a lot of fun at a dance or party.

Materials

Empty egg shells
Confetti
Cologne or perfume
Brightly colored felt markers
A small tube of silicone glue adhesive

Instructions

1. Make a hole at one end of a raw egg with a pin or thick needle.

2. At the other end cut off a small portion of the tip. Be careful to save the cutoff tip and not to break it.

3. Blow out the inside of the egg by blowing through the small hole.

4. Don't be wasteful. Save and use the inside of the egg for cooking.

5. Fill the egg with confetti and sprinkle a few drops of cologne or perfume on the confetti.

6. Reattach the cutoff piece of the eggshell with a smear of silicone glue.

7. Decorate the egg with the colored felt markers.

8. At your next dance or party hand out the eggs to the guests as they arrive. Explain the tradition of the *cascarones* to them and then watch out!

17

Theater

The Hispanic Southwest has a long tradition of folk drama dating back to the establishment of a Spanish colonial culture in the New World. Hispanic theater in the Southwest can be categorized in four historical periods:

- The folk drama of the Spanish colonial period. Religious and secular plays dramatized for entertainment and education in the frontiers of New Spain. These plays originated in Spain.

- The popular professional and amateur Spanish-language productions of the late nineteenth and early to mid–twentieth centuries. A little-known history of touring and resident Mexican theater companies in America. These plays were Mexican plays originating in Mexico.

- The farmworkers' theater beginning in the 1960s. The establishment of a politically active Chicano theater.

- Modern Hispanic theater. New voices, new dramatic visions.

SPANISH COLONIAL FOLK DRAMA

The Spanish brought to the New World a rich dramatic tradition dating back to Spain's Golden Age. The first theatrical presentation in the New World was performed in 1598. Written by Marcos Farfán de los Godos, a *capitan* with Don Juan de Oñate, the play was in honor of Oñate, claiming the new land for the kingdom of New Spain.

Arthur Campa, in *Hispanic Culture in the Southwest*, presents a description of this beginning of Hispanic theater in the New World. Oñate and his men had crossed the northern frontiers of New Spain to establish settlements in the Southwest. Oñate had reached the Rio Grande somewhere near El Paso, and he and his men set up camp.

And finally, in the evening, the performance of an original comedy written by Captain Farfán on a subject connected with the conquest of New Mexico. (1979, p. 226)

Oñate's men also performed the heroic tale of *Los Moros y Christianos*, the story of the Spanish defeat of the Moors and their expulsion from the Iberian Peninsula.

The folk plays of the Spanish colonial period fell into two categories: religious and secular. The religious plays came directly from Spain or were written by Spanish missionaries in the New World. The secular plays were mostly historical, recounting the battles between the

The first theatrical presentation in the New World was performed in 1598.

Moors and Christians as well as depicting the encounters with the established Native American cultures. They often presented the history of early colonization and the battles for European cultural supremacy in the New Spanish empire.

The religious plays had their sources in the mystery, miracle and morality plays of Medieval Spain. The Spanish missionaries brought the traditions of these plays with them to aid in their task of establishing Christianity in the New World. The plays served the dual functions of entertainment and education, but their most important role was to teach the tenets of Christianity to the indigenous populations and to aid colonial settlers in the maintenance of their own religious practices.

The Christmas season especially was marked by plays celebrating the biblical accounts of the birth of Christ. *Las Posadas* was a community reenactment of the nine-day journey of Joseph and Mary to Bethlehem and their search for shelter. The play centers on the refusal of villagers to provide shelter until the last night, *La Noche Buena*, Christmas Eve.

Las Posadas was often a preface play for *Los Pastores*, a play telling of the shepherds' journey to Bethlehem to honor the newborn Christ Child. The play featured several stock comic characters, which greatly endeared it to Spanish settlers.

A third religious play of the season was *Los Tres Reyes*, The Three Kings. This play portrays the visit of the Three Wise Men to the manger in Bethlehem on January 6, the Feast of the Epiphany.

Other religious plays also presented events from the Bible. *Caín y Abel*, the tragic biblical story of Cain and Abel, and *El Auto de Adám y Eva*, the account of Adam and Eve's fall from heavenly grace, are two other examples of plays that brought the teaching of the Catholic Church to the people, both indigenous and Spanish, of the New World. *La Aparición de la Virgen Guadalupe* dramatized the beautiful miracle legend of the Virgin of Guadalupe and Juan Diego. *El Niño Perdido*, The Lost Child, tells the story of the Child Jesus becoming lost during Passover in Jerusalem. His mother, the Blessed Virgin Mary, eventually finds him at a temple explaining the religious mysteries to the rabbis of the temple.

Part III in this book, *La Iglesia*, contains more extensive descriptions of the religious plays and cultural traditions of *Las Posadas*, *Los Pastores* and *La Aparición de la Virgen Guadalupe* as well as a *cuento* (story) based upon the traditional versions of these stories. The secular plays also were varied and instructive. *Los Moros y Los Cristianos* told the historical account of the epic battles between the Moors and the Christians. In this drama the Moors deceive the Christians and steal their holy cross. At the end of the play, the Spanish recapture their cross, defeat the Moors, return Christianity to their land and convert the Moors to Christianity. The dance-drama *Los Matachines*, described in Chapter 16, evolved in the New World from fifteenth-century Spanish sword dances depicting battles between the Moors and the Christians. The New World version, performed in both Hispanic and Native American communities, has as one of its themes the conversion of the Aztec emperor Moctezuma to Christianity.

Los Comanches was another historical play presenting the struggles

The Christmas season especially was marked by plays celebrating the biblical accounts of the birth of Christ.

of the Spanish settlers against the indigenous tribes. It is the first known Spanish-language play with a distinct southwestern U.S. (Colorado and New Mexico) theme. This play was enacted in the open air with the players riding horses as they played out the dramatic events of the defeat of the Comanche braves by the Spanish settlers. The action of this fierce horse battle centers on the pursuit and defeat of the great Comanche chief Cuerno Verde.

The theater of the Spanish colonial period was not a studied professional theater. It was a folk theater, performed by members of the Hispanic community. The secular plays were dramatic battles between good and evil, serving to indoctrinate native tribes into Spanish culture and to reaffirm that culture for Spanish colonists. The religious plays had a greater task, the establishment and maintenance of Christianity in the New World.

Today, Hispanic communities throughout the Southwest are reestablishing these folk plays as part of their efforts to preserve traditional Hispanic culture.

SPANISH-LANGUAGE THEATER FROM THE LATE NINETEENTH TO THE MID–TWENTIETH CENTURY

California during the 1850s was the first site of professional theater in the Hispanic Southwest. Prior to this time, Hispanic theater consisted of folk drama performed in rural communities by amateur community members. When Mexico became independent in 1821, a distinctly Mexican culture began to form in the southwestern United States. Mexican Spanish-language plays were part of this cultural development.

The California port cities of Los Angeles and San Francisco provided available access, because of steamship travel, to the touring companies from Mexico. The professional Hispanic theater of Texas and New Mexico developed after California's blossomed.

By the 1860s California had developed such a strong Hispanic theatrical environment that touring companies from Mexico would establish residence in Los Angeles. Nicolás Kanellos, in his book, *Mexican American Theatre: Legacy and Reality*, states that by the turn of the century Spanish-language companies were performing all along the Mexican–United States border, following a circuit that extended from Laredo to San Antonio to El Paso, through New Mexico and Arizona and on to California.

These touring companies consisted of both Mexican and Spanish performers. The theatrical entertainment presented by these troupes resembled a variety show composed of Mexican and Spanish plays and Mexican melodramas and were interspersed with song, dance and comic dialogue. The repertoire of these companies was diverse and large. A typical company would be able to stage serious dramas, *zarzuelas* (Spanish operettas) and comedies. Larger cities had established theaters featuring major dramas and repertory companies. Smaller cities had tent theaters and makeshift performance spaces. The Mexican Revolution of 1910 further enhanced the Spanish-language theater in the Southwest as Mexican artists came to the United States. When the vaudeville circuits developed in the 1920s, Mexican performers toured in both the Hispanic and American circuits.

The theater of the Spanish colonial period was not a studied professional theater. It was a folk theater, performed by members of the Hispanic community.

The 1960s saw the development of a pioneering style of Chicano *teatro,* with its origins in the social activism of César Chavez and the struggles of the United Farm Workers' union.

Also during this time, Mexican *carpas,* or tent plays, toured the southwestern United States. These *carpa* plays prefaced the Chicano theater movement of the 1960s through the use of stock comic characters, such as the *pelado,* the use of English and Spanish language and skits that commented on social events. The *pelado* (literally bare, skinned or penniless) character was a comic underdog, a combination Mexican hero-victim-trickster. This style of theater would provide a theatrical antecedent and cultural context for Chicano theater artists of later generations.

These Hispanic theater companies and artists served a dual function in their communities. Of course, they primarily provided theatrical entertainment. But another important function of these theaters during this time was the cultural preservation they provided for the Hispanic and Mexican immigrants who were struggling to find a place in America. Kanellos, in *Mexican American Theatre,* describes the profound effect these theaters had on their communities.

The relationship of performers and theaters to the community and nationality was close; the Hispanic stage served to re-enforce the sense of community by bringing all Spanish-speakers together in a cultural act. The professional theater houses became the temples of culture where the Mexican and Hispanic community as a whole could gather and, in the words of a theater critic of the times, "keep the lamp of our culture lighted." (1987, pp. 100–101)

By the 1930s the golden age of Spanish-language theater was diminishing. The forces causing this decline were the advent of the Great Depression affecting all aspects of life in America, the forced and voluntary repatriation of Mexicans back to Mexico and the development of the film age as a form of public entertainment. Hispanic theater did not disappear totally after this time, but it existed in a greatly reduced form. Hispanic artists continued to bring their plays to their communities, but Hispanic theater would not become a strong social force again until the 1960s.

THE FARMWORKERS' THEATER/CHICANO THEATER

The 1960s saw the development of a pioneering style of Chicano *teatro,* with its origins in the social activism of César Chavez and the struggles of the United Farm Workers' union. In the fall of 1965 Luis Valdez, a young Chicano from Delano, California, the son of migrant farmworkers himself, began the work of *El Teatro Campesino.* His *teatro* was dedicated to the cause of the migrant farmworkers who toiled in the fields of agricultural California. The song *De Colores* presented in Chapter 15 is considered the anthem of the farmworkers' union.

In the beginning, the farmworkers' theater grew out of simple dramatic improvisations Valdez would do with the farmworkers about the conditions of their work and lives. These improvisations evolved into a true farmworkers' theater—theater by farmworkers, about farmworkers and for farmworkers. Valdez quickly developed a form of agitprop theater using humor, political awareness, commitment and a broad *commedia dell'arte* theater style based in folklore and popular culture to dramatize the efforts of the farmworkers to gain unionization.

Figure 17.1. The eagle symbol on the United Farm Workers' flag.

These early skits developed in the rich cultural context of Mexican theater influences. They were influenced by the *carpa* Mexican tent shows with their distinct brand of Mexican humor and working-class sentiments. The *carpa teatro* established a precedent for comic skits presenting a satirical reflection of cultural conflict. The *carpa* evolved in Mexico and was performed in the United States until the 1950s.

Another influence was the archetype *pelado*—the comic underdog, tradition of Mexican theater. The great Mexican film star Mario Moreno developed his film character Cantinflas from the *pelado* tradition in Mexican theater. Another influential Mexican character was *El Bato Suave*, a smooth, street-savvy dude who was from San Antonio, wore a zoot suit and spoke *caló*, a Spanish-English urban border slang. These Mexican *teatro* characters became central stock figures in early Chicano *teatro*.

The work of the *teatro* featured *actos*, one-act plays based upon improvisations of political or social issues. These socially and politically oriented *actos* addressed the many pressing issues of the Chicano community: the injustices of the farmworkers' plight, the struggles for quality education, the difficulties of racism, the tragedy of drugs and crime in Chicano communities, the need for cultural pride and knowledge and the power of political action.

Humor and satire were the main dramatic tools used in the *actos*. They also used the dramatic elements of older cultural forms, *cuentos* from the folklore tradition, the Mexican *carpa* or tent play and the popular *corrido* musical form. The performers in the *actos* further reached out to their audiences by performing the plays in both English and Spanish.

One of the greatest strengths of the early *teatro* movement was that it defined a Chicano aesthetic that was enormously appealing to young social activists in the 1960s and 1970s. The *teatro* was a grass roots theater movement speaking directly to the issues of Chicano communities throughout the Southwest. The cultural themes addressed by these numerous community-based *teatros* continued to reflect the experiences of the Chicano community: education, politics, poverty, war, cultural domination, cultural survival, ethnic pride and personal accomplishment from service to one's community.

The *teatros* created a public theater to serve as a platform and opportunity for the public discussion of important community and national issues. The intentions of the first Chicano *teatro* artists were both political and spiritual. Political because they saw *teatro* as their form of political activism to bring about change and improvement to society. Spiritual because they saw *teatro* bringing understanding, strength and hope to their communities.

In addition to social and political issues, the *teatro* also presented a Chicano version of history. This Chicano historical perspective recognized the overlooked contributions of Hispanics to American society. It revealed forgotten heroes and corrected distorted history. It returned to Chicano communities and individuals their own proud history.

Led by the work of El Teatro Campesino, community activists and college students formed dozens of *teatros* in their own communities. Throughout the Southwest, Chicano

The *teatros* created a public theater to serve as a platform and opportunity for the public discussion of important community and national issues.

activists and theater artists used Chicano theater as part of their political activism and cultural teaching. With this development, the *teatro* movement expanded beyond its origins as a farmworkers' theater and became a true community theater movement. Although El Teatro Campesino continued to be enormously influential, the Chicano theater movement developed other effective *teatro* companies. While many of these companies were community based, many others were college based. These college-based *teatros* were connected to the sociopolitical activism of Chicano students during the 1960s and 1970s.

As with other periods of Hispanic theater, the *teatro* period itself evolved as the times and Chicano communities changed. Formed in the glory days of the 1960s social activism, the *teatros* transformed as its founding members dropped out of the movement, continuing the dream of a Chicano theater on their own or moving on to professional theater. Luis Valdez himself moved on to Broadway and Hollywood, directing the successful "New American Musical" *Zoot Suit*, a dramatization of an infamous Los Angeles race riot, and *La Bamba*, the film biography of the first Chicano rock star, Ritchie Valens. The Chicano theater movement of this period, however, was a central and critical part of the establishment of the Chicano movement throughout the Southwest.

Readers interested in reading the plays of Luis Valdez and experiencing his immense contributions to the Chicano *teatro* movement are encouraged to read two books: *Luis Valdez—Early Works: Actos, Bernabe and Pensamiento Serpentino* and *Zoot Suit and Other Plays*, both published by Arte Publico Press and written by Luis Valdez.

As with other periods of Hispanic theater, the *teatro* period itself evolved as the times and Chicano communities changed.

MODERN *TEATRO*

Modern Hispanic theater artists are as diverse as the Hispanic people themselves. It is impossible to mention or describe the full range of theatrical activity in the Hispanic Southwest today, but two carefully chosen examples will illustrate the continuing vibrancy of Hispanic theater and the deep commitment of its artists to give a dramatic voice to their community.

Many theater artists in communities throughout the Southwest have preserved the work of the Chicano *teatro* movement. One of the most successful and artistically respected is *Su Teatro*, a twenty-five-year-old *teatro* from Denver, Colorado. Headed by playwright and artistic director Anthony J. Garcia, *Su Teatro* is the third oldest Chicano theater company in the United States. Along with longtime collaborators Yolanda Ortega-Ericksen and Debra Gallegos, Garcia has guided *Su Teatro* in its long-standing dedication to creating a Chicano theater voice serving its community with plays that address the experiences of the Chicano community. From its beginnings as a grassroots *teatro*, it has become recognized for its original and well-produced plays dramatizing community issues.

Su Teatro has produced plays by such renowned artists as Luis Valdez, Rudolfo Anaya, Cheríe Moraga and Evelina Fernandez. Two of their most significant original productions are *Chicano History 101* and *La Carpa Aztlán Presents: I Don't Speak English Only*. Its work is notable in that the company has produced fifteen "homegrown" original plays,

the largest contribution to Chicano theater by any *teatro* company. *Su Teatro* has recently expanded its work with the establishment of *El Centro Su Teatro*, a Chicano Arts Center producing *teatro*, Chicano film and music events, providing artistic residencies for emerging and established Chicano theater artists and hosting community cultural events.

Su Teatro has persevered through the years and has maintained a careful balance between holding true to its founding commitment to being a people's theater and becoming a well-managed professional company recognized by funding agencies through significant grant support. One aspect of its success is the manner in which it maintains its community base, with local productions at churches, arts festivals and community centers.

As a community *teatro*, *Su Teatro* also addresses the needs of Chicano youth through its outreach work in the schools and community programs for children. Invitations to perform at such esteemed theater centers as Joseph Papp's New York Public Theater confirm its artistic excellence.

Su Teatro is an example of the original vision of the *teatro* movement: a community-based theater using its talents to improve the lives of its community members. Through the years the company has persevered with this vision, dedicated itself to its community and the Chicano experience and grown as respected and accomplished theater artists.

Dr. Carlos Morton, one of a few Chicano Ph.D. professors in theater in the United States, is one of the most successful examples of the transition Chicano artists made from the early *teatro* days to the main stage of American theater.

Recognized by *Time* magazine as one of the most significant Chicano playwrights in the nation, honored with a Fulbright fellowship for study in Mexico and professor of theater and department chair at the University of California–Riverside where he teaches playwriting, Morton is the son of first-generation Mexican-American parents.

An amusing anecdote about the origins of his family name tells of his grandfather, whose name was Pérez, wanting to change his name in order to find work in Chicago after the Mexican Revolution ended in 1917. As Señor Pérez searched for work, he realized that employers were hiring "Europeans" but not Mexicans. As he walked through the streets of Chicago, he saw a billboard with a Morton Salt advertisement and decided then and there to have a good American name, Morton.

At the beginning of his involvement in Chicano theater, Morton studied the techniques of El Teatro Campesino. He later joined the San Francisco Mime Troupe as a playwright and explored their process of collaborative political work. During this time he was forming his own

Figure 17.2. Su Teatro in La Carpa Aztlán *presents:* I Don't Speak English Only. *Background (left to right): Bob Mares, Debra Gallegos. Front (left to right): Manuel Roybal, Sherry Coca-Candelaria, Angela Manzanares, José Mercado.*

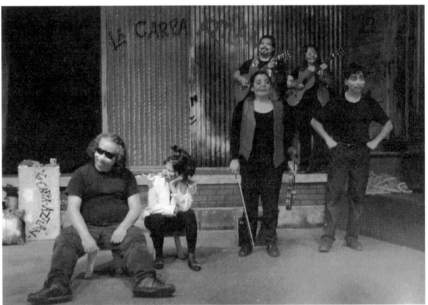

voice as a playwright with *El Jardín* (The Garden), a Chicano version of the Garden of Eden story, and *El Cuento de Pancho Diablo*, which he dedicated to El Teatro Campesino.

Morton has had three books of his works published. *The Many Deaths of Danny Rosales and Other Plays* and *Johnny Tenorio and Other Plays* are collections of his own plays. *The Fickle Finger of Lady Death and Other Plays* is a collection of plays of contemporary Mexican playwrights. Morton translated the plays into English for this collection in order to introduce American theater companies and audiences to the dramaturgy of Mexico's new generation of playwrights.

From his early beginning at the center of the Chicano *teatro* movement, Morton developed into a major Chicano playwright with productions at community *teatros*, university drama departments, regional theaters, international festivals and such renowned national theaters as Joseph Papp's New York Public Theater. In his twenty-six-year career as a theater artist, he has written over two dozen plays with nearly one hundred productions.

Morton is an amazingly diverse and prolific playwright. His plays move easily from historical drama to humorous musicals to social issues. His most constant characteristics as a playwright are a sharp humor, an inventive use of well-known dramatic characters from Chicano culture, a penetrating analysis of cultural issues and a deep, constant commitment to creating a theater reflecting the truths of Chicano experience.

His first major success, *The Many Deaths of Danny Rosales*, is a historical documentary about the death of a young Chicano while in Texas police custody. *El Jardín* is a humorous musical retelling of the Chicano Garden of Eden. *La Malinche*, a play that won first prize in the Arizona Theater Company's National Hispanic Playwriting Contest in 1995, is a reflective and penetrating reconsideration of the native mistress and interpreter for Cortés. *The Child Diego* is a dramatization of the life of the great Mexican muralist Diego Rivera. Concerned about the dropout crisis in schools and teenage drug culture, he has also written a cycle of teenage plays under the title *At Risk*.

Morton is illustrative of Chicano artists remaining true to their roots in the *teatro* movement, while realizing success in American theater. Chicano theater scholar Jorge Huerta in his book, *Chicano Theater: Themes and Forms*, describes Morton:

> No other playwright besides Luis Valdez has been as active and prolific as Carlos Morton. He might be termed a one-man *teatro*, expressing a vision of the Chicano that is informed by his own experiences and his observations of the world around him. (1982, p. 169)

Throughout the Southwest, Hispanic theater artists are writing and producing plays that tell the stories of their communities and people. Given the dearth of opportunity for theater artists of color in the mainstream movie and theater business, Hispanic artists have chosen to create their own opportunities on their own terms. Working from a centuries-old theatrical legacy, modern Hispanic theater artists—in Chicano *barrios*, universities and amateur and professional theaters—are the proud extension of their people's cultural vision.

Throughout the Southwest, Hispanic theater artists are writing and producing plays that tell the stories of their communities and people.

The Denver Center Theater Company commissioned *Cuentos* and produced it in its school touring program. The play targets a school-age audience in its thematic content and its school-assembly period length. It has had successful productions in both school and community theaters. One production mounted it in the traditional Mexican *carpa* tent theater style and toured it in city parks.

TEACHER'S AND DIRECTOR'S GUIDE TO *CUENTOS*

Synopsis

A grandmother finds herself suffering from the "evil eye" and needs special treatment in order to get better. She sends her grandchildren on a quest to get help. On their journey of discovery, the children confront folk figures from Hispanic culture: the Weeping Woman, Death, *duendes* and a *bruja*. As the characters work their magic, the children learn the importance of family responsibility, the values of traditional culture, the wisdom of making good decisions and the strengths of their Hispanic heritage.

Teatro Characteristics Utilized in *Cuentos*

The playwrights wrote the play in the Chicano *teatro* style, utilizing the following aspects characteristic of the style:

- Chicano folklore integrated into the story
- Characters from traditional *cuentos* in the story
- A mixture of English and Spanish dialogue
- Dramatic use of music and song, especially the *corrido* opening and closing the play
- Humor and satire deliberately utilized
- Cultural awareness and pride integrated into the story
- Addresses family, social and community issues
- Dramatically, in the *Teatro Popular* or *Teatro Carpa* style (the traveling Mexican tent theater)

Folk Legends, Mythology and Characters Utilized in *Cuentos*

The full texts of the stories described below are contained in *The Corn Woman: Stories and Legends of the Hispanic Southwest* by Angel Vigil.

- *La Llorona:* The weeping woman is a legendary figure whose folktale tells the reason for her wandering through the night weeping for her lost children. The legend warns that she will snatch stray children to replace her own lost children and is of Mexican-Aztec origin. In folk culture, parents use the legend of *La Llorona* to scare children into good behavior. They tell their children that the sound of the wind in the trees at night is the sound of *La Llorona* crying and looking for children.

- *Doña Sebastiana:* Death herself. In folk legend she wanders the night, pulling the *carreta de la muerte*, the death cart, collecting souls for their long journey into eternity. A powerful folktale tells of her gift of *curanderismo* to a poor farmer.

- The Language of the Animals: A folktale in which a snake gives the gift of the knowledge of the animals' language to a man who saved its life.

- *Duendes:* Mischievous legendary spirits or dwarfs who are common characters in *cuentos*. The legend of the *duendes* is that after the Lord and the devil had their arguments at the beginning of time, some of the angels stayed with the Lord and some went with the devil. When the Lord closed the doors to Heaven and the devil closed the doors to hell, many angels were caught between Heaven and hell with no place to go. These angels came to Earth and became the *duendes*. The *duendes* spend their time on Earth causing mischief in human affairs.

- *Curandero:* A folk healer who uses the knowledge of herbal and spiritual remedies to heal physical and mental illness. (See Chapter 11.)

- *Mal de ojo:* The evil eye. Part of a superstitious belief system in which one person can cause harm to another just with a look. Only a *curandera* can cure the *ojo*.

- *Bruja:* A witch. The belief in witches is part of a complex supernatural legend system in Latino culture. They have the power of making spells, and many legends exist in which *brujas* have special powers of physical transformation, usually into an owl.

- Removable Eyes: Being able to remove one's eyes and still see is a common trait of *brujas*.

- *Adivinanzas:* Riddles. Hispanic culture has a rich oral tradition of riddles. Many *cuentos* exist in which the hero of the story has to answer difficult *adivinanzas* as part of the hero's quest. (See Chapter 14.)

Bruja: A witch. The belief in witches is part of a complex supernatural legend system in Latino culture.

The Songs and Music

The music for the songs can be played to either traditional or modern melodies or rhythms.

- Song #1: Corrido to the melody of *"Juan Charrasqueado"* (see p. 216)

- Song #2: Rap rhythm

- Song #3: Traditional *"La Llorona"* melody (see p. 214–15)

- Song #4: Cumbia rock rhythm

- Song #5: Traditional waltz to the melody of *"Valentín de la Sierra"* (see p. 217)

- Song #6: Same as song #1

(See Appendix 1 for the traditional melodies to "Juan Charrasqueado," "La Llorona" and "Valentín de la Sierra.")

Spanish Language

Translations for the Spanish in the play are in the Spanish glossary at the end of the book.

CUENTOS

Cast of Characters

LATINA WOMAN: plays ABUELITA, BRUJA,
LA LLORONA, DOÑA SEBASTIANA, TIA JUANITA
LATINO MAN: plays DUENDE, TIO JOE, VIBORA
SHERI: sixteen years old, mature, responsible young woman
JOAQUIN: twelve years old, alias "Snake Eyes"
MUSICIANS: music and sound effects

If the play is performed by young people, parts may be assigned to different players for a total of six girls and four boys.

Time: The Present
Place: The City and a Valley Far Away

(Song #1)
COMPANY
We're going to sing for you a very well known story
About what happened in a valley far away
Two city kids in quest of miracles and magic
Who found there's so much more to life than merely play.
Snake was his name and he was quite a "vato loco"
His sister Sheri was the fairest of them all
In their Chevy they would cruise along the highway
Passing up cars on the wrong side of the road.
One day they broke down right outside Chimayo
A giant snake smashed their hood and in their brains
"Hey Sis," said Snake, "this place is weird, let's head on home,
I think the air up here is making me insane."
But let us start the tale right here at the beginning
Brujas and duendes, take your places, por favor
The cuentos starts, the lights they dim, sit down amigos
This is a teatro with much fun and much sabor!
(Song ends)

(SNAKE enters with shawl and medicine bottle.)
ABUELITA: *(Pointing at the foot of the bed.)* That's where I saw her—*Doña Sebastiana, La Muerte!*

SHERI: Abuelita, have you taken your medicine today?

ABUELITA: You call this medicine! Hah! Couldn't cure a cold.

SHERI: Mama and Papa told me to make sure your took your medicine.

ABUELITA: Hah! A lot they care, traipsing around all over the country while *La Muerte* hovers at the foot of my bed.

SHERI: What are you talking about Abuelita? You know they're working. Now, the doctor said … .

ABUELITA: The doctor! *Sin verguenza*, charges you $60 just so the nurse can check your tongue with a little *palito*. (*ABUELITA sticks her tongue out and makes a face.*)

SHERI: Abuelita, how else are you going to get well and back on your feet again?

ABUELITA: *Hijos*, let me tell you a secret. I have something these doctors can't cure.

SNAKE: What's that?

ABUELITA: *Mal de ojo.*

SHERI: The evil eye!

SNAKE: Evil eye?

ABUELITA: You know that *viejo* who lives over by the railroad tracks, the one with all the dogs in his front yard?

SNAKE: He likes you!

ABUELITA: *Es brujo.* That son of a gun *es un* witch!!!

SNAKE: You don't really believe that do you?

ABUELITA: *M'hijos*, I do. He hexed me. And if you don't get me my medicine, I think I'm going to die! (*Starting to choke.*)

SHERI: Joaquin, get her a glass of water! (*Fumbling with the pills.*)

ABUELITA: (*Scattering them to the floor.*) No! That's bad medicine! I've taken it for years now and it hasn't done any good. You're not listening to me!

SHERI: What is it? What do you want?

ABUELITA: (*Panting and gasping for air.*) I need good medicine made by your *Tia* Juanita. Go to her in Chimayo. Tell her I need a cure for the *mal de ojo.*

SNAKE: Are you serious?

ABUELITA: You're darn right I'm serious. Just look at me. I'm dying. (*Beat.*) I told you, this morning I saw *Doña Sebastiana*, *La Muerte*, standing right there. That means she is coming to get me! (*ABUELITA starts coughing and shivering.*)

SNAKE: (*Aside to SHERI.*) She saw death? What does death look like?

SHERI: I don't know. But we've got to help here, Joaquin. We've got to go to the valley.

SNAKE: You're crazy. How are we going to get there?

SHERI: We'll have to take the car.

SNAKE: Mom and Pops will wring your neck.

SHERI: We'll have to take that chance.

ABUELITA: What are you waiting for? (*Taking a list out.*) Here's a list. Tell her I need the special tea. Also ask her for the complete words to the magic spell. How does it go: (*Reading from the list.*) "Cacahuates,

cascabeles. *Ponte trucha,* don't be jealous, throw a pinch of chile powder ... " *(Forgetting the rest.)*

SNAKE: Oh brother!

SHERI: OK, Abuelita, we're going right now. Come on Joaquin.

SNAKE: Can I drive?

SHERI: No, you don't have a license.

SNAKE: I never get to have any fun.

ABUELITA: Don't worry, there's still time. But hurry, *apurense! (Exit ABUELITA.)*

Song #2 (A Rap)
SHERI AND SNAKE
We come from near, we come from far
We sing from here, up to the stars
We be real good, we be real bad
We never down, we never sad.
CHORUS
My name is Snake, My name is Sheri
We sing for you this barrio story.
SNAKE
Now I don't care if you put me down
I'm the baddest kid in town
I drive my Chevy and I go real slow
I drive my Chevy and I ride real low.
CHORUS
My name is Snake, my name is Sheri
We sing for you this barrio story.
SHERI
Now I'm in love with the city fine
I dig its place and I dig its time
I don't care for the country living
Are you hip to the rap I'm giving?
CHORUS
My name is Snake, my name is Sheri
We sing for you this barrio story.
(Song ends)

DUENDE: Look, someone's coming, some kids. Bruja, they're driving past the house!

BRUJA: Oh, this is going to be fun! *(To DUENDE.)* Quick go stop their car.

DUENDE: Oh boy! Oh boy! Ca ... Ca ... Ca... Can I use my special spells?

BRUJA: Go stop their car!
(Exit DUENDE in a hurry. BRUJA addresses the audience.)

BRUJA: They're looking for something. They need something important from here. They think they're looking for one thing, but they're going to find something else.

DUENDE: Pssstttt …

SNAKE: Hey, what's that in the middle of the road?

SHERI: I don't know.

SNAKE: It's not moving.

SHERI: It's just a mirage.

SNAKE: What's a mirage?

SHERI: It's something you see that's not real. It doesn't really exist.

SNAKE: It sure looks real.

SHERI: Yes it does.

SNAKE: Funny, it looks just like a …

SHERI: Giant snake!

SNAKE: A rattler. Hit the brakes! We're going to crash!
(Sound effect of car crashing. SHERI and SNAKE exit.)

DUENDE: I stopped them!

BRUJA: The old giant snake in the road trick?

DUENDE: Smashed their radiator to smithereens.

BRUJA: That's good, very creative. Those two, lost as two babies. We'll start now. We'll teach them lessons they'll never forget … . I need my eyes. Where did you put them?

DUENDE: *(Trying to find them in his pockets.)* Here they are. No they must be over here.

BRUJA: You lost them again! Didn't you! Well you have five seconds to find them. One … two … three …

DUENDE: Over here, uh … . *(Searching.)* Somewhere around here … uh, let me think.

BRUJA: Get me my eyes!!!

DUENDE: *(Proudly.)* Here they are.

BRUJA: *(Inserting eyes. She starts to meow.)* Ouch. these aren't my eyes! These are the cat's eyes! *(She takes them out and hands them back to DUENDE.)*

DUENDE: *Lo siento.* I'm sorry. Here! *(He hands her the right eyes and takes back the cat's eyes.)*

BRUJA: Ahhhhhh! That's better.

DUENDE: Bruja! They're coming this way!

BRUJA: Good. Quick, let's hide. I'll be the rock.

DUENDE: Good. I'll be the owl.

BRUJA: No, no, no. I'll be the owl. You be the rock.

DUENDE: No fair! You always get to be the owl.

BRUJA: Duende! Do you want to be the frog again?

DUENDE: Only if you'll be the fly … .

BRUJA: What?

DUENDE: Never mind. I'll be the rock.
(Frantic scurrying, then stillness as they transform into a rock and an owl.)

SHERI: *(Entering with JOAQUIN.)* I can't get over it Joaquin. I swear we hit a giant snake. But when we got out there was nothing there.

SNAKE: Except a busted radiator.

SNAKE: *(Pointing to her pants.)* Hey look!

SHERI: What?

SNAKE: A snake!

SHERI: *(Screaming.)* Get it away!

SNAKE: *(Teasing SHERI.)* It was just a little snake. Be a little cooler.

SHERI: Grow up Joaquin!

SNAKE: Grow up yourself. You're the one afraid of snakes. Besides, snakes are my *placa*, my nickname … Snake Eyes!

SHERI: We're not in Denver with your stupid friends.

SNAKE: Shhh … did you hear that?

SHERI: Hear what?

SNAKE: Your heart beating!!!

SHERI: Stop it Joaquin! We've got to get help. Here's a house. Let's see if we can use their phone. *(Mimes knocking on door. Guitar makes door opening sound.)*

SNAKE: The door just opened by itself.

SHERI: Anybody home?

SNAKE: *(Entering with SHERI.)* What a weird place. *(They check it out.)* What's a rock doing in the middle of the living room?

SHERI: It's adobe like *Tia* Juanita's house.

SNAKE: Hey check it out. A stuffed owl. *(He pokes the owl and then sits on the rock.)* What now? *(Sarcastically.)* "La Sheri," there's no one home.

SHERI: There's got to be someone around. We have to get the car fixed.

SNAKE: That piece of junk. Now if we had a Camaro … or a Porsche … we'd be cruising right now.

SHERI: Joaquin, we've got to find *Tia* Juanita.

SNAKE: *(Running up behind her and scaring her.)* "We've got to find *Tia* Juanita." I say we go back right now and make Abuelita take her medicine like the doctor said.

SHERI: Joaquin, Abuelita's very sick. You were there. You saw her.

SNAKE: I don't see how some weeds, candles and a few prayers from some old lady are going to make her any better.

SHERI: Joaquin, if we don't find that old lady, Abuelita's going to die. Is that what you want?

SNAKE: No. I just don't see how it's going to make her well.

SHERI: I told you. *Tia* Juanita is a *curandera*.

SNAKE: OK. So she's a "Cura-dera." *(Mispronouncing it.)* No cum-pren-do, Siso!!!

SHERI: *Curandera*. She's like … like a medicine woman. She'll fix a special tea. It'll make Abuelita better.

SNAKE: I know all about that "special tea" to make you feel better.

SHERI: Joaquin! It's not what you think. The *curandera* knows how to use plants and herbs to cure people.

SNAKE: Oh man! You don't believe in that stuff, do you?

SHERI: Abuelita does, and that's what counts.
(The owl winks at Snake.)

SNAKE: Hey that owl winked at me. I swear that owl winked at me.

SHERI: Joaquin, don't be ridiculous. *(She is sitting on the rock. It sneezes. She gets up from the rock and starts backing toward the door.)* Let's go … to another house for … help!

BRUJA: *(Appearing as if by magic.)* Welcome to my house, *mis hijos*.

SHERI AND SNAKE: Ahhhh! Where did you come from?

BRUJA: Why, I've been here all the time.

SNAKE: Where?

BRUJA: Right here. Can I help you?

SHERI: Well … our car broke down and we need to use your phone.

BRUJA: *Lo siento*. I'm sorry. I don't have a phone.

SNAKE: No phone. We're really in the boonies.

BRUJA: Oh you're mistaken. It's just that we live a very simple life up here in the mountains. No radio … no television … .

SNAKE: No TV! What do you do for fun?

BRUJA: We sit around the fireplace and tell *cuentos*.

SNAKE: Quin-tows?

SHERI: *(To JOAQUIN.)* Stories.

SNAKE: How exciting. *(He makes a face.)*

BRUJA: *(Grabbing SNAKE by the ear.)* What's your name?

SNAKE: Ow! *(Pulling away.)* Snake Eyes to you!

BRUJA: Lovely name. You and I are going to get along just fine.

SHERI: His name is Joaquin. I'm Sheri.

BRUJA: *(Pronouncing it Cherry.)* Cherry, a delicious name.

SHERI: That's Sheri, *Señora*.

BRUJA: That's what I said, Cherry.

SHERI: Look, we really need to get to town. What's the quickest way to walk there?

BRUJA: Don't leave so soon. Why don't you stay and have some "special tea." It does wonders for the health.

SHERI: No thanks. We have to be going now.

SNAKE: Finally, a good idea.

BRUJA: What were you doing here? You lost?

SNAKE: We're not lost!

SHERI: We're looking for our *Tia* and *Tio*.

BRUJA: Maybe I know them.

SNAKE: You wouldn't know them. They live in town. They have a TV. (*Laughs at his own joke.*)

BRUJA: Really! Well the back road to town is over there. Just be careful. It's getting dark out. You know what happens when it gets dark?

SHERI: What?

BRUJA: This is the time when *La Llorona* appears in the arroyo or along the river with her long black hair trailing in the wind. You know of *La Llorona* don't you?

SNAKE: We're not afraid … we're from Denver.

BRUJA: Just be careful. I'm here if you need me.

(*Kids exit. BRUJA then transforms DUENDE from a rock back to himself.*)

DUENDE: Awww, my aching back. That's the last time I play the rock.

BRUJA: Well, you know what to do.

DUENDE: Oh, no. Not again. You're not going to turn into *La Llorona*. Last time we did that we got shot at.

BRUJA: Would you like to be a turkey buzzard?

DUENDE: No, no, no … I'm going … I'll meet you there. (*Both exit.*)

Song #3 (Enter LA LLORONA)
LA LLORONA
Everyone calls me the dark one
A spirit no one can see
But I'm like a coal in the fire
Red and hot as can be.
Everyone calls me the dark one
A spirit no one can see
But I'm like a coal in the fire
Red and hot as can be.
MUSICIANS or COMPANY
Why do they call you the weeping woman
What do they say you did
Did you push them in the water, Llorona
Did you really drown your children?
LA LLORONA
They say I feel no pity
Because no one sees me crying

Dead men never make a sound
And painful is their dying.
MUSICIANS *or* **COMPANY**
It seems to me that the flowers
On graves are steadily creeping
And when the wind blows
It seems as if you are weeping.
(Song ends)

(SHERI and SNAKE enter and find themselves face to face with LLORONA.)
LLORONA: *(Low moan.)*

SNAKE: Oh man! Excuse me, *Señora,* are you all right? What's wrong? *(LLORONA points to the river.)* Did something happen? *(LLORONA starts to lead SHERI to the river.)*

SNAKE: Don't go.

SHERI: She's in trouble. She needs help.

LLORONA: *Vengan, mis hijos!*

SNAKE: What did she say?

SHERI: She wants us to go with her.

LLORONA: *Vengan al rito.*

SHERI: To the river.

LLORONA: *El rio negro, profundo.*

SHERI: The dark river, the deep river.

LLORONA: Here, *mis hijos,* in these turbulent waters, a great tragedy!
(At this point LLORONA motions to SHERI with a god's eye for SHERI to come to the river with her. SHERI does so.)

SNAKE: Be careful. Don't fall in.

LLORONA: Many years ago a Spanish captain fell in love with an Indian maiden. Years passed. They lived just like husband and wife and had two children. A boy and a girl.

SHERI: Just like us … .

LLORONA: One day the Comanches captured a Yankee woman and brought her into the village. The Spanish captain took one look at her golden hair and white skin and bought her from the Indians. Then he took her home.

SHERI: He took her home?

LLORONA: The captain told the Indian maiden to serve this Yankee woman well, for he planned to make her his lawful wedded wife.

SHERI: Oh no.

LLORONA: The night before the wedding she kissed her children, her pretty babies, good-bye. *(Starts weeping.)*

SHERI: I don't want to hear this.

SNAKE: What's the matter. What happened?

LLORONA: She walked them down to the riverbank … . (*Weeping louder.*)

SHERI: I don't want to hear the rest of this!

SNAKE: Why not? Just when it's getting interesting.
(*LLORONA motions with the god's eye and they both fall into the river.*)

SNAKE AND SHERI: Oh… . (*Sounds of agony.*)

LLORONA: (*LLORONA with a strong grip on the kids with the god's eye.*) And here, on this very spot, she drowned them. She drowned them! Because he betrayed her! Betrayed her! (*LLORONA still with her grip tight as a vise.*)

SHERI: Please, let us go. Let us go!

SNAKE: Yowwwwwwwwww!!!
(*LLORONA releases her hold on the two.*)

LLORONA: And it is on moonlit nights like this that *La Llorona*, the Weeping Woman, wanders the banks looking for children. Shhhh, can you hear her crying?

SHERI: You poor woman!

LLORONA: I won't harm you, my little one, I won't hurt you. I only want to hold you and pray for their souls—which are surely in heaven! *Vayanse*, go. But never forget this tale I told you. And pass it on to your children. (*Giving them the god's eye.*) Take this!

SHERI: *Si, Señora.* (*Taking the god's eye.*)

LLORONA: Keep it … *es un Ojo de Dios.* It will protect you against evil spirits.

SHERI: *Gracias, Señora.* (*LLORONA vanishes. SHERI places the god's eye around JOAQUIN'S neck.*) I want you to wear this as a good luck charm.

SNAKE: Do I have to?

SHERI: Yes.

SNAKE: Okay. But that did it. We're going back to Denver. Right now!

BRUJA: (*As she enters, SHERI jumps with fright.*) Are you all right?

SHERI: It's you again. Where'd you come from?

BRUJA: I told you. I've been here all along.

SNAKE: *La Llorona*, just like you said, tried to … .

BRUJA: Oh, so now you believe.

SHERI: We saw her. She was right … (*Looking around.*) here … just a minute ago… .

BRUJA: Don't be afraid. It's only the *piñon* trees waving in the wind. Look, it's dark out. You'd better stay with me and start again in the morning.

SNAKE: Good idea. I'm really … (*Looking around.*) tired … yeah … that's it.

SHERI: (*To SNAKE.*) No! We have to keep going. (*To BRUJA.*) We're looking for someone and it's very important we find them right away.

BRUJA: You sure I can't help?

SHERI: We're looking for a cure. We have a list. (*Searching for the list.*) Joaquin, where's the list?

SNAKE: (*Also looking for the list.*) I don't have it. You have it.

BRUJA: (*Producing the list.*) Is this what you're looking for?

SHERI: Yes. Where did you find it?

BRUJA: It just appeared out of thin air. Every item on the list can be found on the hill. Herbal tea, chile powder … .

SHERI: We haven't got much time.

BRUJA: I understand. Young people like you are always looking for a quick solution.

SHERI: We're in a hurry.

BRUJA: Well, why didn't you say so! (*Calling out.*) Duende! Duende!

DUENDE: (*Entering.*) Mande.

BRUJA: Take these children up the hill.

DUENDE: My pleasure. Follow me.
(*All exit.*)

Song #4 (Cumbia rock)
DUENDE
The monte, the monte
Has a horizonte
That makes you makes you think big
That makes you want to flaunt it.
Up here on the hill
You simply eat and swill
There ain't any work
Or any bossy jerks.
SNAKE
I dig it, I dig it
I'm hip to what you're saying.
SHERI
It sounds like,
To me that you're lying.
DUENDE
Up here on the hill
To hell with Jack and Jill
They don't have any clocks
You never have to change your socks.
There ain't no grammar books
No one give you dirty looks
The licorice grows on trees
You can do as you please.

SNAKE
You never go to school
There ain't any rules.
SHERI
You don't get flu or colds
It hardly ever snows.
DUENDE
There are Coca-Cola springs
Everybody having flings
Rock 'n' roll bands everywhere
People flying through the air.
SNAKE
I dig it, I dig it
I'm hip to what you're saying.
SHERI
It sounds like,
To me that you're lying.
(Song ends)

SNAKE: Is this the place?

DUENDE: Looks like it.

SHERI: That's not licorice. Those are cigarettes.

DUENDE: Well, I'll be darned.

SHERI: Are these the famous Coca-Cola springs?

DUENDE: Taste it. Now, what we have here is your famous Colorado Kool-Aid.

SNAKE: Colorado Kool-Aid!

SHERI: *(Tasting from the stream.)* Yuck! Warm beer!

DUENDE: *(Drinking from a can of beer he just opened.)* That's what it is, all right.

SHERI: We have a list of things to get. *(Reading from the list.)* Herbal tea … .

DUENDE: Like Lipton.

SHERI: Chile powder …

DUENDE: *Mucho caliente.* But we have that.

SHERI: Sow's ear…

DUENDE: *(Making a sound like a pig.)* We have that.

SHERI: Dried salamander?
(SNAKE makes a face.)

DUENDE: *(Making fun of SNAKE.)* Yeah we have that. We have all these things, but first you each have to answer an *adivinanza*, a riddle.

SHERI: Go ahead.

DUENDE: What saint smells best of all?

SHERI: That's easy, *Santa Rosa. (To SNAKE who doesn't understand.)* Saint Rose.

SNAKE: That's not fair, it's in Spanish.

DUENDE: You'll learn. What has a mouth, but cannot eat?

SNAKE: I'll never get this. Quiet, let me think. What has a mouth but cannot eat. (SNAKE doesn't get it.) Oh well, I guess I can't … .

SHERI: He said it! A "well" has a mouth but cannot eat! So, what can we get here? Come on.

DUENDE: You're standing right on top of it.

SNAKE: What's this? (Picking up cans from the garbage and reading from one.) Canned promises.

SHERI: Canned promises. What's that supposed to mean?

DUENDE: Ya git what you pay for.

SHERI: You mean we came here for canned promises!

DUENDE: Well, it just goes to show you.

SHERI: What? (Kicking the cans at DUENDE.)

DUENDE: You reap what you sow.

SHERI: Come on Joaquin, let's get out of here. (JOAQUIN sits down.) Oh, for crying out loud!

SNAKE: (Lying down.) Slow down Sis, relax, we've been up all night.

SHERI: Joaquin, get up!

SNAKE: What's your hurry? (To DUENDE.) You know a guy could get used to a place like this.

DUENDE: Yup, it's habit forming.

SHERI: Joaquin, what's happened to you?

SNAKE: Sheri, you are such a drag.

SHERI: JOAQUIN!

SNAKE: (Mimicking her.) Good-bye.

SHERI: Joaquin!

SNAKE: I said good-bye!
(SHERI exits angrily.)

DUENDE: (Handing SNAKE a joint.) Man this is paradise. No school. You sleep late. You don't have to do anything you don't want to.

SNAKE Yeah, that's right. (Looking at the joint.)

DUENDE: No homework. You're the boss.

SNAKE: Right …

DUENDE: No older sister telling you what to do.

SNAKE: You know, I think I could stay here for the rest of my life.

DUENDE: Well, OK. (DUENDE slowly starts to exit.)

SNAKE: Seriously though, what do you eat around here besides cigarettes and warm beer? Haven't you got any nachos? Duende?

Duende! He's gone! I'm all alone! (*Inspecting joint.*) Oh well, might as well (*He goes into a dream-like trance.*)

SHERI: Yes, Joaquin, blow your brains out.

DUENDE: (*Entering.*) Don't listen to her *vato*. A little *mota* is just what you need to make you *suave*.

ABUELITA: Joaquin! It's me, your Abuelita!

SNAKE: Abuelita?

ABUELITA: I'm sick *hijo!* (*Starts to cough.*)

DUENDE: Didn't you take your medicine like the Doc said?

SHERI: Joaquin! Don't you care about us?

DUENDE: Ah, *viejas* ... always complaining!

SNAKE: (*Throwing down the reefer.*) OK! OK! I'm coming. I'm coming. Abuelita, I'm coming.

SNAKE: (*As SNAKE tries to get to Abuelita DUENDE stops him with a bag of crack.*) Check it out *vato*. There's more.

SNAKE: (*As DUENDE snaps a bag of drugs in front of him.*) Huh? What's this?

DUENDE: Something special.

SHERI: Don't listen to him. (*She exits the dream sequence.*)

ABUELITA: *Viejo boracho!* (*She exits the dream sequence.*)

SNAKE: Stop it! Stop it! What's got into me? (*SNAKE throws the canned promises upstage.*) Man, I don't need this! Where's Sheri? Sheri, wait for me! (*SNAKE and DUENDE exit the dream sequence.*)

SHERI: That good for nothing lazy bum.

BRUJA: (*As owl.*) You shouldn't talk that way about your brother. He really loves you.

SHERI: He doesn't care about anybody but himself. (*Stopping, realizing that someone has said something to her.*) Who said that?

BRUJA: I did, the wise old owl.

SHERI: Oh, it's you again. What are you winking at me for?

BRUJA: I'm here to give you some free advice. If you're looking for a way down the mountain, don't go right, go left.

SHERI: I don't need your advice. I can take care of myself. (*Starting down the wrong trail.*)

BRUJA: You think you're all grown-up, don't you?

SHERI: I practically raised that little snotnose myself.

BRUJA: Your parents were busy working hard, *que no?*

SHERI: Yeah. How did you know?

BRUJA: Stop, you've gone too far. There's danger up ahead. *Doña Sebastiana's* spider web!!!

SHERI: (*Looking around.*) Looks clear to me.

BRUJA: You're blind.

SHERI: (*Leaping over last obstacle.*) There, I made it.
(*SHERI exits. BRUJA follows.*)

BRUJA: Watch out Cherry, watch out Cherry … .

SNAKE: (*Entering.*) Sheri! Where are you? She was right. I should have gone with her. Some *bruja* put an evil eye on us. First Abuelita, now Sheri.

VIBORA: Hsssssss.
(*This stops SNAKE in his tracks.*)

SNAKE: Hey there, you don't have to hiss at me. You're my *placa*. They call me "Snake Eyes."

VIBORA: It'ssssssss me.

SNAKE: What?

VIBORA: If you free me from this trap I'll give you a surprise, a gift.

SNAKE: I must be going crazy. I'm talking to a snake. *La Vibora.*

VIBORA: Don't be afraid *vato*, come close … .

SNAKE: I'm not afraid.

VIBORA: Ussssss snakessssss are misunderstood. People think we're sssssinister, but we're not, eh? Now pick me up and look at me eyeball to eyeball.
(*SNAKE picks up VIBORA and then VIBORA spits in his eye.*)

SNAKE: Yow! Why'd you do that?!!

VIBORA: That'sssss my special gift. Now you have the power to under-stand the language of the animals, Snake Eyessss. Soon many things will happen. As long as you are in this place you shall have the power I gave you. And not a second too soon. (*VIBORA exits.*)

SNAKE: What will happen? Don't leave … . (*He exits.*)

Song #5
MUSICIANS or COMPANY
Comes the sad part of the story
Of Snake Eyes and Sheri Medina
They were two babes in the woods
Who got caught by Doña Sebastiana.
"Promise me one thing," she said
"Just one thing my dearest brother
If something happens to us
You'll do all in your power
To rescue grandmother."
Little did Sheri know
What waited for her up ahead
There in a fork by the road
Was a lady in black

The Queen of the Dead.
(Song ends)

SHERI: Joaquin! Joaquin!
(DOÑA SEBASTIANA points dramatically at SHERI. SHERI reels. A gigantic spider web encircles SHERI. SHERI falls to the ground. SNAKE enters.)

SNAKE: *(Seeing SHERI and going to her.)* Sheri!

DOÑA: It's no use.

SNAKE: What'd you do to my sister?!

DOÑA: Don't you know. She got bit by black widow spiders … would you like to pet them? *(Magically spiders appear.)*

SNAKE: She's still breathing. *(To SHERI.)* Try to speak.

DOÑA: Her last words.

SNAKE: What are you talking about?

DOÑA: Her time has come.

SNAKE: What time? Who are you?

DOÑA: I … am *Doña Sebastiana!*

SNAKE: *Doña Sebastiana.*

DOÑA: *¡Doña Sebastiana! ¡La Muerte!*

SNAKE: *La muerte …*

DOÑA: *¡La mera-mera!*

SNAKE: The mirror-mirror …

DOÑA: *¡La cu-cuy!*

SNAKE: The cookie?

DOÑA: The Grim Reaper! Death! Don't you speak English or Spanish?

SNAKE: Sheri, Sheri, please, wake up! Oh God, first Abuelita, now Sheri.

DOÑA: All your weeping won't save her … she's mine!

SNAKE: *(Standing up to her.)* You … will … not … take … her.

DOÑA: Oh yes I will!

SNAKE: *(Assuming karate stance.)* Get back!

DOÑA: You dare to threaten me! *(To black widow spiders.)* Have at him my pets.

SNAKE: Back off! I speak your language.

SPIDERS: *(Overlapping and ad-libbing.)* He's a brother. He's one of us. Leave him alone. I'm not going to bite a brother. So what are we going to do? Let's get out of here. *(Spiders scatter.)*

DOÑA: *(Surprised by what she sees.)* So, you do have some power. You're not such a dummy after all.

SNAKE: What do I have to do to get you to let her go?

DOÑA: Answer my riddles.

SNAKE: I know this game. They're *adivinanzas*.

DOÑA: If you answer, she's cured. If you fail she dies.

SNAKE: You'll let her go if I answer the *adivinanza*?

DOÑA: Yes. What is full of meat by day, but full of air by night?

SNAKE *(Thinking.)* A shoe!

DOÑA: Not bad. What is black as coal, tells jokes, prays, is in every book and speaks every language?

SNAKE: *(Repeating.)* Black as coal. Tells jokes, prays, is in every book, speaks every language. Paper … no wait, I get it. Ink!

DOÑA: Confound it!!!

SNAKE: Now let her go.

DOÑA: Not so fast … here's the last one. He who makes it, doesn't use it. He who sells it doesn't use it. But *(Pointing to SHERI.)* she who uses it won't ever see it.

SNAKE: The ones who make it and sell it never use it. But she who uses it never sees it. Just a minute.

DOÑA: She has all eternity to think.

SNAKE: You're talking about a coffin!

DOÑA: Lucky guess! You win! I guess I'll have to "let her go."
(DOÑA motions to SHERI. SHERI gives off a shudder and goes dead.)

SNAKE: What did you do to her?

DOÑA: *(Crackling with laughter.)* I let her go.

SNAKE: Sheri! My God! Why didn't I believe! How can I help you now? If only I knew a spell to break your evil magic.

DOÑA: Too little, too late.

SNAKE: Wait, I remember now. Abuelita's spell. *(Casting spell.)*
Cacahuates, Cascabeles
Ponte trucha, don't be jealous.
Throw in a pinch of chile powder
for a spell of *mucho* power!
¡Arriba! ¡Arriba! Little flower!
(SHERI rises.)

DOÑA: How did you do that! Can't you see that I'm just doing my job? How am I going to make my quota this week? I'll just have to take you instead! *(DOÑA starts to attack SNAKE.)*

SHERI: Joaquin! *¡El Ojo de Dios!* The god's eye! The god's eye *La Llorona* gave us!
(Snake pulls off the god's eye and in the ensuing battle pokes out DOÑA'S eye.)

DOÑA: Ouch! My eye! You've blinded me! Oh me, oh my! You'll hear from my lawyer about this! I'll sue! I'll sue! *(DOÑA exits.)*

SHERI: Joaquin …

SNAKE: *La Muerte* … I answered her *adivinanzas. El ojo de dios.* Hey!! This is so cool. I'm speaking Spanish. I never thought I'd be this cool.

SHERI: Joaquin … *(Hugging him.)*

SNAKE: Hey, well, like I had to save my favorite sister.

SHERI: I'm your only sister!

TIA: *(Entering.) Mis hijos.* What's going on? Are you all right?

SHERI: *Tia* Juanita! *(Hugging TIA.)* We've been looking all over for you.

TIA: Why, I was here all the time.

SHERI: Abuelita's dying. A *bruja* was trying to keep us from finding you … .

SNAKE: And we got lost … .

SHERI: And then we ran into *La Llorona* … .

SNAKE: And then *Doña Sebastiana* … .

TIA: Slow down *hijos,* slow down. One thing at a time.

SHERI: Abuelita has the *mal de ojo.* She needs you to help her.

SNAKE: We have a shopping list. *(Hands TIA the list.)*

TIA: *(Taking the list and looking it over.)* Don't worry. She'll be all right. I'll cure her.

SHERI: You'll have to come to Denver with us.

SNAKE: But the car is broken.

TIA: Don't worry, your *Tio* Joe'll fix it. Here he comes now. You remember him don't you?

TIO: *(Entering with a wrench in his hand.)* Joaquin, is that you? Sheri, look at you, you're so big! *(He hugs SHERI.)*

SHERI: *Tio* Joe! *(Hugging him back.)*

TIO: I found this rattler stuck in the radiator. *(SHERI jumps with fear.)* What did you guys hit?

SNAKE: Sheri said it was a mirage.

SHERI: OK, I was wrong. Tia, are you really a *curandera?*

TIA: Why, yes.

SNAKE: Are you a *bruja?*

TIA: A witch! Me? Don't be silly. Witches only exist in fairy tales.

TIO: Hah! You should see her with a broom!

SHERI: How about *duendes?* Are they for real?

TIA: Well, your *Tio* Joe looks like a dwarf, *que no?*

SNAKE: A little.

SHERI: *Tio* Joe, what do you think? Is there magic up here in Chimayo?

TIO: Who knows?

TIA: Some people say yes, some people say no.

SNAKE: I say yes.

TIO: Ah baloney. That's kid stuff. Stories. Fairy tales. *Puro cuentos … .*

Song #6
COMPANY
And now we're going to end for you these puros cuentos
About what happened in a valley far away
Two city kids in quest of miracles and magic
Who found out there's more to life than merely play.
Snake was his name and he was quite a "vato loco"
His sister Sheri was the fairest of them all
In their Chevy they would cruise along the highway
Passing up cars on the wrong side of the road.
One day they broke down right outside Chimayo
A giant snake smashed in their hood and in their brains
"Hey Sis," said Snake, "this place is weird, let's head on home,
I think the air up here is making me insane."
So now we'll end this story here on a bright note
Brujas and duendes, strike the set, por favor
The curtain falls, house lights come on, adios amigos
This was a teatro with much fun and much sabor!
(Song ends)

THE END

18

Visual Arts—
The Chicano Muralist Movement

Along with the development of the *teatro* movement, Chicano communities witnessed in the 1960s the blossoming of the Chicano mural movement. Throughout *barrios*, Chicano neighborhoods in the Southwest, as well as in other parts of the country, students and community activists painted large murals on the walls of schools, churches, stores, libraries, highways and public buildings. Even today, the Chicano mural movement continues to be a significant artistic presence in Chicano communities. The most casual exploration of a Chicano community will reveal the continuing vibrancy and importance of this art form.

The mural movement had its community origins in the rise of social activism among Chicanos influenced by the Civil Rights movement, the United Farm Workers' movement in California and the student activism of college campuses. Energized by the struggles and successes of other activists, Chicano artists recognized the enormous power of mural art to contribute to the awareness of Chicano issues.

The spirit of Chicano muralism reaches as far back as the pre-Conquest era of ancient Mexico, an era characterized by the intense visual creations of ancient cultures. The indigenous civilizations of Mexico utilized mural painting to express their mythic histories and spiritual cosmologies. At the great religious center Teotihuacán, near the Pyramid of the Sun, painted murals depict Tlaloc, the God of Rain. At Tulum, the ancient Mayan citadel, murals cover the Temple of the Descending Deity. The Mayans also painted sacred murals on the interior walls of the Temple of Warriors at Chichén Itzá. The Aztec *codices*, folding multipanel paintings, were mural-like stories of their culture, history and world. The Aztecs also painted the inner and outer walls of houses and temples of the City of Gods, their sacred city Teotihuacán.

These are just a few examples of innumerable instances of mural painting from the pre-Conquest era of Mexico's history. The rediscovery and affirmation of their indigenous heritage by Chicano activists led them to include this artistic legacy in their own murals.

Early Chicano mural artists were also greatly influenced by the work of *Los Tres Grandes*, the Three Great Ones: Mexican muralists Diego Rivera, José Clemente Orozco and David Alfaro Siqueiros. *Los Tres Grandes* were important models for Chicano activists, demonstrating how an artist could use mural painting for social and political causes, and were pioneering leaders of the Mexican mural movement beginning in the 1920s. Diego Rivera was

> Throughout *barrios,* Chicano neighborhoods in the Southwest, as well as in other parts of the country, students and community activists painted large murals on the walls of schools, churches, stores, libraries, highways and public buildings.

Each of *Los Tres Grandes* was central to leading the Mexican mural movement that became an important factor in the revolutionary fight for justice in Mexico.

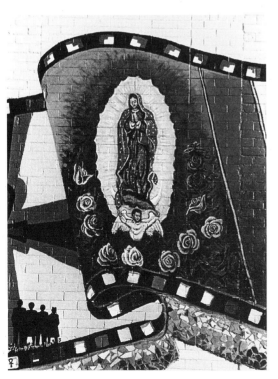

Figure 18.1. A section of a community-created mural with a religious theme, Our Lady of Guadalupe. Five Points Media Center, Denver, Colorado.

known for his magnificent murals illustrating the entire history of Mexico. José Orozco painted murals in a stark, dramatic style, lamenting the ravages of the modern industrial world on the human soul. His murals are famous for their depiction of Mexican workers. David Siqueiros not only painted impressive murals of humankind's struggle for justice and well-being, he also dedicated his time to assisting those fighting for social causes. His murals, with their themes of the revolution, reflected his lifelong support of political activity in Mexico.

Each of *Los Tres Grandes* was central to leading the Mexican mural movement that became an important factor in the revolutionary fight for justice in Mexico. Their murals portrayed working peasants in their noble work; the artists elevated to mythic status the history, life, work and aspirations of Mexico's working class. Each was a social activist as well as a powerful artist. They saw painting as the language of Mexico. They believed that mural painting, dating back to the pre-Conquest era, was the natural form of expression for the Mexican people. Together they led mural painting to the center stage of Mexican artistic consciousness. Through their work, mural painting became the genuine expression of the Mexican spirit, a true national art form.

Chicano artists used the example of *Los Tres Grandes* as models of what Chicano murals could be for the Chicano movement. They worked to create a mural movement, a public art that would express a collective vision of contemporary Chicano culture.

The Chicano mural movement was a public folk art. Its purposes were to illustrate Chicano history for ordinary people, demonstrate cultural pride and identity, reinforce community consciousness and empower communities in their struggles for social justice. Chicano mural artists created murals in response to the needs of their communities, and the public accessibility of mural art was critical to this movement because traditional artistic venues were closed to the Chicano experience. Another important aspect of the mural movement was the public ownership of the murals. The murals belonged to the community, not the artist, collector or gallery owner.

One reason the Chicano mural movement took off so quickly was that it was a community-wide event, a shared experience. While often an individual artist or group of artists were commissioned to paint a mural and did the work themselves, it was just as often the case that the artists were coordinators for the work of community members, both adults and children, on the mural. An often repeated but true bit of folk legend is the story of how a community would paint a mural, and it would remain unmarked by graffiti because of the respect community members had for it. A legendary enhancement of this story has graffiti artists filled with remorse for defacing a community mural and repainting it themselves.

Chicano murals are powerful artistic statements presenting many themes. Murals literally cover the totality of Chicano experience: Aztec mythology, imagery and heritage; the farmworkers' exploitation and efforts for unionization; the injustices of the judicial and police systems; the failure

of the education system; the devout sense of spirituality and Catholicism; the destructive evil of drugs; the awareness of ethnic pride; the veneration of cultural heroes; community issues and history as well as a catalog of other sociopolitical concerns. Artists create murals to educate their communities, to increase cultural sensitivity in observers, to express solidarity with the struggles of the community and to give artistic voice to the heart and soul of their people.

A wonderful example of the power murals can have on a community is the story of Chicano Park in San Diego, California. In 1970 the residents of *Barrio* Logan, a Chicano *barrio* in San Diego, asked the city of San Diego for a park. The city responded by building two freeways through the heart of the neighborhood and had plans for installing parking lots under the freeway spans.

The community rallied together and eventually won its battle with the city for a park, and the land under the freeways was declared Chicano Park. The neighborhood

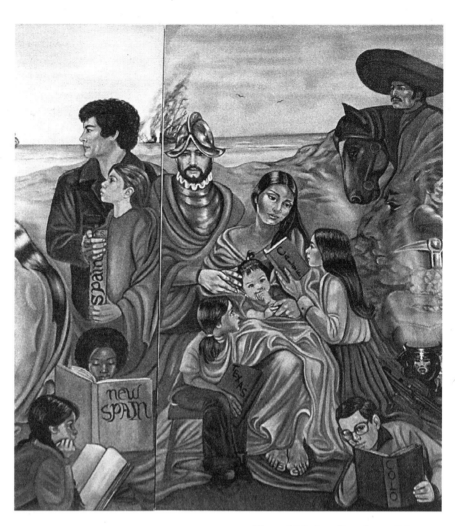

Figure 18.3. A section of an artist-created mural depicting Chicano history and culture, using community members as character models. Notice especially the face hidden at the far right of the mural. Byers Public Library, Denver, Colorado.

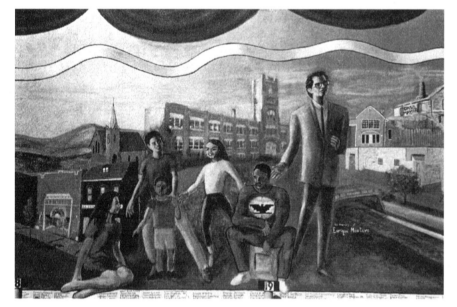

Figure 18.2. A portion of a community-created mural in memory of community artist Enrique Montoya and his work with young Chicanos. The Art Center of the West/Denver Civic Theatre.

Chicano artists ... worked to create a mural movement, a public art that would express a collective vision of contemporary Chicano culture.

residents soon painted murals on the concrete freeway-support columns, and these murals are what give Chicano Park its distinctive quality. Now Chicano Park is world famous, a local site pointed out by tourist buses passing over *Barrio* Logan on the freeways.

On the park's twenty-sixth anniversary, the community experienced another crisis when the city notified the community that the aging concrete support columns needed reinforcing, a construction project that would cause the destruction of the murals. The community rallied again, this time around their crucial desire to save the murals. Over the years, the murals had become a source of immense community pride and identification. The community voiced its realization that the mural

art must be respected as more than just simple paintings—it must be respected as important symbols and representations of Chicano culture for the residents of *Barrio* Logan.

Antonio Rodríguez, in his magnificent book, *A History of Mexican Mural Painting*, quotes Orozco in a statement that best expresses the sentiments and dreams of the Chicano mural movement:

Mural painting is the highest, most logical, purest and most powerful form of painting. It is also the least selfish, for it cannot be turned into an object of personal gain or be hidden for the enjoyment of a privileged few. It is for the people, it is for everyone. (1969, p. 492)

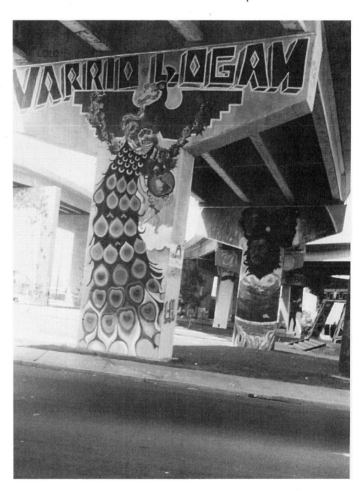

Figure 18.4. Barrio *Logan* freeway community murals, San Diego, California.

ACTIVITY—CREATING A CHILDREN'S COMMUNITY MURAL

Mural projects have a lot of potential for teaching, providing opportunities for both social and artistic learning experiences. As most murals are collaborative efforts, they teach important cooperation skills to students. In addition, the design and painting of a mural requires students to learn about color theory, picture composition, thematic development and the process of artistic choice.

This mural project describes a process to introduce children to mural art and guide them in the creation of a simple wall mural with a defined theme and unified composition. This project has been successful with students from upper-elementary to high school.

An excellent resource for the teacher or youth leader wanting to explore mural painting in greater depth is *Mural Manual: How to Paint Murals for the Classroom, Community Center, and Street Corner* by Mark Rogovin, Marie Burton and Holly Highfill, published by Beacon Press.

Materials

Createx paint, 32 fl. ounces. Createx paint is a water-based, nontoxic paint that is cheaper than acrylic and better than tempera paint. It can be purchased at art supply stores, and some school districts have it in stock. Acrylic is a longer-lasting paint, but it raises the cost of the project.

4 white	1 purple—secondary color
1 red—primary color	1 orange—secondary color
1 blue—primary color	1 brown
1 yellow—primary color	1 black
1 green—secondary color	

Mixing containers with lids. Have students save whipping cream and margarine containers.
Brushes. Stiff hog hair #2, #4, #6, #8, # 10 or inexpensive brushes from hobby supply store.
Paint shirts (Mom or Dad's old shirt)
Banner, plywood or masonite. A preprimed canvas banner can be purchased from American Canvas, Denver, Colorado; (303) 399-3232. Request a primed canvas with edges already sewn and with grommets attached. It comes in 4-foot widths and is cut to length size. A good size for a beginning mural banner is either 4 x 10 feet or 4 x 15 feet. A 4 x 8 sheet of masonite or plywood, with one side smooth grade, can also be used for the mural surface. If using masonite or plywood, first prime the surface with white gesso or white house paint.
Drawing paper, white construction paper
Pastels. They come in sets of twelve, twenty-four and forty-eight. The set of twelve is good for beginners. Alpha children's pastels are inexpensive and nontoxic.
Water-base markers can be used instead of pastels.
Buckets for cleanup
Color wheel for color-mixing demonstrations

Instructions

PREPARATION WORK

1. Introduce the students to mural art. Show them slides of murals. Check out books from the library about murals and mural artists and examine them with the students. Take a field trip to view murals in your neighborhood and city. Invite a mural artist to speak to your class.

2. Get to know your school or community. Have students interview teachers, each other and parents about the school or community: its history, its most beloved members, favorite anecdotal incidents, favorite memories. Read community literature.

3. Discuss the steps of making a mural with the students. If appropriate, this is a good opportunity to assign various duties to individuals or groups of students.

4. Discuss necessary decisions about your mural. Will it be permanent or portable? What size will it be? Where will it be painted? Who is the intended audience? Who will work on it? What will happen to the mural after it is finished?

5. Discuss and choose the theme of the mural. The theme should have a relationship to the class or community. Suggestions for themes are:

cultural diversity	cultural background	environment
family	neighborhood	historical
current events	important people	class topics
school activities	children's play	children's literature
legends	folktales	celebrations

6. Have students draw sketches based on the selected theme. Have discussions with the students about how their sketches relate to the theme.

7. Lead discussions about which student sketches to include in the mural.

8. With the students, design and compose a mural picture incorporating their sketches based on the intended theme.

PAINTING THE MURAL

Step 1: Drawing basics
Use pastels or markers to teach the drawing basics of line, shape, value, color, texture and pattern. Use the pastels and markers to teach about tinting, shading and color value—the lightness and darkness of a color:
Tint=color + white
Shade=color + black
Use the color wheel to teach about color mixing and about primary, secondary and intermediate colors.
Use the pastels or markers to practice color mixing.
Discuss the colors for the mural.

Step 2: Draw the rough outlines
Lay out the mural and draw the outlines of the mural images.
First method: Student drawn, free-drawing technique
Following the student drawing as guides, use paint and stiff brushes to outline the mural images. Make sure the outlines are large enough for the mural to be seen from a distance and can be filled with color. Have each student draw a person, animal or object to go with the intended theme.

Second method: Teacher drawn, student filled in, free-drawing technique
The teacher or artist develops a theme and preliminary sketches for the mural. The teacher or artist roughs in the outlines, and the students complete them.

Third method: Opaque projector tracing
The teacher, artist and/or students choose pictures or combinations of pictures for the mural. An interesting variation—and experiential enhancement—on this idea is to use photographs of students acting out the images of the mural. Project the images on the mural surface with an opaque projector.

Use a slide projector if the student photographs are color slides. Trace the image outlines onto the mural surface.

Step 3: Coloring in the outlines

Step three consists of painting in the outlines with a flat, basic color base and filling in the background color.

Mix paint colors in containers with lids. Make colors opaque by adding white to the primary, secondary and intermediate colors. It is necessary to make the paints lighter, whiter in value because paint without white mixed in is too bright and transparent.

Fill all of the mural with color and let paint dry before going on to the next step.

Step 4: Adding color texture

Step four involves adding color overlays to the flat color bases, adding texture by filling in the outlines and adjusting the color values of the mural by adjusting the lightness and darkness of the flat colors. This step is especially important for keeping your mural from having a flat two-dimensional look.

Adding a color overlay to the flat color bases consists of painting a second layer over the base color. The color overlay can consist of a contrasting or different color, which will be the final top surface color of the mural. The overlay is the color that will be manipulated in the next part of this step, the adding of texture.

Adding texture, or pattern, can be accomplished in several ways. The first is to use a dry-brush technique. To dry-brush, add a very little bit of paint to the brush and lightly brush over the selected mural part. A good image for children for this technique is to have them imagine the mural surface is very hot, so they can only touch the surface lightly. Because you do not load up the brush with a lot of paint, the brush is said to be "dry." The light brush strokes can be applied in straight, irregular or random patterns.

Another technique is to use a sponge to speckle the mural surface. Apply a small amount of paint to a sponge and dab the surface of the mural for an interesting texture effect.

A third technique is to use the brush to scrape paint off of the mural, using interesting variations in line and line direction. This technique reveals the bottom base layer of color peeking through the scraped lines.

A final technique to add texture is to use the brush to add a pointillism effect. Add a small amount of paint to the brush and dab many small points of color in a selected mural area.

The final part of this step is to adjust the color values by lightly targeting areas for light and shadow relief. This is accomplished by over-painting with small, light amounts of the surface color, which has been adjusted by the addition of white or black.

Let the paint dry thoroughly before proceeding to the final step.

Step 5: Finishing details

Add details: eyes, noses, jewelry, shoestrings, small objects, small parts, etc.

Think of repetition. Use and repeat patterns. For example, stripes on a shirt, spots on a dress, leaves on a tree, bricks on a wall.

Finish the mural by going over the outlines again with a dark paint to redefine the shapes. This step will help give dramatic contrast to the shapes and help redefine the design elements to the students.

After the paint is completely dry, finish and protect the mural by coating it with an acrylic varnish.

19

Literary Arts

For our discussion of the literary arts we will use a slightly different breakdown of the historical eras in the Hispanic Southwest than used in other chapters of this book. The four eras defining the evolution of the literary arts in Hispanic culture in the Southwest are Spanish colonial (1598–1821), Mexican (1821–1846), Mexican-American (1846–1960s) and Chicano (1960s–present).

As has been discussed in previous chapters, the Aztecs had a flourishing artistic culture at the time of the Spanish arrival in the New World, and their literary arts were especially developed. Aztec *codices*, a type of visual narrative recording history and cultural practices, were an important part of the indigenous literary heritage collected by the Spanish. Aztec poetry was especially profound, reflecting the people's love of nature and consciousness of their status as a chosen but doomed people. They also had a complex pantheon of gods and an oral tradition of stories about them. These *codices*, poems and stories presented a literary legacy, which, centuries later, would greatly influence Chicano literature.

The Spanish brought to the New World the literary heritage of Spain's sixteenth-century Golden Age. The *conquistadores*, missionaries and later settlers had Cervantes and Lope de Vega as their literary legacy,

The *conquistadores,* missionaries and later settlers had Cervantes and Lope de Vega as their literary legacy, and this heritage would define the literary arts in the Spanish colonial New World for three centuries.

and this heritage would define the literary arts in the Spanish colonial New World for three centuries. One of the soldiers in Oñate's colonizing expedition in 1598, Gaspar Pérez de Villagrá, began the Spanish literary tradition in the Southwest with his epic poem *La Conquista de la Nueva México,* or *The Conquest of New Mexico.*

During the Spanish colonial era, the primary literary forms were historical, religious and oral folk literature. Historical plays such as *Los Moros y Christianos* recounted great historical Spanish victories. Religious plays such as *Los Pastoreles* originated in Medieval Spain and supported the work of the Catholic Church in establishing and maintaining its religion in the New World. The great oral literature of *cuentos, dichos* and *adivinanzas* (stories, proverbs and riddles) was firmly established in Spanish tradition and widespread throughout the Southwest.

During the short Mexican period, the literature, both written and oral, of the Spanish colonial period continued. The plays, which were historical and religious, and the *cuentos* continued to be active in the daily lives of the Mexicans of the northern frontier. These Spanish colonial traditions were extended by the introduction of *corridos,* narrative songs and, because of the proliferation of

the printing press, an increase in the publication of poetry and prose. The picaresque novel and autobiographical accounts were especially enjoyed prose forms.

The long period from 1846 to the 1960s was a time of great social, political and cultural change for the Hispanic Southwest. The area became American in 1848 with the Treaty of Guadalupe-Hidalgo, and the Mexican Revolution in 1910 caused another cultural upheaval and further immigration of Mexicans into the United States. These two factors were critical in the development of the Chicano literary movement in the 1960s.

During the latter part of the 1800s, numerous Spanish-language newspapers began publishing throughout the Southwest. These newspapers published poetry, short stories and serialized novels, and in many ways were the literature of the common folk.

The great immigration of Mexican workers and educated professionals after 1910 caused another change in the literary habits of the Southwest. Publishing houses began producing novels, many with stories set in the context of the Mexican Revolution. After the depression, the literary writers continued to expand their themes, exploring personal narrative, social history and social commentary.

A major literary development that began in the late 1800s and continued into the twentieth century was that many authors began writing in English. This language change made the works of these authors available to the much larger English-speaking audience.

All the literary and historical events of more than 350 years came to focus in the Chicano movement of the 1960s. The writers of the Chicano movement gave literary voice to the realization that Chicanos had their own historical, cultural and aesthetic heritage and identity. These writers, along with visual artists, theater artists and community activists, used the arts to explore the issues of Chicano communities.

Chicano poets Rodolfo "Corky" Gonzales, Alurista and Abelardo Delgado created a Chicano poetry that served as political, social and artistic expression. Novelist Tomás Rivera and Rudolfo Anaya wrote novels that would set standards for later generations of Chicano writers. Publishing houses such as Arte Publico Press dedicated themselves to publishing the works of Chicano writers.

Chicano writers used all of history as their sources and inspiration. The myths and legacy of the Aztecs created the artistic homeland of Aztlán for Chicano writers. Spanish and English both served as expressive languages for these writers, their works often reflecting the bilingual world they lived in. Their themes covered the full gamut of the Chicano experience, including Aztec spiritualism, Mexican revolutionary pride, Catholic religious beliefs, oral folklore traditionals and political and social issues. The writers explored their complex history, traditions, religion and culture and used literature to create images and metaphors for Chicano social conditions and yearnings. The purpose of their work could not have been more noble: personal and community self-awareness and cultural pride.

The following is a selection of representative literary works by writers of the Chicano movement. The list, of course, is by no mean comprehensive or complete, but it does include many books that would

Chicano writers used all of history as their sources and inspiration. The myths and legacy of the Aztecs created the artistic homeland of Aztlán for Chicano writers.

appear in any expert's top-ten list and is representative of many of the best recognized Chicano writers. View these books as a quality introduction and foundation to Chicano literature that will prepare you for your own discovery of other Chicano writers.

The recommended activity, of course, is to read as many of them as you can. These stories are intended for adults and mature teens, offering important cultural, historical and personal insight into the Hispanic experience in the United States.

Bless Me Última by Rudolfo Anaya (Warner Books, 1994). The literary classic by an author acknowledged as one of the deans of Chicano literature. Set in northern New Mexico, it tells the poignant story of a young boy and *la Grande 'Ultima,* and how she teaches him about life. Especially moving portrayal of family life and cultural traditions. (Excerpted from book cover.)

Tomás Rivera: The Complete Works by Tomás Rivera (Arte Publico Press, 1991). Rivera is the acknowledged father of the Chicano literary movement. His prose, poetry and essays set the standards for Chicano writers who followed him. His greatest masterpiece is *Y No Se lo Tragó la Tierra/And the Earth Did Not Devour Him.* In twelve thematically linked stories, the book tells the story of the migrant farmworkers' plight, as seen through the eyes of a child. (Excerpted from book cover.)

House on Mango Street by Sandra Cisneros (A. A. Knopf, 1994). Award-winning book by contemporary Chicana author about growing up Chicana in Chicago. Poignant story told through the eyes of a young girl. (Excerpted from book cover.)

So Far from God: A Novel by Ana Castillo (W. W. Norton, 1993). A story of a New Mexican family of four exceptional sisters. A triumph of magical realism, sly social commentary and feminist perspective that is both funny and heartbreaking. Includes anecdotes about *santos* in the lives of the characters. (Excerpted from book cover.)

Barrio Boy by Ernesto Galarza (Ballantine Books, 1971). Autobiography of a young boy's youth in Mexico and his family's move to the United States. Galarza grew up to be an important Chicano labor organizer, scholar and activist. He was one of the first Chicanos to receive a Ph.D. (Excerpted from book cover.)

Drink Cultura: Chicanismo by José Antonio Burciaga (Capra Press, 1992). An entertaining and enlightening collection of essays with a variety of topics revolving around one common denominator: *Chicanismo,* the life and culture of Chicanos in the United States. Funny, insightful, thought-provoking. (Excerpted from book cover.)

Rain of Gold by Victor Villaseñor (Arte Publico Press, 1991). The story of the Villaseñor family, from idyllic Mexico to Prohibition-era United States. A love story as well as a family odyssey. A literary masterpiece. A Chicano *Roots.* (Excerpted from book cover.)

Pocho by José Antonio Villarreal (Anchor Books, 1989). Set in depression-era California, this novel tells the story of *pochos,* Americans whose parents

came from Mexico. The story details the conflicts between two lives—the traditional life of the family's past in Mexico and their new life in America, as well as the culture shock experienced by immigrants. The first significant Chicano novel. (Excerpted from book cover.)

Juanita Fights the School Board by Gloria Velásquez (Pinata Books, 1994). The first novel in Velásquez's *Roosevelt High* series. A Ph.D. poet and known as the "first Chicana Judy Blume," Velásquez created the *Roosevelt High* series to present stories featuring characters with whom all characters can relate, especially U.S. Hispanic children. The stories in the series deal with the traumatic issues facing today's youth. (Excerpted from book cover.)

Yo Soy Joaquin—I Am Joaquin by Rodolfo "Corky" Gonzales (available from Cultural Legacy Bookstore, 3633 West 32nd Avenue, Denver, CO 80211; (303) 964-9049. A heroic, epic poem tracing the roots of Chicano heritage and politics. The poem covers Aztec mythology, Mexican history and contemporary Chicano sentiment. Joaquin is the personification of all Chicano people and their struggles. The poem was immensely influential in the Chicano movement and helped define Chicano political and cultural identity. (Excerpted from book cover.)

Luis Valdez—Early Works: Actos, Bernabe, and Pensamiento Serpentino and *Zoot Suit and Other Plays* by Luis Valdez (*Actos,* Arte Publico Press, 1992; *Zoot Suit,* Arte Publico Press, 1992). Valdez is the most important and influential of all Chicano playwrights. His plays are central to the history and development of the Chicano movement and are amazingly entertaining dramatic literature. (Excerpted from book cover.)

After Aztlán, Latino Poets of the Nineties edited by Ray González (D. R. Godine, 1992). The first comprehensive poetry anthology of Latino poets who write primarily in English. The best of contemporary Latino poets. (Excerpted from book cover.)

20

New Arts

LOWRIDER CARS

"Low and Slow." The motto of lowriders throughout the Southwest. In Los Angeles, San Antonio, Houston, San Francisco, Phoenix and the lowrider capital of the world, Española, New Mexico (this is one good way to start an argument!), as well as many other cities throughout the Southwest, exotic custom cars cruise the streets in their full majesty.

As a folk art, the lowrider car symbolizes a cultural pride and identification that it shares with other more traditional folk art. The lowrider car has become a unique part of the Chicano experience, a focal point of many aspects of Chicano life in the *barrio*.

Befitting its position as a modern folk-art form, the origins of lowrider cars are clouded by legend and personal versions of lowrider history. One version of their origin has it beginning in the 1930s and later being part of the zoot suit cultural expressions of the 1940s. Another tells the story that lowrider culture began in the 1950s when Chicano youth, too poor to build expensive custom cars, simply removed the front suspension coils and rear leaf springs, thereby creating a low-sitting car. These early car customizers were part of the hot rod era of the 1950s, which in their own words produced cars "chopped, channeled and lowered."

In her essay, "Remapping: Los Angeles Lowriders" (a chapter in her book, *Looking High and Low*), Brenda Bright places the origins of the lowrider name "tag" in the 1960s. According to her version of lowrider history, the modern lowrider evolved from the low custom look of the 1950s when the California State Vehicle Code outlawed car chassis bodies riding lower than the bottom of the wheel rim. In order to evade this limitation, lowriders began installing airplane and industrial hydraulic pumps to their suspension systems. These hydraulic systems allowed the lowriders to raise their cars when necessary. And as they say, "the rest is history."

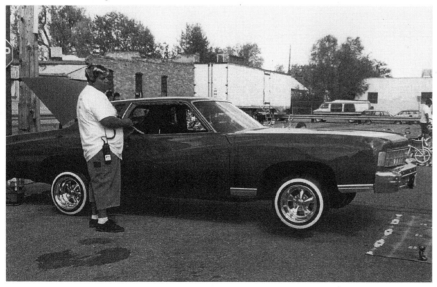

Figure 20.1. Alfredo Herrera "hops" his award-winning lowrider car.

An extremely important part of the lowrider experience, and the clubs that form around them, is their potential to be a positive alternative to the street and gang life afflicting Chicano communities and youth. In magazines dedicated to lowriders, articles and letters to the editor give testimony to lowriders as being a positive outlet for Chicano youth, if led by older, more responsible men of the community.

The lowrider car is a highly developed artistic statement: The art of lowriders can be compared to that of the Chicano mural movement. Lowrider artists paint their cars with highly detailed and colorful scenes, with images similar in content to those in murals: Aztec warriors, fanciful geometric designs, personal images and Catholic religious icons—Our Lady of Guadalupe being the most frequent. Indeed, because of their extraordinary paint jobs, the lowrider car can be seen as a moving mural.

The cars themselves are amazing artistic creations. Originally, the cars were American classics from the 1950s and 1960s, but recently foreign cars and minitrucks have been customized into lowriders. Outfitted with expensive paint jobs, plush interiors, sound systems rivaling the best home-stereo systems, special chromed wheels and, of course, the unique hydraulic systems giving the cars their distinctive hopping ability, a lowrider car can be a very expensive expression of cultural and personal pride. Lowriders with less financial resources will build their cars from inexpensive used vehicles outfitted with a simple hydraulic system and a special set of inexpensive wheel rims.

Lowrider cars fall into three distinct categories. "Bombs" are classic American cars built between 1939 and 1958. "Traditional" cars are full-size American cars built between 1959 and 1996. "Euros" include sports cars, imports and trucks.

At lowrider shows, cars are judged in three categories. "Street customs" are built without any sponsorship or professional assistance. "Mild" are cars built with some professional assistance. "Full custom" cars are the elite, extraordinarily expensive show cars built by a professional customizing shop.

A central aspect of the lowrider experience is its reflection of Chicano pride. Lowrider magazines and car shows include expressions of Chicano issues and the importance of cultural awareness. Car owners speak to the pride they have in their cars and their culture.

The cars themselves are amazing artistic creations. Originally, the cars were American classics from the 1950s and 1960s, but recently foreign cars and minitrucks have been customized into lowriders.

LOWRIDER BICYCLES

A recent development in the lowrider world is the lowrider bicycle. By customizing a bicycle, Chicano youth, usually junior high and high school–aged students, can participate in the lowrider experience before they are old enough or have the financial means to build a lowrider car.

The lowrider bicycle is also an amazing creation. Sitting so low to the ground that its pedals cannot turn, tricked out with elongated frames, chromed and painted just like their big brothers, the lowrider car, the lowrider bicycle is a personal artistic statement. It is common to see lowrider bicycles displayed at Chicano community festivals. The young builders proudly present bicycles artistically positioned over engraved mirrors, pulling miniature trailers holding portable sound systems.

As a modern folk art in Chicano communities, the lowrider car and bicycle are the symbols of individual aspiration, the expression of artistic craft and skill and an accepted part of the Chicano community experience. From their beginnings as a fringe experience of car customizers, lowriders have evolved into their present cultural acceptance to such an extent that it has become commonplace for community fairs and festivals to advertise their lowrider car and bicycle shows as part of the festivities. Also, the lowrider car show with its cars, music and festive atmosphere has become a *fiesta* of Chicano cultural life in *barrios* throughout the Southwest.

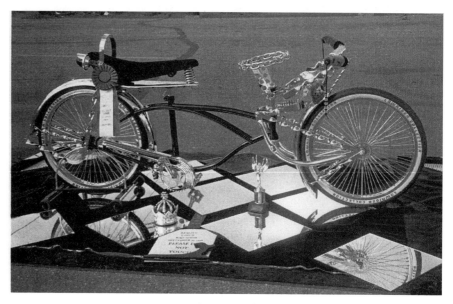

Figure 20.2. Teenager Leroy Rodríguez's award-winning lowrider bicycle creation.

21

Traditional and Celebratory Foods

Panza llena, corazón contento.
Full stomach, contented heart.

El pan partido, Dios lo aumenta.
God blesses the bread that is shared.

In the Aztec creation legend of the Five Suns, Quetzalcoatl, one of the Aztec's supreme gods, transforms himself into an ant in order to enter a sacred mountain. Once in the mountain he steals *maíz*, "corn," and like the Greek Prometheus bringing fire to humans, he introduces this staple of life to the Aztec people.

This legend and its description of how corn came into Aztec life illustrates the importance of corn to the native life that existed when the Spaniards arrived in the New World. Corn was a New World food, the most important food staple for native culture. In time, corn became a central staple for the Spanish also. As with so many others aspects of Hispanic life in the American Southwest, the history of food is the history of the blending together of Native American and Spanish customs and practices.

Even though the Spaniards brought with them the tastes and traditions of European foods, they quickly adapted to the foods of the New World. The indigenous cultures all had their own food practices, plus a specialized knowledge of the land and its agricultural possibilities to produce native foods. The natives introduced the Spaniards to corn, beans, tomatoes, potatoes, pumpkins, turkey, chocolate and *chiles*. *Tortillas* and *atole* (a thin-liquid blue cornmeal drink) are two of the native foods adopted by the Spanish. A few of the foods the Spaniards in turn introduced to New World cooking included pigs, rice, wine, wheat, cinnamon, black pepper, garlic, lettuce, carrots, oranges, peaches, apricots and milk and cheese, which came from the cows and sheep they brought from Spain.

Over the centuries, Hispanic culture developed a cuisine integrating both native foods and Spanish traditions. Present-day Hispanic foods are a combination of Native American, Mexican and Spanish influences. *Chile con carne*, *chile* with meat, and *tamales*, meat and *chile* wrapped in steamed cornmeal dough, are two examples of the combination of New World and Old World foods.

It is important to remember that Hispanic foods developed in a culture that was rural and agricultural. Hispanic people, like all other people forging a life based on the land and self-reliance, got their food from the land they worked and the animals they raised. Food was planted, grown and harvested. Animals were raised and slaughtered, with every part being utilized. The diet of the early Hispanic settlers was determined by how successfully they worked their farm. The food of present-day southwestern Hispanic culture is easily recognized as having originated on the farm and being

Present-day Hispanic foods are a combination of Native American, Mexican and Spanish influences.

> The foods of the Hispanic Southwest ... share basic staples with the foods of Mexico. And the cultures of both regions share a culinary heritage with Native American foods.

based on the necessities of agricultural life, without the conveniences of modern store-bought foods.

A folk saying states that a true Mexican eats only corn, rice, beans and *chile*. While this statement has an element of truth to it, representing as it does the basic staples of the Hispanic diet, it does not allow for the wide variety of foods found on Hispanic tables throughout the Southwest. Eating practices vary from family to family, region to region. Southwestern Hispanic cuisine is as varied as Hispanic people are.

While there are restaurants that advertise a specialty in Spanish or Hispanic foods, the most common practice is to categorize it all as "Mexican food." This is obviously an oversimplification, for Mexico has its own varied and rich cuisine, often without any similarity to food found in the Hispanic Southwest. The foods of the Hispanic Southwest do, however, share basic staples with the foods of Mexico. And the cultures of both regions share a culinary heritage with Native American foods. The *enchilada* is one ready example of this cultural cross-fertilization. The Spanish simply took the Aztec dish known as *chilaquiles,* added cheese, onions and a fried *tortilla* and created the *enchilada.*

The recipes presented in this section of the book are meant to serve as representative examples of traditional southwestern Hispanic foods. For the cook interested in exploring further southwestern Hispanic foods, there are numerous excellent cookbooks that provide a much deeper presentation of the great variety found in this cuisine. Many of the cookbooks feature recipes for delicious variations on traditional foods. These recipes have in their own right introduced even more variety into Hispanic cuisine.

The recipes presented here are for traditional foods found in Hispanic homes all over the Southwest. Several of the recipes are for foods associated with seasonal celebrations.

A favorite joke among Hispanics is the answer to the question, "What is the best Mexican food restaurant in town?" Of course, there is only one answer, "My mom's house." Of course, there is some truth to this joke, for the food of one's home is the food of one's warm childhood memories. I have included two of my mother's own recipes: her *chile* and her beans.

The recipes (with the exception of the *chile* and the beans) are presented with the generous permission of Angelina Delgado of Santa Fe, New Mexico, who is a master folk artist in tinwork. She is part of a five-generation family of tinsmiths whose grandfather was the renowned New Mexican tinsmith Don Francisco Delgado, whose picture is on page 84.

The recipes are adapted from the cookbook *Comidas de New Mexico* by Lucy Delgado, Angelina Delgado's sister (the cookbook is available from Angelina D. Martinez, 1127 Maez Road, Santa Fe, NM 87505). Also an accomplished tinsmith, Señora Lucy Delgado was, in addition, recognized as a master cook and a repository of cultural knowledge about the traditional foods of the Hispanic Southwest. These recipes are the result of her dedication to preserving for future generations the foods of her family kitchen.

CHILE

We might as well start at the center of Hispanic cuisine. The heart and soul of southwestern Hispanic food is the *chile,* and the following poem by the esteemed Chicano poet Abelardo Delgado best presents the spirit of *chile* in the Hispanic soul.

CHILE
by Abelardo Delgado

Symbols come, symbols go
but for those in the know
a chile
best explains
the culture of my gente,
PICOSEO PERO SABROSO
Pico de gallo,
salsa picante,
as well as jalapeños,
have carried on
an invasion of their very own
into gringolandia.
We can now say,
As American as chile,
and I'll bet
we are right.
Chile bola,
chile serrano,
chile pasilla, chile piquín,
chile güero,
chile para rellenar
and chile all around.
As to why
some think
chile best depicts
our gran cultura,
it's because it, like us,
gives life flavor.
Chile en el menudo
and chile in los frijoles,
chile con carne
and chile dogs.
Soon there will be
chile ice cream.
In football
we'll have
our own chile bowl.
We hang in Aztlan
like chile ristras in the sun.
As Aztec myth has it,
it was a handful
of chile pods
that drove Quetzalcoatl away
to return that chile colored day.

Figure 21.1. Roasting chile *the old-fashioned way. Cooking* chile *in a traditional* horno *and stringing* chile ristras. *Jarales, New Mexico, 1939.*

Chile is more than a sauce, a condiment, a flavoring, an ethnic cooking ingredient, a hot pepper. *Chile* is more than just the most distinctive ingredient in Mexican and southwestern Hispanic cooking.

Chile is a source of cultural pride. It is the pride of your mother's kitchen. It is the pride of learning how to skin the pods for the first time. It is the pride of knowing your *chile* is better than any other in the neighborhood. It is the pride of finally being able to sit at the table with the men and match them spoonful for spoonful. It is the pride of telling all within earshot that this year's batch is the hottest ever, wiping your brow and serving another helping. It is the pride of winning first prize in the best *chile* contest.

Two of my own family anecdotes illustrate the importance *chile* plays in the life of a family's meals. As a child we lived in Kansas City, and my mother and father both longed for true New Mexico *chile*. Each year when the *chile* harvest was happening in New Mexico, my uncle would dutifully pack a box of fresh-picked *chile* and send it by the bus overnight to Kansas City. As soon as we were notified by the bus station that the package had arrived we, as a family, would trek to the station and claim the longed-for package. The Holy Grail itself would not have been more welcomed. An especially funny memory of this scene is the pungent odor of fresh *chile* that filled the bus station when we entered.

Another childhood memory is of a different uncle in a fancy restaurant taking a container out of his jacket pocket, opening it and pouring homemade *chile* on his meal. He honestly and simply could not stand a meal, no matter how good or how expensive, without his own *chile*.

In many southwestern cities in the early fall, the streets are marked with *chile* stands, with vendors selling *chile* by the sack and roasting it on the spot for the customer. Then begins the family chore of peeling the *chile*, packaging it and storing it for a future time.

While there is no substitute for fresh *chile*, there are other choices the cook has if none is available. Modern stores stock frozen and canned *chile*, and powdered *chile* is readily available, as are *chile* sauces and salsas. Jalapeños, fresh or pickled, can serve as a green *chile* substitute. Each of these products has its own best use and will add its spicy flavoring to a meal.

There are many different types of *chile*. Each varies in look, size, texture and, most important, hotness. The critical ingredient giving *chile* its hotness is an oily acid called capsaicin; the hottest *chile* is the *habanero*, and it is usually the rule that the smaller the *chile*, the hotter it is.

The standard cooking *chile* is the *poblano chile*, and two of the most common types are the Anaheim and New Mexico Green. Each is a bright green *chile* about 6 to 7 inches long. Both *chiles* are usually roasted and used in green *chile* sauces and *rellenos*. *Chile* growers argue over which and whose *chile* is the superior *chile*—it is truly an argument that will never be settled.

When buying fresh *chiles*, look for shiny and unblemished skins. Also feel them and buy those that are dry and heavy for their size.

There are as many recipes for *chile* as there are cooks. Some like their *chile* like a sauce. Some like it thick. Some fix it with meat, others, vegetarian. Some add corn, potatoes, onion and tomatoes. Some prefer green *chile*, others, red *chile*, which is really just green *chile* pods

Chile is a source of cultural pride. It is the pride of your mother's kitchen. It is the pride of learning how to skin the pods for the first time. It is the pride of knowing your *chile* is better than any other in the neighborhood.

that have matured and aged into red pods. As the pod ripens, it becomes sweeter and more flavorful. A common site in the Southwest is a wreath or string of red *chile*, called a *ristra*, hanging outside the home.

Before they can be used, *chiles* must be roasted and peeled, which helps remove the bitter skin and bring out the chile's flavor. There are many methods of roasting *chiles*, but the easiest is to have the *chile* vendor roast them for you before you take them home. If you decide to roast them yourself, wear rubber gloves and whatever you do, do *not* rub your face or eyes. Many a cook has regretted a simple gesture to the face while peeling *chile!*

One way to roast *chiles* is to spread them on a pan in a medium-hot oven. The house will be filled with the delicious and unmistakable smell of roasting *chile*, and if your windows are open, so will the neighborhood. Turn the *chiles* until they blacken and blister. When they are fully blistered, remove them from the oven and place them in a paper or plastic bag. Let then steam for about fifteen to twenty minutes. After they have steamed, the skin should peel off easily. Do not peel under running water because this removes the oils and smoky flavor of the *chile*. Remove the skin, ribs, seed, and core of the *chile*. The remaining *chile* meat can then be used immediately, stored for a few days or frozen for use at a later time. One of the great pleasures of life is to take out a bag of frozen *chile* in the cold winter month of January, thaw it and make a fresh batch of *chile verde*.

An excellent book about the history and traditions of *chile* is *The Chile Chronicles: Tales of a New Mexico Harvest,* by Carmella Padilla (Museum of New Mexico Press, 1997). It contains extraordinarily beautiful photography.

Carmen Jean's *Chile Verde*

Here is my mother's own *chile* recipe. (Keep it a secret!)

1 pound lean pork steak, cut into small cubes
2 tablespoons vegetable oil
2 tablespoons flour
2 cloves garlic, crushed
1 cup chopped fresh green chile *(used frozen or canned if you have to)*
1 14-ounce can chopped tomatoes
2 cups water
salt to taste
optional: 1 medium onion, chopped; 2 medium potatoes, cubed, to tone down the heat if the chiles *are too hot*

Fry the meat in the oil until brown. Add the flour to the meat and stir until the meat is covered with the flour. Mix the garlic and *chile* together, adding the mixture with the tomatoes to the meat in the pan. Add the optional ingredients if desired. Pour in the water and simmer for approximately 30 to 40 minutes. Adjust the water amount to desired thickness.

Serves 4 to 6, depending on how much you serve and how hot you like your food.

FRIJOLES—PINTO BEANS

Beans, beautiful beans! No meal is complete without beans. Beans in burritos. Beans with *chile*. Beans with cheese. Beans with onions. Beans with *chicos* (corn). Beans with ham. Beans by themselves. Beans with everything. Beans freshly made, beans refried. Beans as a side dish

or the main course itself. Beans are basic nutritious food, and there is no end to their possibilities.

Many a parent, with the end of the month at hand and the paycheck still days away has proudly announced, "Only beans for the rest of the month!"

Before beans can be cooked, they must be cleaned. A ritual in itself, the cook must sort the beans, separating out the rocks and debris that accompany the beans on the journey from the farm to the kitchen.

Individual opinion varies on how best to prepare the beans. Some cooks put the beans right in the pot and start cooking them. Some swear by soaking them overnight. Some use an old-time pressure cooker to speed the process. The modern cook throws them all in the Crock-Pot, adds water and ingredients according to the secret family recipe, puts the lid on and walks away. Soon the house is filled with the unmistakable aroma of cooking beans.

Beans are basic nutritious food, and there is no end to their possibilities.

Carmen Jean's Beans

2 cups dried pinto beans
5 cups water
1 clove garlic, diced
1 cup onion, diced
1 cup pork or ham-hock, diced

Sort the beans, cleaning out the rocks and debris. Wash the beans after cleaning and put them in a Crock-Pot and cover with water. Add garlic and onion. Add pork or ham hock. (It is possible, of course, to make the beans without the meat for dietary or health reasons, but the flavor is lessened.) Put the Crock-Pot on high. Monitor temperature and reduce to low when water becomes hot, almost boiling. Monitor water level. If water drops below level of beans add hot water to cover beans. When beans are cooked to tenderness, eat and enjoy.

Serves 4 to 6.

TORTILLAS

Hecho a mano, hecho de harina, hecho con cariño.
Made by hand, made with flour, made with love.

Tortillas are another basic food of the Hispanic culture. Flat like a pancake, they are the bread staple enjoyed by all with their meals. The recipe presented here is for flour *tortillas*.

The original *tortilla* was made from corn in a long arduous process. Women would first soak dried corn in lime water, then mashed the softened corn in the *metate*, a concave grinding stone, with the *mano*, a handheld stone. This ground corn became the *masa*, which was patted by hand into round little pancakes and cooked over the fire or on a griddle.

Today, of course, cooks go to the store and buy packaged *tortillas*. But just like homemade *chile*, there is no better taste than fresh-made *tortillas*, hot off the griddle.

Flour *Tortillas*

4 cups flour
1 1/2 teaspoons baking powder
1 1/2 teaspoons salt
2 tablespoons shortening
1 1/4 to 1 1/2 cups warm water

Sift flour, baking powder and salt together. Cut in shortening, add water and knead dough until well mixed. Form into balls about 3 inches in diameter and roll out into round flat-shaped cakes about 1/8 inch thick. Cook on hot griddle, flipping *tortillas* to cook on both sides.

Makes approximately 18 tortillas.

The perfect *tortilla* is round with light brown spots. A common joke is for cooks to dismiss their *tortillas* by saying, "My *tortillas* come out shaped like Texas."

The original *tortilla* was made from corn in a long arduous process.

CALABACITAS —GREEN SUMMER SQUASH

Calabacitas is a delicious way to enjoy green summer squash. Easy and fast to make, it is a great side dish to any meal. A tasty Mexican variation adds Monterey Jack cheese, red and green peppers and picante sauce. Proportions are to individual taste, because this is basically a stir-fried vegetable dish.

Calabacitas

4 medium green summer squash (zucchini is most readily available),
cubed
2 small green chiles, chopped
1 small onion, chopped
1 clove garlic, minced
3 tablespoons cooking oil
1 small can drained whole kernel corn
1 cup milk
salt and pepper to taste

Fry squash, green *chile*, onions and garlic in oil until tender. Add corn and milk and simmer for 15 minutes. Season to taste. For a different taste, add 1/2 cup grated Longhorn cheese before serving.

Serves 4.

POSOLE —HOMINY STEW

The Christmas season would not feel like Christmas without *posole* at holiday gatherings. Christmas would not be Christmas without a bowl of *posole* after Midnight Mass. And no New Year's Eve party can really herald the New Year without a large pot of *posole* simmering on the kitchen stove for the revelers. *Posole* is especially good with red chile poured on top.

Posole is similar to hominy in that it is made from large white corn kernels. Some people make *posole* with

canned hominy, but as usual, it does not taste as good. Any supermarket carrying a good supply of Mexican foods will have *posole*. Specialty Mexican delicatessens also will carry *posole*.

Posole

2 pounds posole *cooked until burst or 6 cups of canned hominy*
6 cups water
3 pounds lean pork, cut into chunks
1 small onion, chopped
2 cloves garlic, minced
1 teaspoon crushed oregano
3 tablespoons ground red chile *or 4 red* chile *pods*

Cook *posole* in water until it bursts or opens up. Drain water and save it. Boil meat until tender in the 6 cups of water. For added flavor this should be the same water used to burst the *posole*. Add burst *posole*, onions, garlic, oregano and ground *chile* to cooked meat and water. Let simmer for 30 minutes. Serve with red *chile*.

Serves 12.

Menudo is often referred to as the "breakfast of champions" because of its curative powers.

MENUDO

Menudo is a traditional tripe soup served in homes and restaurants throughout the Southwest. Many consider it a specialty food, with legendary medicinal and recuperative powers for anyone who has partied too long and too hard. Often a Sunday morning after an especially late Saturday night will begin with a bowl of *menudo*; it is often referred to as the "breakfast of champions" because of its curative powers. As with many traditional recipes, each family has its own *menudo* recipe that it swears is the real one.

Menudo

3 pounds honeycomb-cut tripe
6 cups water
shortening
2 tablespoons onion, chopped
2 cloves garlic, minced
2 tablespoons flour
1 tablespoon oregano
1 tablespoon chile powder
1 can peeled green chiles, chopped, or 4 chile *pods*
1 cup onion, chopped, for serving
salt to taste

Trim excess fat off tripe, then into small pieces. Cook in water until tender. Saute onion and garlic in a small amount of shortening. Add flour and brown slightly. Add cooked tripe, spices and *chile* and cook 30 minutes. Serve with chopped onions.

Serves 6.

ARROZ A LA ESPAÑOLA—SPANISH RICE

Rice is another basic staple of southwestern cuisine. Spanish rice is a common side dish, usually accompanying beans.

Arroz a la Española

2 tablespoons onions, chopped
1 clove garlic, minced
$^{1}/_{2}$ cup celery, chopped
1 cup uncooked rice
3 tablespoons shortening or olive oil
1 tablespoon parsley, minced
3 cups canned tomatoes, drained and chopped
salt and pepper to taste

Cook onion, garlic and celery in shortening or olive oil. Add rice and brown slightly. Add remaining ingredients. Cook covered over low heat and check after 15 minutes, adding water if necessary. Cook until rice is tender and liquid is absorbed.

Serves 6.

SOPAIPILLAS —FRIED BREAD

Sopaipillas have become a dessert specialty at many Mexican restaurants. They are very easy to make and are delicious eaten with honey, jam or powdered sugar. Native American fry bread and even French *beignets* are variations on the same idea—fried puffed dough eaten with sweetening. Some cooks and restaurants put cinnamon in the batter before cooking to vary the taste. It does produce a good-tasting treat, but true traditionalists think this practice ruins the *sopaipillas*.

Native American fry bread and even French *beignets* are variations on the same idea as *sopaipillas*—fried puffed dough eaten with sweetening.

Sopaipillas

4 cups flour
3 teaspoons baking powder
1 teaspoon salt
2 teaspoons sugar
3 tablespoons shortening
water as needed
cooking oil
paper towels

Sift flour, baking powder, salt and sugar together. Mix in shortening. Add water, about $^{3}/_{4}$ cup, and mix to make a dry dough. Let dough sit for 20 minutes. Roll out dough on floured board to about $^{1}/_{4}$ inch thickness. Cut dough into 3-inch squares, and fry in deep pan filled with hot oil. (Careful—hot oil may splatter.) Flip squares with fork or tongs until puffed and golden brown. When *sopaipillas* are cooked, remove from oil and drain on paper towels. Eat warm, covered with honey, or cut open and fill with honey.

Makes about 4 dozen.

EMPANADITAS — MINCEMEAT FRIED TURNOVERS

A favorite of the Christmas season, traditional *empanaditas* are sweet fried turnovers, filled with meat, nuts, spices and mincemeat.

There are two ways to make *empanaditas*, quick-and-easy or the traditional way. The quick-and-easy substitutes pie pastry for the *masa de empanaditas,* simplifying the process because the pie pastry is simply cut, filled, rolled closed and fried.

As with most changes to traditional recipes for convenience's sake, the results are pleasing in themselves but do not compare with the traditional taste. (A similar situation exists in restaurants, where *chile rellenos* [cheese-stuffed *chiles*] are made with egg-roll wrappers, instead of the more laborious but much better-tasting process of dipping them in floured egg batter before frying.)

The following recipe is for the traditional sweet *empanadita.*

Empanaditas

FILLING

2 pounds cooked beef, or 1 pound beef and 1 pound pork
2 cups prepared mincemeat, available at stores
1/2 teaspoon allspice
1 teaspoon nutmeg
1 teaspoon ground coriander
1/2 cup whole piñon or chopped pecan nuts
3/4 cup brown sugar
1 teaspoon salt
corn syrup as necessary

Boil meat until tender; let cool and grind fine. Add mincemeat, spices, nuts and sugar. If filling is too dry, add a little corn syrup to hold together.

MASA DE EMPANADITAS (DOUGH)

3 cups warm water
1 teaspoon dry yeast
1 tablespoon sugar
1 1/2 teaspoons salt
1 egg
4 tablespoons shortening
6 cups flour

Combine water, yeast, sugar and salt in mixing bowl. Mix until dissolved. Add beaten egg and shortening. Add flour and mix to form a smooth, dry dough. Roll out dough 1/8 inch thick on lightly covered board. Cut dough into 3-inch circles. Fill half of each cut dough circle with 1 heaping teaspoon of filling. Fold over the other half of each dough circle and pinch it. Use your judgment as to how full to fill the *empanadita;* you don't want it to burst open while frying, and make sure the filling is not too close to the edge of the dough. Deep-fry at 350° F until golden brown. As with *sopaipillas,* drain on paper towels when finished cooking.

Makes about 6 dozen.

BISCOCHITOS —ANISE COOKIES

These licorice and cinnamon-fla-
vored cookies are another favorite
treat of the Christmas season.

Biscochitos

6 cups flour
3 teaspoons baking flour
1 teaspoon salt
2 cups shortening
1 cup sugar
2 teaspoons anise
2 egg yolks
$1/2$ cup orange juice or water
cinnamon and sugar mixture

Preheat oven to 400° F. Sift flour, baking powder and salt together and set
aside. Cream shortening and sugar together. Add anise and beaten egg
yolk to shortening and sugar mixture. Add flour mixture and orange juice
or water to shortening mixture. Knead shortening and flour mixture until
well mixed. Roll out dough $1/8$ inch thick on lightly floured board, and cut
out with cookie cutter or with Christmas cookie cutters for special sea-
sonal shapes. Sprinkle with cinnamon and sugar mixture and place on a
greased cookie sheet. Bake for 8 to 10 minutes.

Capirotada —Bread Pudding

3 cups toasted bread, cut into small pieces
1 cup raisins
$1^1/2$ cups grated Longhorn cheese
1 cup brown sugar
2 tablespoons cinnamon
$1^1/2$ cups water
whipping cream

Preheat oven to 350° F. Place a layer of bread pieces in casserole dish.
Place a layer of raisins and cheese over bread layer; continue layering until
all bread, cheese and raisins are used. Dissolve brown sugar and cinna-
mon in water, and pour brown sugar mixture over bread mixture. Bake
until all liquid is absorbed. Serve with whipping cream!

Serves 6.

Flan Caramelisado—Caramel Flan

1 1/2 cups sugar for caramel custard
1 14-ounce can sweetened condensed milk
1/4 cup water
5 eggs
1 1/2 teaspoon vanilla

Preheat oven to 350° F. Caramelize sugar in a heavy skillet, using low heat until syrupy and golden brown. While still hot, pour into 1 1/2 quart mold, swish around to cover bottom and sides of pan. Set aside. Mix custard ingredients in order given, and pour into caramel-lined pan. Place in pan of hot water and bake for 1 hour. Cool for 10 minutes, and turn out into serving dish.

Serves 6.

ATOLE—BLUE CORNMEAL DRINK

The original use of blue corn in the New World was in the Aztec drink *atolli*.

Food made with blue corn has become very trendy recently. Restaurants featuring new southwestern cuisine have begun offering blue corn *enchiladas* as a featured dish, and a recent trip to the grocery store found blue corn flakes in the health food section!

The original use of blue corn in the New World was in the Aztec drink *atolli*. When the Spaniards arrived in the New World, they discovered this favorite Aztec drink made by grinding cornmeal into a light-flavored drink that was greatly enjoyed.

In the Spanish colonial years, atole was the drink of those who could not afford coffee or chocolate. Made from the same *masa* used for making *tortillas*, this *atole blanco*, white atole, was the poor people's drink throughout New Spain and the Southwest.

Today this Aztec drink continues in the Southwest as *atole*. People enjoy *atole* like the Aztecs did, as a light blue cornmeal drink, sweetened with sugar or honey. When flavored with chocolate it is called *champurrado*, and some people make it thick as a hot cereal in the winter months. Blue cornmeal can be found in any supermarket with a good supply of Mexican food.

Atole

1 cup water
1 cup blue cornmeal
1 cup milk
Sugar or honey

Mix the water and blue cornmeal together and heat over a low flame, stirring continuously to avoid lumps. Boil the mixture for about 5 minutes. Add the milk and boil for another 5 minutes. Continue to heat to the desired consistency. Sweeten with honey or sugar.

Serves 4.

Part VI

El Mundo: The Affairs of the World

La verdad padece pero no perece.
Truth suffers but does not perish.
Truth will endure.

The people of the Hispanic Southwest join Mexico in celebrating two Mexican holidays: *El Cinco de Mayo*, the fifth of May, and *El Diez y Seis de Septiembre*, the sixteenth of September. Each holiday commemorates an important historical event in Mexican history. *El Cinco de Mayo* is a holiday celebrating an important victory of the Mexican army over the French army, and *El Diez y Seis de Septiembre* is the Mexican Independence Day, similar to July 4 in the United States.

In Mexico, *El Diez y Seis de Septiembre* is the biggest national holiday in the country, while the celebration of *El Cinco de Mayo* is a secondary holiday not celebrated as largely as *El Diez y Seis de Septiembre*. In the southwestern United States, however, the celebration of *El Cinco de Mayo* has become a larger celebration than *El Diez y Seis de Septiembre*. The celebration of *Cinco de Mayo* in the United States has expanded in spirit to become a celebration of Hispanic culture itself and not just of an important Mexican historical event and is a much larger event in the Hispanic Southwest than in Mexico.

Both events in the United States, however, are marked with celebrations of cultural pride. Even though the events celebrated are Mexican in origin, people transform the celebration to a larger personal and community awareness of the beauty and strengths of Hispanic culture. School, churches, art centers and communities all sponsor parades, art shows, picnics, street fairs and dances to add to the *fiesta*. Print and TV media also contribute special articles and broadcast coverage for events of the celebrations. In addition, May and September both have become Hispanic culture months in schools.

Even though the events celebrated are Mexican in origin, people transform the celebration to a larger personal and community awareness of the beauty and strengths of Hispanic culture. School, churches, art centers and communities all sponsor parades, art shows, picnics, street fairs and dances to add to the *fiesta*.

22

El Diez y Seis de Septiembre

On September 16, 1810, Father Hidalgo rang the church bells at Dolores to gather his parishioners. He called for the expulsion of the *peninsulares,* the independence of Mexico and the end of the Indian tribute system.

In 1810 the Spanish had ruled Mexico for three hundred years. During that time, they had instituted tribute and land ownership systems that put *peninsulares,* pure-blood Spaniards born in Spain, in the elite ruling class. *Criollos,* pure-bred Spaniards born in Mexico, were second-class citizens in their own country; a system of slavery existed for Mexican Indians.

During the nineteenth century, *criollo* priests led the movement for Mexico's independence from Spain. They were educated members of colonial society and they were aware of Enlightenment ideas of individual worth and freedom from autocratic governments. France's defeat of Spain in 1808 filled the *criollos* with the French ideals of *liberte, igualite,* and *fraternite,* freedom, equality and fraternity. They resented *peninsulares* who kept them from rising in the church hierarchy. Even though they were *criollos,* they viewed themselves as equals to the *peninsulares.* They also held grievances against the church, which also favored *peninsulares.* Finally, they were in sympathy with the plight of the Mexican Indians.

The area of Querétaro was a center of the independence movement. Its conditions as a mining area and the harsh treatment of the Indian laborers in the mines contributed to the Querétaro people's aggressive stance toward independence. The leaders of the independence movement formed the Querétaro Society.

Father Miguel Hidalgo y Costilla, a *criollo* Catholic priest, was born in 1753 near Guanajuato. As a priest, he worked in Dolores and eventually became involved with teaching the Indians. He had mastered the Otomí Indian language of his parishioners and worked hard to improve their lives. He also was a member of the Querétaro Society and shared the belief that Mexico had a right to independence.

Father Hidalgo was an active participant in a plot to gain Mexico's independence from Spain. The plotters planned on forming an army, seizing towns and expelling the *peninsulares.* The members of the Querétaro Society chose Father Hildalgo to lead the independence movement.

After government officials discovered their plan, Father Hidalgo, along with three other independence leaders, decided to begin immediately the fight for independence. On September 16, 1810, Father Hidalgo rang the church bells at Dolores to gather his parishioners. He called for the expulsion of the *peninsulares,* the independence of Mexico and the end of the Indian tribute system. His followers went on to capture Guanajuato and other small towns, eventually marching on Mexico City.

He is remembered for the *Grito de Dolores*, the Cry of Dolores, calling for all patriots to begin the struggle for Mexican independence.

Father Hidalgo did not live to see Mexico's independence, for he was eventually captured and executed. Mexico independence fighters continued to struggle in their attempts to defeat royalist forces and establish an independent government, but it would be eleven years before Spain recognized Mexico's independence in 1821.

On the night of September 15 all of Mexico remembers Father Hidalgo's *Grito de Dolores* and calls out "*¡Viva Mexico! ¡Viva La Independencia!*," Long Live Mexico! Long Live Independence! Father Hidalgo is known as the father of Mexico, and *El Diez y Seis de Septiembre* is celebrated as Mexican Independence Day.

Figure 22.1. Father Miguel Hidalgo y Costilla standing before the church bell he rang at Dolores, Mexico, to begin the Mexican fight for independence.

23

El Cinco de Mayo

Since its independence in 1821, Mexico had experienced great civil strife and economic struggle under a series of governments and leaders.

After Mexico had finally gained independence from Spain in 1821, the concentration of wealth remained in the hands of an elite class of government and church rulers. The life of the Mexican Indian remained as poor as it always had been under the *encomienda* system of the pre-Independence era.

Benito Juárez, a Zapotec Indian, realized the injustice of the political and social system and fought for the equality for all Mexicans. Because of his efforts to establish equal justice for Mexican Indians, he has been referred to as the "Abraham Lincoln of Mexico."

Since its independence in 1821, Mexico had experienced great civil strife and economic struggle under a series of governments and leaders. It had also lost a disastrous war with the United States and ceded half of its land to its northern neighbor. When Juárez assumed leadership of Mexico, it was an economically bankrupt country torn apart by years of internal hostilities. Even the great silver mines had been allowed to stop production by previous governments. In order to have the time and resources to rebuild the Mexican economy, one of Juárez's first acts as president was to suspend the interest payments on the country's foreign debts. He also acted to institute the Constitution of 1857, which established a republican form

of government under which he was elected president. The constitution also ended special privileges and political power for the church and the ruling elite.

Mexico's refusal to pay the interest on its debts angered the European powers of England, Spain and France. At the time, Mexican conservatives, who were not in agreement with the idea that a republican form of government was best for Mexico, created political unrest in the country and tried to change the government of Mexico back to a conservative form with power in the hands of a ruling elite and the church. These conservatives also sought supporters in France to aid them in the overthrow of the elected Juárez government.

At the same time, France was seeking to establish an extension of its own empire in the Americas. Even though one tenant of the Monroe Doctrine of the United States was that no European power would establish a governmental presence in the Americas, France knew that the country was engulfed in its own civil war at the time and seized the opportunity to send an invading force to Mexico.

Juárez felt that he could assure the three countries that Mexico would honor its debts, but it needed time to establish a new government and rebuild its economy. Mexico

owed the largest debt to England: 69 million *pesos*. It owed 10 million to Spain; the smallest amount owed was 2 million to France. The Mexican Congress voted to support the debt moratorium, and both England and Spain eventually agreed to Mexico's request to delay debt payment. Only France denied the request for a debt moratorium and demanded payment.

Mexican conservatives, led by General Juan Almonte, the Mexican ambassador to France, had convinced Emperor Napoleon III to invade Mexico and establish a conservative government to rule in France's name. Napoleon agreed to send a French army of six thousand troops to invade Mexico under the leadership of the famous French general Charles Latrille.

Even though the French forces were vastly superior, the Mexican forces were in a desperate battle for their country. This realization and their valor and courage prepared the Mexicans for an astounding victory. Roberto Cabello-Argandoña, in his book *Cinco de Mayo: A Symbol of Mexican Resistance*, reports the stirring words Mexican General Ignacio Zaragoza used to encourage the Mexican fighters:

> Today you fight for something sacred. You shall fight for your Fatherland, and I promise you that this day's journey will bring glory. Your foes are the first soldiers of the world. But you are the first sons of Mexico. They have come to take your country away from you. Soldiers, I read victory and faith on your foreheads. Long Live Independence! Long Live the Fatherland! (1993, p. 61)

The French army was the greatest military force in the world at that time. Its soldiers were professional, well trained, well equipped and experienced in battle. The Mexican army, in contrast, was a peasant army, ill equipped and gathered together just to fight the invading French.

On May 5 the French army attacked the Mexican town of Puebla, intending to defeat easily the Mexican defenders and continue its march to Mexico City. Three times the French attacked the forts surrounding Puebla. And three times the Mexican army, under the leadership of General Ignacio Zaragoza, repelled the French army. Fighting valiantly, the Mexican army finally succeeded in defeating the vastly larger French army, forcing its retreat. The French army was stunned by its defeat. The Mexican army had won one of the most astounding victories in military history.

Napoleon III remained determined to conquer Mexico. In response to the defeat of his forces at Puebla, he sent an army of thirty thousand troops to restore France's efforts to conquer Mexico. Eventually, the immense size of the French forces proved victorious, and a year later Napoleon III placed Count Maximilian in Mexico City, establishing a French monarchy in Mexico. Juárez fled Mexico City with the vow to never give up the fight for his country.

In 1867 Juárez and his followers of Mexican loyalists finally succeeded in defeating the French and once again established Mexico as an independent nation. Count Maximilian was executed, the French left Mexico and Juárez resumed leadership of his country.

The victory at Puebla on May 5, 1862, came to symbolize the

On May 5 the French army attacked the Mexican town of Puebla, intending to defeat easily the Mexican defenders and continue its march to Mexico City.

strength, determination and national pride of the Mexican people. The victory of the Mexican army on that day was an important historical moment for the new country of Mexico. Through the years, the holiday of *Cinco de Mayo* has evolved in the United States from just a memorial of an important historical event to a more encompassing celebration of cultural pride and accomplishment. Benito Juárez's own words about the great victory at Puebla best represent the spirit of *Cinco de Mayo*, "Between two individuals as between nations, respect for another's rights is peace!"

LA BATALLA DE CINCO DE MAYO
The Battle of *Cinco de Mayo*

By Angel Vigil
Excerpted from *¡Teatro!*
Plays from the Hispanic Culture for Young People

Through the years, the holiday of *Cinco de Mayo* has evolved in the United States from just a memorial of an important historical event to a more encompassing celebration of cultural pride and accomplishment.

Submit inquiries for production rights and royalty information to Fulcrum Publishing, 350 Indiana Street, Suite 350, Golden, Colorado 80401-5093.

While the scenes of this play are fictionalized, the events dramatized in the play are factual and historically accurate, based on historical accounts of the *Cinco de Mayo* battle. Each scene is designed to convey an important set of facts representing the events leading up to and causing the Battle of Puebla. The statements and political positions taken by the principal characters are based on historical records and interpretations of historical events.

Cast of Characters

NARRATOR
BENITO JUÁREZ, president of Mexico
GENERAL IGNACIO ZARAGOZA, leader of the Mexican armies
GENERAL MIGUEL NEGRETE, a Mexican general
GENERAL COLOMBRES, a Mexican general
GENERAL ARRATIA, a Mexican general
GENERAL ROJO, a Mexican general
GENERAL ÁLVAREZ, a Mexican general
GENERAL PORFIRIO DÍAZ, a Mexican general
GENERAL CHARLES LATRILLE, leader of the French armies
GENERAL JUAN ALMONTE, the conservative Mexican ambassador to Paris
GENERAL HARO, a conservative Mexican general
NAPOLEON III, emperor of France
GENERAL DOBLADO, the Mexican secretary of state
COMMODORE DUNLOP, the British envoy
JEAN PIERRE DUBOIS, the French ambassador
GENERAL JUAN PRIM, a Spanish general
MEXICAN OFFICIAL #1
MEXICAN OFFICIAL #2
FRENCH OFFICIAL

Scene 1: The Office of Newly Elected Mexican President Benito Juárez

NARRATOR: The nineteenth century was a time of great historical importance for the new nation of Mexico. Mexico, known as New Spain during the Spanish colonial period, did not become an independent country until 1821. Mexico's independence day, similar to the United States' July 4 celebration, is September 16. That date commemorates the famous day in 1810 when a priest, Father Miguel Hidalgo y Costilla, began the series of events that would lead to Mexico becoming its own independent country and no longer being subject to Spanish rule. After its independence, Mexico tried several forms of government, from dictatorship to monarchy. During this time, the new nation of Mexico suffered from great civil strife and economic struggle. During this time, it also lost a disastrous war with the United States, in which it lost half of its land to the United States. Finally in 1857, Mexico established a government based upon a democratic form of government. Benito Juárez became Mexico's president and assumed the leadership of a country torn by years of internal hostilities and with its economy bankrupt. At the beginning of his term of office, President Juárez faced many difficult decisions.

(JUÁREZ and two Mexican OFFICIALS enter.)

OFFICIAL #1: President Juárez, we have received notice from Spain, England and France that they demand payment of our foreign debt.

OFFICIAL #2: It can't be a serious demand. They must realize that we are a new government of a country with no economic resources. Even our silver mines, which in the past served as a source of income, are no longer in production.

OFFICIAL #1: If only the previous governments had realized the mines' economic importance and not neglected the mining industry, we could now use the income from silver to pay these foreign debts.

JUÁREZ: But that is all wishful thinking. The facts are that Mexico's economy is bankrupt and that our country doesn't have the money to pay these debts.

OFFICIAL #1: There is word that they are going to invade Mexico.

JUÁREZ: Preposterous! Mexico is no longer a colony up for invasion and conquest. We are an independent nation recognized in the world community.

OFFICIAL #1: Mexican conservatives have been in France trying to gather support to overthrow your government, President Juárez.

JUÁREZ: Who has been doing these treasonous acts against the elected government of Mexico?

OFFICIAL #2: General Almonte is trying to convince the French court that it should establish itself in Mexico and return the country to conservative rule.

JUÁREZ: We will fight to the death all efforts to invade our country.

OFFICIAL #1: France is using our nonpayment of the foreign debt to her as a just cause for invasion.

JUÁREZ: What is the debt to the three countries?

OFFICIAL #1: The debt to England is almost 69 million *pesos*. The debt to Spain is almost 10 million *pesos*. The debt to France is 2 million *pesos*.

JUÁREZ: The debt to France is the smallest of all. It is almost insignificant compared with the debt to England. And yet she is the most demanding.

OFFICIAL #1: Almonte is behind this.

OFFICIAL #2: He has convinced Napoleon that we should be invaded.

JUÁREZ: There is only one course of action for us. We will have to declare a payment moratorium on all domestic and foreign debt for a period of two years. This will give us time to build and strengthen our economy.

OFFICIAL #1: The countries will still demand payment.

JUÁREZ: We will assure our world partners that we will religiously resume payments when circumstances allow it. These are agreements countries make in situations such as this one.

OFFICIAL #2: We will have to ask Congress to vote on the moratorium.

JUÁREZ: Of course, that is required by our new democratic constitution.

OFFICIAL #1: I don't think the French will agree to it. Almonte and his followers are determined to overthrow this government, and they have the ear of the French emperor.

JUÁREZ: These forces threaten the very survival and existence of our democratic government. War seems inevitable and Mexico is worth a battle, but we must do everything we can to avoid one.

(ALL exit.)

Scene 2: France, the Court of Napoleon III

NARRATOR: The Mexican Congress voted and supported the debt payment moratorium by a vote of 1,112 to 4. The moratorium was a democratic decision supported by the elected Congress of Mexico. This decision was vigorously attacked by the Mexican conservatives in Europe. At the court of the French Emperor, Napoleon III, Mexican conservatives have convinced the French to invade Mexico.

(NAPOLEON, ALMONTE and a FRENCH OFFICIAL enter.)

FRENCH OFFICIAL: We have received word that Juárez is declaring a stop to foreign payments.

ALMONTE: Mexico is politically weak. It is unable to pay these debts. Now is the time to establish France in the Western Hemisphere.

FRENCH OFFICIAL: Mexico is an independent nation. It is an act of war to invade a country and overthrow its elected government.

ALMONTE: But Mexico itself has delivered to us a "just cause" for intervention by not paying its foreign debts.

NAPOLEON III: Then we will invade Mexico and make it a part of France.

ALMONTE: It is in Mexico's best interest that you invade and help establish a more conservative government.

NAPOLEON III: The United States has declared the Monroe Doctrine stating that no European government shall interfere in the affairs of the Americas.

ALMONTE: The United States is right now deeply engaged in its own civil war and it will not have the will or resources to oppose your intervention. You will have a clear path to Mexico City.

NAPOLEON III: It is in France's best interest to invade Mexico. The United States has declared its Monroe Doctrine, but it has its own expansionist impulses. If it becomes the master of all of the Americas, it will be the only power from that area. But if a stable government is established in Mexico, with French assistance, then we have placed a dam to the expansion of the United States. It is our political and economic interests that compel us to march over Mexico and establish our flag.

FRENCH OFFICIAL: Juárez has vowed to defend Mexico.

NAPOLEON III: France has the mightiest armies in the world. We will send our most experienced troops under the command of one of our most experienced generals. Mexico's efforts will be of no consequence.

(ALL exit.)

Scene 3: The Office of Mexican President Benito Juárez

(JUÁREZ and two Mexican OFFICIALS enter.)

OFFICIAL #1: France, Spain and England have agreed to protect the life and property of their Nationals and to obtain collection of their debts.

OFFICIAL #2: The world press has criticized their positions, but the three countries are united behind enforced collection, and they are preparing to invade.

JUÁREZ: What are the conservatives saying?

OFFICIAL #1: They are supporting the invasion. They see it as the opportunity they have been seeking to overthrow the government. Their newspaper, *La Sociedad*, has spoken in favor of the invasion and describes our democratic government as corrupted tyrants.

JUÁREZ: What is the state of the invasion?

OFFICIAL #1: Spain has prepared three divisions under the command of General Gutiérrez. The troops number over six thousand men. They have occupied the castle of San Juan de Ulúa and the port of Vera Cruz.

OFFICIAL #2: The French have sent nine companies of their most experienced African troops. The British have also occupied Vera Cruz.

OFFICIAL #1: They have delivered an ultimatum to the Mexican government: collection or intervention.

JUÁREZ: Then we have but one response to this invasion of our country. We will enact a law condemning to death all invading forces in Mexican territory.

OFFICIAL #1: President Juárez, that is declaring war against the invaders.

JUÁREZ: I call on all Mexicans to bury the hatred that has divided us and to unite in the defense of a greater and more sacred cause for all men and our people: the defense of the fatherland.

OFFICIAL #2: Is there no other course?

JUÁREZ: We will give peace one last chance. Send General Doblado to the village of La Soledad to try to reach one last compromise with the invading armies.

(ALL exit.)

Scene 4: Negotiations for Peace

(As the NARRATOR begins the scene, DOBLADO, PRIM, DUNLOP, DUBOIS and ALMONTE enter. They set up in four distinct and separate areas on the stage. ALMONTE and DUBOIS are together in one area. The NARRATOR moves from one group to the other and discusses events with each set of characters. The characters hold frozen, tableau poses until engaged in the scene.)

NARRATOR: General Doblado met with representatives of the invading countries in order to negotiate a possible peace. Here we have Spanish General Juan Prim. He was the selected representative of the invading forces. Next we have General Juan Almonte, the Mexican conservative. He is with the French ambassador Jean Dubois. Finally, we have the British envoy, Commodore Dunlop.

DOBLADO: *(Speaking to PRIM.)* Then it is agreed.

PRIM: Yes, we will sign the document known as the Agreement of La Soledad. In it we will recognize the government of Benito Juárez and the sovereignty of Mexico.

DOBLADO: In turn, we will allow the invading troops to relocate from the yellow fever infected city of Vera Cruz. And we give you our government's assurances that Mexico will resume payment of its debt to your countries. *(He goes to COMMODORE DUNLOP.)* Commodore Dunlop, the Mexican government has reached an agreement with Spanish General Prim and we also give the British government our assurances that the Mexican government will resume its payments to England.

DUBOIS: *(Speaking to ALMONTE.)* Doblado has assured the Spanish and English representatives that it will repay its foreign debt.

ALMONTE: The Emperor Napoleon has assured me that France is committed to a path of intervention. Even though Mexico's debt to France is by far the smallest debt, that debt is a "just cause."

DUBOIS: You are here under the protection of the French fleet and you have been appointed dictator of Verz Cruz. In addition, there are Mexican conservative troops supporting the invasion.

ALMONTE: Napoleon III is determined to overthrow the Mexican government and establish a French monarchy in Mexico. He has selected the Austrian Maximilian von Hapsburg to be the monarch of Mexico.

DUBOIS: He has placed General Charles Latrille as the commander of over six thousand French troops. With his thirty years of army service and eleven campaigns, he is one of France's most experienced and successful generals. We will use the same road to Mexico City that Cortés used centuries ago to conquer Old Mexico. Our path is already determined.

PRIM: The Spanish government is satisfied with the Mexican government's assurances of repayment. We will withdraw our troops from Mexican land.

DUNLOP: Even though our debt is by far the largest, the English government is also satisfied with the Mexican government's assurances of repayment. We too will withdraw our troops from Mexican land.

DUBOIS: France does not accept the Mexican reassurances on the debt payments, and our intention is to establish a French monarchy in Mexico.

DOBLADO: The French intentions are clear and they leave Mexico no choice. The constitutional government, the guardian of the Republic, will meet force with force and shall wage war to the end, as justice is its cause.

Scene 5: The City of Puebla

NARRATOR: England and Spain did withdraw their troops from Mexico. France, however, continued its military march to Mexico City. Between the French and Mexico City stood the City of Puebla. The French General Charles Latrille was so confident in his army's military superiority and so dismissive of the Mexican defense, that he made an arrogant statement that would come to destroy his military career.

(LATRILLE enters and addresses the audience.)

LATRILLE: We have over the Mexicans the superiority of race, of organization, of discipline, of morality and morale, and to further show our excellence, I say to our emperor, that from this time, at the head of six thousand soldiers, I am the master of Mexico. (He exits.)

NARRATOR: As the French approached Puebla, Mexican General Ignacio Zaragoza met with his generals to plan the defense of the city. One of his generals was Porfirio Díaz, who would one day become president of Mexico.

(ZARAGOZA enters with his GENERALS.)

ZARAGOZA: Generals, let me hear your reports on your preparations for battle. Today is May 4, and as we speak the French are preparing to battle tomorrow. I have already sent General O'Horan with four thousand soldiers to meet the conservative forces sixty miles from Puebla and to block their advance.

NEGRETE: Sending O'Horan with those forces leaves us with a smaller force than the French. We will be outnumbered.

ZARAGOZA: Both our size and inexperience will be our greatest weakness tomorrow. But the traitorous conservative forces must not join with the French or our cause will be even more outnumbered.

NEGRETE: But O'Horan's troops include the best units of the Mexican cavalry.

ZARAGOZA: General Álvarez will command five hundred riders in our defense. Their bravery and valor will teach the French about Mexican courage.

COLOMBRES: I have commanded troops to build fortifications around the forts of Guadalupe and Loreto.

ZARAGOZA: We will make those forts the focus of our defense of Puebla.

COLOMBRES: We have fortified old churches and estates and we have dug trenches and constructed obstacles to the French troops. The forts are ready.

DÍAZ: I will command an infantry division between the two forts. We will defend the forts with infantry and cannons.

ZARAGOZA: Good.

NEGRETE: I will occupy and defend the hills surrounding the forts.

ARRATIA: My men and I are in place to defend Fort Loreto.

ROJO: And I am ready to defend Fort Guadalupe.

ZARAGOZA: Generals, now it is time to prepare the troops for the defense of our homeland. The resistance that this nation so far has offered is almost nothing. It is a shame that we have such a small contingent of troops to fight the foreign enemy. For this reason, we must all commit ourselves to die in our positions, because it is not logical to aspire for victory with such a small, ill-equipped army, but we shall inflict the greatest damage. Today you shall fight for something sacred. You shall fight for your fatherland, and I promise you that this day's journey will bring you glory. Your foes are the first soldiers of the world, but you are the first sons of Mexico. They have come to take your country away from you. Soldiers, I read victory and faith on your foreheads. Long Live Independence! Long Live the Fatherland!

(ALL exit.)

Scene 6: Outside the City of Puebla in the French General's Headquarters

NARRATOR: Zaragoza and his generals were ready to defend their homeland. French General Latrille was also planning his attack on the fortifications at Puebla. But his reasoning was affected by his arrogance and his desire to demonstrate French superiority. His dismissal of the advice of Mexican conservative generals would spell his defeat.

(LATRILLE enters with Mexican conservative generals ALMONTE and HARO.)

ALMONTE: General Latrille, we have learned that Zaragoza has built fortifications around the Forts of Loreto and Guadalupe. Also Guadalupe is higher on a hill and will be more difficult to attack.

HARO: Even though he has less men, these are very strong fortifications and they will be difficult to take.

LATRILLE: I am anxious to show the world the superior military skills of the French troops.

ALMONTE: It is our advice that you avoid Fort Loreto and Fort Guadalupe and that you attack from the southern and eastern flanks.

HARO: They are less protected and offer the greatest chances of breaking through.

LATRILLE: It does not matter where we attack. We are the greatest military force in the world. Our soldiers are professional, well equipped, well trained and experienced in battle.

ALMONTE: But Zaragoza is also experienced, and his troops have fought valiantly and defeated the conservative forces before. He has great power over his troops, and his men will fight to the death for him.

LATRILLE: Well this time he is facing French troops, not your Mexican troops. We also have the best military strategists, so I do not think I will be needing your advice on how to win the battle. I have instructed Commandants Cousin and Morand to make a frontal assault on Fort Guadalupe. We will begin our assault tomorrow, the fifth of May.

(ALL exit.)

Scene 7: *Cinco de Mayo*

NARRATOR: A Mexican conservative, Francisco Arangois, wrote, "The contempt of the French senior officers for the advice of Mexican conservatives has been the cause of many obstacles during this campaign." These words, and the actions of the French General Latrille, accurately describe the disregard the French had for all things Mexican. At eleven o'clock on the fifth of May, the Mexican forces began the defense of their homeland.

(ZARAGOZA and his GENERALS enter.)

ZARAGOZA: The French have begun the attack.

NEGRETE: Genera Zaragoza. The French are not attacking from the eastern flank of Puebla as we had anticipated. All our forces are arranged to defend an attack from the east.

ZARAGOZA: I sent Comandante Martínez and his sixty raiders of the cavalry battalion out to engage the French troops first, and I can tell by the dust in the sky from their horses that the French are attacking Guadalupe first.

NEGRETE: It goes against all good military sense, but they are making a frontal attack on Fort Guadalupe.

ZARAGOZA: Generals, marshal your forces to defend Guadalupe!
(ALL exit.)

NARRATOR: The French had indeed decided to attack Fort Guadalupe. In his arrogance, Latrille had decided to go for the dramatic victory and glory. His decision was built on the fact that he had never considered the possibility that the Mexican forces could win. Three times the French forces attacked Fort Guadalupe. Three times the Mexican forces fought back desperately. Three times the French forces had to retreat under heavy fire and sustained casualties. Realizing that he had been defeated, General Latrille ordered a full withdrawal of the French troops. On the fifth of May, at the City of Puebla, the Mexican force defending their homeland from foreign invaders had defeated the mighty French forces. History records best what happened after the battle.
(JUÁREZ, ZARAGOZA and NAPOLEON enter.)

ZARAGOZA: After the victory at Puebla, I wrote President Juárez. I told him, "The French army has fought gallantly, however its general has acted clumsily. On this long battle, the Mexican troops never turned their backs to the enemy. The armies of the nation have been covered with glory." (He exits.)

NAPOLEON III: Defeated by the Mexicans! My plans stopped! This will not be. I will replace that disgraced Latrille with Supreme Commander Bazine and this time I will send thirty thousand troops! (He exits.)

NARRATOR: Napoleon did send thirty thousand troops to Mexico and a year later he succeeded in placing Count Maximilian in Mexico City and establishing a French monarchy in Mexico.

JUÁREZ: In three years of dedicated battle, the loyal Mexican forces finally defeated the French once and for all. In 1867 the French left Mexico and Mexico once again was an independent nation.

NARRATOR: The victorious General Zaragoza never lived to see his beloved Mexico free, however. A few months after his mighty effort, General Zaragoza died. To commemorate this valiant general, Mexico renamed the city he defended with his life *La Ciudad de Puebla de Zaragoza*, the City of Puebla-Zaragoza. Even the French

came to admire the unbreakable will of the Mexican soldiers. In 1863, a Paris newspaper said, "The defense of Puebla-Zaragoza was one of the greatest in the history of warfare." President Benito Juárez's famous quote summarizes the historic efforts of the Mexican forces at the Battle of Puebla-Zaragoza on *Cinco de Mayo*.

JUÁREZ: Between two individuals as between nations, respect for another's rights is peace!

THE END

Appendix 1

Traditional Songs

Appendix 1 contains the music for three traditional songs. The three melodies are used for songs in the play *Cuentos* in Chapter 17.

LA LLORONA

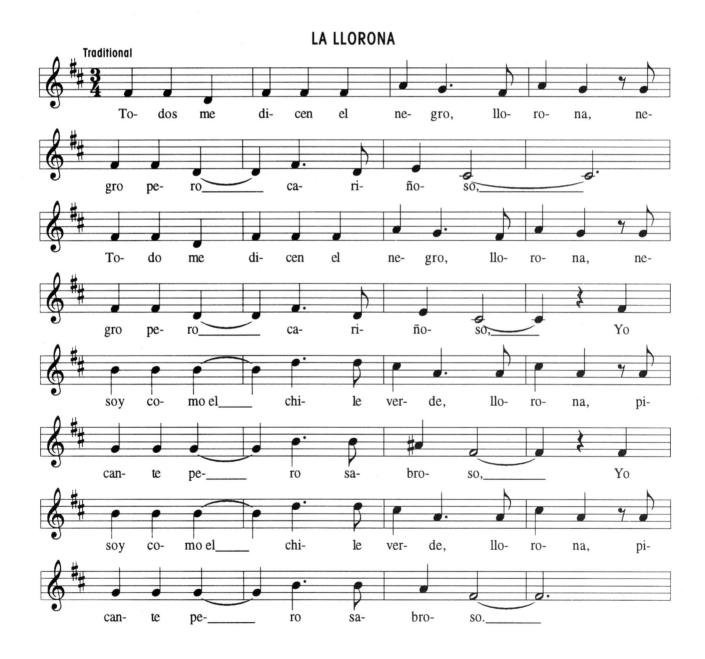

Todos me dicen el negro, llorona, negro pero cariñoso,

Todo me dicen el negro, llorona, negro pero cariñoso, Yo

soy como el chile verde, llorona, picante pero sabroso, Yo

soy como el chile verde, llorona, picante pero sabroso.

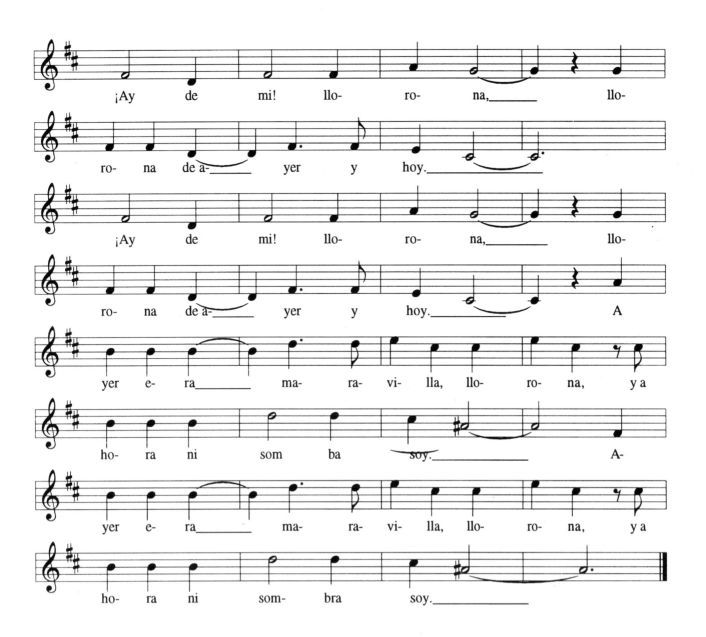

JUAN CHARRASQUEADO

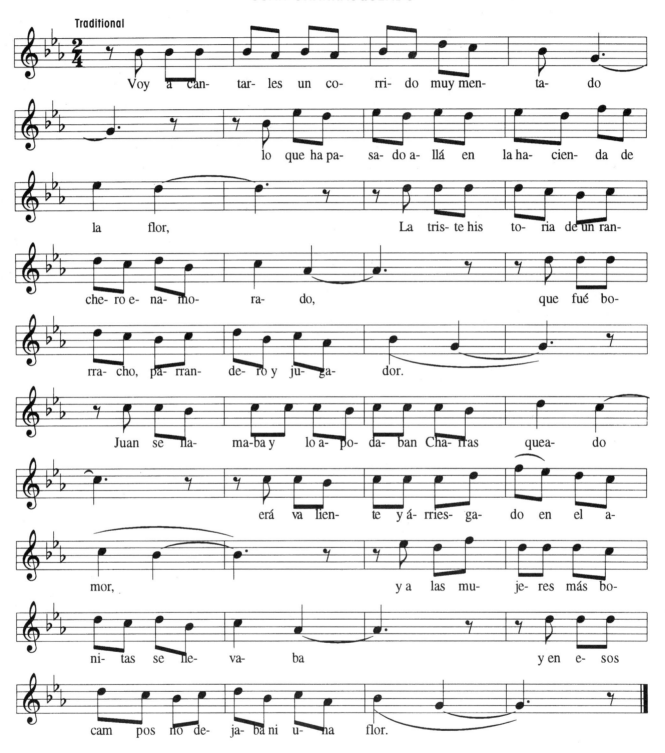

Voy a can-tar-les un co- rri- do muy men- ta- do
lo que ha pa- sa- do a- llá en la ha- cien- da de
la flor, La tris- te his- to- ria de un ran-
che- ro e- na- mo- ra- do, que fué bo-
rra- cho, pa- rran- de- ro y ju- ga- dor.
Juan se lla- ma- ba y lo a- po- da- ban Cha- rras quea- do
erá va lien- te y á- rries- ga- do en el a-
mor, y a las mu- je- res más bo-
ni- tas se lle- va- ba y en e- sos
cam pos no de- ja- ban i u- na flor.

Reprinted from *Hispanic Folk Music of New Mexico and the Southwest* by John Donald Robb, University of Oklahoma Press, Norman, Oklahoma, © 1980. Used by permission.

VALENTÍN DE LA SIERRA

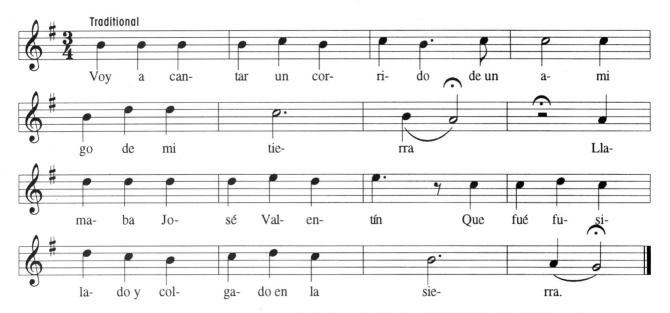

Voy a can- tar un cor- ri- do de un a- mi
go de mi tie- rra Lla-
ma- ba Jo- sé Val- en- tín Que fué fu- si-
la- do y col- ga- do en la sie- rra.

Reprinted from *Hispanic Folk Music of New Mexico and the Southwest* by John Donald Robb, University of Oklahoma Press, Norman, Oklahoma, © 1980. Used by permission.

Appendix 2

Recommended Movies

Movies can offer wonderful additional insight into Hispanic culture. I have included a list of significant movies for the reader who enjoys this art form and who is interested in additional ways to gain insight and understanding into the heart and soul of the Hispanic people. Each movie offers an individual and artistic interpretation of Hispanic life in the United States, presenting part of the great mosaic of the Hispanic experience. And, of course, each is a must-see.

These movies are extensions and enhancements of the information presented in this book, and they give cinematic expression to the cultural and historical context within which Hispanic traditions flourish.

Each movie offers an individual and artistic interpretation of Hispanic life in the United States, presenting part of the great mosaic of the Hispanic experience.

Salt of the Earth: The classic 1954 semidocumentary account, based on true events, of a bitter strike of Chicano workers in zinc mines in New Mexico. One of the first films to feature Chicano actors playing Chicanos, the movie was a rallying point for the 1960s Chicano movement. The movie was also one of the first major American films to present minority workers and their causes with dignity and understanding. It was blacklisted in the McCarthy era.

¡Alambrista!: The deeply moving story of a Mexican youth who illegally immigrates to the United States, the movie realistically and painfully depicts his struggle to maintain a sense of pride and dignity. It clearly presents the social and economic difficulties and injustices of life at the bottom of the American dream.

El Norte: An amazing movie. Surreal, lyrically beautiful, frightening. The story of two Guatemalan refugees, a brother and sister, who dream of going to *El Norte,* the land to the north, America. The movie tells of their harrowing journey and noble but tragic efforts to have part of the American dream.

The Ballad of Gregorio Cortez: The true story of the most famous manhunt in Texas history, and the subject of one of the most well-known *corridos* in *Tejano* music, it is based upon the groundbreaking study of Mexican-American folklore, *With a Pistol in His Hand: A Border Ballad and Its Heros,* by Américo Paredes. A good historical presentation of Hispanic life at the turn of the century and a sobering look at Anglo law and justice of that era.

Chulas Fronteras and Del Mero Corazon: Two documentaries (both on the same videocassette) about Tex-Mex *conjunto* music in southern Texas. *Chulas*

Fronteras features *conjunto* music and *Tejano* culture, showing food preparation, family life, dances, fieldwork and other social activities. *Del Mero Corazon* explores the Mexican-American *Nortena* music tradition, showing various performers in dance halls and cantinas. If you love Tex-Mex *conjunto* music, you have to see these films.

The Milagro Beanfield War: The movie version of the John Nichols book of the same title. An energetic and funny story of a group of northern New Mexico families who stand up and wage battle against greedy and insensitive land developers. A very good depiction of the life and culture of northern New Mexico.

Zoot Suit: The film version of the Luis Valdez musical about the 1940s race riots in Los Angeles. A culturally and artistically successful musical that went to Broadway, the movie is part documentary, part history, part social and cultural analysis, featuring the energetic song and dance of the fabled zoot-suit era. Valdez billed the show "A New American Musical."

Stand and Deliver: The true story of Jaime Escalante, a math teacher in East Los Angeles, who guides a class of Chicano students to educational success. An important film about education and the critical need for teaching Chicano *barrio* students.

La Bamba: Another Luis Valdez film, this one is the biography of the first Chicano rock star Ritchie Valens. Music by the great Chicano band Los Lobos.

Mi Familia: Mi Familia is the story about three generations of the Sanchez family from the 1920s to the 1980s. The movie covers the familiar territory of a Mexican family that comes to America and its struggle to make a successful life. By the director of *El Norte*.

Lone Star: A challenging, complex and engaging film, this movie is about life at the Texas-Mexican border. Accurately creates the feeling of life in border towns. Depicts the cultural tension of these towns and the stuggles of immigrants to find their way in America.

Glossary

Abuelita. Grandmother

Actos. One-act Chicano plays with political or social statements

Adios. Good-bye

Adivinanzas. Riddles

Adobe. Mud and straw brick used in southwestern construction

Agua. Water

Aguinaldos. Little gifts

Ajenjibre. Ginger

Ajo. Garlic

Alabados. Religious songs, mournful hymns, often associated with members of the fraternity of Penitentes.

Álamo asuco. Poplar

Albácar. Basil

Alfalfa. Alfalfa

Alhucema. Lavender

Amigo. Friend

Amole. Yucca root

Ancianos. Old ones, elderly

Ante pasados. Ancestors

Apurense. Hurry up

Arbolario. Healer who specializes in casting out evil spells

Arriba. Up, get up

Arroz. Rice

Artes. Arts

Atole. Blue corn drink

Atolli. Aztec word for a cornmeal drink

Baile. A social dance, also the dance and reception of the courtship and wedding ceremony

Bajo sexto. Twelve-string guitar

Barba de maíz. Corn silk

Barrio. Chicano neighborhood

Belén. Bethlehem

Blanco. White

Boda. Wedding

Bolero. Musical form with romantic lyric content common to mariachi music; "slow couples dance music"

Borracho. Drunk

Brujas. Witches (the belief in witches is part of a complex supernatural legend system in Latino culture)

Bueno. Good, well

Cacahuates. Peanuts

Caliente. Hot

Caló. Spanish-English urban street dialect

Cancioneros. Spanish *romance* songs

Canela. Cinnamon

Capulín. Wild cherry

Caravelas. Spanish galleons (large Spanish ships of the fifteenth and sixteenth centuries)

Carpa. Mexican tent play

Carreta de la muerte. Hand-carved wooden cart; the death cart of Doña Sebastiana

Cascabeles. Sleigh (jingle) bells

Cascarones. Eggshells

Casorio. Actual wedding of the courtship and wedding ceremony

Cebolla. Onion

Cempasúchil. Aztec Nahuatl name for marigold, the "flower of the dead," used in celebrations of *día de los muertos*

Chambelán de honor. Young man who escorts the honoree at the *Quinceañera*

Chambelánes. Young men who are escorts at the *Quinceañera*

Champurrado. Chocolate-flavored cornmeal drink

Charro. A rural horseman from Jalisco, a traditional Mexican horseman

Chicos. Dried corn kernels cooked in beans

Chile colorado. Red chile

Chile con carne. Chile with meat

Chile rellenos. Cheese-stuffed green chile, fried in an egg batter

Chile ristras. String of chiles

Chile verde. Green chile sauce

Chistes. Short anecdotal stories, usually with a comic twist at the end

Arriba. Up, get up

Cilantro. Coriander

Cocina. Kitchen

Colcha. Quilt

Comida. Meal

Commedia dell'arte. Italian theater form from the Renaissance, characterized by masks, zany energy, traveling troupes and improvisational comical and satirical plots

Compadre. Godparent of one's child; more commonly, a very close friend

Compradrazco. System of naming a child's godparents

Con. With

Conchero. Dancers who perform the traditional and sacred Aztec dances

Conjunto. Musical ensemble featuring accordion and polka music

Conquistadores. Spanish soldiers and explorers

Copal. A resin incense

Copla. Most common verse structure of Hispanic music: four lines to a verse, eight syllables to a line

Corridos. Narrative song

Criados. Native American servants of the Spanish

Criollos. Pure Spaniard, born in the New World

Cuentista. Storyteller

Cuento. Story

Cuetlaxochitl. Aztec name of the poinsettia plant

Cuialli. Aztec school of song and dance

Cupil. Headdress of the dancers in *los matachines*

Curanderismo. Practice of Hispanic folk medicine

Curandero. Healer; person who has the knowledge of the healing powers of plants and natural substances

Curar. To heal

Damas. Young women who are escorts at the *Quinceañera*

Despedida. Final, farewell verse of a *corrido*

Diablo. Devil

Dichos. Proverbs

Duendes. Mischievous wandering spirits or dwarfs.

El Diablo. The devil

Elote. Corn

Encomienda. Spanish land grant system

Entregador. The singer who sings the verses of the *entriega de novios*

Entriega de novios. Delivery of the newlyweds; a part of the Hispanic wedding ceremony in which the newly wedded couple is presented to their families, and they receive the blessing and advice of their families. Also consists of verses sung and accompanied by violin and guitar

Es. Is, it is

Familia. Family

Farolitos. Candle-lit paper bags

Fiesta. Celebration

Flor. Flower

Flor de Santa Rita. Indian paintbrush

Folklórico. Mexican traditional dance

Frijoles. Beans

Gato. Cat

Gracias. Thank you

Grito. Yell or cry

Guaje. Gourd rattle used in the dance of *los matachines*

Guitarrón. Six-string bass guitar

Hacienda. Estate

Hermana. Sister

Hermano. Brother

Hijos. Children, sons

Hojalateros. Mexican-Indian tin artists

Horno. Traditional outdoor oven made with adobe bricks

Iglesia. Church

Incensario. Incense burner

Independencia. Independence

Indio. Indian

Indio-Hispano. Indian-Hispanic; a term recognizing the mixed nature of a culture containing both Indian and Hispanic influences

Indita. Spanish narrative song influenced by Indian rhythms

Inmortal. Antelope horns

Jarabe. Mexican dance style

Jarana. Guitar-like stringed instrument

Jerga. Rough-wool woven rug

Jita. Diminutive form of *hija*, daughter; term of endearment

La Gloria. Heaven

La Llorona. The Weeping Woman

Lazo. Rope or lasso

Lecheros. Milkweeed

Leña. Firewood

Leñero. Firewood seller

Lengua del toro. Bull's tongue

Linda. Beautiful, pretty

Listones. Ribbon and material hanging from the back of the headdress in the costumes of the *los matachines* dancers

Lo siento. I'm sorry

Criollos. Pure Spaniard, born in the New World

Loco. Crazy

Luminarias. Small bonfires; also refers to candle-lit paper bags

Madrina. Maid of honor at a wedding

Maíz. Corn

Mal de ojo. Curse caused by a harmful look

Mamacita. Term of endearment for mother

Mande. Command me; order me to do a task; at your command

Manito. Diminutive form of *hermano;* term describing the descendants of Spanish colonialists in southern Colorado and northern New Mexico

Mano. Handheld stone used for grinding corn

Mantas. Spanish term for Native American woven cotton cloth

Manzanilla. Chamomile

Masa. Corn dough

Matraca. Rattle used to accompany an *alabado*

Médico. Healer who combines the knowledge of natural remedies with religious practices

Mestizo. Person of mixed Indian and Spanish heritage

Metate. Concave stone used for grinding corn

M'hijos. My children

Milagro. Miracle

Mis. My

Monte. Mountain

Mota. Slang for marijuana

Mucho. Very

Muerte. Death

Mulatto. Person of mixed African and Spanish heritage

Mundo. World

Muralistas. Muralists

Nahuatl. Aztec language

Nichos. Niche or holder for a santo or other religious object, often made of tinwork

Nopal. Cactus

Nuestras raíces. Our roots

Ofrenda. Altar decorated for the Day of the Dead celebration.

Ojo de Dios. God's eye; a folk craft of yarn wrapped around a cross

Oregano. Oregano

Oshá. Root of wild celery

Padre. Father, a priest

Padrino. Child's godparents, the best man at the wedding

Padrino de arras. Attendant who gives the bride and groom a box with gold or silver coins in it in a traditional wedding

Padrino de lazo. Attendant who wraps an ornamental rope around the bride and groom in a traditional wedding

Palito. Little stick

Palma. Three-pronged fan representing the Holy Trinity used in the dance of *los matachines*

Pan de Muertos. Special bread baked for the *Día de los Muertos* celebrations

Papel picado. Cut-paper decoration

Para. For

Partera. Midwife

Pastores. Shepherds

Patron. Owner of a *hacienda*

Pedimiento. Proposal part of the courtship and wedding ceremony

Pelado. Mexican theater comic character

Peninsulares. Pure Spaniards born in Spain

Peones. Native slave workers on *haciendas*

Peso. Basic Mexican monetary unit

Piñon. Pine tree that provides piñon nut, a favorite edible nut of the region

Pito. Reed flute used to accompany *alabados*

Placa. Nickname

Plaza. Central square typical of Spanish cities

Poeta. Poet

Poncho. Woolen blanket with a hole in the middle, worn pulled over the head

Ponte trucha. Slang for "get wise," "wise up" or "keep your eyes and ears open"

Posada. Inn

Posole. Hominy stew

Prendorio. Engagement party of the courtship and wedding ceremony

Puro. Purely, totally, completely

Que delicioso. How delicious

Que no. Idiomatic phrase for "don't you think so?" or "isn't it?"

Que viva. Hurrah

Quinceañera. Girl's fifteenth birthday celebration

Raíces. Roots

Rancheras. Mexican rural "ranch" folk music

Ratoncitos. Little mice

Raza. People, race

Rebozo. Mexican shawl

Rellenos. Cheese-stuffed green chile fried in an egg batter

Peso. **Basic Mexican monetary unit**

Remedios. Remedies

Retalbo. Altar piece

Rio. River

Ristra. String of red chile, usually hung outside the home

Rito. Archaic Spanish for river

Romances. Oldest style of southwestern Hispanic music; a narrative ballad of Spanish origin

Rosa de castilla. Rose

Sabanilla. Light, plain, white-wool woven cloth, the backing for *colcha* embroidery

Sabor. Flavor

Santero. Sculptor who carves small wooden religious statues called *santos.*

Santos. Small wooden carvings of Catholic saints and religious figures

Sarape. Mexican blanket worn as a poncho

Savana. Sheet or plains

Señor. Mister, sir

Señora. Married elder woman

Señorita. Unmarried or young woman

Sí. Yes

Sin verguenza. Without shame, shameless, scoundrel, rascal

Sobadora. Healer specializing in bodily manipulations

Sones. Most typical style of mariachi music

Sopa. Soup

Suave. Slang for "cool"

Tamales. Chile and meat wrapped in steamed cornmeal dough

Teatro. Theater

Tejano. Spanish name for Mexican-Texan culture

Tia. Aunt

Tilma. Poncho or sarape

Tio. Uncle

Toloache. Jimson weed

Tololoche. Stand-up string bass

Tsihuri. Mexican Huichol god's eyes

Un. A, one

Valses. Waltzes

Vato. Street dude

Vayanse. Go

Veintenas. Aztec calendar festival days

Velorio. Funeral wake

Vengan. Come

Vibora. Snake

Vieja. Old woman

Viejo. Old man

Vihuela. Small round-back five-string guitar

Virgen. Virgin of Guadalupe

Yerba. Herbs

Yerba buena. Mint

Zambos. Person of African and Indian heritage

Zapateado. Characteristic heel-toe Mexican dance step common to *sones* and *jarabes*

Zarzuelas. Spanish operetta

Zorra. Fox

Suave. Slang for "cool"

BIBLIOGRAPHY

This bibliography contains commentary for each entry on its merits as a reference to help the reader in making decisions on which reference to utilize for further and more in-depth research. The comments are also meant as guides for the reader interested in selecting references for more casual pleasure-reading.

Acordándose del Pasado, Extenderse al Futuro (Remembering the Past, Reaching for the Future). Pueblo, Colo.: El Escritorio, 1995. A varied and interesting small collection of folklore. The booklet presents a folklore research model and publication example that is perfect for schools and communities.

Aranda, Charles. *Dichos: Proverbs and Sayings from the Spanish*. Santa Fe: Sunstone Press, 1977. A small collection of folk proverbs. Contains all the common and well-known *dichos*. A good beginner's or children's collection.

Boss, Gayle, and Cheryl Hellner. *Santo Making in New Mexico, Way of Sorrow, Way of Light*. Washington, D.C.: Potters House Press, 1991. A beautiful presentation of the art, craft and spirituality of *santeros*.

Boyd, E. *New Mexico Santos: Religious Images in the Spanish New World*. Santa Fe: Museum of New Mexico Press, 1995. A beautiful small book with illustrations and short descriptions of forty-one *santos*. An excellent reference book. Also, a really cool cover!

_____. *Popular Arts of Spanish New Mexico*. Santa Fe: Museum of New Mexico Press, 1974. Extensive presentation of Hispanic traditional arts and crafts. Scholarly discussion of origins, history and artistic practices. Excellent color plates of traditional arts. The first large comprehensive ethnographic study of the material folk culture of New Mexico Hispanic culture.

Bright, Brenda Jo, and Liza Bakewell, eds. *Looking High and Low: Art and Cultural Identity*. Tucson: University of Arizona Press, 1995. An extremely interesting collection of essays examining the expressions of ethnic art, especially in Hispanic and Native American communities. Read it to be challenged with new intellectually stimulating ideas about the relationships between high art, popular art and ethnic culture. Ms. Bright's Ph.D. dissertation was on lowriders!

Brose, David A., comp. *Do Not Pass Me By: A Celebration of Colorado Folklife*, vols. I & II. Two thirteen-part radio series documenting musical (vol. I) and narrative (vol. II) folk traditions of Colorado. Compiled from field recordings by David A. Brose. Available on cassettes through the Colorado Council on the Arts Colorado Folk Arts Program, 750 Pennsylvania, Denver, CO 80203. An eclectic mix of singers, instrumentalists and storytellers. Gives voice to what is only described in books.

Cabello-Argandoña, Roberto. *Cinco de Mayo: A Symbol of Mexican Resistance*. Encino, Calif.: Floricanto Press, 1993. A small easy-to-read presentation of the historical events of *Cinco de Mayo*. Also contains Mexican poetry about *Cinco de Mayo*.

Campa, Arthur L. *Hispanic Culture in the Southwest*. Norman: University of Oklahoma Press, 1979. A classic scholarly book. A must for every collection on the Southwest.

Especially thorough presentation of the historical development of the area. A good book to begin your collection.

Campbell, Richard C. *Two Eagles in the Sun*. Las Cruces, N. Mex.: Two Eagles Press International, 1995. Extensive information about the Hispanic Southwest presented in an engaging and accessible question-and-answer format. Covers culture, history and politics. A good book for the generalist and casually interested person.

Caso, Alfonso. *The Aztecs: People of the Sun*. Norman: University of Oklahoma Press, 1958. An excellent history of the Aztec culture and society. One of the classic texts on Aztec culture. Detailed colorful illustrations of Aztec gods; especially good discussion of the Aztec gods and cosmology.

Champe, Flavia Walters. *The Matachines Dance of the Upper Rio Grande*. Lincoln: University of Nebraska Press, 1983. An excellent reference book on the *matachines* dance. Scholarly analysis of history and development. Detailed diagrams of dance steps and formations. Historical documentary photographs.

Chavez, Fray Angelico. *My Penitente Land*. Albuquerque: University of New Mexico Press, 1974. A deep heartfelt presentation about the spirit of the Hispanic Southwest.

Cobos, Rubén. *Refranés: Southwestern Spanish Proverbs*. Santa Fe: Museum of New Mexico Press, 1985. Very complete collection—more than sixteen hundred—of folk proverbs. Very helpfully indexed by subject.

Cockcroft, Eva, John Weber, and James Cockcroft. *Toward a People's Art: The Contemporary Mural Movement*. New York: E. P. Dutton, 1977. A very informative book written at the height of the mural movement. Written from the perspective of both the scholar and the active mural artist. Covers the complete mural movement in the United States, not just the Chicano movement. Interesting section on children's mural art.

Coles, Robert. *The Old Ones of New Mexico*. Albuquerque: University of New Mexico Press, 1973. Very highly recommended. Essays and wonderful photography of the Hispanic elderly.

Colorado Endowment for the Humanities. *Recuerdos del Pasado, Recollections of the Past*. An eight-tape cassette program on the Spanish presence in the Southwest, from the sixteenth through the nineteenth centuries. Available from Exceptional Student Training Institute, R. B. Payne, Box 134, San Luis, CO 81152. Narrative tapes covering southwestern Hispanic history and culture. Easy listening, well produced, very informative.

Coulter, Lane, and Maurice Dixon, Jr. *New Mexican Tinwork*. Albuquerque: University of New Mexico Press, 1990. A magnificent book on a little-explored traditional art. Exhaustive research. Insightful historical analysis. Beautiful photography.

Díaz del Castillo, Bernal. *The Discovery and Conquest of Mexico, 1517–1521*. London: George Routledge & Sons, 1928. A vivid eyewitness account of the Mexico conquest by one of Cortés's soldiers, written fifty years after the historic events. Detailed, in-depth, astounding recollection. This is as good as a personal account of history gets. Several translations exist; the more recent, the easier to read.

Dickey, Roland F. *New Mexico Village Arts*. Albuquerque: University of New Mexico Press, 1990. Very enjoyable and easy-to-read essays on traditional southwestern Hispanic culture. Good coverage of traditional arts in daily village life.

Duggan, Anne Schley, Jeanette Schlottman, and Abbie Rutledge. *Folk Dances of the United States and Mexico*. New York: Ronald Press Company, 1948. Presents historical and background information on traditional Mexican dances. Includes music notation and illustrated diagrams of steps for dances. Costume color plates also.

Espinosa, Aurelio. J. Manuel Espinosa, ed. *The Folklore of Spain in the American Southwest: Traditional Spanish Folk Literature in Northern New Mexico and Southern Colorado*. Norman: University of Oklahoma Press, 1985. A detailed collection of information on all aspects of Hispanic culture. Another must-have book for your collection.

Flores, Richard R. *Los Pastores: History and Performance in the Mexican Shepherd's Play of South Texas*. Washington, D.C.: Smithsonian Institute Press, 1995. A scholarly examination of the *los pastores* play. The author spent two years performing the play with a south Texas community. Excellent personal observations as well as academic analysis of the meaning of the play in Hispanic culture.

Frank, Larry. *New Kingdom of the Saints: Religious Art of Northern New Mexico, 1780–1907.* Santa Fe: Red Crane Books, 1992. A coffee-table book on the *santo* tradition of the Spanish colonial era. Extraordinarily beautiful photography. Scholarly informative essays on classic *santos* through the early twentieth century.

Galván, Roberto A., ed. *The Dictionary of Chicano Spanish.* Lincolnwood, Ill.: National Textbook Company, 1995. A dictionary of the Spanish spoken in the U.S. Southwest. Includes words, slang and expressions not found in standard references. Also includes a section on *dichos*, folk proverbs.

Glazer, Mark, ed. *A Dictionary of Mexican American Proverbs.* New York: Greenwood Press, 1987. An immense and scholarly collection of folk proverbs.

Hoobler, Dorothy and Thomas Hoobler. The *Mexican American Family Album.* New York: Oxford University Press, 1994. A thorough presentation of the history of Mexican Americans in the United States. Contains many period photographs and personal narratives and does read like a family album. A very interesting way to present history.

Huerta, Jorge. *Chicano Theater: Themes and Forms.* Tempe, Ariz.: Bilingual Press, 1982. A detailed scholarly presentation on the history and practice of Chicano theater; provocative discussion of its cultural importance.

Kalb, Laurie Beth. *Crafting Devotions: Tradition in Contemporary New Mexico Santos.* Albuquerque: University of New Mexico Press, 1994. A beautiful book. Discusses the history, development, tradition and craft of s*antos*. Special profiles on *santeros*. Excellent photography.

Kanellos, Nicolás, ed. *Mexican American Theatre: Legacy and Reality.* Pittsburgh: Latin American Literary Review Press, 1987. A fascinating collection of "you must read these" essays on Mexican-American theater. Covers theater as a cultural, historical and political force. Even includes an essay on the Mexican-American circus in the Southwest.

———. *Mexican American Theatre: Then and Now.* Houston: Arte Publico Press, 1983. A small academic discussion of Mexican-American theater. Good discussion of little-known theater groups.

Lankford, Mary D. *Quinceañera: A Latina's Journey to Womanhood.* Brookfield, Conn.: Millbrook Press, 1994. A children's picture book about the *quinceañera*. Many excellent photographs giving the reader a clear idea about the preparation and ceremony of the *quinceañera*.

Miller, Robert R. *Mexico: A History.* Norman: University of Oklahoma Press, 1985. There are many books about the history of Mexico. This is one of the most thorough and easiest to read. In historically detailed text, covers all the ground from the ancient indigenous cultures to the turmoil of the modern area. But the writing style is a great improvement over the usual dry and dense academic treatment of history. Enjoyable reading for the history buffs and layperson alike.

Moore, Michael. *Los Remedios, Traditional Herbal Remedies of the Southwest.* Santa Fe: Red Crane Books, 1990. A very thorough presentation of traditional herbal remedies. Describes the uses and preparations for a wide variety of medicinal plants used in the Southwest. Covers both traditional and recently recognized medicinal herbs. One of the few books to address the issue of toxicity in herbal remedies. An excellent resource.

Museum of International Folk Art. *Spanish Textile Tradition of New Mexico and Colorado.* Series in Southwestern Culture. Sante Fe: Museum of New Mexico Press, 1979. A deeply informative collection of essays about the history, textiles and techniques of Hispanic weaving. Many quality photographs of representative textiles.

Myres, Sandra L. *Westering Women and the Frontier Experience, 1800–1915.* Albuquerque: University of New Mexico Press, 1982. A unique in-depth and scholarly examination of western history during the frontier days, with an emphasis on women's experiences.

Newall, V. *An Egg at Easter.* London: Routledge & Kegan Paul, 1971. A fascinating book about the egg and the symbolic and ritualistic role it has played in world cultures. Discusses in great detail world history, myth and legends, cultural rites and traditional practices of decorating eggs in cultures throughout the world. Beautiful color plates also included.

Pearlman, Steven R. "Mariachi Music in Los Angeles." Ph.D. Diss. Los Angeles: University of California, 1988. Ann Arbor: University of Michigan, 1988. 8907580. A doctoral dissertation on mariachi music in Los Angeles. Emphasis on the origins and development of mariachi music, musical analysis of mariachi music and the culture and social structure of mariachi groups in the Los Angeles area.

Peña, Manuel. *The Texas-Mexican Conjunto*. Austin: University of Texas Press, 1985. A fascinating, scholarly, in-depth study of *conjunto* music. Covers the origins and development of the music as well as its founding and most influential musicians. Also examines the cultural and social interaction of *conjunto* music and Mexican-Texan culture.

Philippus, M. J., and John F. Garcia. *The Two Battles of Cinco de Mayo*. Denver: Education Foundation, 1990. Another small and easy-to-read text on the history of *Cinco de Mayo*.

Rael, Juan B. *Cuentos Españoles de Colorado y Nuevo Méjico*. New York: Arno Press, 1977. The classic and definitive collection of Hispanic folktales. Hundreds of complete tales in original Spanish, with accompanying story synopses in English.

Rietstap, J. B. V. & H.V. Rolland's *Illustrations to the Armorial General*. Baltimore: Heraldic Book Company, 1967. A multivolume reference of family-name crests. Thousands of entries, very complete. Illustrations of each crest entry. The best reference for looking up your family crest.

Robb, John Donald. *Hispanic Folk Music of New Mexico and the Southwest*. Norman: University of Oklahoma Press, 1980. Very detailed and scholarly presentation of traditional music forms. Extensive verse and music notation. In-depth essays on origins and development of music and traditions. A true reference book on the subject.

Robe, Stanley L., ed. *Hispanic Folktales from New Mexico: Narratives from the R. D. Jameson Collection*. R. D. Jameson Collection, Folklore Studies, 30. University of California Press, 1977. A good collection of folktales. Tales in English, mostly in synopsis form. Easy reading.

_____. *Hispanic Legends from New Mexico: Narratives from the R. D. Jameson Collection*. Berkeley: Folklore & Mythology Studies, 31. University of California Press, 1980. Another good collection of folk legends and lore. Easy reading.

Rodríguez, Antonio. *A History of Mexican Mural Painting*. New York: G. P. Putnam's Sons, 1969. A magnificent coffee-table book. A complete work of in-depth scholarship. Extensive analysis and discussion of the history, development and leading painters of the Mexican mural movement. Hundreds of photographs.

Rogovin, Mark, Marie Burton, and Holly Highfill. *Mural Manual: How to Paint Murals for the Classroom, Community Center, and Street Corner*. Boston: Beacon Press. 1973. An excellent resource book covering all aspects of creating public murals. Clear instructions and advice for the artist, educator and community activist.

Romero, Brenda M., Lorenzo Trujillo, and Bea Roeder. "Canciones del Pasado, Los Días." Denver: KUVO Radio, 1995. A concise, scholarly article on *Los Días*.

Salinas-Norman, Bobbi. *Indio-Hispanic Folk Art Traditions*., vols. I and II. Albuquerque: Piñata Publications, 1987. Informative and good presentation of Hispanic Day of the Dead and Christmas traditions. Excellent activity guides.

Schindler, Kurt. *Folk Music and Poetry of Spain and Portugal*. New York: Hispanic Institute in the United States, 1941. Music arrangements of Spanish folk music.

Schwendener, Norma, and Averil Tibbels. *Legends and Dances of Old Mexico*. New York: A. S. Barnes and Company, 1933. An old you'll-only-find-it-in-your-public-library book. Worth the search, however. Legends about the musical accompaniments to and origins of Mexican dances. Costume illustrations and step diagrams included.

Sedillo, Mela. *Mexican and New Mexican Folkdances*. Albuquerque: University of New Mexico Press, 1935. Another small, old and hard-to-find book, but also worth the search. History of the dances. Costume illustrations. Music notation. Step diagrams. Simple but more than sufficient.

Thompson, Stith. *The Folktale*. New York: Holt, Reinhart, & Winston, 1946. The classic academic book on folktales. Also good for its discussion of folk culture.

Toor, Francis. *A Treasury of Mexican Folkways*. New York: Crown Publishers, 1947. A true classic. An immensely detailed presentation of Mexican society, life and culture. An extraordinarily valuable and complete resource. Photographs, color plates, musical scores.

Townsend, Richard. *The Aztecs*. London: Thames & Hudson, 1992. An excellent scholarly study of Aztec history, society and culture. Comprehensive, well researched, enjoyable reading.

Trotter II, Robert T., and Juan Antonio Chavira. *Curanderismo: Mexican American Folk Healing*. Athens: University of Georgia Press, 1981. Good reading for someone interested in a more in-depth, reflective discussion. Emphasis on the examination of the spiritual, psychological and cultural meaning of folk healing, not just information on the actual practices of *curanderismo*.

Trujillo, Lorenzo. "Hispanic Tradition, Folkloric Music and Dance." *Ayer Y Hoy*, Issue 13. Taos, N.Mex.: Taos County Historical Society, 1992. Scholarly article on Hispanic dance traditions. Detailed dance descriptions of two traditional dances with musical arrangements.

Trujillo, Lorenzo, and Marie Oralia Trujillo. *"La Entriega de Los Novios."* *Ayer Y Hoy*, Issue 19. Taos, N. Mex.: Taos County Historical Society, 1995. An easily readable scholarly article on *la entriega*.

Tushar, Olibama López. *The People of El Valle: A History of the Spanish Colonials in the San Luis Valley*. Pueblo, Colo.: El Escritorio, 1992. Wonderful and personal book with an interesting history of publication. Insightful chapters on the historical settling of the Southwest.

Valdez, Luis and Teatro Campesino Staff. *Luis Valdez—Early Works: Actos, Bernabe and Pensamiento Serpentino*. Houston: Arte Publico Press, 1992. A collection of Luis Valdez's early plays written during his United Farm Workers' days.

_____. *Zoot Suit and Other Plays*. Houston: Arte Publico Press, 1992. Another collection of Luis Valdez plays.

Vigil, Angel. *The Corn Woman: Stories and Legends of the Hispanic Southwest*. Englewood, Colo.: Libraries Unlimited, 1994. An award-winning collection of folktales from the Aztecs to modern times. Includes discussion of origins and development of oral traditions. Beautiful photographs of Latino art commissioned for the stories.

_____. *¡Teatro! Hispanic Plays for Young People*. Englewood, Colo.: Libraries Unlimited, 1996. Fourteen short, easy-to-produce plays for elementary and junior high students. Folktales, Hispanic historical and seasonal celebrations. A good resource for the elementary and junior high school teacher and youth leader.

Weigle, Marta, and Peter White. *The Lore of New Mexico*. Albuquerque: University of New Mexico Press, 1988. Very detailed scholarly presentation of Hispanic culture. Many interesting photographs. Another good addition to your collection.

West, John O., ed. *Mexican American Folklore*. Little Rock, Ark.: August House, 1988. Excellent presentation of Hispanic culture. Easy reading, detailed, scholarly. Another good addition to your collection.

Wroth, William, ed. *Hispanic Crafts of the Southwest*. Colorado Springs, Colo.: Colorado Springs Fine Arts Center, 1977. A museum exhibition catalog. Extensive and thorough discussion of traditional arts and crafts. Good historical essays. Many illustrations and photographs of both arts and artists. Puts the traditional arts in the context of practicing artists.

_____. *Weaving and Colcha from the Hispanic Southwest*. Santa Fe: Ancient City Press, 1985. A good hands-on, how-to presentation of two traditional arts. Little discussion of the history of the art; emphasis is on the practice. Many line art illustrations of traditional patterns.

Index

ABOUT THE AUTHOR

photo by Jan Pelton

Angel Vigil is chair of the Fine and Performing Arts Department and director of Drama at Colorado Academy in Denver, Colorado. He is an accomplished performer, stage director and teacher. As an arts administrator he has developed many innovative educational arts programs for schools and art centers. In his work in theater he has directed more than one hundred productions for school, community and professional theaters.

Angel is an award-winning educator and storyteller, and he has appeared at national storytelling festivals throughout the United States. His awards include the Governor's Award for Excellence in Education, a Heritage and Master Artist Award, a COVisions Recognition Fellowship from the Colorado Council on the Arts and the Mayor's Individual Artist Fellowship from the Denver Commission on Cultural Affairs.

Angel is the author of *The Corn Woman: Stories and Legends of the Hispanic Southwest*, winner of the New York Public Library Book for the Teen Award for 1995. He is also the author of *¡Teatro! Hispanic Plays for Young People*. He cowrote *Cuentos*, a play based on the traditional stories of the Hispanic Southwest. He is featured storyteller on the audiotape *Do Not Pass Me By: A Celebration of Colorado Folklife*, a folk arts collection produced by the Colorado Council on the Arts.

838013

DATE DUE

JUN 2 9 2001		
OCT 2 2 2001		
DEC 0 6 2001		
JAN 1 9 2004		
SEP 0 7 2002		
NOV 0 9 2004		
JUL 2 6 2007		

Demco, Inc. 38-293